Art by the Book

Art by the Book

Painting Manuals and the Leisure Life

in Late Ming China

J. P. Park

A CHINA PROGRAM BOOK

University of Washington Press

Seattle and London

THIS BOOK IS MADE POSSIBLE BY A COLLABORATIVE GRANT
FROM THE ANDREW W. MELLON FOUNDATION.

Publication of this book has been aided by a grant from the Millard Meiss Publication Fund of the
College Art Association.

Publication of this book is also supported in part by the James P. Geiss Foundation; the China
Studies Program, a division of the Henry M. Jackson School of International Studies at the
University of Washington; and the Eugene M. Kayden Endowment at the University of Colorado.

UNIVERSITY OF WASHINGTON PRESS
P.O. Box 50096, Seattle, WA 98145 U.S.A.
www.washington.edu/uwpress

LIBRARY OF CONGRESS
CATALOGING-IN-PUBLICATION DATA
Park, J. P.
Art by the book : painting manuals and the lei-
sure life in late Ming China / J. P. Park. — 1st.
 p. cm.
Includes bibliographical references and index.
ISBN 978-0-295-99176-4 (cloth : alk. paper)
1. Art and society—China—History—Ming
dynasty, 1368–1644. 2. Painting, Chinese—
Handbooks, manuals, etc. 3. China—Social
life and customs—960–1644. I. Title. II. Title:
Painting manuals and the leisure life in late
Ming China.
N72.S6P313 2012 759.951'09031—dc23
2011039283

ハイデルベルク、三軒茶屋、私の美しい高松

Contents

Plates follow page 178

Acknowledgments

S OMETIME IN LATE 2002, I WAS HAVING A CASUAL CONVERSATION WITH A historian of Japanese art at the University of Michigan. I don't recall the exact context, but for some reason our conversation turned to the topic of links between Chinese and Japanese art. Among the issues we discussed, one topic, the export of Chinese painting manuals to Japan in the Edo period, became a particular interest of mine, once I realized how little I knew about it. Late Ming painting manuals apparently were one of those areas that everybody in the field had heard of and talked about, yet, surprisingly, resources about them remained few and far between. Just out of curiosity, I began to research them, and I soon identified one work that was the starting point of the painting manual fervor in late Ming China. After one semester's consideration and research, I chose this as my new primary research focus, and it has proved a fruitful and rewarding topic. Over the past few years, I have discovered a range of new information and ideas on the genre, and this volume is my report on the history and significance of the manuals.

My research has led me from country to country, from city to city, and to various archives to study these publications and other relevant materials. I am especially grateful for the assistance of Dr. Mi Chu Wiens at the Library of Congress in Washington, D.C., Kilja Dacosta Song and Dr. Nathalie Monnet at the Bibliothèque nationale de France (BnF), Tsao Huei-chung at the Musée Guimet in Paris, Liu Qiang at the Qinghua University Library, Mr. Ma Xiao-He at the Harvard-Yenching Library, Dr. Martin Heijdra and Dr. Soren Edgren at the Princeton University Library, Mr. Wu Ge at the Fudan University Library, Mr. Zhao and Ms. Dong Rui at the National Library of China in Beijing, Maki

Kimura at the Nara National Museum, Willow Chang at China Institute in New York, Li Yuting at the National Palace Museum in Taipei, Christer von der Burg at the Muban Foundation in London, and Hiroko Ishida at Hiroshima Central City Library.

I also have appreciated the resources at the Peking University Library rare book collection and its helpful and patient staff, who bore up so well through my yearlong investigations into a number of the collections housed there. The library and storage staff at the Arthur M. Sackler Gallery and Freer Gallery of Art must also be thanked for allowing me access to their unparalleled collection of materials. I also want to express my sincere gratitude to Jiang Wenxin for her help with arranging my research at the Shanghai Library Rare Book Collection. In addition, the New York Public Library, the C.V. Starr East Asian Library at Columbia University, Zhejiang Library, Huadong Teacher's University Library in Shanghai, Nanjing Library, Nanjing University Library, Beijing Capital Library, Kexueyuan Library, Renmin University Library, Shandong Provincial Library, Nagoya Hosa Bunko, Toyo Bunka Kenkyuso at Tokyo University, and Eisei Bunko and the National Archives of Japan in Tokyo all kindly opened their doors and allowed me to study their rare book collections. All of this research was made possible by generous fellowships and opportunities granted by various institutions, including the Princeton University Library, Peking University, the Freer Gallery of Art, the University of Michigan, Columbia University, and the Metropolitan Center for Far Eastern Art Studies in Kyoto.

I owe a debt to my mentor, Martin J. Powers, which I don't think I can ever repay. I gained a great deal of knowledge and insight from him, not only in our occasional meetings, but also during conversations at local pubs in Ann Arbor or on market streets in Beijing. He must be warmly credited for shaping me into the scholar I have become. I also owe a special debt of gratitude to Professor David Rolston for sharing his rigorous scholarship on late Ming literature, the mastery of which will remain my lifetime dream. Professors Shuen-fu Lin and Celeste Brusati offered both sincere support and intellectual challenges, which I will always remember as a model of mentorship. Professor Craig Clunas at Oxford University also kindly offered his insights about my project, which were a tremendous asset as I moved toward its completion. I must also acknowledge the interest and comments of other professors at the University of Michigan: Elizabeth Sears, Alex Potts, Megan Holmes, Margaret Root, Pat Simons, James Lee, Mark Elliott, and William Baxter. I also hold in tremendous respect Professors Ahn Hwi-Joon, Kim Young-Na, and Rhi Ju-Hyung at Seoul National University, who first introduced me to art history.

I would like to thank the scholars and teachers I met during my field research. Professor Gu Xinyi was my field adviser at Peking University, and she has won my utmost veneration in every respect. Over the course of my year there, she taught me the details of traditional scholarship and recent research methodology, which I never could have learned elsewhere. My loyal friend Wu Yang at Renmin University in Beijing definitely deserves more than a thank-you here. He was not only my drinking buddy in smoky bars and restaurants in Beijing but also a mentor who introduced me to so many research skills and topics I could never have learned elsewhere. His friendship and support have been a huge asset in the completion of this research. Professor Shen Pei at Peking University and Mr. John Wang at the Freer Gallery of Art shared their special skills on decoding seal scripts. Professor Dorothy Ko at Barnard College and Dr. Ellen Laing at the University of Michigan kindly helped me with clarifying my direction and perspectives in the early stages of my research. Stephen Allee and Joseph Chang made significant contributions to my research, providing lots of useful comments and suggestions during my year-long residency at the Freer Gallery. In addition, Professors Robert Harrist at Columbia University, James Cahill at University of California, Berkeley, Katherine Burnett at University of California, Davis, Alfreda Murck at the National Palace Museum, Katherine Carlitz at University of Pittsburgh, Tamara Bentley at Colorado College, and Chen Zhenghong at Fudan University all took time to discuss their research with me and offered helpful insights on my project. While I was in Japan, Professor Kobayashi Hiromitsu at Sophia University in Tokyo kindly introduced me to many important archives.

Two anonymous readers of my manuscript and their comments helped me tremendously in the final revision of this book. Modern Language Initiative copy editor Laura Iwasaki offered many constructive suggestions, which improved the text. I also appreciate my editor, Terre Fisher, for her keen observations and insightful suggestions about writing style. Michelle Wang at Georgetown University kindly helped me with the final proofreading. My colleagues at the University of Colorado at Boulder—Garrison Roots, Kirk Ambrose, Bob Nauman, Deborah Haynes, Keum Hyun Han, and many others—also offered much in the way of collegial support over the past few years. I also greatly appreciate Lorri Hagman, executive editor at the University of Washington Press, for creating this opportunity to bring my manuscript to print. Parts of this book were previously published in different versions in the *Chinese Historical Review* and *Artibus Asiae*.

From the time I first decided to pursue a life in art history scholarship, my parents, Chul Kyu Park and Soo Young Lee, have always encouraged and supported

me. I will be forever grateful for their belief in me. The years spent researching and writing this book have definitely been the most interesting and stimulating period in my life. The people I met, the streets I wandered, the libraries and museums I entered, and every page of the century-old books I turned over the past few years all over the world now come to a conclusion here. This book will be my personal reminder of these precious and memorable experiences . . . especially those in Heidelberg and Sangenjaya.

Chronology of Chinese Dynasties

Shang dynasty, ca. 1600–1045 B.C.E.
Zhou dynasty, 1045–256 B.C.E.
Qin dynasty, 221–206 B.C.E.
Han dynasty, 206 B.C.E.–220 C.E.
 Former (Western) Han, 206 B.C.E.–8 C.E.
 Wang Mang Interregnum, 8–23
 Later (Eastern) Han, 25–220
Three Kingdoms, 220–265
 Wei, 220–265
 Shu, 220–265
 Wu, 222–280
Western Jin dynasty, 265–317
Eastern Jin dynasty, 317–420
Northern and Southern Dynasties, 420–589
Sui dynasty, 589–618
Tang dynasty, 618–907
Five Dynasties, 907–960
Song dynasty, 960–1279
 Northern Song, 960–1127
 Southern Song, 1127–1279
Yuan dynasty, 1260/1279–1368
Ming dynasty, 1368–1644
 Jiajing reign period (1522–1566)
 Longqing reign period (1567–1572)
 Wanli reign period (1573–1620)
Qing dynasty, 1644–1911

Art by the Book

Introduction

William Shakespeare, a Great Painter?

A good painter does not demonstrate his talent by painting.

—Li Rihua (1565–1635)

AROUND THE TURN OF THE SEVENTEENTH CENTURY IN CHINA, A LARGE
number of how-to-paint publications emerged and quickly achieved
unprecedented levels of popularity among the public. Simple statistics
on such publications throughout Chinese history clearly demonstrate that the
last century of the Ming dynasty (1368–1644) was the apex of painting manual
culture. From the seventh century, when wood-block printing was invented in
China, to the end of the mid-Ming, roughly around the 1550s, only a couple of
painting manuals had been published and printed; however, that number shot up
to easily two dozen between 1570 and 1620, a number far greater than all those
published before and after this fifty-year period.[1] Their number forcefully indi-
cates the public's growing interest in the practice of art in late Ming society.

This peculiar development suggests the close implication between the prolif-
eration of painting manuals and the cultural environment of the late Ming. As a
special commodity of early modern China, when people's cultural standing was
measured by their command of literati taste and lore, painting manuals provided
the growing reading public with a device for enhancing its social capital. Through
their textual and pictorial guides, these books were designed to meet the public's
desire to acquire artistic taste, technique, knowledge, and sensibility, all of which
were promoted as prerequisites of elite status. Therefore, this book will examine
how painting intersected with the changing cultural and social landscape of the

3

time and, ultimately, with social positioning and the subjectivity of superiority. The fundamental question of investigation will be "Why did it become so important to possess artistic talent in late Ming China?"

William Shakespeare, a Great Painter?

The late Ming scholar-official Li Rihua noted, "Wang Xianzhi [344–386], Xie An [320–385], Tao Hongjing [456–536], Huang Changrui [1079–1118], Sima Guang [1019–1086], Chao Wujiu [1053–1110], and Zhang Yu [1283–1350] were all good at painting, but that was not made known through their paintings. However, [their paintings] surpassed those by known painters, in some cases, even ten or one hundred times more superior."[2] Like his father, Wang Xizhi (303–379), Xianzhi was a well-known calligrapher in his day, whose work has been admired throughout Chinese history. Considering his excellence in brushwork, it is probable that he actually could have been good at painting, yet it is an odd truth that no art historical record ever listed him as a painter.

Also mostly ignored in historical writings prior to Li Ruhua's comment are Xie An, a scholar of the Eastern Jin dynasty (317–420); the Liang dynasty (502–557) Daoist philosopher Tao Hongjing; Song dynasty (960–1279) scholar-officials Huang Changrui, Sima Guang, and Chao Wujiu; and a Yuan dynasty (1279–1368) calligrapher, Zhang Yu. Had their talent in painting been recognized as Li claimed, why should their names not have appeared in the earlier art historical texts, including Zhang Yanyuan's (815–875) comprehensive account of artists before the ninth century, *A Record of the Famous Painters of Successive Dynasties* (Lidai minghua ji), and later publications on artists and their works such as *Experiences in Painting* (Tuhua jianwen zhi) by Guo Ruoxu (act. 1070s) and *Precious Mirror of Painting* (Tuhui baojian) by Xia Wenyan (act. 14th century)? Anyone familiar with Chinese art and culture would not consider any of these men an artist. Why should Li Rihua have asserted that they were good painters when it is more than obvious that none of them was held in special esteem for that type of work? Is this an isolated record by a late Ming cognoscente who erroneously attributed the identity of artist to renowned figures of the past?

Surprisingly, Li Rihua was not alone in this matter. A number of late Ming writers produced statements that diverge from what is known of Chinese art. One, Shen Defu (1578–1642), narrated, "Heroes and sages have the ability of grasping the world not seen by our naked eyes. In the past, many notable scholar-officials were immersed in the art of ink and brush, yet only few were known for their painting skills. During the Three Kingdoms period (220–265), Zhuge

Liang (181–234) and his son, Zhuge Zhan (227–263) were both good painters, thus they had unique status [distinctive from their contemporaries]."[3] Zhuge Liang, a legendary genius, military strategist, statesman, and chancellor of the Shu Kingdom (220–265), has been venerated for his wisdom, insight, and loyalty throughout Chinese history. Then, by the brush of Shen Defu, he suddenly acquired the added reputation of being a good painter. This is not impossible to believe, but it seems less than probable.

A similar kind of statement is found in a record on Zhuge's contemporary, the fierce warrior-general Zhang Fei. A modern scholar, Deng Tuo, excavated a Ming record stating that Zhang Fei loved painting beauties and excelled in cursive-style calligraphy.[4] The more such claims that come to light from this era, the more dubious they seem. On the basis of no reliable evidence, these writings re-identify many historical figures—politicians, philosophers, and even generals—as renowned and skillful artists. This is roughly equivalent to a hypothetical situation in which Joseph Addison (1672–1719) might characterize military generals and writers of the past, such as Hannibal (247–183 B.C.E.), Dante Alighieri (1265–1321), and William Shakespeare (1564–1616), as great painters without providing a shred of evidence.

A modern Chinese scholar has noted that these comments reflect late Ming scholars' misinterpretations of old texts or their inadvertent misconstruing of the art historical past.[5] This may explain the surface of the practice, but it does not address its cultural rhetoric or social semantics. Then, what drove late Ming art critics to make such provocative propositions? To whom were they addressing these comments? And if, as Li Rihua claimed, a good painter did not prove his talent by painting, what would be the alternative way of demonstrating his artistic chops? By such comments, many of Chinese history's most renowned officials and scholars, previously unheralded for artistic accomplishments, assumed a new identity in Ming times. The embedded rhetoric in this claim is that history has proved that the identity of the accomplished gentleman is tied to artistic talent and creativity. Or, put another way, "If you are a man of literary, political, or military merit, you must know how to paint."

Nonetheless, things get more complicated with the discovery that some late Ming critics left records about actual paintings supposedly attributed to these names. Chen Jiru (1558–1639), Zhan Jingfeng (1519–1602), and Li Rihua documented paintings by three philosophers and politicians of the Song dynasty— Wang Anshi (1021–1086), Zhu Xi (1130–1200), and Sima Guang. For example, Li Rihua stated, "Sima Guang's small landscape painting is a close copy of Li Sixun (651–716). In my household collection, I own one of Sima's paintings titled *Garden*

of Lonely Pleasure. [A Song dynasty calligrapher] Zhang Jizhi (1186–1263) left a colophon that reads 'This painting is by Master Sima. In terms of coloring, gradation, and mode, this painting was definitely made before the Southern Song (1127–1279) period.'"[6] In addition, Zhan Jingfeng noted, "Wang Anshi's landscape painting on a small piece of paper is extremely labored and delicate and its overall style followed Li Zhaodao (ca. 675–741)."[7] Similarly, Chen Jiru wrote, "Zhu Xi's painting followed the principles of [Tang master] Wu Daozi's (ca. 685–768) brushwork."[8] A comparable comment made by Xu Bo (1592–1639) reads, "Zhu Xi's original painting is now in Huizhou. Its brushwork and handling of drapery show his solid understanding of Wu Daozi's style. There are (still) originals of his painting nowadays."[9]

At first glance, these examples sound like convincing pieces of evidence, validating both the artist identities attributed to famous names and the authenticity of their paintings. Renowned critics of the time saw these paintings and left comments on them. What could be better proof? However, we can also sense a certain level of insecurity in those comments. They provide simple descriptions of the styles and techniques of each painting, but these commentators do not seem to have been confident enough to fully explore individual paintings. While discussing a painting in his collection attributed to Sima Guang, Li Rihua relied on a colophon on the painting for its dating instead of offering his own opinion. A certain level of skepticism regarding the authenticity of these works probably existed in the late Ming period. If not, Xu Bo would not have had to defend his comments on Zhu Xi's painting. Xu Bo further argued that the artistic talents of Zhu Xi and certain other Song scholar-officials were not known because their fame as writers had overshadowed their painterly accomplishments.[10]

In fact, it is fairly likely that the above-mentioned works were mere counterfeits. It is especially difficult to believe that scholar-officials such as Wang Anshi and Sima Guang would have followed the manner of Li Sixun and Li Zhaodao, father-and-son painters of the Tang dynasty (618–907) who were known for their highly decorative, elaborate, and colorful expression. If Wang and Sima had really painted, they are more likely to have chosen the monochrome ink styles universally favored by their peer literati. Then, does this suggest that accomplished connoisseurs such as Chen Jiru, Zhan Jingfeng, and Li Rihua were all hoodwinked by forgeries? An observation made by Dong Qichang (1555–1636) on a painting by Sima Guang provides some clues. Dong recollected, "When I was in Guangling [Yangzhou], I saw Sima's landscape painting. It was very detailed and definitely looks like the work of Li Cheng (919–967). Many Song and Yuan scholars left colophons on it, but this painting is not listed in any painting catalogues.

Thus, presumably, someone in the past simply appropriated his name."[11] Apparently, Dong was not familiar with Sima's painting; thus, even with the colophons on the painting, supposedly written by scholars from previous generations, he firmly concluded that the painting was a fake. Here, Dong's grounds for doubt were not the style or the format of the painting but its conspicuous absence in art historical treatises.

Furthermore, in Li Rihua's comment on Sima Guang's work listed above, Sima is said to have followed Li Sixun's style, not Li Cheng's as Dong observed. These are two quite distinctive landscape styles: one of craggy rocks in the blue-and-green color scheme and the other of monumental landscapes done in ink. Both required a professional level of dedication and practice. It is doubtful that Sima would follow either, since mastering even one would already be a daunting task. Regardless of the authenticity of these particular paintings, the timing of their discovery suggests a rhetorical purpose. Most of these spurious works appeared only in the late Ming period; even if they were genuine, it also seems meaningful that they were found all of a sudden, incorporated into art critics' dialogue, and so thrust in this manner into the public domain.

Toward a Modern Society: Population, Economy, and Urbanization

Starting in the early sixteenth century, the grand metropolitan areas of southeastern China—Nanjing, Suzhou, and Shanghai—grew with unprecedented speed, while commerce and entertainment businesses there boomed in response to the demands of the new urban public. This transformation was initiated by a couple of factors in commerce and the economy at large. First, New World crops, such as sweet potatoes, corn, and peanuts, were introduced in the sixteenth century and grown widely. These new crops helped sustain the fast-growing population and further commercialized agriculture and trade in foodstuffs.[12] Standard estimates speculate that China's population was approaching 150 million by 1600, though working from a modestly higher base figure suggests it may have reached 175 million. This figure represents a significant increase from the 30 million estimated for the late fourteenth century.[13] Second, a tax reform of 1581, the Single Whip Tax, consolidated various taxes and mandated that they be collected in silver; this stimulated greater use of money and further mobilized China's already thriving economy.[14]

The new economic conditions were a key catalyst for changes in the social structure. The lifestyles of the upper class—families with high education, past or present official rank, and wealth founded on income from land—were changing,

while a large urban middle class that engaged in commerce and the service industry had also emerged. Simultaneously, many traditional local elites moved from rural villages to towns and cities. With this move, they came to rely more on contracts with independent farmers who worked their land than on personal supervision. These new urban dwellers began living more luxuriously than before, some adding to their incomes through investments in pawnshops, commerce, and urban real estate.[15] Part of the reason for urbanization can be understood in terms of the changing view of city life. Even until the mid-sixteenth century, visits to cities for no official or administrative reason were viewed with a certain level of disdain among the literati in rural areas; this changed dramatically in the late sixteenth century, when cities became the ideal locale for the literati elite. The local *Huizhou Gazetteer* (Huizhou fuzhi) recounts, "During the Jiajing (1522–1566) and Longqing (1567–1572) periods, some people never went to the city during their entire lives. If a scholar went to the city but didn't take civil examinations, or meet with officials, his father and brothers were ashamed of it, and his fellow local literati disapproved." But this attitude completely changed a couple of decades later. Regarding the Wanli (1573–1620) period, the same local gazetteer further notes, "Those who only stay at home in the village get laughed at and are considered unsophisticated geeks."[16] As the city became a coveted and celebrated place to live in or visit, even its representations carried an appeal and became popular. Scroll paintings on the subject of urban life were sold on the streets of prosperous cities from Beijing to Suzhou at the price of one ounce of silver or even less, a relatively low price for paintings.[17]

Determining the population of late Ming cities would involve speculations with certain margins of absurdity, yet it is generally agreed that a few massive metropolitan areas emerged in the southeast. One modern scholar has estimated that late Ming China had 106 metropolitan areas with populations of more than one hundred thousand, 40 metropolitan areas with populations of more than four hundred thousand, and 8 with more than one million residents.[18] Among these, Suzhou and adjacent cities would become economic and cultural centers. The city of Suzhou itself had more than one million people and was required to cover 10 percent of the national grain taxes from its mere 1 percent of the Ming dynasty's registered land.[19] This testifies to Suzhou's unparalleled economic prosperity and further explains how the city became the standard for culture and the leisurely life.[20] What was known as elegant in Suzhou was quickly adopted as such in other cities; Suzhou was the New York City or Paris of late Ming China. Surrounding cities and towns, such as Nanjing, Hangzhou, Songjiang, and Jiaxing, shared similar cultural tastes with Suzhou, and these cities of the southeast,

the so-called Jiangnan area, formed a block where the new urban culture boomed and was celebrated by its citizens.

The increased population, rapid urbanization, and economic growth provided the foundation for a fluid and flexible status system, free of legal barriers to status mobility. Toward the end of the Ming dynasty, it became clear that the hereditary system of status, down to the lowest classes of artisans, merchants, and salt merchants, had broken down over the course of time. State regulation and sumptuary laws no longer interfered with people's rights to occupational and status mobility.[21] The most prestigious route to upward mobility, the imperial examination, was also open to all males in society. Only a very small number from certain ethnic groups and occupations, including former slaves, families of prostitutes, entertainers, and lictors, were still not eligible to take part in the examinations; however, these groups made up less than 1 percent of the late Ming population.[22] In reality, many of the prominent scholars and officials of the late Ming, including Wang Daokun (1525–1593), Gu Xiancheng (1550–1612), Gao Panlong (1562–1626), Xu Guangqi (1562–1633), Li Zhi (1527–1602), and Jin Sheng (1598–1645), were sons of merchants and attained higher position in society with the help of their familial backgrounds and fortunes. In the meanwhile, with the rapid development of the educational infrastructure, including the publishing industry, schools, and libraries, academic competition reached its apex in late Ming China, when many members of society felt that the exams had become almost impossible to pass.

Apparently, public schools and the library system were not new with late Ming society, yet in terms of their numbers and distribution over the empire, these institutions now provided the greatest access to education to the largest public in Chinese history. For example, "community schools" (*shexue*) in the Ming were charitable elementary schools established by local initiative in towns and villages. One study points to 3,837 community schools in 472 administrative units in Ming China, or an average of slightly more than 8 schools per town. Children were also educated in family schools, village schools, and private schools run in the households of the well-to-do.[23] Furthermore, thousands of public and private libraries were open to the public in the late Ming period.[24] To a definitive degree, both the school and library systems were made possible by the publishing industry, which was growing with unprecedented speed. Books had been sold in markets as early as the Tang dynasty; however, as with the schools and libraries operating in the late Ming, the number of books produced during this time far exceeded those of the Song, Yuan, and mid-Ming dynasties. For example, in Jianyang, a center of commercial publishing in Fujian, of 1,700 imprints from the Ming, only 11 percent are dated to before 1500, indicating that almost 90 percent

of the books were printed during the sixteenth and early seventeenth centuries.[25] In addition to the staple Confucian classics, new genres targeted a wider educated public; these included popular literature such as novels, dramas, and music along with professional handbooks for industrial artists and carpenters.

People who had no previous access to printed materials or had never been able to find the books they needed began to participate in the consumption of this cultural product. Students, lower-degree holders, rural landlords, urban merchants, and women from elite families now could easily purchase books at the market.[26] Ch'oe P'u (1454–1504), a fifteenth-century Korean emissary, recorded in the diary he wrote during his trip from southern China to Beijing, "Even village children, ferrymen, and sailors could read."[27] An illustration in *Complete Compendium of Agricultural Practices* (Nongzheng quanshu) (fig. I.1) shows a peasant man apparently reading while pedaling a "chain-pump irrigation device" (*fanche*). As Anne McLaren has insightfully suggested, this illustration at the very least exhibits the widespread level of reading among the larger public and further highlights the end of an era characterized by unchallenged literati ownership of reading culture.[28] The increased interest in reading material was naturally implicated in the proliferation of writers from many different classes. After the Ming, scholars were no longer ashamed to sell the products of their intellectual and creative labors. In fact, expressions like "farming with the brush" (*bigeng*) and "inkstone rice field" (*yantian*) emerged as common vocabulary.[29] For many unsuccessful examination candidates, writing became an attractive alternative occupation. For example, among those books published after the mid-sixteenth century that appear in the comprehensive bibliographic catalogue *Index of One Thousand Qing Halls* (Qianqingtang shumu), one-third were published by commoners (scholars without official degrees) or merchants.[30] In addition, women had also become important suppliers of texts. Especially in the seventeenth century, women in almost every Jiangnan city wrote, published, and engaged in discussing the literary works of others.[31] Altogether, people who participated in reading activity in late Ming China can be identified as one large social group for the first time in Chinese history; they formed, in Dorothy Ko's words, a "reading public."[32]

Elite Identity at Stake

Growing literacy in late Ming society was indirectly reflected in the increased number of candidates who attained the lowest official degree of *shengyuan* in the imperial examinations. *Shengyuan* status offered a starting point for those who

1.1 A chain-pump irrigation device (fanche), from Xu Guangqi's *Complete Compendium of Agricultural Practices*, 1639, 17:7b. Courtesy of the Harvard-Yenching Library.

sought to climb the ladder of the official hierarchy and was obtained upon passing the local-level examination. However, this title alone did not confer much economic or social benefit; only after a person achieved the *juren* degree at the provincial exam was he entitled to a minor official appointment. The ultimate reward was the *jinshi* degree. It could be won only by passing the metropolitan examination and automatically led to a position in the middle strata of the bureaucracy. The system was relatively stable until the late Ming period.

The number of *shengyuan*-degree holders was around thirty thousand in the middle of the fifteenth century; this increased to half a million by the Wanli period.[33] These men made up an educated elite group who possessed a solid understanding of classical and historical literature. Obviously, the inflated number of those holding *shengyuan* degrees must have resulted in a huge glut at the higher-level examinations and engendered a significant number of frustrated candidates. The competition was forty candidates for one degree for the provincial exam during the early Ming but jumped to three hundred or four hundred candidates for one degree in the late Ming period. Even entry-level competition for the *shengyuan* degree rose from fifty-nine candidates to three hundred candidates for one degree. Most of the *shengyuan* who survived this brutal competition, however, never succeeded in moving up to the next level, but the state could not afford to abandon its quota on higher degrees, because it had to maintain control over the size of the bureaucracy.[34]

The number of *shengyuan*-degree holders in late Ming China was approximately 0.3 percent of the total population, or only 1 percent of the total literate male population.[35] At a minimum, this number indicates how large the reading public had grown by the late Ming. If there were half a million *shengyuan* in society, all well versed in classics, law, poetry, and other literary works, this suggests a much larger pool of candidates who were not fortunate enough to achieve this first level of official expertise. Benjamin Elman aptly analyzed the overlooked social functions of the government examination system in the late Ming. He proposed that the focus on opposition between those who passed and those who failed is the source of a false perspective on the overall function of education in late Ming China. Instead, in its gate-keeping function, the civil service examination generated a critical degree of cultural and linguistic "uniformity" among young elites that only a classical education could provide.[36] His argument suggests the education level of the late Ming public: millions and tens of millions of students who prepared for the examinations, whether they succeeded or not, now shared the same literary and cultural background, not to mention their qualified literacy.

Ironically, the increased number of *shengyuan*-degree holders brought about the collapse of this degree's value as a status marker. The highest degree, *jinshi*, remained the most prestigious official honor, one that conveyed a truly elite class of achievement, but as for the *shengyuan*, its society of lower elites seemed to be searching for an alternative status marker. Traditionally, *shengyuan*-degree holders were regarded by law and society as the leading group among commoners. They were exempted from corvée duty and allowed a modest stipend from the local government. However, by the late Ming, the degree no longer provided much in the way of social privilege or even economic compensation due to the massive numbers of degree holders. Nevertheless, the degree still required certain types of bureaucratic service and other obligations.[37]

Furthermore, the high level of competition for a *jinshi* degree caused a range of problems in the examination system, such as corruption, nepotism, and the asking and granting of personal favors.[38] Ho Ping-ti notes that official positions were bought and sold as early as 1450, but it was in the late Ming that this deterioration in practice hit bottom. One disgraced former Minister of Rites, Dong Fen (1510–1595), paid twenty thousand taels of silver, a hefty sum, to ensure that his grandson was awarded the *jinshi* degree in 1580 at the age of twenty.[39] In addition, during the Wanli period, the reputation of National University students was so bad that some claimed that up to two-thirds of them were no better than louts with money. As bad habits worsened, the pay-to-play system became ever more blatant; in Henan's 1642 provincial examinations, qualification was awarded to anyone who could afford the bribe.[40] There is ample empirical and anecdotal evidence for these practices, all of which suggests that success at the examinations was becoming purely a matter of wealth.[41] If we take this observation at face value, we can understand that *shengyuan*-degree holders of the late Ming confronted multiple obstacles on their way to the *jinshi* degree—not only high levels of competition but also the attendant expenses and moral issues. This situation must have been inescapable for the majority of *shengyuan*-degree holders; they would probably never ascend higher on the social ladder via the examinations.

Given this situation, in order to avoid the official tasks that burdened *shengyuan*-degree holders, and in recognition of the degree's emptiness as a mark of elite status and means of earning a living, some degree holders began to voluntarily renounce their official titles and positions starting in the late sixteenth century. Not all were permitted to discard their degrees, so some simply ignored or deserted their positions, while others sought official permission and even paid bribes to return their *shengyuan* titles.[42] Among those who left, some sought profits in business and thus became merchants, while others became Daoist or

Buddhist monks, and still others chose a carefree life.[43] Young educated men began to pursue such options as early as the first half of the sixteenth century, and they came to represent a radical movement that eventually spread throughout the Jiangnan region by the late Ming. A renowned critic, calligrapher, and writer of the late Ming, Chen Jiru, was one of them. He abandoned his degree sometime around 1585.[44] This does not mean, however, that Chen Jiru and other former *shengyuan*-degree holders gave up their dreams of status upgrades completely; they just looked for alternative and possibly more effective ways of achieving this goal via the social display of their education, knowledge, and social decorum.

As Ann Waltner has noted, formal academic qualifications and office holding were not the only ways of ascertaining elite status during the Ming; it could be also determined by wealth, education, networks, influence, and accomplishment in the literati arts.[45] The family of a high-ranking official might maintain its influence and wealth over a couple of generations, but if it did not produce additional established officials, its social status remained precarious and could be easily challenged.[46] This is why and how "alternative" qualifications to elite status were avidly pursued in late Ming society. Cultural activity, then, was thought of as a major repertoire that provided its practitioners the means of creating a sense of superiority and maintaining social networks that set them apart from the majority of the population.[47] Converging in the urban environs of southeast China, where networking and communications were highly developed, members of the educated public built up the prestige of their own social circles in order to assert and publicize their membership within the elite class. In this regard, it is no coincidence that the late Ming represents the peak of literati gathering culture. Recent research by He Zongmei introduces three hundred literati societies of the Ming period. Not even close to comprehensive, this figure must be understood as a minimum indicator of their numbers. Among these three hundred, about 90 percent were established after the sixteenth century.[48] Most of these elite meetings took cultural pursuits such as chess, zither (*qin*), poetry, prose, antiques, and painting as their focus.[49] People maintained memberships in more than one such cohort and so were able to extend their social networks in various directions.[50]

Even certain religious societies were identified as "literati" phenomena and publicized as such. Local records from the late Ming confirm that monastic patronage was maintained exclusively by local elites, and support for Buddhist institutions was not votive as much as associational. Qualification for membership in these patron groups was not based on official degrees but instead on skill at some literati art, whether poetry writing, musical performance, or painting. Thus, as Timothy Brook has forcefully argued, "Monastic patronage served as

an opportunity for the gentry (literati) to associate with each other in a public context and to publicize their common identity as the privileged elite of local society."[51] These cultural activities could surely be of genuine interest to members but also indicated the polite behavior, literary refinement, and cultural sensibility that asserted participants' common identity as privileged social elites.[52] Furthermore, other elites organized around their personal interests in entertainment and hobbies: there were gourmet clubs, summer vacation clubs, flower appreciation clubs, hiking clubs, dove's letter clubs (*nufeishe*), drinking gatherings, comedy clubs (*jueshe*), crying clubs (*kuhui*), cock-fighting clubs (*doujishe*), and dream interpretation clubs.[53] It is especially noteworthy that eligibility in many of these societies was not confined to government officials or known scholars. As early as the later fifteenth century, literati gatherings such as the Broom Tree Stream Union (Tiaoxishe) attracted members from such diverse occupations as medical practitioners, professional painters, farmers, artisans, merchants, monks, poets, and schoolteachers.[54]

In this regard, we need to rethink the concept of "literati" in late Ming China. These gatherings involved people who consciously strove to project a literati identity but represented a range of different occupational groups such as merchants and artisans. There is no lack of historical evidence showing that men of these two occupations—traditionally recognized as the lowest classes of the social order—actively participated in various so-called literati associations. One example, the family of Pan Zhiheng (1556–1622), pursued both commerce and scholarship and kept company with cultural celebrities of the period, such as Wang Daokun, Wang Shizhen (1526–1590), Tu Long (1543–1605), Tang Xianzu (1550–1616), and Yuan Zhongdao (1570–1623). Pan was originally a merchant but later became recognized as a poet among his literati friends.[55] Likewise, many contemporary merchants joined literati clubs such as the Western Bamboo Society (Zhuxishe) and the Brisk West Club (Xilingshe), developed connections with members of the scholar-official class, and collaborated with them on organizing friendly gatherings.[56]

Zhou Danquan (fl. 1577–1606) was another member of the successful elite. Zhou was a portrait painter, bamboo craftsman, dyeing specialist, ceramicist, entrepreneur, and horticulturist. He was best known for his imitations of Song dynasty porcelain, yet his calligraphic, literary, and painterly creations gained status equal to that of his literati friends Chen Jiru, Li Rihua, Yuan Hongdao (1568–1610), and Wang Zhideng (1535–1612). Zhou eventually enjoyed unequaled celebrity, like the scholars and artists whose cultural accomplishments and authority were glamorized across society.[57] Late Ming records feature the names

of many of these craftsmen, who possessed literary minds as well as the skills to produce items of exquisite craftsmanship.[58] If people were willing and qualified, they could disassociate from their original backgrounds or careers and cultivate a literati identification. The boundary between artisan and artist, between merchant and scholar, was now being bridged, if not completely broken, by the open and flexible social system.

The late Ming scholar Gui Youguang (1506–1571) once observed, "In ancient times, the four orders of commoners [literati, farmers, artisans, and merchants] had their distinct functions, but in later times, the status distinctions among them have become blurred."[59] This comment testifies to the dramatic changes in the class structure in the late Ming. The traditional social hierarchy was being questioned, and occupation no longer functioned as the definitive determinant of social standing. Although the traditional lack of regard for occupations such as merchant and artisan remained to a certain degree, members of these professions could cross the boundaries of occupational status and become recognized as literati elites.[60] In this sense, it is no surprise that sumptuary laws regulating social and consumption codes, such as those concerned with clothing and carriages, were no longer in force. Originally only high-level officials could ride in carriages, yet starting from the mid-Ming, if one could afford it, carriage travel became an effective symbol of social and economic status. Likewise, different types of scholars' gowns, caps, and shoes became popularized among the broader public.[61] No longer were people's character and appearance fixed by the status system; instead, their own taste, wealth, and networks shaped such things. Elite identity was thus up for grabs. No matter how they led their lives, if they could prove their competence in literary and cultural skills, their standing as literati was acknowledged and celebrated; this development opened the door to a new society in which everyone could become at least "a part-time literatus."

Painting as a Civilized and Thus Civilizing Art

Art as a public pastime was a new phenomenon in sixteenth-century China. A ninth-century critic, Zhang Yanyuan, once declared, "The skills of painting and calligraphy are not a subject the sons of commoners can learn." This claim presupposes that art is only for a limited number of privileged members of society, that is, aristocrats, which responded to the institutionalization of its practice as a key element of class distinction.[62] In medieval Chinese history, in which rigid social hierarchy was based on strictly hereditary status, art was an apparatus of class re-affirmation. Art maintained its merit and caliber in the Song dynasty,

but with a new development. Painting was accepted, along with poetry, musical performance, and calligraphy, into the exclusive group of polite arts that the educated gentleman might practice as leisure-time activities and modes of self-cultivation.[63] The Song literati class, whose members rose through the imperial examinations, engendered and developed a new theory on art that was different in style and subject matter from art favored by the aristocracy. The artistic distinctions elaborated by the literati class are too lengthy to discuss in full here but can be summarized thusly: in contrast to the realistic, detailed, labored, and colorful depiction of nature and human figures cultivated in the imperial academy, the literati class found its artistic niche in paintings of anti-mimesis and anti-artifice, done in monochrome ink. In this process, it successfully established a visual rhetoric that linked cultural taste with social position. This subtle language in art continued to be developed through later periods.

The classification of painting as a polite art assumed more special meanings and functions in late Ming China, when people with no official degree had to find other ways of establishing and confirming their status in society. As Willard Peterson has rightly observed, for those only minimally involved in officialdom, or not at all, the arts came to mean more than a pastime or entertainment.[64] Artistic knowledge and practice were channels by which a person could display and publicize his or her or even a family's wealth, education, and cultural accomplishments along with a certain sense and sensibility. Even if they lacked these qualities, some people cultivated the illusion of superiority and decorum by invoking art. Still, art was not the only way of displaying cultural accomplishment and retaining prestige and status. Many literati wrote and published popular novels and dramas, which fell outside the traditional literary genres, even though publication of academic works was likely a more direct way of announcing the authors' intellectual superiority among the reading public. Other literati indulged in music and poetry. But art possessed a distinctive cultural aura, merit, and territory via its very immediacy and materiality. While music was constrained by the necessity of being performed in a particular time and place, and literature might achieve little recognition despite long training and commitment, painting had much to recommend it in terms of instant prestige, aesthetic pleasure, and historical interest.

Along with education, the improved economic standing of the late Ming urban classes laid the foundation and provided momentum for their pursuit of artistic hobbies. Yuan Hongdao once observed, "People in Huizhou have recently become more and more prosperous. Merchants competitively try to compose poetry, and those who are not able poets find enjoyment in collecting paintings,

calligraphy, and other collectibles. The number of painters and calligraphers has noticeably increased."[65] This comment makes clear the relationship between Huizhou's prosperous economy and the emergence of cultural hobbies there. A late Ming critic, Xie Zhaozhe (1567–1624), left a comment regarding the social charms of collecting and making art that at the same time betrays his frustrations with the democratization of art.

> Mi Fu (1051–1107) speaks of two classes, connoisseurs (*shangjianjia*) and art lovers (*haoshizhe*) in his *History of Painting* (Huashi), where he hits the nail on the head. A connoisseur has a deep love for the subject, sees a great many paintings and remembers them; some are artists themselves. Their collections consist of works only of the top quality. [And then] there are people today who happen to have money. They have no real love for art, but think of it as a *social decoration*. They rely on others who know and keep scrolls and paintings in rich brocade cases, tied with jade-tipped rollers. It is really amusing. These are the art lovers. There are sons of rich families today who cannot qualify as art lovers. They have piles of money and do not know what to do with it. They hear that such painting exists in the world, casually buy it, and put it on the shelf or hang it on the wall. They never look at it again, and these things are kept in cabinets to undergo slow rot. Nine-tenths of them are like this; they do not even take the trouble to have them properly mounted and protected.[66]

Indeed, art collecting was one of the popular hobbies of the period; many late Ming paintings and prints describe the street art markets of the time (see plate 1), which shows how society facilitated the public's needs and desire for art collecting. However, this very democratization gave rise to Xie Zhaozhe's condemnation. And it was not only Xie who felt this way; many of his contemporaries criticized the art collecting of rich merchants or marginally educated public. Dozens of similar comments claim a cultural hierarchy between art lovers and connoisseurs and try to establish clear class distinctions within the now fast-growing art public.[67] These criticisms can be seen as unfair diatribes from an elite class that strove to discredit the cultural agency of the nouveau riche, but they also clearly suggest the anxiety and insecurity of traditional elites.[68] The bottom line was that art had become a universal medium of "social decoration." For emerging urban capitalists, art collecting provided a channel by which they could transform their monetary power and status into cultural and thus social prestige.[69]

The distinction between art lover and connoisseur fed an ongoing conversation regarding the ownership of high art and taste. Noteworthy here, actual practice

often became the critical criterion for true belonging in the artistic arena. As proposed in Xie's comment above, one of the most important measures for differentiating someone from the common herd of art lovers was the command of painting skill. Xie also notes that not every connoisseur could paint, which suggests the challenging nature of painting practice and the recognition and rewards that must have accompanied mastery. Likewise, other contemporary writings on art and elegant life, including those by leading critics of the time such as Yuan Hongdao, He Liangjun (1506–1573), and Gao Lian (1573–1620), repeatedly valorized painting skill as a key to identifying the true connoisseur, the cultural and social reputation that so many among the middle and elite classes aspired to attain.[70]

No surprise, then, that many late Ming literati clubs involved the practice of art. There was even a literati club that specialized in painting. Wang Wenyao, an amateur painter and art collector from Nanjing, organized a painting society around 1568. Zhou Hui (b. 1546) notes that its sixteen members were all renowned figures of local elite society, yet none of their names has been found in contemporary documents.[71] This may imply that most of the participants were local elites who never reached the regional or national level of academic, cultural, and economic accomplishment. While Wang's painting society is the only one specifically noted in local documents, the actual practice of painting had nonetheless clearly become a widely favored hobby. This inevitably caught the attention of the professional literati class. The essayist Fan Lian (b. 1540) wrote,

> Practicing poetry, practicing painting, and practicing calligraphy—all three are said to flourish in Suzhou. Recently these ways have come into Songjiang. Friends all join together in poetry clubs and write pieces to set themes. Who can say that among them none at all has followed the trail of talent and ability of earlier generations? But among them there are those who pick up the dregs of Zong Chen (1525–1560) and Tu Long, patch together some colloquial language, and call themselves poets. Oh, how could there be so many! As to the rest, those whose written characters and paintings have ruined papers and fans are beyond counting. If they happened to be sought after by leading gentlemen, they rank themselves with the old masters, saying "so and so is Mi Fu, so and so is Zhao Mengfu (1254–1322), and so and so is both Huang Gongwang (1269–1354), and Wang Meng (ca. 1308–1385)." Alas! How is it that an excellence that was extraordinary and rare among the ancients now occurs in one and all in Songjiang?[72]

In this paragraph, composed in slightly exaggerated language using historical metaphor, Fan Lian notes how people in his town had begun to follow the

high-culture fashion from Suzhou. He seems to be willing to admit there may be truly talented writers in Songjiang whose genius matched the quality of classical masterpieces, yet the much larger number of local writers who were self-appointed poets simply emulated known poetry by copying and pasting. Their literary creations were not at all satisfactory to Fan's keen eye and judgment. Similarly, novice painters of the town, upon receiving a modicum of local recognition, were eager to compare themselves to master painters and calligraphers of the past. This points to the wide social significance of assuming the artist identity in late Ming society: art was a potent type of democratized yet still privileged cultural activity, an essential form of production and consumption central to the display of an "artistic," thus "superior," and even "authentic" persona.

Zhou Hui commented, "Gu Yuanbo once said that among the 'first-place winners of the imperial examination' (*zhuangyuan*) in our dynasty, Zhu Zhifan (1548–1626) is the only one who is good at painting."[73] At first glance, this sounds simply like a compliment to the artistic talents of Zhu Zhifan. In fact, this comment may insinuate a possible gap between even the highest level of official honor, the *zhuangyuan*, and true literati status on the basis of possessing a particular set of skills. Maybe we should remember that literati status does not automatically guarantee possession of artistic skill. A fourteenth-century critic, Tang Hou, once noted, "Among the late Song literati, there were many who did not understand paintings. [Still] they insolently gave themselves the title of connoisseur. That is just pathetic."[74] This assumes that artistic skill demonstrates essential gentlemanly quality beyond one's confirmed social status. Painting skill, then, was not simply an alternative vehicle through which to display one's literati quality; it had become an independent criterion and, to a certain degree, could be understood as the ultimate qualification of true gentlemen.

The popularization of artistic leisure was not confined to the male sector of society. Painting also became an important leisure activity in the inner quarters, along with other types of literati leisure arts including music, chess, calligraphy, and reading. History records only a handful of female artists before the sixteenth century. Toward the end of the Ming dynasty, however, clusters of women poets and painters emerged, their numbers grew fast, and some of them gained a degree of celebrity as professional painters or even master artists among the educated public. *History of Silent Poems* (Wushengshi shi), a book by Jiang Shaoshu (1573–1638) cataloguing renowned master painters and works across the sweep of Chinese history, includes twenty-two female painters of the Ming dynasty. Tang Shuyu's (fl. 1810) *Story of Arts on the Jade Terrace* (Yutai huashi), a history of women artists from ancient times to the nineteenth century, lists only 4 women

artists from the Yuan dynasty; the number increases to 97 for Ming times (1368–1644) and 59 for the Qing period (1644–1911) out of the total of 216.[75] This fashion for female painters was, to a certain degree, bolstered by contemporary courtesan culture.[76] In order to communicate with and entertain their male clients, courtesans had to possess a command of literati art skills. It was in the late Ming that people developed a romantic idealization of "talent" (*cai*) itself, and women who specialized in poetry, painting, and the dramatic arts would become objects of wide adoration.

Accordingly, painting was incorporated into the core curriculum for daughters of middle-class families. Dorothy Ko has studied the family-education program of one late Ming household. The mother of twelve children, Shen Yixiu (1590–1635), set a timeline for her four daughters' homeschooling. She registered painting, along with music and chess, as composing a suitable program of study for her daughters between the ages of thirteen and fifteen.[77] Daughters might also receive private painting lessons from friends and family members, and when there were no immediate family members who could teach them, parents often hired female tutors. This practice eventually gave rise to a class of professional women teachers in the seventeenth century known as "teachers of the inner chamber" among contemporaries. They were itinerant women or nuns who made a living teaching girls of elite households the classics, the art of poetry, and painting.[78] In the course of their lessons, female students consulted antique artworks, painting manuals, and other illustrated publications, including pharmacopoeia or "materia medica" (*bencao*) as references.[79] For these daughters and their families, art was not merely a pastime; it also served more practical functions. As Dorothy Ko has forcefully argued, painting, along with other female skills, helped display a daughter's talent and level of cultivation and politeness so that her family could find a better match in the marriage market.[80] All in all, a daughter's education in Ming society was another important medium through which a family could publicize its cultural awareness and even elite status.

The Mountain Hermit: A Popular Icon of the Cultural Elite

One special social group referred to as "mountain hermits" (*shanren*) provides an important piece of evidence for establishing the link between cultural skills and elite identity. This term further affords indirect and symptomatic yet convincing measures by which to speculate on how widely literati art and culture touched upon and seeped into various echelons of late Ming society. By awarding themselves this title, people laid claim to a certain level of cultural capital and

social eminence. The traditional definition of the mountain hermit has a range of meanings that includes a person living in the mountains, a forester, a recluse, a Daoist monk, and a fortune-teller. The term in itself did not definitively indicate a particular social class; instead, it carried a strong anti-institutional and Daoist charge that belittled worldly success and fame. However, starting from around the early sixteenth century, the tag of "mountain hermit" began to be used as a mark of honor testifying to a person's claimed talent and status. It became glamorized as an elegant reference to unrecognized literati. The late Ming scholar Xu Yinglei (fl. 1600) announced,

> Those people who call themselves mountain hermits are known to be able to compose poetry and are adept at calligraphy and painting. For example, the mountain hermits of our dynasty include Li Mengyang (1475–1531), He Jingming (1485–1521), Xu Zhenqing (1479–1511), Li Panlong (1514–1570), Zong Chen (1525–1560), Wang Shizhen, Zhu Yunming (1460–1527), Wang Chong (1494–1533), Wen Zhengming (1470–1559), Shen Zhou (1427–1509), Tang Yin (1470–1524), and many more.[81]

This comment specifies the qualifications possessed by mountain hermits. Accordingly, the names included are all renowned scholars, officials, writers, critics, and artists, and Xu's statement defines their group identity as erudite, refined, creative, and artistic.

The writer, critic, and artist Chen Jiru, the Crane of Songjiang (Yunjianhe), was venerated as an exemplar of the mountain hermit ideal. He never proceeded beyond the *shengyuan* degree, yet his literary and artistic excellence trumped that of the most recognized literati of the time. He succeeded in building a national reputation based solely on his network and literati skills.[82] He epitomized the scholar-recluse standard—living away from the seat of government and devoting his time to artistic pursuits while earning a living as a professional writer of popular books, epitaphs, and birthday congratulations as well as dabbling in various publishing ventures. As the majority of the educated public struggled over the tantalizing promise of success at the higher-level government examinations, social upstarts must have seen Chen, with his "mountain hermit" label, as a more attainable and immediate model of access.[83] The extra-institutional nature of the mountain hermit identity created an ambience of detachment, which enabled people to disguise their failure and frustration with exams as a voluntary choice; thus, they could transform themselves from fallen-behind stragglers to disinterested and undiscovered talents. "Mountain hermit" was becoming a fashionable title. As Qing dynasty scholars later noted,

After the mid-Ming period, there emerged a trend among the people to use the tag "mountain hermit writer." [Of these people], those who have some knowledge of composition, calligraphy, and painting are to be found below, among the hangers-on, and above, among those who affect to own the glorifying title of "recluse." They model themselves on the scholar-official class. The scholar-officials also followed this custom and called themselves mountain hermits.[84]

This expressly states that people pursued the arts and literature and took on the mountain hermit appellation regardless of their social rank or cultural talents. On the one hand, the fundamental requirement for mountain hermit status was the practice and knowledge of cultural leisure, a point repeatedly acknowledged by contemporary scholars. On the other hand, people who lacked cultural standing could also benefit from the "mountain hermit" tag, since this could effectively mask incompetence. The status of mountain hermit granted, at a minimum, the reputation or illusion of being smart and educated. In sum, for people in the late Ming, the mountain hermit identity implied elite status and the possession of literary and cultural merit.[85]

As this fashion took hold, even high-ranking officials, imperial princes, and eunuchs preferred to refer to themselves as mountain hermits rather than use their official titles. Some women writers were also known as mountain hermits; it was a compliment to one's literary and artistic accomplishments and was recognized beyond the women's quarters. The scholar Tan Yuanchun (1586–1637) left a record of a lady named Lan Ru. He noted that she was an expert at orchid paintings and calligraphy, and possessed wide knowledge of poetry. In addition, she associated with many known literati of the period, who gave her the honorary title "female mountain hermit" (*nü shanren*).[86] Some courtesans versed in art and literature, such as Huang Yuanjie and Wu Yanzi, were recognized for their talent and also awarded the "mountain hermit" title.[87]

This fashion soon enough got out of control. Anyone who coveted the cultured aura of a mountain hermit reputation began to claim it willy-nilly, with no regard for its cultural requirements. It was even referred to as a common title for people with no official degrees, so much so that illiterate peasants, actors, bandits, and even beggars began to call themselves "Mountain Hermit XX."[88] This profligate use of the term frequently triggered anger among late Ming critics. An official, Xue Gang (b. 1561), complained at the label's deterioration as a reliable social marker.

Scholars seeking for purity used to be awarded the appellation "mountain hermit"; it was an honorable label. [However] nowadays those debauchees with no

rank in Chang'an, regardless of their talent, all refer to themselves as mountain hermits. The people, moreover, have no clue, so they follow the custom and also call themselves "mountain hermits." Indeed, they are not careful about how they use the term.[89]

A number of other contemporary scholars left writings on the mountain hermit that tended to criticize the trendiness of the tag. Dozens of late Ming writers, including Xie Zhaozhe, Shen Defu, Li Zhi, and Fan Lian, launched harsh criticisms on this point. As one modern scholar, A Ying, has noted, the great number of these writings effectively defines a new literary genre that can be classified "anti–mountain hermit literature" (*fan shanren wenxue*).[90] Xie criticized a group of poseurs who were completely ignorant, even illiterate, yet adopted the tag "mountain hermit" for its glorifying effect. This group also included lowlife losers who lived off their rich and powerful families, drank all day, sought sexual pleasure, were hungry for money, and often intimidated people by using violence and filing unreasonable lawsuits.[91] The term "mountain hermit" as a group identity even came to be identified with beggars, robbers, con artists, and stingy merchants.[92]

Paraphrasing Roger Fry, the tag "mountain hermit" provided an opportunity for certain snobbists to march in step with the vanguard of a certain cultural production that obtained its raison d'être among the legitimate producers of culture.[93] Many self-appointed mountain hermits possessed little cultural, intellectual, or ethical knowledge to speak of.[94] As it became more of a universal nickname, "mountain hermit" maintained only a sliver of its cultural and social aura as a label of distinction. This problem is reflected in the attempts of some scholars to differentiate between "authentic" and "fake" mountain hermits.[95] In sum, public obsession with the "mountain hermit" label testifies to a desire for cultural capital and the dream of being elegant and artistic in the late Ming.

Perhaps something similar to the attitude against mountain hermits is reflected in a painting by Zhang Lu (ca. 1490–1563), an artist from a wealthy aristocratic family (see plate 2 and fig. I.2). The picture shows a group of rustics standing around a hanging scroll. A barefoot man leaning on a stone bench is unrolling the scroll and squinting critically at the image as if something has caught his attention and left him with serious concerns. A fisherman strokes his whiskers as if he, too, has noticed something intriguing there. A woman at her loom inside the house cranes her neck as if for a better view of the scroll. A boy darts under the scroll for a closer look, while a father with his baby son on his back appears to be completely engrossed in the painting. The only person in this group who is not interested is the man on the bench; he stretches his arms and

I.2 Detail of Zhang Lu, *Studying a Painting* (plate 2).

looks away from the painting and surrounding group. His disgruntled face suggests that his sweet afternoon nap has been disturbed by the fuss over the scroll. But none of these people appears to belong to the class of persons who would possess the knowledge, wealth, and artistic taste to enjoy the art of painting. Their poor clothing, exaggerated expressions, inappropriate handling of the scroll, and even the location of the activity lend a certain overdramatic feel to the scene and betray our expectations of the Ming art public. This scroll, titled *Studying a Painting*, is rightly considered to be a parody of a literati gathering; it is intended to mock the local peasants' attempted emulation of literati leisure.[96] What is represented in the painting might or might not be an objective portrayal of the time, but it suggests at the very least that in the eyes of its privileged creator, Zhang Lu, the deterioration of culture had gone too far.

Why Late Ming?

Historians of East Asian art are certainly familiar with the historical significance of late Ming painting manuals. Not only sinologists but also specialists in Korean and Japanese art history have encountered them as important references for painting practice; to a certain degree, they have become an academic cliché in

discussions of East Asian art in general. Yet the very dearth of research on them remains a serious problem. Simply put, we don't know how many of them were printed and circulated; neither do we have any critical research on how and why they were published and who published them. Without knowing this fundamental information, scholars often consider the very late Ming to have been the era of painting manuals. They often introduce the *Mustard Seed Garden Manual of Painting* (Jieziyuan huazhuan) of 1679 as the epitome of the multi-genre painting manual, not realizing that this work in fact took much of its program from earlier manuals such as *Forest of Paintings* (Huilin) and *Grove of Paintings* (Huasou), both published by Zhou Lüjing (1542–1633) sometime before 1579.

Zhou's works constitute some of the earliest multi-genre painting manuals in Chinese history. Their popularity was immediate, and their contents and format were widely reprinted and disseminated in a number of painting manuals of the time. The following chapters discuss various topics registered in Zhou's and other late Ming painting manuals: landscape, general theory, figure painting, and still life. Interestingly, in these manuals, the late Ming public learned how and what to paint, and readers were also invited to invest in and enjoy texts and images they could appreciate, emulate, comment upon, and cherish. While investigating the reasons for and consequences of the success of these publications, this book intends to unpack how they fed the late Ming public's desire to get ahead.

1

Genre and Biography

Elle is a highly valuable journal, from the point of view of legend at least, since its role is to present to its vast public which (market-research tells us) is working class, the very dream of smartness.

—Roland Barthes (1915–1980)

A GROUP OF SKETCHES IN THE PALACE MUSEUM IN BEIJING BEARS THE SIG-nature of the tenth-century professional artist Huang Quan (903–965). The motifs represented are animals and insects realistically rendered and colored, showing their characteristic movements and poses in nature (see plate 3). A brief inscription on the painting notes that the sketches were made as a "study copy" (*fenben*), also known as a "reference copy" (*gaoben* or *huagao*), for his oldest son, Huang Jubao (d. ca. 960).[1] In traditional China, the practice of art was taught as a hereditary skill-set or part of family schooling; thus, studies like those Huang Quan made for his son were passed from master to pupil or father to son as a principal means of transmitting motifs and designs. Not only professional artists but also scholar-amateur artists, including Huang's contemporary Xu Xi (d. before 975), passed on their art in this way.[2] Artists also made their own reference copies of original masterpieces, which served as a source for their future practice and inspiration. In a short note inscribed on Dong Qichang's album *Sketches of Traditional Tree and Rock Types* (fig. 1.1) in the Palace Museum in Beijing, his friend Chen Jiru observed that "whenever [Dong] made a large composition, he copied from these sketches."[3] Thus, the study copy was the means by which painting practice was transmitted and model images were preserved for

private use. Nevertheless, its practical aspect did not prevent it from possessing its own value as a piece of art or a collectible item.

A fourteenth-century writer, Xia Wenyan, once commented that study copies were prized by collectors "for their rough and unplanned look, a spontaneous quality."[4] A collection in album form of forty-six leaves by the seventeenth-century painter Gu Jianlong (1606– ca. 1687), now in the Nelson-Atkins Museum of Art, Kansas City, represents well the artistic quality valued in study copies (see plate 4). The pages show Gu's copies of figural images attributed to masters of the Tang dynasty such as Yan Liben (ca. 601–673) and Zhou Fang (ca. 730–ca. 800); it represents Gu's own art historical research on masterpieces and his personal notebook for future reference. It is likely that Gu had no specific audience in mind when he compiled and copied this group of motifs from the originals. We may imagine that freedom from public evaluation allowed him to work in looser and less calculated compositions and execution. Unlike Huang Quan's and Dong Qichang's study copies, which maintain a certain refinement of detail and calculated composition, Gu's album shows many different figural motifs randomly scattered across its pages; their subject matter, sizes, poses, color schemes, and level of detail and finish are all different. Thus, the overarching concern seems to be the absence of finish, composition, and artifice. These values, not present in artists' ordinary works, must have made such albums especially interesting and attractive to collectors and art lovers.

Both the practical and artistic merits of study copies explain their unique status in the art world. When the practice of art was transmitted largely within families or by way of master-pupil relationships, study copies as textbooks or personal references were a special commodity that could be accessed only by a limited number of family members and perhaps friends. As Richard Vinograd has explained, painting manuals likewise facilitated the process of transmission and represent a painstaking recollection of artistic knowledge in publicly accessible graphic and linguistic forms, and therein lies their historical value.[5] Painting manuals decode the secrets of artistic leisure by a mnemonic and cognitive system in which the practice and knowledge of painting are explained through individual motifs and encyclopedic entries. They were a kind of mass-produced study copy with textual instructions.

Therefore, the public nature of these books, evident in both their programs and their formats, made them a site of negotiation that marked the tastes, cultural standing, and even the artistic subjectivity of their publishers and audiences. Publishers of these manuals had varying levels of education, artistic knowledge, access to social networks, and economic resources, and these differences are

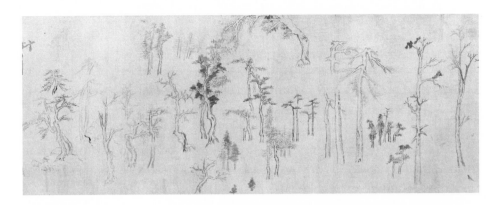

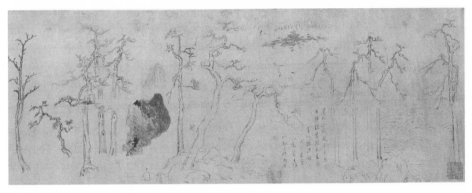

1.1 Dong Qichang (1555–1636), detail of *Sketches of Traditional Tree and Rock Types*, ca. 1611. Hand scroll, ink on silk, 53 x 110 cm. National Palace Museum, Beijing.

often evident as they strove to attract the widest possible readership for their publications. In addition, there are examples of publishers using these manuals to assert their own cultural superiority and elite status in society. A painting manual might well come into the hands of diverse social groups—sons and daughters of the middle class, aspiring local scholars, merchants planning to join literati clubs, or even pretentious mountain hermits who had gotten themselves invited to a painting society. The diversity within and between publishers and readers was the starting point of my investigation. We will see the ongoing conflicts of tastes reflected in the formats, programs, editorial comments, and prefaces included in these publications. Therefore, although painting manuals seem to be all about art, the complicated webs of interaction detected in their production and consumption prove that they were really engaged with something much broader—the field of play wherein artistic discourse meets social history.

Painting Manuals before the Ming Dynasty

In contemporary art historical parlance, painting manuals are understood to be illustrated publications containing detailed instructions on how and what to paint. But in traditional China, no term specifically referred to "painting manuals" per se; such manuals were grouped under the broad genre of *huapu*. This term can refer to painting catalogues, manuals, collection books, and art treatises, or picture albums, as well as any possible combination of these.[6] For example, a published painting album could also be consulted as a pattern book or manual; a printed artistic treatise could provide textual information on how and what to paint, content also commonly found in painting manuals. Yet this ambiguity is not due to a lack of vocabulary or categorization schemes in Chinese language and culture; rather, it testifies to the multivalence of the genre, which encompassed a range of functions and uses. Among the varieties of *huapu*, one primary utility was typically stressed more than others in each publication, and from our modern perspective, we cannot help but note their functional differences.

In his study of early modern Dutch publications on art, Jaap Bolten makes a distinction between model books (albums) and drawing books (manuals). The first is defined as "merely a storehouse of iconographic and formal elements," while the latter includes "those printed didactic works in the field of the pictorial arts, in which the instruction makes use of the visual, rather than the verbal medium"; the latter is also "designed to provide instruction in the creation of images and is designed for the use of painters, graphic artists, and (with some exceptions) sculptors."[7] Bolten's definition of the drawing manual, while helpful, does not flawlessly fit its Chinese counterparts. Unlike Dutch drawing books, Chinese manuals were published (or at least so it was often claimed) for a larger public than the limited audience of painters and sculptors; additionally, in their pedagogical structure, both pictorial and textual instructions were treated as equally important. Furthermore, most Chinese painting manuals allot sizable space to iconographic motifs, a defining character of model books in Bolten's scheme. Still, given the similarities in their fundamental nature, it can be said that "painting manuals"—printed aids contrived to teach readers the execution of painting practice—were produced and consumed in both of these early modern cultures.

Modern scholarship often regards *Register of Plum Blossom Portraits* (Meihua xishenpu), a work by Song Boren, a minor official in the state salt administration, as the earliest example of *huapu* in Chinese history. It was originally published in 1238, but only a copy printed in 1261 survives in the collection of the Shanghai

Museum. As the term "portrait" (*xishen*) in its title indicates, illustrations in the volume capture the subtle changes in the plum as it develops from a bud through full flower to spent blossom, representing fully one hundred of its configurations. The bloom and fall of the plum flower had strong political resonance as a metaphor for dynastic change and dissent against Yuan (Mongol) governance. Song Boren, a loyal official of the Song dynasty, intended to call for dynastic renovation, renewal, and reunification, and these ideas are metaphorically encoded in his book.[8]

Each image, surmounted by a title and matched with a quatrain, characterizes the morphology of the plum. Many of them present an allusion or allegorical construct that refers to a historical situation, which is further elaborated in the matching poems. In the case of "Ancient Coin" (Guwenqian) (fig. 1.2), we see a plum flower whose petals resemble the shape of an ancient Chinese coin with a square hole in its center. The poem on its left reads, "What the hell is that stuff? Rotten cords are so disgraceful. One thing fills an empty purse; the ages value honesty."[9] The poem makes historical reference to a Jin dynasty (265–420) official, Wang Yan, who was known for his vanity and precocious use of words. His meticulousness in avoiding any sign of corruption made him refuse to use the word "money," which he called "that stuff" instead. Rotten cords here symbolize unused coins filling up someone's coffers; thus, the poem censures the excessive

wealth of unprincipled subjects. The image of the plum flower in the shape of an old coin generates and amplifies iconographic discourses of didactic and moral suggestions.

To a certain degree, the images of the plum flower in this volume, each representing its different aspects, and their accompanying text could be used as pedagogical models since they show how a stylized graphic image resonates with a poetic verse and vice versa. Thus, readers of this album could learn to create paintings or poetry based on the play between word and image. Song Boren specified in his preface, however, that the book was not intended to be a model book for painting practice because "the 'school methods' (*jiafa*) of two artists, Huaguang (d. 1123) and Yang Wujiu (1097–1169), are already in place, and [teaching plum painting is] beyond my ability."[10] By its self-definition, then, *Register of Plum Blossom Portraits* took up particular functions within the genre of *huapu*; it could be considered a painting album, poetry-painting collection, or even a history book, but it had only a slim affinity to the subgenre of painting manuals.

Acceding to Song's comment and other art historical records, some studies regard *Huaguang's Guidebook to the Plum* (Huaguang meipu) by the Buddhist monk Zhongren (d. 1123) to be the first guide to painting plum flowers.[11] Although the known contents of this manual include no illustrations, its program nonetheless covers a whole gamut of topics that would presumably be useful to painters: it provides a botanical description of the plant and its diverse historical and symbolic meanings followed by textual instructions on how to depict the plant in its varying appearances. Some of the book's contents appear to have little to do with painting the plum but can perhaps be understood as supplements to help readers better understand the plum as a pictorial motif. Certain types of botanical knowledge and literary interpretations had often been incorporated into the corpus of visual art—for plum and the two other mainstays of Chinese painting, bamboo and rocks.

Works such as *Album of Rocks by Master Yunlin* (Yunlin shipu) by Du Wan (act. 11th century), *Second Treatise on Bamboo* (Xu zhupu) by Liu Meizhi of the Yuan dynasty, *Stone Lake Plum Register* (Shihu meipu), and *Stone Lake Chrysanthemum Register* (Shihu jupu) by Fan Chengda (1126–1193) do not address painting practice at all; instead, they are guidebooks to decorative rocks or botanical treatises. The contents of *Stone Lake Plum Register*, also known as *Fan-Village Plum Register* (Fancun meipu), mostly describe the eleven varieties of plum trees the author had planted and observed in his orchards in Suzhou. This is the earliest botanical treatise devoted exclusively to the flowering plum. However, the entries in this volume characteristically combine physical with metaphorical

description, thereby, in effect, creating the plum as an aesthetic and literary motif. For example, "river plum" (*jiangmei*) represents the unpruned, uncultivated wild plum growing unattended in the mountains, by the waterside, and in wintry desolation. Fan Chengda explains that river plum is the exemplar of purity, which is represented in its small and sparse blossoms, hard fruit, and fragrance. These noted characteristics would inform the use of wild plum in poetry and painting as a charged motif identified with abandoned beauty and the neglected scholar or, more positively, with the scholar living in seclusion and his pure, unworldly life.[12] Thus, even lacking illustrations, Zhongren's work may be thought of as a guide for certain aspects of painting.

Still, this does not establish *Huaguang's Guidebook to the Plum* as the earliest printed manual on the practice of art because there remains the question of its authenticity. The text has survived only as a part of other art historical texts, such as *Pine Studio Plum Painting Manual* (Songzhai meipu) by Wu Taisu (ca. 1290–ca. 1359) (fig. 1.3), *Plum Painting Guide* (Meipu) by Wang Mian (1287–1359), and *Appendix to Recollection of Calligraphy and Paintings by Master Wang* (Wangshi shuhuayuan buyi) by Zhan Jingfeng. Furthermore, *Huaguang's Guidebook* is not listed in any of the bibliographical records of the Song dynasty. Was this due to its less renowned status? Was it the result of simple but repeated mistakes by compilers of contemporary bibliographies? Or perhaps it was not printed in book format during the Song? The key to these questions is found in *Pine Studio Plum Painting Manual*, another painting manual of plum flowers, originally compiled around 1350. Meticulous research on this manual by Shimada Shūjirō and Maggie Bickford clearly disentangled the complex threads of publication history regarding these early plum-flower manuals.

According to their research, references to Wu Taisu's manual do not appear until the late Ming period. *Complete Methods in Painting of Plum* (Huamei quanpu), a text credited to Wu Taisu, is collected in *Forest of Fragrant Snow* (Xiangxue linji) of 1603 by Wang Siyi (act. early 17th century). The same title is cited by Li E (1692–1752) in *Records of the Southern Song Painting Academy* (Nan Song yuanhua lu), published in 1721. During the 1930s, Japanese scholars rediscovered *Pine Studio Plum Painting Manual*, which is now known through four incomplete editions in Japan, ranging in date from the fifteenth to the nineteenth century. Shimada believes that it probably was brought to Japan by Zen monks returning from China during the late fourteenth century, when exchanges between Chinese and Japanese monks were frequent. He has also discovered that elements of artists' biographies in Xia Wenyan's *Precious Mirror of Painting* of 1365 duplicate materials in *Pine Studio Plum Painting Manual*, which sets the

松雨梅譜卷弟六

鈞有神一氣枹芳供

物維春巾孤根弓

很撮提東掃弓方

仰天枸弓周流荦

左斗

1.3 A page from Wu Taisu's *Pine Studio Plum Painting Manual*, ca. 1351. 21 x 18 cm. Asano manuscript copy, Hiroshima Central City Library, Japan.

book's *terminus post quem*. Through comparative analysis of its contents, he further revealed that texts collected in *Pine Studio Plum Painting Manual* form the content of *Plum Painting Guide*, a manual attributed to the contemporary ink-plum master Wang Mian, which was later collected in the imperially sponsored encyclopedia *Vast Documents of the Yongle Era* (Yongle dadian) of 1408. His research also concluded, on the basis of collation, that the so-called *Huaguang's Guidebook*, considered by many scholars to be the earliest surviving plum manual, is in fact a greatly abbreviated version of Wu Taisu's writings and dated it to the early Ming period.[13] It is no surprise, then, to learn that many bibliographers of the past also questioned the authenticity of both texts and ascribed them to a later period.[14]

However, this is not definitive proof that there were no manuals written by Wang Mian or Zhongren. Instead, as Song Boren specified in his preface to *Register of Plum Blossom Portraits*, it is likely that their guides on the practice of plum-flower paintings were known and circulated in contemporary society. Simply, what are known as such texts to us appear to be much later fabrications. Wu Taisu's plum painting manual shows most of the features commonly found in later painting manuals. In its surviving program of fourteen chapters (*juan*), it covers multiple topics related to plum painting as well as to the plum as figure in literature and history. These include detailed explanations of theory and practice, a well-illustrated typology manual, botanical guide (emended from Fan

Chengda's *Stone Lake Plum Register*), a plum poetry manual, and even a register of plum painters from the Song to the Yuan.[15] Wu's preface reveals a great deal regarding the book's proposed function and use.

> In scholar-officials' playing with brush and ink, excellence consists of meanings being there, not in the attempt to capture formal likeness. However, it is hard to do away with forms and have sufficient meaning, which is why this album was made. Generally, if representation does not conform to the [correct standard given in] handbooks, where can one find a model? When after long imitation one's style is in accord [with the model], and brushwork and meaning fuse, one leaves the able class and enters the divine. Thus, one can look on the album as a useful tool. . . . Huaguang, Yang Wujiu, and [Yang's nephew] Tang Zhengzhong were famous for ink plum. I sought out manuals; and looking at them it was as if I personally were receiving painting pointers from their lips. Copying and imitating [these models], I worked day and night without idleness. From this [I learned] the methods of sprouting branches, dotting blossoms, verticals and horizontals, looking down and facing up, and the compositions of front and back, opening and closing. [I practiced these until] in every detail they closely conformed to the manuals. . . . Cognoscenti frequently approved [my paintings], but I dared not be satisfied. I simply studied pictures of no less than a myriad plums. [Now] when I am tipsy and my spirit is aroused, and I make a sketch in a state of exhilaration, it is certain to conform to the rules. Were there no manuals, how could I arrive at this? Thereupon, I took up the technical secrets of the masters and the painting scrolls in old collections. Then, according to my own ideas, I deleted superfluities and supplemented deficiencies, compiling these into one collection. It is titled *Pine Studio Plum Painting Manual*, and it is [intended] to aid art lovers. . . . As for later painters, how could they understand were there not such as I who [have undergone] the hardship of preserving a steadfast heart and [have acted with] the earnest concern of devoted attention? Not daring to keep this secret to myself, I have had woodblocks carved to widen its transmission. Therefore, I related this outline at the head of this book.[16]

In this comment, Wu Taisu clearly explains that novice artists could use his manual as a textbook. He recognizes previous masters' absolute authority in plum-flower painting, and even when he is intoxicated, his painting still cleaves to rules they established. By extolling the merit of such a technical guide yet alluding to his own superb hand and mind, Wu claims a place in the pedigree of master plum-flower painters. The proposed readership of his manual—art

lovers—further points to the societal context of the time: Wu's publication was addressed to an emerging educated leisure class.

It was only during the Yuan dynasty that specialized writings on painting practice began to appear in any number. Specialized and illustrated textbooks were becoming available, such as the bamboo painting manual by Li Kan (1245–ca. 1320), short treatises on landscape painting by Rao Ziran (1312–1365) and Huang Gongwang (1269–1354), and a guide to portraiture by Wang Yi (act. ca. 1360).[17] The emergence of such writings may have been related to the political situation, since Yuan dynasty literati under the Mongol rulers had only a narrow path to official-dom and so pursued alternative pastimes in order to affirm their group identity. These books offered a fast track to the practice and knowledge of art.

In terms of its contents and format, *A Detailed Treatise on Bamboo* (Zhupu xianglu) by Li Kan predates *Pine Studio Plum Painting Manual* by half a century, which makes this book a top candidate for the first publication in Chinese history that can unequivocally be called a painting manual. Written by one of the highest-ranking Chinese serving in the Mongol regime, it contains seven parts, with a preface dated 1299. It explains the history and method of bamboo paint-ing and includes extensive botanical information.[18] Furthermore, its 150 illustra-tions show the various parts of the bamboo plant, the plant's appearance and movement in specific weather conditions, and its stages of growth and techni-cal information about how to represent them (fig. 1.4). The text further provides would-be bamboo painters with useful pointers—such as how leaves are to be grouped in certain patterns and how these patterns are repeated to make larger masses. A good example is this instruction: "If you paint only one or two stalks, you can use whatever values of ink you want to; but if there are three or more stalks, those in front must be painted in darker ink and those behind in lighter. If you use only a single shade of ink, you won't be able to distinguish the nearer from the farther."[19] Thus, Li Kan's main concern clearly was proper method, knowledge, and skill, which were to be acquired through systematic guidance and practice. He stated, "He who is able to follow the rules and principles will not cause any defects . . . whereas he who is hasty and reckless will never, I fear, be able to grasp the rules and principles, or accomplish anything [worthwhile]. Consequently, the student must start from the rules, only so can he reach the goal [grasp the art]."[20] Li Kan emphasized the significance of basic technique and systematic accumulation of knowledge as preparatory steps toward accomplish-ing true artistic mastery.[21]

In addition to the texts discussed so far, other works such as hand-drawn painting albums specifically made for teaching purposes are also treated as

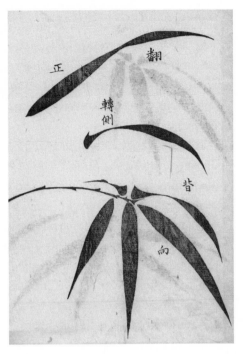

1.4 A page of illustrations from Li Kan (1245–ca. 1320), *A Detailed Treatise on Bamboo*, 1299. Reprint, Kyoto, 1756.

painting manuals, or at least as *huapu* in the modern scholarship. These include *Ink Bamboo Manual* (Mozhupu) by Ke Jiusi (1290–1343), the bamboo painting album by Wu Zhen (1280–1354), an excerpt from *Orchid Painting Manual* (Lanpu) by Puming (act. 1340–1350), and the illustrated tree-and-rock manual by Ni Zan (1301–1374) preserved as part of a later publication.[22] *Ink Bamboo Manual* is noted to have had thirty-six illustrations, but existing copies contain only twenty-two images of various types of bamboo. Each example is in the format of one image with a caption and very limited textual explanation.[23] In 1350, an amateur painter, Wu Zhen, made three bamboo paintings after an engraving of a bamboo painting by Su Shi (1037–1101) that he had seen during his travels. Originally made for his son, Fonu (b. 1340s), the project was later expanded to an album of twenty bamboo paintings.[24] The images cover unique types of bamboo in various seasons, weather conditions, and stages of growth, while the text, written mostly in cursive script, narrates stories or poems that reflect the sources of the images or Wu's personal feelings at the moment of painting. Thus, this album was a textbook for his son as well as a collection of copies of old masterpieces and

even included some of Wu Zhen's original paintings.[25] Both Ke Jiusi's and Wu Zhen's works, however, are collections of paintings and were not printed for wide circulation. Historical records also register the titles of a few publications that may well belong to the genre of *huapu*. Unfortunately, since physical copies no longer exist, it is hard to verify whether they were painting manuals or botanical guides.[26]

To summarize the issues discussed so far, characteristics of the *huapu* published during the Song through Yuan periods may be counted thus: First, although there were study copies and written guides on landscape and bird-and-flower paintings (for example, those by Huang Quan, Ni Zan, and Huang Gongwang), the majority of known painting guides focused on only one of two specific subjects, bamboo or plum. This uneven distribution in subject matter may have been rooted in the narrow interests of the audience or simply the ease of pedagogy for these subjects. At the same time, the symbolic meaning of both bamboo and plum, emblems of scholars' integrity, faith, purity, and artistic genius, would have appealed to the majority of readers of the time: educated males who sought artistic means of displaying such qualities. Second, except for *A Detailed Treatise on Bamboo* and *Pine Studio Plum Painting Manual*, it is less likely that the other publications were prepared as illustrated painting manuals or were made in wood-block prints. This means that from the time wood-block printing was invented in China around the seventh century to the end of Yuan dynasty—a period of more than six centuries—only two publications unerringly meet the modern definition of painting manuals. Third, as seen in the cases of *Huaguang's Guidebook* and Wang Mian's *Plum Painting Guide*, some of them appear to have been compiled, or even fabricated, later. Thus, although a few such publications seem to have been in circulation, they likely had little presence or impact on society at large. In sum, painting manuals, though likely extant, were not impressively conspicuous in Chinese society before the fifteenth century; this situation would markedly change by the late Ming.

The Early to Mid-Ming Period (1368–1550)

In terms of publication date, *Apprenticeship in the Painting Business* (Huishi zhimeng) may fairly be considered China's earliest multi-genre painting manual, despite the uneven treatment of its various topics and its ultimately hybrid nature;[27] however, its coarse format and rather haphazardly organized contents made it far less marketable and attractive, and so much less significant in its

impact, than *Forest of Paintings*, which soon eclipsed it. Its compiler, the Master of Serene Dwelling (Jingcun jushi), Zou Dezhong, is likely to have been active in the early Ming period, but he is all but unnoted in the historical sources.[28] The only record of him that survives is in the preface to this manual, written by Zhang Chun, another historically obscure figure, in which Zou Dezhong is described as a recluse from Shandong who possessed profound knowledge of the art of painting. Zhang Chun's preface is dated to spring of the year *jisi*, which could refer to 1389, 1449, 1509, or 1569. To complicate things further, the name Zhang Chun appears in a number of documents compiled in several eras, which obviously makes verification of the preface's publication tricky. Among these figures, at least three were scholars who could have authored the preface—or whose name was simply borrowed for effect. The Hangzhou gazetteer compiled in the eighteenth century documents that one Zhang Chun was appointed to office there in 1408.[29] Another source discloses a scholar with the same name in official service during the later fourteenth century.[30] The latest occurrences of the name are for a Zhang Chun who held various official positions and lived during the reign periods Jiajing (1522–1566) and Longqing (1567–1572).[31] Who, then, among these three figures, was the author of the preface? Without other corroborating evidence, any hypothesis regarding the identity of this figure must remain in the realm of conjecture.

In addition, another name in *Apprenticeship in the Painting Business* makes the investigation of its publication date even more challenging. A short postface at the end of the manual reads, "If your mind is listless, then the stone [in your painting] cannot look firm; if your heart is impatient, the water [you draw] cannot be serene. A subtle brush makes branches and leaves delicate, while faded ink gives clouds over the field lightness. A writer once chanted this quatrain. [Although] I learned painting only in middle age, when I think of this poem, I feel greatly inspired. Written by Dongyuan in the year of 1473."[32] This colophon, like the colophons inscribed on paintings or calligraphy executed at the end of scrolls, celebrates the links between painting and emotion and proclaims the virtue and pleasures of the practice of art. Dongyuan was the sobriquet of the well-known literati artist Du Qiong (1396–1474). Does this confirm the range of the manual's publication date? There is still a considerable time gap between it and the proposed date of Zhang Chun's preface. Furthermore, this date does not quite fall within the range of the periods in which the above-mentioned three figures were supposed to have been active. There is also the possibility that somebody simply inserted Du's name. No scenario perfectly matches present-day historical knowledge. If the Zhang Chun of the Hangzhou local gazetteer was the author

of the preface, the book appears to have been published in the early fifteenth century. On the one hand, this inevitably suggests the publication of another, 1473 edition, to which Du Qiong added his comments. On the other hand, it is also possible that the preface was written in 1449 by Zhang Chun and signed by Du Qiong in 1473. This still presents a puzzle, however, since a gap of twenty-five years between the dates of the preface by Zhang Chun and the signature of Du Qiong, although not entirely improbable, seems less than likely. Does this mean that at the very least there was an edition published soon after the year 1473 when Du Qiong's signature was added? Unfortunately, any speculation leads to further questions.

If we take Du Qiong's postface as the date for *terminus post quem*, we can assume *Apprenticeship in the Painting Business* was published in 1473. Then it was reprinted with at least two additional sets of blocks. The first is Hong Pian's edition of the mid-sixteenth century, a copy of which was once held by the private collector Zhang Congyu in Beijing.[33] This edition now appears to be lost, but the commercial publishing house Zhongguo Shudian brought out a reproduction of it in 1960. The second edition, published by Hu Wenhuan (act. ca. early 17th century), is included in the three collectanea (*congshu*) Hu published; Hu used the same set of blocks to print each one.

Hong Pian was a book collector, publisher, and painter who lived during the Jiajing era.[34] He published many titles at his private publishing house, Peaceful Mountain Hall (Pingshantang), covering a range of literary genres including prose, poetry, medicine, gazetteers, and anthologies.[35] In addition, although he is less well known to modern scholarship, Hong seems to have been an established painter; his landscape painting and a painting of the Peach Blossom Garden are included in the list of property confiscated from Yan Shifan (1513–1565), a minister who was disgraced and executed in 1565.[36] Apparently, some of the illustrations in *Apprenticeship in the Painting Business* are Hong's creations, and some model images of leaves are labeled as his own additions.

The edition published by Hu Wenhuan, a well-known writer and publisher of the late Ming, was part of his three collectanea series, all published around the beginning of the seventeenth century: *Works Inquiring into and Extending Knowledge* (Gezhi congshu), *Renowned Works of the Hundred Schools* (Baijia mingshu), and *Four Traditions of the Leisure Arts* (Youyi sijia).[37] While the contents are unchanged, Hu's edition is slightly different from Hong Pian's in size and layout. Thus, Zou's painting manual had been printed in at least three different sets of blocks by the early seventeenth century, which testifies to the favor in which it was held in society at large. This hypothesis is further supported by

the recycling of its program in later publications; many subsequent multi-genre painting manuals would appropriate much of its text, illustrations, and overall editorial plan, a clear indication of its popularity and circulation in late Ming society.

If the preface to Wu Taisu's *Pine Studio Plum Painting Manual* was intended to explain the basics and merits of painting, the importance of traditional method in depiction, and the author's dedication to sharing his artistic mastery with the public, Zhang Chun's preface in *Apprenticeship in the Painting Business* provides valuable clues with which to further unpack the social discourse around the use of painting manuals. Wu's confidence in his artistic accomplishment certainly comes through loud and clear, but Zhang's writing introduces new claims about the utility of such mastery and guidance in achieving the desired result.

When you consider the art of painting, it is no trivial matter. Assisting the development of skill and teaching method isn't in the least bit shallow. Those who undertake such study will not be slighted by literati. For those who do wish to undertake study, is there a reliable method? Unfortunately to date there have been no guide books, and so art lovers cannot pursue this field of study. Generally, the art of chess and pitch-pot are difficult but still can be learned. [This is] because what comes first and later, what decides who wins and who loses are written down and compiled into books; thus, these methods will never be lost. [Then] who says there should be no instructional guide for painting? In the past, before painting a picture, people licked their brushes and chewed their ink sticks until a thousand varied images welled up in their hearts. Looking at their works, the artists appear now unsure, then [all of sudden] confident; sometimes as if they have a thousand things to say, other times even a word is too much to speak; should they say they'll paint curves, you still can't be sure, should they wish to paint angles, there's no way to predict. As for length and size, coarse or detailed, even spirits can't fathom their actions—how much less mere mortals? And how much less still those [whose education is] below that of the literati?

[Art] may be known, but people naturally cannot learn by themselves how to get to the point where your brush completely expresses your ideas, and though the surface be less than a foot yet the color is fresh and varied, completely conveying the scene. . . . This is why, when someone draws mountains, forests, and gorges, he forgets mundane affairs and loses vanity and ambition. If one paints streams, rivers, or seas, his imagination and spirit will roam free. If he draws a picture of a son helping his father carry a burden, he will learn filial piety. From a painting representing the emperor and officials in their proper

relations, he will understand forthright integrity. . . . For spreading proper values and discouraging iniquity, nothing is better than paintings because they are profound and readily motivate people. In its capacity to promote good values, painting is on a par with literature, so could anyone claim that providing a guide for the practice of art is a vulgar business? This is a beautiful enterprise! There is so much of value to appreciate in painting, how dare I take this pursuit lightly? How could those wishing to learn painting undertake it in a casual way? . . . I met Mr. Zou in Hangzhou. He is a retired gentleman and shares the same passion for art as I do, but he is more skilled than I am. Painting is his profession; he excels in understanding it and has mastered its essence. One day he told me, "In general, in painting the composition should suit the eye; the conception and taste should be vivid; they should be consistent with classical flair yet suitable for modern taste. One must be learned in all things and have studied widely. Only then will the brush flow without obstruction and the scene avoid vulgarity. . . . Art should flow from the heart and emerge from the bowels, so that the events of all time, all good and evil things may be known in general through a single glance. The wonder of art lies in this." When I heard this, I was delighted and asked him to summarize his thought. Mr. Zou then took out a book titled *Apprenticeship in the Painting Business* and gave it to me. The book explains the rules of composition, coloring, brush techniques, and copying in detail without missing any subtlety. . . . I presumed to write and append a preface at the beginning of the book and asked him to print it. [Thus] this manual helps students of painting conveniently learn its art and lets people understand that textbooks are not only for chess and pitch-pot but also for painting. In the year of *jisi*, [I] Zhang Chun write on my way to Hangzhou.[38]

This preface addresses a variety of issues. First, Zhang Chun confidently claims that his book is the first manual on painting. Since some painting manuals had been published during the Yuan period, this claim suggests that they were not in wide circulation in the Ming. Next, Zou's book was published for a broader public—lower-level literati and other educated readers who had limited education in art.[39] Presumably, then, a market for such manuals existed outside the literati class as early as the early fifteenth century. Furthermore, the preface alleges that the practice of painting can instill moral values such as filial piety, loyalty, and integrity.[40] The promotion of art's didactic function has a long history in China. An early example is found in Zhang Yanyuan's *Record of the Famous Painters of Successive Dynasties*, which reads, "Painting promotes culture and strengthens the principles of right conduct. It penetrates completely all the aspects of the

universal spirits. It fathoms the subtle and the abstruse, serving thus the same purpose as the Six Classics, and it revolves with the four seasons. It originated from Nature and not from any decrees or works of men."[41] This is an interesting claim in that it promotes painting not only as a leisure activity or hobby but also as a humanistic discipline and even a force of nature. In addition, throughout the preface, Zhang Chun repeatedly asserts that the publication or reading of painting manuals is no philistine affair, which implies that he anticipated disapproval of the work and its use by the public. This points to the increased social and cultural agency of a larger educated public in the mid-fifteenth century. As Jürgen Habermas has observed, in a growing modern society the public first asserts its political and economic presence via cultural debate initiated by the cultural media it produces.[42]

In terms of its contents, *Apprenticeship in the Painting Business* covers a wide range of subjects, but in a rather disorderly manner. Although the entries are not numbered, there are exactly eighty-five in the volume. Among them, some cover topics similar to those in other manuals of the past. These include definitions of basic terminology, rules of composition in landscape painting, twenty-seven names of rocks, nine brush techniques for rocks, how to express the four seasons in ink, and how to represent trees and clouds as well as proper representation of sky and ground based on season, weather, and time of day. Some entries provide basic rules for painting bamboo, plum, branches, and bird-and-flower scenes. The manual's contents seem to include a proper distribution of topics; however, each entry's level of usefulness tells a different story.

The entries on clouds, the four seasons, and trees provide very detailed and useful explanations. For example, for the expression of the four seasons, the manual cites the proper colors, motifs, and scenes for each season over a couple of pages. This content is not inferior to that of other painting manuals of the Ming period. This is not the case with other entries, which are covered only briefly. It is even doubtful whether they were provided for any genuine pedagogical purpose or simply for the sake of a superficial comprehensiveness. The section titled "Brief Rules on the Landscape" is only four lines, which read: "In placing the distant and close, [you can use] layered mountain-tops with trees and hills. Brushwork and lines have colors and gradation; [you must] ultimately remove flashy and vulgar expressions."[43] The explanations for bamboo and plum are even shorter, and the section on leaves has no textual explanation at all. Instead, it comes with illustrations featuring different types of leaves arranged in rectangular grids (fig. 1.5), altogether forty-four items, seventeen of which were added later by Hong Pian. The grid arrangement offers a variety

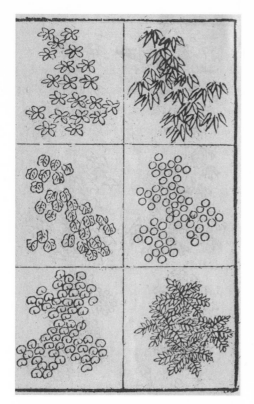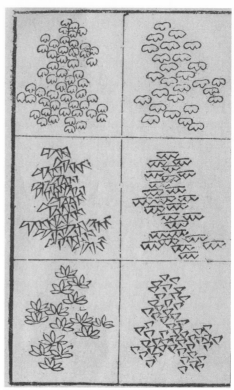

1.5 Pictorial motifs of trees from Zou Dezhong, *Apprenticeship in the Painting Business*, Hong Pian edition, mid-16th century. Reprinted in the 1960 Zhongguo Shudian edition, 9b–10a.

of pictorial motifs in a compact fashion, so readers can easily choose a specific example to practice or copy. This is the earliest example of landscape motifs offered in a painting guide, and it would be adopted by the publishers of many other late Ming painting manuals, including *Forest of Paintings* and *Elementary Learning in the Rules of Painting* (Huafa xiaoxue).

Although landscape is treated throughout *Apprenticeship in the Painting Business*, most of the manual's program covers programs related to another genre, religious figures. Much of the contents explain, in considerable detail, how to present images of Buddhist, Daoist, and historical themes. These entries include the sequence of coloring in figures (body and face),[44] color schemes for facial expressions, images of Buddhist monks, eighteen types of brushwork for the expression of clothing, embroidery patterns, armor designs, silk brocade patterns, designs on dyed fabric, precious beads, and lotus leaves and flowers. Even minor objects included for embellishment in religious figure paintings, such as

1.6 Patterns of armor in Zou Dezhong's *Apprenticeship in the Painting Business*, 31b–32a.

lacquerwares, porcelains, jade wares, quartz, garden railings, pavilions, moss on rocks, wisteria, fish (carp) scales, and flowers (plum, apricot, pear, and wild rose), are given individual entries that offer greatly detailed descriptions of their exact shapes, colors, sizes, and even locations in paintings. Among these, some have illustrations. Figure 1.6 shows sample images for armor patterns. Such motifs are not usually found in scholar-amateur paintings but figure frequently in images of religious or history paintings done by professionals (fig. 1.7).

This manual, then, seems to have been geared more toward apprentice painters of Buddhist or Daoist subjects, a genre that was the special province of professional painters. Possibly the most unusual feature of *Apprenticeship in the Painting Business* is that it deals with the very technical aspects of painting practice: the proper use of gold color in paintings, glue-mixing techniques for different colors, the technique for duplicating paintings by tracing, the pouncing technique, how to erase colors from paintings, how to make ink sticks, how to make rouge red, how to make colors by mixing different colors, and even how to boil

1.7 Artists unknown, detail of *Daoist Divinity of Water*, 15–16th century. Hand scroll, ink on paper, 49.9 x 264.5 cm. Freer Gallery of Art, Smithsonian Institution, Washington, D.C., Gift of Charles Lang Freer, F 1917.185.

glue and then mix it with alum, two major substances and chemical solutions for the execution of colors. The last entry in the book even explains nine different ways of removing undesirable odors from old religious paintings along with two methods for making new paintings look aged. This type of technical and practical information is rarely found in publications for literati artists. Most of the entries provide such detailed accounts of each practice that, properly followed, they may be useful even for modern painters and craftsmen. This clearly suggests that the knowledge in the book was meant for professional artists (or even forgers) who dealt mostly with colors and gold and the pictorial schemes of religious paintings.

The use of pigments was not entirely forbidden within the literati tradition, but given the negative implications of the heavy use of colors among literati, this emphasis on coloring method may be an important clue concerning the intended readership of the book. It is hard to imagine that heavy coloring and gold, not to mention the religious and bird-and-flower subject matter, were much appreciated by the scholar-elite class in traditional China. These styles and subject

matter would not have been considered elegant by contemporary literati, and this weighting of the contents suggests the author's expertise in religious paintings and related practicum as does the incoherent and poorly organized contents on landscape painting and theories of art. The book's clumsy editorial finish, with its unsystematic page design and format as well as numerous errors throughout its texts, provides additional evidence by which to gauge its status in society.

All this is at odds with the claims made in the preface, which aim the book at members of the general public and their leisure. The degree to which its contents are designed for professionals also contradicts the ideal function attributed to painting manuals in late Ming society—that they were works from which general readers could learn good taste in art. This disjuncture may testify, to a certain degree, to the wider culture's ignorance of art in the fifteenth century, before the reading public had become a ready market for this kind of cultural education. Or possibly the publisher, Zou Dezhong, being a professional artist himself, was simply trying to capitalize on his knowledge of religious painting by adding a modicum of information on the literati tradition. Any hypothesis must remain speculative, but *Apprenticeship in the Painting Business* seems to have enjoyed a certain success and perhaps even seeded a new market for multi-genre painting manuals.

Another painting reference of the period, *Gao Song's Painting Manual* (Gao Song huapu), also deals with multiple subjects. It comprises a series of painting manuals published in the 1550s by Gao Song (act. 1522–1566), a painter from Wen'an county, Hebei. Gao is noted to have received an offer of government service, but he did not accept it and instead relied on family wealth to sustain himself and his artistic career. His biography notes that he was adept at poetry, calligraphy, small landscape paintings, and still-life paintings.[45] Gao authored three manuals on bamboo (dates unknown), chrysanthemums (1559), and bird-and-flower painting (1554). It has been suggested that he published on more topics, but this requires further investigation since no physical evidence had been discovered so far.[46] Many of Gao's textual explanations are copied almost word for word from previous publications such as Li Kan's *A Detailed Treatise on Bamboo*. But Gao Song discarded many topics not directly relevant to painting, such as the botanical study of bamboo featured in Li Kan's work, and so his works represent a more specialized guide on the practice of art. In addition, Gao Song's manuals feature pedagogical devices designed to expedite the reader's learning process and facilitate memorization of basic rules. For example, "summary songs" (kou-jue) were used throughout Gao Song's manuals and in other late Ming manuals as well. This formula provided readers with the foundation for proceeding to a

more advanced level of study (discussed in chapter 5). Nowadays, Gao Song is better known for his painting manuals than for his paintings.

The function of authorship is clearly key in the study of late Ming painting manuals. The author's authority and status could be built on the production of such manuals, and the manual's program allowed the room to maneuver. The author could manipulate the space in his publication in order to display and even enhance his artistic and cultural persona. A plum painting manual, *Liu Xuehu's Plum Painting Manual* (Li Xuehu meipu), by Liu Shiru (1535–1625), a native of Shaoxing, Zhejiang, provides insight on this matter. The popularity and impact of Liu Shiru's manual in late Ming society can be at least partially assessed in terms of its different editions. A preface by Wang Siren (1575–1646, *jinshi* 1595) comments, "[The woodblocks for this manual] have been cut four times. Each time the blocks were carried away by art lovers and Liu was unable to cut a new edition because his family is poor. Now I have cut [them] for him from an office in Anhui."[47] This comment reveals that Wang's preface was written after 1595, when he obtained the *jinshi* degree, so he could publish this edition using the facilities of his office. The publication of this edition can be dated to no later than 1619 because its texts contain characters that were considered taboo after 1619.[48] Among the volume's eight prefaces and postfaces, the earliest dates to 1555 and the last to 1595. The rest date to 1557, 1561, 1569, 1575, and 1578.[49] Thus, if the blocks for the manual had been cut four times as Wang noted, new prefaces must have been added each time. After Wang's publication, the manual was printed at least twice more in the seventeenth century, but both used the blocks created for Wang's edition.[50]

The author of the work, Liu Shiru, never obtained an official degree, yet his artistic talent presumably allowed him to participate in a social network that included contemporary luminaries such as the writer of his manual's preface, Wang Siren. Wang extols Liu's artistic talent, describing how Liu became engrossed with Wang Mian's plum paintings during his youth and practiced without eating and sleeping, only thus finally achieving mastery in his subject. This commentary establishes Liu as a legitimate specialist and successor to Wang Mian's fame, a status that had been earned only after a long period of hard work and commitment. Wang's underlying rhetoric is quite clear: readers should not question or doubt Liu's artistic excellence. Interestingly, the volume carries many features obviously designed to promote Liu Shiru and his artistic persona. First, Liu's self-portrait (fig. 1.8) is printed in the beginning of the volume. This was unusual in late Ming publications, though not unprecedented. Yu Xiang-dou (fl. 1596), a commercial publisher in Fujian, and Yang Lun, the publisher of

1.8 Self-portrait of Liu Shiru in his *Liu Xuehu Plum Painting Manual*. Published by Wang Siren, 1595, 1681 reprint, 1:5a. 23.6 x 16.4 cm. East Asian Library and the Gest Collection, Princeton University.

the manual *Zither Playing: A Guide for Perfection* (Qinpu hebi), included their own portraits at the beginning of their works.[51] These images present them as qualified cognoscenti, assuring readers of the authenticity of the books and the publishers' status as legitimate purveyors of cultural knowledge. In this sense, Liu's portrait, too, must be understood in line with its rhetorical function. Next, the text of the manual contains more than one hundred commentaries, letters, encomiums, and poems extolling the beauty and virtue of plum flowers, many of which are also dedicated to Liu Shiru and his paintings. These were written by contemporary luminaries—scholars and painters including Wen Zhengming (1470–1559), Xu Wei (1521–93), and Wang Shizhen. Roughly 90 percent of the volume is devoted to such prefaces, poems, and commentaries.

Ironically, the part of the manual that explains painting practice is minimal. It begins with a page of illustrations displaying the different types of plum petals followed by twenty-five individual plum paintings offered as finished works. Each of these has a poetic theme, which is inscribed on the page. For example, an image showing plum branches and flowers under the moon features a caption that reads "The same heart a thousand miles away" (*qianli tongxin*) (fig. 1.9). The moon was often used to suggest two lovers thinking of each other as they gaze at it. Unlike other plum painting manuals, which provide systematic illustration

1.9 A plum-flower motif representing "The same heart a thousand miles away," in *Liu Xuehu's Plum Painting Manual*, 2:29a.

of individual parts of the plum, such as flowers and branches, discussion of their poetic symbolism, and things to be avoided, this manual offers only completed paintings that are supposedly the creations of Liu Shiru. In a sense, the volume functions as an exhibition catalogue. Textual guidance for painting the plum is also minimal. Items such as "The twelve essentials of plum paintings," "Things you must remember," "Things to avoid," "Huaguang's guide," and "Discussion of Yang Wujiu" are spread over fewer than ten pages. This content is made up mostly of text from previous writings on the topic tailored to fit the new publication. The pictorial and textual guides take up only 10 percent of the volume, so it is not entirely clear that Liu's primary goal was to provide systematic knowledge about plum painting to his readers. Instead, he appears to have been more enthusiastic about publishing writings dedicated to him that would publicize his social network and artistic achievements.

Zhou Lüjing and the Display of Artistic Virtuosity

Plum Addict (Meidian), Zhou Lüjing, was born in 1542 and died in 1633 at the age of ninety-one.[52] He never obtained an official degree but was an established literatus, poet, calligrapher, dramatist, publisher, connoisseur, and painter. His

friends often complimented him for his carefree lifestyle and compared him to the iconic Tao Yuanming (ca. 365–427), a gifted poet, voluntary recluse, and untrammeled drinker.[53] His hometown gazetteer reports that he never even sat for a government exam, yet it is difficult to verify this claim.[54] As was the case with many non-degree-holding literati of the time, Zhou's achievements in art and literature are what underlay his fame as a cultural luminary. The list of his literary and artistic creations is impressive. His publications include a collection of various literary creations: *Garden of Classics* (Yiyuan) in one hundred chapters, *Collected Writings of a Silk Chapeau* (Luoguanzi tie) in eight chapters, *A Collection of Poetry on Objects* (Yongwushi) in ten chapters, *Improvisations on Tao Yuanming's Poetry* (He Taoshi) in four chapters, *One Hundred Poems on Plum Flowers* (Meihua baiyong) in a single volume, and the multi-genre painting manual *Master Zhou's Forest of Paintings* (Zhoushi huilin) in twenty chapters.[55] Zhou was also a noted painter of various topics and genres: *The Orchid Pavilion Gathering* (Lanting tu), *Portraits of Grand Masters* (Dashi xiang), *Portraits of Arhats* (Luohan xiang), and *Stone Engravings of Twenty-eight Buddhist Patriarchs* (Ershiba zu shike). In addition, he even wrote a romantic *chuanqi* drama, *The Letter on Silk* (Jinjian ji), which was first published by Chen Bangtai's Studio of Enduring Discipline (Jizhizhai) in Nanjing in 1608 and republished elsewhere at least five more times by the end of the Ming.[56] Two of these editions were printed with commentaries written by cultural celebrities of the time, Li Zhi and Tang Xianzu, a clear indication of the drama's quality. Furthermore, Zhou's poetry and prose take up more than half of the literary section in his hometown gazetteer published in 1600, which helps us measure his status as an acknowledged writer, at least at a local level.[57]

Zhou owned a studio and publishing house called Atelier of Idle Clouds (Xianyunguan), which Li Rihua noted was Zhou's "hobby" (*bieye*).[58] His friend Zheng Qingfu once wrote, "Zhou stayed at his Atelier of Idle Clouds and published various books such as the *Thousand-Character Essay in Ten Calligraphic Styles* (Shiti tianwen) using stone blocks and circulated [these books] among the public."[59] Zhou published his magnum opus collectanea, *Extensive Records from Secluded Doors* (Yimen guangdu) under this studio name in 1597. Ownership of a private publishing house was a popular sideline among late Ming scholars. They ran publishing houses either to generate income or to publish their own books. Notable examples include He Liangjun's Fresh Forest Pavilion (Qingsenge); Zhu Cunjue's Gallery of Existential Leisure (Cunyutang) and Master Zhu's Stationery Shop (Zhushi wenfang); Wen Zhengming's Jade Orchid Hall (Yulantang), Studio of Azure Bamboo (Cuizhuzhai), and White Magnolia Hall (Xinyiguan); and

Wang Shizhen's Hall of Minor Excellence (Xiaoqiuguan) and House of Natural Virtues (Shidetang).[60] It seems likely that Zhou expected to profit from his publishing business, although a couple of contemporary sources contradict this notion. The 1597 gazetteer from Zhou's hometown notes that he did not pursue monetary gain through his literary and artistic works.[61] This comment cannot be taken at face value, however, since expressions of antipathy toward profit-making among or concerning the literati were essentially de rigueur in Ming biographical records. Still, in Zhou's case it might have actually been the case since a contemporary noted that he funded his studio and publishing house using his family's ample wealth. This also allowed him to freely purchase books, have stone rubbings carved, and satisfy his wanderlust.[62]

Given his cultural accomplishments and assets, Zhou Lüjing appears to have enjoyed a considerable level of influence and recognition during his lifetime. His network covered a wide swath of late Ming elite society, including officials, local literati, well-known scholars, and Buddhist and Daoist monks.[63] First, he studied under a famous writer and official of the time, Huangfu Fang (1498–1583, *jinshi* 1530).[64] His hometown gazetteer further relates that he had a close relationship with contemporary celebrities such as Wang Shizhen, Wen Jia (1501–1583), Liu Feng (*jinshi* 1544), Mao Kun (1512–1601), Tu Long (1543–1605), and Dong Qichang, all of whom were successful officials, scholars, writers, publishers, or painters of the time.[65]

Zhou was also the maternal uncle of Li Rihua, a scholar of humble peasant background who attained the *jinshi* degree in 1592; his fame and influence as an art critic and writer surpassed Zhou's in many respects.[66] Li Rihua left many bits of writing that extol his uncle's personality and artistic talent. In one, he comments that local collectors often sought Zhou's appraisal for their antiques or old paintings. Zhou evaluated these items, which, Li noted, would "fill more than a hundred carts," but never once made a questionable or erroneous judgment.[67] Even Dong Qichang, the unchallenged cultural arbiter of the time, left a similarly respectful comment on Zhou and his painting manuals in his *Notes from the Painting-Meditation Studio* (Huachanshi suibi).[68] Other historical documents testify to Zhou's close personal relationships with many contemporary scholars and critics, including Zhou Tianqiu (1514–1595) and Chen Jiru.[69] Furthermore, when Zhou organized his own literati society, Eastern Woods (Donglin), sometime before 1580, many of his contemporaries competed to join.[70] He seems to have enjoyed solid membership in top social echelons outside his locale.

In this context, the last volume of *Grove of Paintings*, Zhou's multi-genre painting manual, *Colophons of Recognition for Forest of Paintings* (Huilin

tizhi)—a collection of forty-two laudatory reviews by accomplished scholars of the period—highlights some of the lesser-known aspects of late Ming painting manuals and the society that produced and consumed them. This last volume was exceptional in its scope in that other late Ming publications typically offered only a couple of prefaces by famous scholars. Similar works did publicize the collective participation of contemporary scholars, such as the above-mentioned example of *Liu Xuehu's Plum Painting Manual*, which contains more than one hundred poems and prose pieces written for its author, Liu Shiru. The most extreme example of this type is *Bequeathed Jades to Plum Village* (Meiwu yiqiong), a six-volume collection prefaced in 1581 and included in Zhou's *Extensive Records from Secluded Doors*; that work contains no less than 164 encomiums, colophons, poems, and letters valorizing the life and works of Zhou Lüjing.[71]

Many late Ming publications list famous scholars as their editors or collators, but it is highly likely that these men did not always participate in the preparation of those works.[72] The names of two famous writers, Chen Jiru and Li Zhi, may be found in dozens of late Ming books as contributors of prefaces, but these men can actually be associated with only a very small number of the books that carry their illustrious names.[73] In this regard, it is not surprising that some scholars have expressed reservations about the authenticity of *Colophons of Recognition for Forest of Paintings*.[74] Some have pointed out that some contributors such as Wen Jia (d. 1583) had passed away before the wood-block edition of *Forest of Paintings* was produced in 1597, but *Forest of Paintings* was already in circulation by 1579. Furthermore, although Zhou Lüjing never held an official degree, there is ample evidence that he maintained continuous membership in elite literati circles. It would not have been difficult for him to seek writings from these illustrious colleagues, among whom was his own nephew, Li Rihua. Thus, *Colophons of Recognition for Forest of Paintings* is not the complete fabrication suggested by current scholarship.

Who, then, endorsed Zhou's manual in their contributions? Half of the contributors to *Colophons of Recognition for Forest of Paintings* held *jinshi* degrees, the most unimpeachable mark of status among the literati. Some of them were also known as writers, calligraphers, and painters, for example, Han Shineng (1528–1598), Dong Qichang, Wang Shizhen, and Liu Feng. Among the rest are well-known artists, connoisseurs, collectors, and essayists such as Wen Jia, Sun Kehong (1533–1611), Xiang Yuanbian (1525–1590), and Chen Jiru. A few of the contributors lacked the social and cultural credentials of most of their fellows; their names are hardly, if ever, listed in historical documents or even in local gazetteers, and only rarely do the literary creations associated with their names

survive. The compiler-editor of the volume, Wang Xianjie, appears to have been one of them. His name appears in Zhu Bingqi's *Concise Chronicle of Floating Clouds* (Tingyun xiaozhi), which records Wang's membership in the Blue Stream Society (Qingxishe) along with dozens of scholars. Among them, Zhang Xianyi (fl. 1573) was another contributor to the volume and an established scholar-official.[75] The absence of Wang's biography in the histories, however, suggests that he had an unsuccessful career as either an official, a scholar, or a writer. His name is thus less prominent than that of Zhou Lüjing and the majority of the contributors. Perhaps this was the reason he took up the job of requesting and collecting the commentaries for Zhou's painting manual. The task might also have provided a chance to expand his social network. Similarly, the listing of other minor scholars' names alongside those of the illustrious contributors must have helped publicize their identity as members of the literati elite.

While this account may clarify the background of *Colophons of Recognition for Forest of Paintings*, there remains one simple yet intriguing question: Why so many encomiums? Recent research on a late Ming letter-writing manual, *Models of Letters from Wisteria Studio* (Luoxuan biangu jianpu), proposes that this work lacked the prestige of publications with multiple prefaces written by contemporary luminaries.[76] Although this interpretation is not disputed here, it has overlooked the problem of why publishers felt compelled to promote their books by including dozens of prefaces and postfaces. If a publication must promote its virtues by including the laudatory comments of established cultural luminaries, this suggests the product's lack of prestige, not its cultural weight. So, at a minimum, *Colophons of Recognition for Forest of Paintings* indirectly implies a certain insecurity on the part of Zhou Lüjing about the reception of his painting manuals. A look at three of the encomiums will show how that insecurity was addressed and how they summarized and highlighted the work's content and purpose.

Chen Jiru:

> Master Zhou's calligraphic style is refined, and he has mastered the principles of painting. [This is why] literati in the Suzhou area compete in seeking his opinion regarding the evaluation and appreciation [of art]. He has had the works of various collectors engraved on stone. As for the classic calligraphy works and famous paintings of the past, most have been destroyed by war and fire; those that have fortunately survived represent only one in every ten, and these have been preserved only in *tie* format. How can we say that Zhou's *Forest of Paintings* does not preserve the essence of the old masters?[77]

Feng Mengzhen (1548–1595, *jinshi* 1577):

The calligraphy and painting of former ages has spread throughout the world, but as for classic calligraphy and famous paintings, most are [now] in Suzhou. This is because people in Suzhou spare no expense in buying and collecting them. But they are all works on silk and paper. The reason the stone-block-printed Dingwu edition [of *Preface to the Orchid Pavilion*] is far superior to the tracings and counterfeits on paper is that calligraphy cut on stone can be transmitted over a long period of time. Calligraphy pieces engraved on stone are numerous, but when it comes to painting, very few were made. My friend Zhou Lüjing has insight into the keys to [the best] painting. Accordingly, he took the paintings of divine quality in his collection and completely inscribed them on hard stones without missing the smallest detail and the sense of inner liveliness. They almost snatch away the powers of heaven. As for books on paintings, why should there be only *Commentary on Paintings in History* [Lidai huaping] written by Emperor Wu of the Liang dynasty? There are many art lovers among the public. I have read through *Forest of Paintings* and gladly leave a few comments for Mr. Zhou.[78]

Zhou Tianqiu:

When we look at the pictures and paintings of the past, they depict landscapes in the mind and figures beyond the human world. When it comes to paintings such as *Gazing after the Flying Geese* and *Geese on a Foggy Shore*, they are remembered by their titles, but the details of the originals are not faithfully preserved. Most of these works manifested the ultimate representational prowess of the brush. One day Master Zhou from Jiaxing unexpectedly visited my studio and took *Forest of Paintings* from his sleeve to show me. It connects to the past and benefits the next generation. Moreover, Zhou possesses unusual talent and clarity; he also has the air of Tao Yuanming. I have added this postface to his work, which will live through the ages. Readers should please not look upon it as one of those common publications on art found everywhere.[79]

Most of the encomiums in *Colophons of Recognition for Forest of Paintings* praise Zhou's mastery of literature, calligraphy, poetry, and painting. Especially interesting is Chen Jiru's comment. Here, Zhou's fame as a connoisseur is presented as unquestionable common sense. Although Zhou did achieve a certain level of

cultural fame, the validity of this comment is hard to ascertain. Obviously, he lacked the social credentials and scholarly fame of Dong Qichang and Chen Jiru. Maybe this kind of promotion implies his lack of recognition as an established aesthete. Such an assumed lack of prestige is further reflected in Feng Mengzhen's and Zhou Tianqiu's comments in which they promote *Forest of Paintings* as a reliable source of artistic knowledge and practice while portraying Zhou Lüjing as the cultural equal of great poets and painters of the past. Zhou's use of stone-block printing, which could achieve artistic quality reputedly matching that of the originals, is repeatedly praised in not only the example above but dozens of the other comments in the volume; such claims were meant to establish *Forest of Paintings* as a masterpiece, a classic, and even a canonical art publication. Furthermore, the closing remark of Zhou Tianqiu's note clearly brings the rhetoric of cultural negotiation to bear regarding the use of painting manuals in late Ming society. By emphasizing the unique features of *Forest of Paintings*, Zhou Tianqiu argues that readers should not compare this manual with other titles of a similar kind, which presumes the circulation of art textbooks among the educated public.

Taking all these factors into consideration, we can summarize the meanings and functions of *Colophons of Recognition for Forest of Paintings*. First, its laudatory reviews certainly served as a form of endorsement that would have had positive implications for its marketing. Second, these reviews publicized Zhou Lüjing's social network, portraying him as one of the cognoscenti and a man qualified to purvey culture to aspiring aesthetes. Third, these congratulatory pieces may have functioned as rhetorical armor against potential criticism, since illustrated books were frequently stigmatized as "philistine" by contemporary literati. In all these respects, *Forest of Paintings* offers a rare opportunity to examine the nexus of production considerations—the late Ming market, various reader groups, cultural capital, and the critical debates of the time.

Zhou Lüjing's Painting Manuals

In *Auxiliary Records on Master Plum Hill* (Meixu xiansheng bielu), a biography and collection of Zhou Lüjing's literary work prefaced in 1579, Zheng Yanhan briefly explained the books Zhou had published.

> Zhou's works on art such as *Forest of Paintings* and *Grove of Paintings* number several dozen to one hundred chapters. For these books, he sought widely for paintings of divine quality among the collections of a number of well-known

collectors. He inscribed them on the stone blocks and compiled them by categories. Their exquisite craftsmanship and supreme value make them objects of great elegance, suitable only for connoisseurs.[80]

Zheng's commentary here sounds very close to the encomiums in *Colophons of Recognition for Forest of Paintings* and was probably not so different in terms of its rhetorical function. It is noteworthy, however, that these comments challenge our previous knowledge about the publication of Zhou's painting manuals. First, Zheng notes that both *Forest of Paintings* and *Grove of Paintings* were already available to readers in 1579. Previous scholarship had taken 1597 as the publication date for *Grove of Paintings*, mainly because that was the year when Zhou's collectanea *Extensive Records from Secluded Doors*, which includes *Grove of Paintings*, was prefaced and published. Second, this comment stands at odds with current knowledge of the printing technology of the time; the one printed from stone blocks is titled *Forest of Paintings*, while the wood-block edition included in *Extensive Records from Secluded Doors* is called *Grove of Paintings*. Whether another edition of *Grove of Paintings* was printed from stone blocks is hard to verify given current knowledge.[81] This question, however, leads to another point of interest: Were they both published at the same time, or did one of them come out first, to be used as the model for the other? It is more likely that *Grove of Paintings* was a reorganized edition of *Forest of Paintings* or, at minimum, that the latter had a more conspicuous presence in the early years. The text of *Grove of Paintings* repeatedly refers to itself as *Forest of Paintings*, which suggests that the contents of *Forest of Painting* were included in its sister edition without careful editing. Third, few of Zhou's contemporaries ever wrote anything about *Grove of Paintings*, while dozens of commentaries addressed the title *Forest of Paintings* as the object of their admiration. Again, *Colophons of Recognition for Forest of Paintings*, the final volume of *Grove of Paintings*, is an important piece of evidence in itself. Every single commentator in it praised the title *Forest of Paintings*, which clearly links the two titles and their contents.

Parts of the stone-block edition of *Forest of Paintings* (eighty-nine pages of pictures along with the remains of texts) are now housed at the Bibliothèque nationale de France (BnF) in Paris.[82] Its frontispiece labels it a "later imprint" (*houke*) printed in 1587. Although fragmentary and missing many pages, the BnF copies provide many useful clues for figuring out the work's general format and contents. Zhou Lüjing seems to have prepared for producing *Forest of Paintings* by studying various works by past masters and consulting other publications of the time. In the pages discussing bird-and-flower painting, for instance, he writes

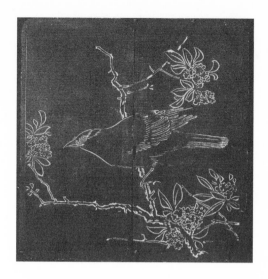

1.10 Bird on a tree, from Zhou Lüjing's *Forest of Paintings*, second edition, 1587. Rubbing of incised stone plate on paper, approx. 29 x 28 cm. Bibliothèque nationale de France (BnF), Curtis AC 9042, D7374.

that one day he discovered that his friend Zhou Banxiang owned twenty-eight well-preserved pages of Huang Quan's original work, paintings Zhou himself had always wished to see. Elated, Zhou borrowed these paintings, which he carefully studied all day long and copied with his own hand.[83] On other pages, he writes that he studied bird-and-flower paintings by Qian Xuan (ca. 1235–before 1307) held by another friend, Zhu Dashao (1517–1577, *jinshi* 1547), as well as two dozen insect paintings by Wang Yuan (ca. 1280–ca. 1329) in another friend's collection. Furthermore, he admits that he pulled content from Gao Song's painting manuals in composing his summary guide for bird-and-flower painting. Accordingly, the pages of *Forest of Paintings* at the Bibliothèque nationale de France contain dozens of images of bird-and-flower themes (fig. 1.10). There are paintings of different types of birds (pheasant, wild goose, oriole, eagle, crane, swallow, sparrow, and peacock) engaged in flying, flocking, resting, and eating while perched on various flowering trees. In addition, there are images of insects and small animals including lizards, frogs, butterflies, dragonflies, mantises, and beetles. These supposedly are Zhou's copies of works by master artists.

Most of the textual contents of the *Forest of Paintings* at the Bibliothèque nationale de France are identical to the wood-block edition of *Grove of Paintings*. Still, *Forest of Paintings* offers a number of unique pictorial and decorative features. Unlike its sister edition, *Forest of Paintings* contains many illustrations of trees, branches, and landscapes. Some images are formatted for instructional purposes. The model images of trees in rectangular boxes (fig. 1.11) show that Zhou must have been aware of this format, already introduced in *Apprenticeship in the Painting Business*. In addition, there are seven illustrations of full double-page landscapes

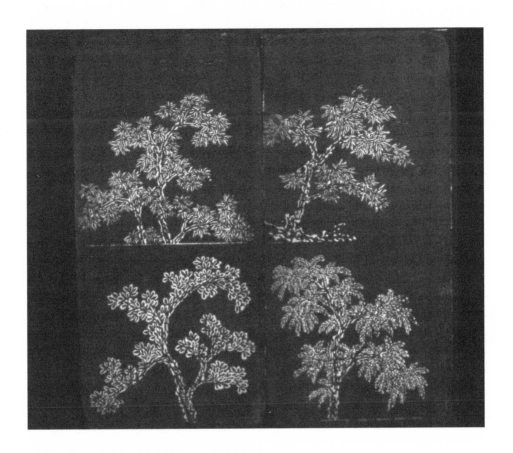

1.11 Pictorial motifs of trees from *Forest of Paintings*.

(fig. 1.12). This difference needs further consideration since it relates to cultural protocols of the time regarding the use of illustrations in wood-block-printed works. While most types of images were acceptably reproduced by wood-block printing, landscape, the holy grail of literati art, may not have been considered an appropriate genre for wood-block production. (This issue will be discussed in more detail in chapter 2.) In addition, *Forest of Paintings* features many seal imprints that are not found in *Grove of Paintings*. Among the many pages with seals, the first page is especially interesting in that it bears the seals of a number of Zhou's contemporaries (fig. 1.13). Here, along with a group of characters identifying the page as the first one of the volume, are the seals of Wen Zhengming, Wen Jia, Huangfu Fang, Wang Shizhen, Liu Feng, Tu Long, Mao Kun, and Dong Qichang, most of whom also contributed encomiums to Zhou Lüjing in *Colophons of Recognition for Forest of Paintings*. Appearing on the very first page of the work, these personal seals lend further weight to their owners' endorsement of Zhou and his project. For readers,

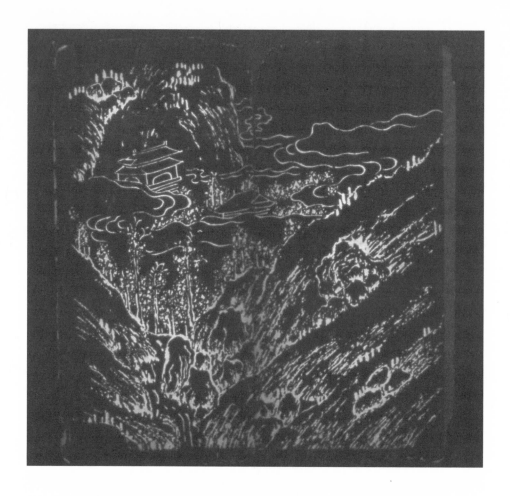

1.12 Landscape image from *Forest of Paintings*.

this page must have functioned as unquestionable assurance of the publication's quality and merit.

Furthermore, it is interesting that the seal of Wen Zhengming appears along with the others, given that he had passed away in 1559. If this mark was actually placed by Wen Zhengming himself, the publication date of the first edition of *Forest of Paintings* must be much earlier than is currently believed. In addition, unlike *Grove of Paintings*, whose wood-block imprint used only a regular script, *Forest of Paintings* has a variety of calligraphic styles. Many pages are printed in regular scripts, but others show cursive or the highly decorative seal scripts. On a page of texts on bird-and-flower painting, the lower part of each character is embellished with leaf-shaped patterns (fig. 1.14). This ornamental element must have required the hand of a skilled craftsman. In short, *Forest of Paintings* clearly

1.13 Title page and seal images from *Forest of Paintings*, 29 x 14 cm.

is a deluxe collection of paintings, writings, seals, and calligraphy designed to appeal to the eye. As Zhou declared, it was created to be a "pure desk copy" (*antou jingshu*), a solid piece of art in its own right, suitable for the scholar's studio along with the classics and other renowned literary creations.

One of the most exceptional features of *Forest of Paintings* is its use of the stone block as a printing medium. Stone-block printing was often adopted as an important medium in model calligraphies, but paintings printed from stone plates were relatively rare. Zhang Fengyi (1527–1613) and Wang Zhideng both noted in *Colophons of Recognition for Forest of Paintings* that such images were hard to find compared to specimens of calligraphy. The practice of inscribing images on stone goes back as early as Han dynasty (206 B.C.E.–220 C.E.) funerary art. Even in later periods, people continued to produce pictorial representations using stone plates, even though this was never the most widespread medium. For example, during the Song dynasty, images of notable scholars were inscribed on stone tablets for public display. Furthermore, one of the guidelines for painters-in-attendance established by the Song emperors stipulated that court painters learn to copy pictures and calligraphy on stone. As for the Ming dynasty, *Wangchuan Villa* (Wangchuan tu) by Wang Wei (701–761), based on a copy by Guo Zhongshu (ca. 910–977), was inscribed on a stone plate in the fifteenth century (a rubbing is now housed at the Princeton University Art Museum). In 1591, He Chuguang (*jinshi* 1583), the governor of Shandong, inspected the Confucian temple there. He noticed that scenes from Confucius's life, the *Illustrations of the Life of Confucius* (Shengji tu), were carved on wooden panels displayed along the covered walkways of the temple. Concerned about wood's susceptibility to decay, he proposed transferring the images from wood to stone, and the project was completed in 1593.[84] This episode shows that stone was regarded as a durable medium most suitable for content worthy of being transmitted through the ages. However, stone was not an easy material to handle. Its hard surface required extra time, effort, and skill and thus made engraving on stone more difficult and costlier than carving wooden blocks. Even production of the flat-surfaced printing blocks must have been a challenge with the tools and techniques of the time. Additionally, stone is heavier and more fragile than wood. Obviously, it was not a medium suitable for mass production. Then why did Zhou choose it? Interestingly, many contributors to *Colophons of Recognition for Forest of Paintings*, including Han Shineng and Wang Lingyue, compared *Forest of Paintings* to a collection of canonical calligraphies commissioned by Emperor Taizong (r. 976–997) of the Northern Song.

1.14 A page from *Forest of Paintings.*

For that project, a total of 419 classic pieces of calligraphy in the Imperial Archives were gathered and engraved on wooden and stone blocks, prints of which were later presented to high-ranking officials.[85] Although never officially titled, this set of blocks became known as *Model Calligraphy from the Imperial Archives of the Chunhua Era* (Chunhua getie), and it became the canonical collection for the art of calligraphy. Soon after its completion, the original blocks were damaged by a palace fire or by time and weather. Starting in the 1040s, the throne and also private citizens began to make reproductions of *Model Calligraphy from the Imperial Archives of the Chunhua Era* based on rubbings from the original edition, and dozens of imitations have been produced since that time.[86] These successive efforts to preserve the classics in Chinese calligraphy perpetually re-consecrated the original edition of *Model Calligraphy from the Imperial Archives of the Chunhua Era*. As Wu Hung has explained, these re-makings and celebration of the famous calligraphic masterpieces were executed not by producing new sets of rubbings from the original engravings but by producing new engravings based on older rubbings.[87] It may suggest that these engravings had their own value as a legitimate transmitter of the artistic canon and principles.

As a cultural genre, *tie* refers to rubbings made from blocks carved specifically for transmitting exemplary calligraphy.[88] As a medium, however, *tie*'s function goes beyond the genre of calligraphy in that it provides a major means whereby an artistic style could be commemorated and standardized. As Amy McNair has demonstrated, the ink rubbings taken from engravings were appreciated not for their content but for their ability to convey style. The costly engravings and ink rubbings from the model-letters compendia were collected as prime models for personal calligraphic style and as high-status art objects for appreciation.[89] Therefore, a style reproduced in *tie* format was effectively institutionalized and positioned as a classic. This explains why *Forest of Paintings* was often referred to as *tie*; it was being promoted as an instant classic. In this regard, the work's originality lies not only in its program but also in the material on which it was engraved. In terms of both the prestige of being produced from stone and its cultural pedigree, especially its comparison to *Model Calligraphy from the Imperial Archives of the Chunhua Era*, the production of *Forest of Paintings* appears to have been aimed at securing it the status of a classic, as a masterpiece painting manual.

The wood-block edition of the manual, *Grove of Paintings*, was published by Jingshan Shulin, an old commercial publishing house in Nanjing. The earliest record of Jingshan Shulin goes back to the late fourteenth century, when it published Cao Zhao's *Essential Criteria of Antiquities* (Gegu yaolun) and Zhou

Zhizhong's *Record of Strange Regions* (Yiyuzhi).[90] The first run of *Extensive Records from Secluded Doors* probably consisted of about eighty titles as stated in Zhou's preface. This set is now stored at the National Library of China in Beijing.[91] In later runs, the number is recut to "one-hundred-something titles," which indicates that an expanded edition was published sometime after 1597. The frontispiece of this collectanea at the Capital Library in Beijing testifies to this. It reads, "Expanded and revised *Extensive Records from Secluded Doors*: Printed from the blocks owned by Atelier of Idle Clouds." This edition is composed of about 106 titles.[92] Then which parts of the later editions were added to the edition of 1597? A preface written by Zhang Xianyi provides an important clue. Zhang lists different genres of topics in this work one by one, but here, three groups of subjects found in the later edition are missing: calligraphy (*shufa*), paintings (*huasou*), and entertainment (*yuzhi*). These three sections together include eighteen titles. Thus, if they were missing in the first series, the number of titles there would come to eighty-eight, which agrees with the approximation mentioned in Zhou's original preface.[93] From this, it seems likely that *Grove of Paintings* was not included in the 1597 edition but existed as an independent publication and was incorporated into this larger work only later.

Extensive Records from Secluded Doors covers a range of topics—literature, antiquity, hygiene, health care, calligraphy, cuisine, fortune-telling, entertainment, music, biology, life in retirement, and wine drinking. Not all of these works were Zhou's creations. Some were re-edited from publications of the Song and Yuan dynasties; others were the writings of his contemporaries, including a poetry collection, *Incense Case Poetry Collection* (Xianglian shicao), written by his second wife, Sang Zhenbai.[94] Furthermore, dozens of contemporary literati registered their names as writers, editors, or revisers of various pieces. They include Chen Jiru, Liu Feng, Mao Kun, Li Rihua, and Xiang Yuanbian, most of whom are also contributors to *Colophons of Recognition for Forest of Paintings*. Chen Jiru's name appears especially often, as the editor and reviser of six different titles. The association of these scholars with the project suggests the collective nature of *Extensive Records from Secluded Doors*, if not the deliberate aim of enhancing the collectanea's reputation and sales.

It is apparent that collectanea was a genre of publication that grew in popularity, especially in the late imperial period. Among the forty-five collectanea listed in the *Complete Library in the Four Branches of Literature* (Siku quanshu), the largest collection of literature compiled before modern times (completed in 1782) except for one published in the Song period, the rest were all produced during the Ming-Qing period. Many of the late imperial Chinese collectanea were

commercial ventures, and the profit motive was a major reason why late Ming publishers competitively compiled and printed these large collections.[95] Regarding the *Library Collection of the Heavenly City Pavilion* (Tianduge cangshu), a collectanea published by Cheng Yunzhao, Qing bibliographers commented, "Overall, this book is published for profit by a commercial publisher." Another well-known Ming collectanea, *Works Inquiring into and Extending Knowledge* (Gezhi congshu) by Hu Wenhuan, was also understood as "a series published for profit by a commercial publisher during the Wanli (1573–1620) and Tianqi periods (1620–1627). Its contents are haphazardly taken from various other texts, then provided under changed titles."[96] Zhou's *Extensive Records from Secluded Doors* also fell prey to this kind of criticism. The annotated bibliography in *Complete Library in the Four Branches of Literature* offers the following complaint:

> Among the books in the series, both authentic and forged are mixed; thus, it's almost impossible to know which is which. Books like Guo Tuotuo's *Book of Horticulture* (Zhongshu shu) are almost a joke. A couple of old texts are haphazardly edited and copied into this one. In the case of *Explanation of Names* (Shiming), it consists of one short chapter but is titled *"Explanation of Names, A Complete Set."* It's an outrage. Zhou's own writings are just like old tricks perpetrated by [imposturous] mountain hermits. Although the series includes various topics, in fact there is nothing worthwhile to learn from it.[97]

Given this sort of evaluation of collectanea as a genre and the criticism of Zhou's effort in particular, it is difficult to consider *Extensive Records from Secluded Doors* an exception among contemporary publications. Such series seem aimed at attracting the wider readership of people who sought a fast track to literati culture and skills. While such works covered a great number of topics, the quality of content and rigor of their editorial efforts clearly suffered.

The section on painting, *Grove of Paintings*, is composed of seven chapters (or titles). The first, *Painting Critique and the Sea of Art* (Huaping huihai), addresses general theory and landscape painting and is followed by *Heavenly Forms and Exemplary Manners* (Tianxing daomao), a manual specializing in figure painting. After that come four titles on still-life painting: *Shadows over the Hills of the Qi River* (Qiyuan xiaoying), *Dreaming of the Mountain of Floating Silk* (Luofu huanzhi), *Lingering Beauty of the Nine Fields (Jiuwan yirong)*, and *Chirping and Flying in a Spring Valley* (Chungu yingxiang) on the genres of bamboo, plum, orchids, and bird-and-flower respectively. The last volume is *Colophons of Recognition for Forest of Paintings*, the collection of comments and encomiums

originally written for *Forest of Paintings*. All sections are printed in black ink, but Wang Zhongmin has written that he saw a color edition of *Grove of Paintings* in a private collection in Paris; however, this copy has not been located.[98]

Other Manuals of the Late Ming Period (1550–1644)

On their publication around 1579, both *Forest of Paintings* and *Grove of Paintings* must have earned immediate recognition and become popular among the public since so many multi-genre painting manuals of the time copied, reorganized, and reprinted their content and format. These manuals include *Digest of the Rules of Painting* (Huafa yaojue), *Canon of Paintings* (Tuhui zongyi), *Painting Manual Revised by Master Chen Jiru* (Chen Meigong xiansheng dingzheng huapu), *Four Keys to an Ideal Life* (Yanxian sishi), *Great Synthesis of the Rules of Painting* (Huafa dacheng), and *Elementary Learning in the Rules of Painting*. They were all published in the early seventeenth century, and many of them were printed more than once using different sets of blocks.

Among these books, *Digest of the Rules of Painting* by a certain Zheng En was the closest reproduction of *Grove of Paintings*.[99] It was printed by a commercial publishing house, Studio of Inquiring Antiquity (Geguzhai) in Jin'an, Fujian, a region notorious for playing fast and loose with business practices—engaging in piracy, producing poor-quality prints, and setting cheap prices—all for the purpose of turning a quick profit. This manual lifts the figure, plum, orchid, bamboo, and bird-and-flower sections wholesale from *Grove of Paintings*. Each painting section is then matched to another famous title on the same topic: *Register of Bamboo* (Zhupu) by Gu Kaizhi (ca. 345–ca. 406), *Orchid Guide by Wang Guixue* (Wangshi lanpu), Shi Guang's *Ornithology* (Qinjing), and Zhongfen Mingben's *One Hundred Poems on Plum Flowers* (Meihua baiyong). Only the figure painting section, *Heavenly Forms and Exemplary Manners*, is not paired with another title. Zheng made no changes to the content of the manuals; the only differences are the size of the imprints and the print quality.[100] In addition, there are some typos scattered throughout the texts, including misspelling the name of the painter Gu Kaizhi as Dai Kaizhi.

The poor quality of Zheng's edition becomes obvious in a simple comparison of Zheng's "Playing the zither" (fig. 1.15) and Zhou's original (see fig. 3.16). The delicate lines in Zhou's figure painting manual are replaced with bold, clumsy, and stiff lines in Zheng's manual. The printed ink line is smudged and blurred, while the figure's pose, gaze, and action are no longer as vivid as in the original. In some volumes, Zheng replaced Zhou Lüjing's name with his own, thus claiming

1.15 "Playing the zither," from Zheng En's *Digest of the Rules of Painting*, Geguzhai edition, late Ming, 1:6a. 24.2 x 14.8 cm. C.V. Starr East Asian Library, Columbia University.

authorship of the publication.[101] During the Ming period, private printers could bring suit against offenders who produced pirated copies, and many did so.[102] But piracy had already become a deep-rooted practice as early as the Song period, and legislation never effectively controlled it. Although such practices must have been a constant irritant for the original publishers, these editions would have provided the general reading public with easier, cheaper access to books, which boosted the speed with which knowledge circulated in society.

Unlike *Digest of the Rules of Painting, Canon of Paintings* maintained the outline of the content of *Grove of Paintings* but made elaborate changes in its program. Published in 1607 by a commercial publisher, Yang Erzeng of Wulin (present-day Hangzhou), from his publishing house Grand Clarity Hall (Yibaitang), the overall format and contents closely resemble those of Zhou's manuals, except for the absence of *Colophons of Recognition for Forest of Paintings*.[103] Needless to say, Yang consulted Zhou's works as models for his book. As for the illustrations, most were copied from *Grove of Paintings*, but some of the figural images come from *Album of Paintings by Famous Masters of Successive Dynasties* (Lidai

1.16 "Listening to and looking at the waterfall," in Yang Erzeng's *Canon of Paintings*, Yibaitang edition (1607), 1:8b. 23.5 x 15.5 cm. East Asian Library and the Gest Collection, Princeton University.

minggong huapu), also known as *Master Gu's Painting Album* (Gushi huapu), of 1603.[104] Some other images are also borrowed from *Marvelous Tales of Daoist and Buddhist Immortals* (Xian Fo qizong), a collection of religious biographies and portraits published in 1602. Since the latter contains images of a spiritual nature, certain religious touches can be seen in the examples of figure painting. Yet Yang Erzeng's most obvious innovation is the high level of detail and decor in the illustrations in *Canon of Paintings*. This is particularly true of the images in the figure painting section. Although the subject matter and compositional schemes are not so different from Zhou Lüjing's originals, Yang's illustrations show a more delicate and keen delineation of facial expressions and bodily features. Furthermore, Yang Erzeng has inserted rich backgrounds that enliven each scene (fig. 1.16), in contrast to the blank ground behind the figures in Zhou Lüjing's example (see fig. 3.7). Their detailed descriptions of clothing and interior designs suggest that these illustrations were meant not only as pictorial motifs but as finished works of art. The emphatically pictorial nature of these images must have responded to the late Ming public's increased taste for illustrations in popular literary works. In addition, the detailed expression of the backgrounds provides pictorial interest that could overcome the limitations of the monochrome lines of wood-block printing; rich landscape elements are also employed to indicate the inner feelings of the figure represented in terms of his or her links to the outside world.[105]

Recent scholarship has shown that soon after its initial publication, *Canon of Paintings* was printed again twice from new sets of blocks. One run was a pirated

1.17 Bodhisattva, in *Canon of Paintings*, Yibaitang edition (1607), 1:5a. 23.5 x 15.5 cm. East Asian Library and the Gest Collection, Princeton University.

1.18 Bodhisattva, in *Canon of Paintings*, Wenlinge edition (1608), 1:5a. 23.0 x 14.7 cm. Shanghai Library.

edition, which introduced minor changes in the illustrations; the other edition was published by the commercial printing house Literary Woods Pavilion (Wenlinge) in Jinling (present-day Nanjing), run by Tang Jinchi. Kobayashi Hiromitsu has suggested that Yang may have sold his copyright to Tang, or Tang may have copied Yang's publication without permission.[106] Both the pirated edition and Tang's Wenlinge edition differ from the original edition of *Canon of Paintings* in many aspects. Some images are changed in their details in both later editions. For example, in the first image of the volume, that of the bodhisattva Avalokitesvara (Guanyin), some attributes have obviously been altered. The bodhisattva's headdress is different, and the motifs of the venerating boy-worshipper Sudhana (Shancai) and clouds in the air have been deleted (figs. 1.17, 1.18).[107] The printed pages are also different in size; the printed area in the original edition is larger than those in Tang Jinchi's reproduction and the pirated editions by at least 0.5

centimeter in both length and width. Besides, the order of the volumes is changed in later editions, with the volume on plum painting and the volume on bird-and-flower paintings reversed. This may appear insignificant, yet this change required cutting a new list of contents as well as changing volume numbers in each chapter. In addition, some images in the figure painting section appear in different order in later editions; the eleventh and twelfth pages in Yang's original edition are reversed in Tang's later copy, with the page numbers changed. This implies that some of the illustrations were printed from new sets of blocks, which could have been mixed up during the editing and engraving process of later editions. Altogether, this evidence firmly announces the use of new blocks.

This observation, however, still leaves one question: What is there to distinguish the pirated and Tang's editions, which appear almost identical in size, format, and illustration style? One page from Tang's copy now housed at the Shanghai Library has an inscription that displays the name Grand Clarity Hall, the publisher of the original edition of *Canon of Paintings*. This inscription appears to have been accidentally added when the carver copied the original edition.[108] Not all copies of the pirated edition have this mistake. This is the only difference between the two editions. Nevertheless, both editions were apparently printed from the same set of blocks, with the "Grand Clarity Hall" signature in Tang's reproduction deleted in the pirated edition. A copy categorized as the pirated edition now held at the Harvard-Yenching Library is also inscribed "Grand Clarity Hall." A more important piece of evidence may be gleaned from a comparison of the image "Taming a parrot" (*diaoying*) in Tang's edition at the Shanghai Library and the pirated edition at Peking University. The print quality and the discoloration of the papers are slightly different, but in both editions the shape and location of marks made by cracks in the block are identical, which proves they were printed from the same block (figs. 1.19, 1.20). It is thus likely that Tang's and the pirated edition are the same publication, which means that *Canon of Paintings* existed in only two editions in late Ming China, not three as current scholarship suggests.[109]

These multiple editions produced in such a short period of time, with the good possibility of transfer of ownership and/or piracy, indicate that *Canon of Paintings* had gained currency in the late Ming print industry. A substantial portion of one page from the edition in the Renmin University collection in Beijing did not print due to damage to the woodblock (fig. 1.21). That the publisher did not bother to fix it suggests that he expected sales regardless of the quality of the print run. Considering the fact that traditional Chinese woodblocks could print up to thirty thousand copies before showing significant signs of wear on

1.19 "Taming a parrot," in *Canon of Paintings*, Wenlinge edition (1608), 1:15a. 23.0 x 14.7 cm. Shanghai Library.

1.20 "Taming a parrot," in *Canon of Paintings*, pirated edition, 1:15a. 23.0 x 14.7 cm. Peking University Rare Book Collection.

printed images and texts, this damaged page helps in estimating the volume of prints in circulation.[110] In addition, *Canon of Paintings* was taken to Japan in the mid-seventeenth century and reprinted there in 1701; three more editions were produced in Kyoto and Tokyo, the third in 1735.[111] Like the programs in Zhou Lüjing's manuals, those in *Canon of Paintings* appear again and again in other contemporaneous publications, confirming that *Canon of Paintings* also had a certain prestige and currency as a painting manual.

A manual on the literati arts, *Four Keys to an Ideal Life* (Yanxian sishi), represents another recycling of this sort of material. It was published by Sun Pixian in 1611. The manual contains four sections, covering the zither, chess, calligraphy, and painting. The section on painting reproduces the content and format of *Grove of Paintings* and *Canon of Paintings* without major modifications.

1.21 A damaged page from *Canon of Paintings*, pirated edition, 3:2a. Renmin University, Beijing.

The illustrations are nearly identical to those in the latter.[112] Sun also printed another painting manual, *Painting Manual Revised by Master Chen Jiru*. Its frontispiece proclaims that it is printed from blocks owned by Dong Qichang's studio, Precious Cauldron Pavilion (Baodingzhai). Thus, the names of Chen Jiru and Dong Qichang are put forward as author and publisher. It is likely that the insertion of these names was meant to elevate the cultural prestige of the publication, but the actual participation of these men in the project is doubtful. Sun published the manual in two different installments. One edition, at the National Library of China, has four subjects, the same ones featured in *Four Keys to an Ideal Life*. The other edition, at the Chinese Department Library at Nanjing University, has only the two subjects, landscape and figure painting.[113] However, it is highly possible that Sun's painting manuals, although published under two different titles in three editions altogether, could have been printed from the same set of blocks, given that the block size and details of the prints are almost identical.[114]

The publication and consumption of painting manuals was not confined to the private sector. During the Ming period, many "regional princes" (*fanwang*) or "collateral members of the princes' lineage" (*tongfan zongshi*) published books celebrating their literary and cultural accomplishments, and these are categorized as "princely editions" (*fanben*).[115] According to one partial statistic, Ming imperial clans published at least 430 titles of various books,[116] covering a wide range of interests besides the traditional subjects of classics and poetry, such as medicine, hygiene, entertainment, music, and behavioral guides for princes and

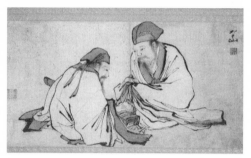

1.22 Figural motifs from Zhu Shouyong's *Great Synthesis of the Principles in Painting*, 3: 11a. 22 x 15 cm. National Library of China, Beijing.

1.23 Zhang Lu (ca. 1490–ca. 1563), *To Play the Zither for a Friend*, first half of the 16th century. Watercolor and pastel on silk, 31.4 x. 61 cm. Museum für Asiatische Kunst, Berlin. Photo: Jürgen Liepe.

women.[117] Although not all of the princes were interested in scholarly and literary pursuits, many owned outstanding libraries and were capable of recruiting the scholars, collators, and skilled woodblock carvers necessary to produce quality publications. Thus, a majority of the books they printed are of outstanding quality and are considered textually reliable.

Zhu Shouyong (d. 1639), an eleventh-generation descendant of the tenth son of Zhu Yuanzhang (r. 1368–1398), the founder of the Ming dynasty, was appointed king of the Lu imperial clan in present-day Shandong. He published the comprehensive painting manual *Great Synthesis of the Principles in Painting* (Huafa dacheng) in 1615. Its preface was written by Zhang Quan, prefect of Chongzhou in Shandong. Zhu Shouyong's son Zhu Yipai (d. 1642) and another member of the clan, Zhu Yiyai, worked on the preparation of the illustrations. The manual's landscape paintings were based on the compositions of Zhu Guan'ou, a member of the Lu imperial clan during the Jiajing era, and thus, the

1.24 Landscape by Zhu Guan'ou, in *Great Synthesis of the Principles in Painting*, 8:5a–6b. National Library of China, Beijing.

publication was a collective project of Lu imperial family members and their officials in Shandong.

This manual is composed of eight chapters in four volumes printed in an unusual color of dark blue ink. Like other manuals of the time, its written contents were mostly copied from other texts on art, including *Forest of Paintings* and *Grove of Paintings*. What is noteworthy in this title, however, is the courtly taste embedded in its illustrations. Its bird-and-flower paintings show a close stylistic affinity to the works of the court painters Lü Ji (act. ca. 1500) and Bian Wenjin (ca. 1356–ca. 1428). In its figure paintings, the angular and inconsistent lines apparently refer to the style of Zhe School (Zhepai) masters such as Wu Wei (1459–1509) and Zhang Lu (cf. figs. 1.22, 1.23). Besides this courtly manner, the manual also includes a section listing notable painters throughout history.

Interestingly, it includes the names of many progressive amateur artists of the time, such as Dong Qichang, Zhao Zuo (act. ca. 1610–1630), and Lan Ying (1585–1664), whose painting styles differ considerably from the courtly taste. This may suggest that the publication was also conceived as an attempt to recognize contemporary artistic trends in literati circles.

The last volume of the manual contains a group of landscape paintings by Zhu Guan'ou, representing ideal agrarian societies (fig. 1.24). In the mid-sixteenth century, Zhu Guan'ou once presented paintings on this topic to the Jiajing emperor that were later printed in Zhu's own painting manual, *A Grand Palanquin of the Rules of Painting* (Huafa quanyu).[118] Similar to *Spring Festival on the River* (see plate 1) and *Knick-Knack Peddler*, which testify to and extol the peaceful world created by the ruler's benevolence, this theme must have had significant political and rhetorical meanings for both Ming princes and emperors.[119]

During the Ming, each princely household was granted rich emoluments and great parcels of fertile land, along with an armed force numbering between three thousand and nineteen thousand men. These troops were nominally subordinate to the Ministry of War, but in reality they operated under the direct control of their regional princes.[120] With their vast economic assets and local influence, the princes could hire more men for their private forces if they so desired, since there was no enforced legal barrier to contain their ambitions. Naturally, emperors often viewed these princes as threats to their power. In 1520, Zhu Chenhao, the head of the Ning princely house, actually did revolt, but without success.

With the intent of preventing challenges from outlying princes, Ming emperors adopted a series of measures designed to introduce preemptive models of proper princely behavior. At the same time, regional princes were expected to prove their disinterest in power to the throne, in order to eliminate their emperors' suspicions and secure their own lineage. They often devoted themselves to cultural activities such as poetry, painting, book collecting, and medicine while calling themselves "hermits" or "Daoist monks" as evidence that they lacked political ambition. Book publication also offered late Ming royal families effective political armor against possible suspicion.[121] Editorial duties required considerable time and effort, and the princes themselves often assumed this role. Furthermore, as in the case of *Great Synthesis of the Principles in Painting*, publishing projects might necessitate the collective participation of princely family members and their subordinates. In this sense, we can better understand why Zhu Guan'ou presented his paintings on a sycophantic topic to the emperor and the impulse that led his descendants to include the same in their printed manual.

Printing projects financed and supervised by government bureaus, imperial princes, bureaucrats, or the National University system were "official publications" (*guanke*). Official publications mostly specialized in the Confucian canon that formed the basis of the civil service examination and printed matters necessary for government, such as calendars, gazetteers, and medical treatises. Occasionally, however, they included popular works such as *Romance of the Three Kingdoms* (Sanguo yanyi) and *Water Margin* (Shuihu zhuan).[122] Although published by an imperial clan, *Great Synthesis of the Principles in Painting* appears to have reached the larger reading public. While its original edition, now housed at the National Library of China, uses the dark blue ink employed for prestigious government printing projects, another edition in the usual black ink is held at the Shanghai Library. The print quality of the latter is blurry but indicates that other runs were printed from the original set of blocks.[123] A late Ming writer-publisher, Wang Siyi, in his preface to yet another late Ming painting manual, *Elementary Learning in the Rules of Painting* (Huafa xiaoxue), notes that he went to the trouble of publishing this manual because he was dissatisfied with the rather disorganized editing as well as the simplistic and incomplete contents of *Great Synthesis of the Principles in Painting*. His publication lays out specific expressions, styles, and motifs more systematically, which makes it more accessible and comprehensible. Furthermore, its illustrated demonstration of the brushstrokes used in landscape paintings is uniquely creative (fig. 1.25). The terms for each type of brushstroke were established well before the late Ming period, but it was only by Wang's hand that these techniques were shown in graphic form.

Wang Siyi also published *Assembled Illustrations of the Three Talents* (Sancai tuhui), a daily-use encyclopedia of 106 chapters, with his father Wang Qi (ca. 1535–1614, *jinshi* 1565) in 1609. This encyclopedia provided readers with practical knowledge and leisure reading on topics such as astronomy, geography, agriculture, medicine, and architecture. Like the genre of collectanea, most of its contents are simply copied from published books. This work was printed at least once more before the end of the Ming period. Its sections on painting are included in "human affairs" (*renshi*) along with the other literati arts of calligraphy, chess, martial arts, military strategy, calisthenics, and archery. The format and contents of the painting sections are copied word for word and image by image from Zhou Lüjing's *Forest of Paintings* and *Grove of Paintings* instead of Wang's other publication, *Elementary Learning in the Rules of Painting*.[124]

Wang must have found painting manuals to be good business. He also produced *Forest in Fragrant Snow* (Xiangxue linji), prefaced in 1603. It has twenty-six chapters, the first two of which are in the format of albums, with plum paintings

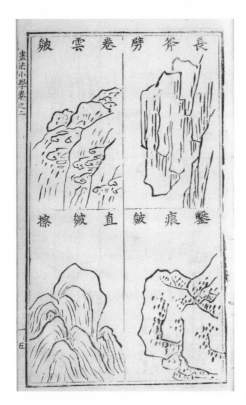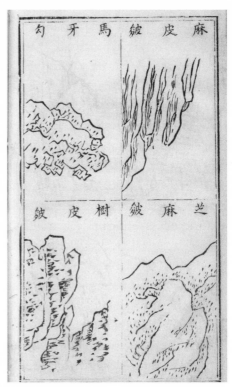

1.25 Brushstrokes for the landscape from Wang Siyi's *Elementary Learning in the Rules of Painting*, ca. 1615, 2:24b–25a. Each page, 27 x 15 cm. Shanghai Library.

accompanied by poems. While much of its program relies on content already presented in the plum painting section of *Grove of Paintings*, *Forest in Fragrant Snow* provides images rather than individual motifs; for example, many of its illustrations show plum flowers within defined environments (fig. 1.26). This is quite different from most plum-flower painting manuals, which show the various types of flowers and branches against a blank background. The unillustrated volumes between the third and twenty-fifth chapters contain poems and prose pieces on plum flowers. Only the last two volumes deal with the technical issues of plum-flower painting, and most of the discussion here represents reorganized texts and illustrations from previous publications such as Song Boren's and Huaguang's manuals. Maggie Bickford has identified sixty-three entries on theory and practice in chapter 25 of *Forest in Fragrant Snow*, most of which correspond closely to the first two chapters of *Pine Studio Plum Painting Manual*; its biographical material also corresponds to that work. She further proposes that

1.26 "Fragrance facing the water," in Wang Siyi's *Forest in Fragrant Snow*, 1603, 2:25a. 19.8 x 11.8 cm. National Library of China, Beijing.

Forest in Fragrant Snow significantly supplements deficiencies in surviving copies of *Pine Studio Plum Painting Manual*. For example, it preserves illustrations from chapter 6, which are represented in extant copies only by titles and verses.[125]

A few additional painting manuals specialize in a single subject. One, *History of the Plum* (Meishi), was published by Wang Maoxiao (act. early 17th century), who studied painting under Zhan Jingfeng and was acquainted with Liu Shiru, the author of *Liu Xuehu's Plum Painting Manual*. Its contents are re-edited versions of text from previous publications, while the illustrations are for the most part based on those of other painting manuals (fig. 1.27). In addition, *Snow Studio Bamboo Guide* (Xuezhai zhupu), compiled by Cheng Daxian (act. early 17th century), was published by the House of Flourishing Iris (Zisunguan) in 1608 and again by Literary Perfection Hall (Wenbitang) in 1618. Some of its illustrations bear no obvious connection to any of the preceding manuals, yet there is nothing special or innovative about its key terminology or the basic pictorial formulas. A late Ming artist, Sun Kehong (1532–1610), also published the manual *A Hundred Flower Manual of Orchid and Bamboo* (Baihua lanzhupu), which was brought out by Studio of Illustrious Paintings (Qinghuizhai) during the Wanli period. It is preserved as a part of *Master Jin's Painting Manual* (Jinshi huapu), compiled by a certain Jin Wan of the late Ming period. This edition is now housed in the collection of the Hosa Bunko, Nagoya, Japan, and bears the name Leopard Skin Pavilion (Baobianzhai), a publishing house in Hangzhou.

1.27 Pictorial motifs from Wang Maoxiao's *History of the Plum*, late Ming, 21b–22a. Each page, 22.7 x 16.2 cm. Library of Congress, Washington D.C.

One work that does not share the common features of other manuals of the time is *Secrets of Portraiture* (Chuanzhen miyao) (fig. 1.28). Even before the late Ming, critics such as Wang Yi (b. 1333) and Deng Chun (ca. 1127–ca. 1167) had often discussed portraiture, but no early illustrated guides for the genre of portraiture have survived.[126] The initial publication of *Secrets of Portraiture* supposedly occurred in the Ming dynasty, when it was written by a certain Weng Ang (ca. 1541–ca. 1612), a little-known artist from Hangzhou who specialized in landscape and figure paintings. Presumably its second edition was compiled and published by Hu Wenhuan in Nanjing, with a preface dated 1592.[127] The structure of the manual is not much different from that of other contemporary publications on art. Its textual contents explain basic terms, concepts, principles, and the importance of portraits. Much of its technical guidance is provided in summaries for easy understanding, and pictorial aids help define the order, placement, and comparative analogies for individual facial features. *Secrets of Portraiture* presents various types of eyes and eyebrows, mouths, ears, and noses. Each illustration has a caption that labels its subject according to its visual similarity to the shapes and poses of animals, mountains, flowers, vegetables, landscapes, and constellations.[128]

The migration of these physiognomic illustrations from fortune-telling to the realm of art is noteworthy. Wang Yi noted, "In general, drawing a portrait is just like getting a thorough understanding of (a person's) physiognomy." This comment suggests a linkage between portraiture and the aspects that physiognomy was believed to reveal: one's future prospects, personality, and state of health. Of the few illustrated works on physiognomy published during the late Ming period, *An Everyman's Physiognomy* (Mayi xiangfa) by Lu Weichong (act. 17th

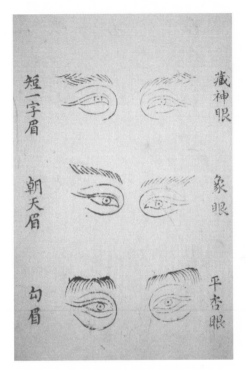
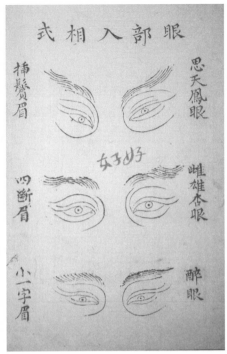

1.28 Pictorial examples of eyes and eyebrows from Weng Ang's *Secrets of Portraiture*, Sisunguan edition, 1592, 10b–11a. Each page, 19.0 x 14.0 cm. Shandong Provincial Library, China.

century) (fig. 1.29) and *Physiognomic Guide of the Willow Pavilion* (Liuzhuang xiangfa) by Yuan Gong (1335–1410) and Yuan Zhongche (1376–1458) both explain how signs of personality and destiny adhere in certain facial features. This type of physiognomic knowledge must have had a certain fascination for the general public, because at least three different editions of *An Everyman's Physiognomy* were produced in the late Ming.[129] Furthermore, popular literature of the time, including *Plum in the Golden Vase* (Jinpingmei) and *Romance of the Three Kingdoms*, provides detailed descriptions of the main characters' facial features as a means of representing their qualities and personalities.[130] Many of the terms and descriptions used in these popular works are also registered in *An Everyman's Physiognomy* and *Secrets of Portraiture*. Thus, *Secrets of Portraiture* occupies an interesting position in late Ming culture since it not only was the sole portrait painting manual but also had links to the popular literature of the period. In late Ming dramas such as *Peony Pavilion* (Mudanting) and *Romance of the Lute* (Pipa ji), portraits were often circulated as a medium of communication, love, and memory. (The connections between painting manuals and other areas of

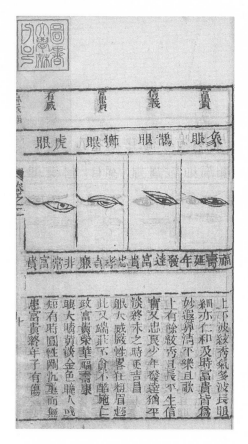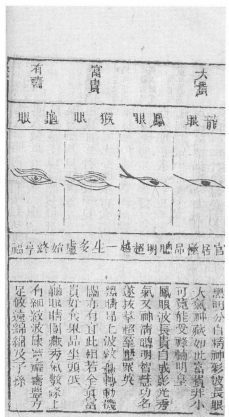

1.29 Illustrations and explanation of eye shapes from Lu Weichong's *An Everyman's Physiognomy*, late Ming, reprint of 1887, 2:9b–10a. Each page, 23.0 x 14.7 cm. Courtesy of Seoul National University Library, South Korea.

contemporary popular culture are explained further in chapters 3 and 4, which discuss Zhou Lüjing's figure painting program at greater length.)

The manuals examined thus far are not the only publications of their type from the late Ming period. Various historical sources mention many more painting manuals and albums, but their original editions are now lost (see appendix 2 for a list). In addition, dozens of late Ming daily-use encyclopedias include how-to-paint sections. Recent research by Wang Cheng-hua aptly shows that, in late Ming society, the registration of art knowledge in these publications draws a clear map of social interactions by which art was incorporated into the general knowledge system and discourse of a larger portion of the Chinese population.[131] Furthermore, the new genre of illustrated painting albums also emerged

at this time and attracted wide public interest, for example, *Album of Calligraphy and Paintings from Ten Bamboo Studio* (Shizhuzhai shuhuapu) of 1627 by Hu Zhengyan (ca. 1582–1672), *Painting Album from Pavilion of Concerted Elegance* (Jiyazhai huapu) of 1621 by Huang Fengchi (act. ca. early 17th century),[132] *Album of Paintings by Famous Masters of Successive Dynasties* of 1603 by Gu Bing (fl. 1594–1603), and *Register of Paintings Left Over from Poetry* (Shiyu huapu). Many of these albums, in particular, *Register of Paintings Left Over from Poetry* and *An Album of Tang Poetry and Paintings* (Tangshi huapu), feature paintings by well-known masters along with a corresponding poem for each. While informing readers about the basics of painting by classic masters, they further helped viewers understand how poetic inspiration could be transformed into painting; thus, to a certain degree, these albums share the function of painting manuals. Works such as *Album of Paintings by Famous Masters of Successive Dynasties* and *Album of Paintings from the Past and Present* (Gujin huapu) were, as Craig Clunas has explained, a "buyer's guide" that could help readers discern genuine paintings from false attributions. In addition, Robert Hegel has proposed that these publications were geared for relatively uninitiated viewers who might expand their knowledge and thereby refine their cultural sensibilities.[133]

The production and consumption of art books in the late Ming went far beyond what was known before. One important part of this boom was the emergence and popularity of the multi-genre painting manual, whose general shape was established by the body of contents of Zhou Lüjing's *Forest of Paintings* and *Grove of Paintings* by 1579. The two manuals Zhou published served as models for most Chinese painting manuals in the seventeenth century, when painting was projected as a form of cultural capital by the reading public as well as an acknowledged skill that was rightfully part of leisure life. The following chapters will discuss the nuts and bolts of Zhou's manuals and seek to answer one very simple question: What made them so popular?

2

Words without Images

The fact is that every writer creates his own precursors. His work
modifies our conception of the past, as it will modify the future.
—Jorge Luis Borges (1899–1986)

P AINTING CRITIQUE AND THE SEA OF ART (HUAPING HUIHAI) IS THE FIRST
volume in *Grove of Paintings*. About two dozen pages of it in the original
stone-block edition, *Forest of Paintings*, survive and are housed at the Bibliothèque nationale de France. That version in *Grove of Paintings* contains two
chapters of text. The first features two treatises explicating general theories of art
and landscape painting, while the second consists of a "summary prose piece"
(*jue*) on landscape painting, two treatises about painting rocks and trees, and
three brief digests explaining landscape painting, which are attributed to master
painters of earlier periods. In sum, *Painting Critique and the Sea of Art* is a collection of various writings designed to account for the practice and knowledge of
landscape painting as well as theories of art.

As an art textbook, this volume has two key characteristics. Much of its contents reproduce earlier texts, and in some cases their discussions are incorporated
into Zhou's own essays. Examining the topics presented in these texts, where
they originated, why Zhou selected them, and how he organized them will lead
to a better understanding of the meanings and functions of authorship as well as
the publication practices of late Ming society. Unlike the other sections in *Grove
of Paintings, Painting Critique and the Sea of Art* is unique in that it contains no
pictorial representations. I argue its absence of illustrations must be understood

as part of the publisher's specific design, based on his understanding of late Ming cultural protocols. For the same reason, this chapter's location as the manual's opener was hardly a random choice. Given the fact that landscape was the most important painting genre among the contemporary literati class, this section's lead position represents a conscious strategy on the part of the publisher. Discussion of these two traits—one intertextual, the other banking on cultural conventions—will explore the interface between artistic knowledge and publication practice through which both the genre of landscape painting and the medium of the painting manual were transformed into market commodities, cultural capital, and the foci of critical debate.

Patched Texts: Organization, Contents, and Plagiarism

Painting Critique and the Sea of Art begins with a brief explanation of the origins of painting. Zhou Lüjing notes that no one knows when pictures and painting first emerged as an art form but claims they enjoy an ancient pedigree. This general claim is followed by the statement that the art of painting grew from the shapes of or decorations on bronze vessels, ancient characters, fabric patterns, and seal images, while its founding principles were adapted from the natural forces of heaven and earth, wind and cloud, the sun and moon, rain and dew, the four seasons, and the oceans and mountains as well as the universe at large. This discussion of painting's origins and principles appears in many other writings on art, characteristically at the beginning of a text. Thus, there is nothing strikingly new in Zhou Lüjing's opening statement, yet he declares that the above-mentioned knowledge is the "secret" of master painters, something they never reveal to common folk. This rhetoric emphasizing "secrets revealed" is universal among late Ming how-to books and guidebooks, and it often serves as an advertisement for or a testament to the cultural merit of a volume.

Zhou's introductory remarks are followed by a collection of the rules of painting: the Six Canons (Liufa) of Xie He (ca. 500–535), the Three Classes (Sanpin) of Xia Wenyan (act. 14th century), the Three Faults (Sanbing) of Guo Ruoxu (fl. 1070–1075), the Twelve Things to Avoid (Shi'erji) of Rao Ziran (act. 14th century), and the Six Essentials (Liuyao) and the Six Qualities (Liuchang) of Liu Daochun (act. 11th century).[1] Extant scholarship has already provided insightful analyses of the meanings of these principles, but it is worth noting their rhetorical function in Zhou's manual, given that, by the time of its publication, they constituted a collection of recognized classics of artistic knowledge.[2] Before the late Ming period, many texts on art had already included these rules. For example, Xia

Wenyan's *Precious Mirror of Painting* cites the Three Classes, Six Canons, Three Faults, Six Essentials, and Six Qualities. Furthermore, in some cases, not only the rules themselves but later commentaries on them were also reproduced. *Painting Critique and the Sea of Art* includes a commentary on Xie He's Six Canons: "The Bone Method of brushwork and the other five canons can be learned, but some subtle knowledge of topics like spirit resonance (*qi*) can be commanded only by those born with it." This comment, attributed to the eleventh-century critic Guo Ruoxu, was later quoted in the fourteenth-century *Precious Mirror of Painting* before surfacing again in Zhou Lüjing's book.[3] While emphasizing the importance of innate talent and native intuition, this comment admits that people can accomplish only so much by practice; thus, it mystifies painting by maintaining that its value lies beyond most people's efforts and experience. Zhou's reuse of this text suggests his apparent acceptance of and agreement with Guo's perspective and further asserts the positive value of Guo's artistic insight. Repeated reproduction of his comments in later publications would institutionalize Guo as an indisputable authority on the history of art.

Among the general public, rules from past masters provided foundational artistic knowledge and terminology, enabling them to comprehend the fundamentals of the painter's métier and the basic knowledge required for appreciation. However, while most of these essays concern art's more conceptual features and qualities, certain others, including Rao Ziran's guide, took a more practical approach. Rao's formula indicates the mistakes to be avoided in actual practice. Those warnings include "overcrowded compositions," "stones showing one face," "paths with no indication of beginning and end," "trees with fewer than four main branches," and "hunchbacked and stooping figures."[4] Guidance of this type was already available in Guo Ruoxu's text written in the Song period, in which Guo warns against such infelicities as "flowers and trees out of season," "figures larger than buildings," "trees higher than mountains," and "bridges not resting on banks." Altogether, such comments testify to a tradition of artistic formulas summoned, not only for critics, but also for novice painters, long before the late Ming period.

The latter part of the first chapter of *Painting Critique and the Sea of Art* discusses a number of technical topics in painting practice: the basics of brushwork, use of ink, the similarity between calligraphy and painting, descriptions of different types of inkstone, various kinds of water for ink-stick grinding, and tones of ink and their applications to specific motifs. Most of these are copied verbatim from the writings of Guo Xi (ca. 1020–1090), with a few sentences from "Secrets of Landscape Painting" (Hua shanshui jue) by Huang Gongwang inserted here and there.[5] Then follows an explanation of how to appropriately express the

four seasons, text copied word for word from Zou Dezhong's *Apprenticeship in the Painting Business*. The choice of this citation is a bit odd since similar texts explaining suitable expression of the four seasons are also found in the writings of more prestigious painters, such as *Lofty Record of Forests and Streams* (Linquan gaozhi) by Guo Xi and *A Pure and Complete Collection of Landscape* (Shanshui chunquan ji) by Han Zhuo (fl. 1119–1125).[6] Zhou seems to have been trying to incorporate a wider range of writers in his manual rather than a handful of the usual masters. It is difficult to judge whether he sought to hide the origins of his texts in this diversity of sources, but in the end he produced an entire volume of treatises on art and landscape without much in the way of new ideas; he did not even bother to paraphrase earlier texts.

This is not a special fault of Zhou's publication. Throughout Chinese history, books on painting tended to be simple compilations of past knowledge, detached from the hot-button issues of contemporary criticism. Zhou's compilation certainly stands out from other writings on art by leading critics of his time. Those critics, many of whom Zhou was friendly with, engaged in heated discussions about evaluating paintings of the past. Critics such as Li Kaixian (1502–1568), Wang Shizhen, He Liangjun, Wang Zhideng, Zhan Jingfeng, Gao Lian, and Dong Qichang produced a series of writings debating stylistic and periodic hierarchical systems, which culminated in the characterization of Southern and Northern Schools by Mo Shilong (1537–1587) and Dong Qichang.[7] Discouraging optical illusionism, the use of color, and pictorial artifice, Dong's critical theory was designed to valorize the art of the scholar-amateur style, the ideal and philosophy of which had been established by Su Shi (1037–1101). This debate had been an ongoing negotiation in literati circles for a few decades before the turn of the seventeenth century, but no hint of it can be found in any of Zhou's publications. I don't believe this is due to Zhou's disinterest in or ignorance of contemporary theories on art; instead, it seems more likely that he did not envision advanced discussion of contemporary art criticism as a useful topic in his manuals. Probably for the same reason, none of the contemporary painting manuals and albums contains late Ming art theory at all. The function of Zhou's manual was to provide summary, accessible knowledge on art and landscape painting in one package; the contents were to guide, not confuse, its readers. What Zhou sought to offer was not great depth but clarity, brevity, and ease of learning.

The second chapter of *Painting Critique and the Sea of Art* begins with "Summary on Landscape" (Shanshui jue), a short exegesis in forty pairs of four-character phrases.[8] This text was supposedly written by Zhou Lüjing. Its overall contents probably paraphrase sentences from various texts and thus may sound familiar

to students of Chinese art. None of its phrases, however, seem to be direct copies from previous texts. The format and the contents of this piece epitomize the simplified textual pedagogy of the painting manual genre.

Among the genres of paintings, landscape is most important. Set first the primary mountain, followed by smaller peaks in hierarchical order. Then rocks in the gorges, stones near streams, and cliffs follow in order. The force of mountains gives rise to fog and mist, and sandy shores are situated under hills. Villages typically lie nestled in the countryside where rice fields are divided by water channels. Streams meander, and mountains appear stern. Rocks must have edgy surfaces and soil richness. Mountain tops are layered, and some rocks are shown only vaguely in the deep gorges. Waterfalls race from the heights, and clouds hover at the mouths of mountain caves. Distant waters have no waves and distant mountains no texture. Trees can be either sparse or dense; bamboo can be thin or packed. Roads can be rugged but should be traversable. Trees can be shown hanging over a steep cliff, and streams can be shown penetrating a deep gorge. The upper part of a painting should be left more open if the lower part is full. The left half remains relatively empty if the right half is dense with detail. The scene should be spacious and open; what art most detests is vulgarity. As clouds whirl around the mountains, a stream runs off a stony cliff. A man walks down the road past a pavilion under a willow tree. A house is tucked in among tall bamboo; along the dam stand willow trees. Peach and plum trees emit fragrance, while pine and arbor trees have a lofty air. There should be both long and short branches while there should be both old stems and fresh ones. If the mountain is one yard high [in the painting], then depict a foot-tall tree, an inch-long horse, and a bean-size human. A traveler crosses a bridge with a young boy's assistance. A fisherman draws in his rod, while a logger carries a tree on his shoulder. Huts in the field and the mountains are thatched in yellow straw. A boat should float like a leaf and a canopy look like a bushel of rice. The moon reflects on the river, and clouds drift under the sun. Birds chirp on a twig, while old men play chess. Trees stand near and far; some people look thin, the rest fat. Wild geese fly in the distance; a hawk rests on a tree. Take [old masters like] Jing Hao as your mentor and Wang Wei as your friend. Cherish liveliness and rhythm, and make your painting firm like clerical script. As for your painting tools, they should also be well prepared. The water must be fresh and the inkstone clean. Enjoyment in painting will find you if you practice long and hard. [But] if your spirit is weary and blue, don't take up the brush [to paint because] if you are distracted, the painting becomes clumsy and

unrefined. Relax and drink some wine; then your inspiration will return. I write these details in the meter of poetry to get at the essence of art. As [you] gentlemen read this, please correct any faults.[9]

In terms of its structure, this summary formula is built on a rhyme structure: the last characters of every second four-word phrase finishes with characters of the same vocal syllable. This composition must have required a critical level of creativity from the author, who at each phrase had to choose a character with a sound and a meaning that match the flow of neighboring words and phrases. In terms of its content, the piece offers a summary of the rules of composition. Its brief text covers a wide range of motifs and further elaborates on their appropriate appearance, location, and scale. Ending with the proper preparation of brush, ink, and water, the piece also makes the handy recommendation that readers could summon artistic inspiration by drinking wine.

Drinking as a means to inspiration had been noted in many different writings. The *Imperial Painting Catalogue of the Xuanhe Era* (Xuanhe huapu) of 1120 mentions that Wu Daozi, a celebrated painter of the Tang dynasty, always drank before he drew. During the Song period, Su Shi, Huang Tingjian (1045–1105), and Mi Fu were all noted artists who often relied on wine for artistic inspiration. They did not conceal this practice, and their works made during intoxication were later called "drunken ink" (*zuimo*). Mi Fu even gave himself the nickname Rice-Wine Addict. A Ming master, Tang Yin, was also reported to be an artist of this sort, and his paintings could be obtained by sharing great amounts of wine with him over the course of a day.[10]

Textual formulas dictating the appearance of pictorial motifs were not a late Ming invention. As discussed above, similar guides were already in circulation in the Song and Yuan dynasties, from authors such as Guo Xi, Guo Ruoxu, and Rao Ziran. Here, Zhou's accomplishment was to condense the guidelines for painting into a format that facilitated readers' understanding and memorization of the basic artistic knowledge and protocols. But this formula has one serious defect. Its rhetoric always stipulates that "X must look thus," which inevitably imposes certain limitations on artistic creation and subjectivity; it does not allow for painters' creativity beyond set configurations. As early as the eleventh century, this over-emphasis on logic or formulas was already being questioned by literati painters. One Northern Song scholar-official, Shen Gua (1031–1095), professed,

The wonders of painting have to be grasped by imaginative communion, not by seeking similitude. Most art lovers can recognize faults in shape, composition,

and coloring, but I've rarely seen anybody who understands the more profound values. According to Zhang Yanyuan's notes, when Wang Wei painted he paid little mind to the regularities of the four seasons. For example, when he painted flowers, he often had peach, apricot, rose-mallow, and lotus flowers all together. The Wang Wei painting in my collection, *Yuan An Lying on Snow*, has a banana tree in the midst of snow. This is what I call letting the hand respond to novel inspiration. As soon as the idea emerges, it appears complete in the painting. Therefore the artist creates his own world, which enters the imagination, in the end returning to naturalness. This is difficult to discuss with vulgar people.[11]

In this comment, Shen Gua acknowledges the educated public's basic knowledge of the principles of painting. Then, citing Zhang Yanyuan, he notes that real masters should not be bound by the rules of art and the natural world—an observation found nowhere in Zhang's extant writings.[12] Wang Wei's banana tree in winter is introduced as a positive example of artistic creativity unfettered by logical constraints; thus, the utmost level of artistic creativity is said to reside within an artist's subjectivity and inspiration, not in any rules. Shen practically spits out his dissatisfaction with the common understanding of these matters. His commentary suggests the presence and impact of set rules for artistic preparation as early as the eleventh century.

Pivotal to the evaluation of instructions of this type is their efficiency as a pedagogical device. In her recent book on Buddhist art practice, Sarah Fraser has correctly observed that guidebooks on painting such as Han Zhuo's *A Pure and Complete Collection of Landscapes*, containing format and contents similar to the programs of most late Ming how-to-paint books, have serious limitations as a pedagogical medium; they deal mostly with the list of activities an artist would have considered in the painting process, including conventions in practice and artistic tropes of production such as the names for different kinds of brushwork, ratios of proportion, and the correct colors for certain motifs. Thus, she defines these treatises as post-production documents, which provide a view of the process only after a work is finished or appreciated.[13] The summary instruction by Zhou Lüjing cited above explains the rules and procedures for the genre of landscape. Just reading and understanding the text, however, does not guarantee mastery of landscape painting. Instead, it better serves the viewer's understanding of proper expression, compositional schema, and different types of motifs, thus, knowledge equivalent to that of an artist but not his skills or techniques.

Zhou's concise formula in verse is followed by two specialized texts, "Abstruse Theories on the Painting of Rocks" (Huishi aolun) and "Regarding Painting

Trees" (Huashu lun), which explain the different motifs, techniques, settings, and compositions involved in the painting of landscape motifs. Like other passages in *Painting Critique and the Sea of Art*, these texts take much of their content from previous publications on art, such as those penned by Han Zhuo, Guo Xi, Huang Gongwang, and Zou Dezhong, yet what distinguishes both titles from the rest of the volume is their inclusion of purely literary texts on rocks and mountains. For example, "Abstruse Theories on the Painting of Rocks" contains lines from classic lyrics such as Zheng Weizhong's "Poetic Essay on Old Rocks" (Gushi fu), Da Xixun's "Ode to Mountain Hua" (Huashan fu), and Li Yong's "Stone Rhapsody" (Shifu). These passages show a more complicated structure and highly elaborate vocabulary than the rest of the text. Although a drawback of this compositional scheme is the higher standard of literacy required of readers, the bits added from these literary works burnish the literary quality of the text as a whole. These carefully inserted lines of rhyme-prose provide more vivid descriptions of the motifs. Zhou Lüjing created a textual collage, a technical guide elevated by literary genius and command. In the process, he transformed a mere technical guide into a celebrated article of artistic excellence and rhetorical quality that was shaped for more educated readers. This seems to be one case, as Osvald Sirén has noted, in which the reproduction of classical knowledge in a treatise on art could be no less a guiding principle for writers than for painters.[14]

Regarding the recycling of previous texts, one important issue still requires consideration. As we have seen, the quoted texts in this work are often mixed up with Zhou's own writing or otherwise reorganized into new texts. According to modern standards, this practice seems more or less an unethical exercise in plagiarism, yet the situation is somewhat more complicated with *Painting Critique and the Sea of Art* and other similar publications of late Ming China. The common practice of this type of composition and editing does not mean that late Ming society (and traditional China generally) had no understanding of the issue of intellectual property or concern for illegal or unsolicited reproduction of earlier texts. We know that copyright was an established category in the Chinese legal system starting from the Tang period (618–907), and publishers throughout Chinese history tried to discourage copyright infringement by placing warnings on their books, seeking official support, and reporting abuses to the juridical authorities.[15]

Besides this legal aspect, at least in late Ming China, there were certain cultural perimeters that advised against the unauthorized use of others' texts. First, fellow readers disapproved of the mechanical copying of phrases or sentences from earlier texts. Barbara Volkmar featured a good example in her research. A

medical practitioner of Huangzhou, Wan Quan (1500– ca. 1585), wrote a special-ized treatise on pox around 1546. It was prepared for family use only; thus, he blended many earlier texts with no concern about peer review. But the manu-script was stolen by Wan's eldest son and sold commercially. In 1562, a flamboy-ant and presumptuous imposter, Huang Lian (d. 1580), published this text under the title *Complete Book on Pox* (Douzhen quanshu), inserting his own name as author of the book. It gained immediate popularity and soon caught the atten-tion of astute readers. Probably without knowing the text's original author and purpose, a contemporary medical author, Gao Wu (fl. 1515–1559) of Ningbo, left a scathing review, "The author refers in many parts to the theory of a thirteenth-century pediatrician, Chen Wenzhong. At the beginning of every paragraph he echoes the statements of famous physicians of the past, but still he pretends that these are his own [insights]."[16] This observation clearly shows that textual recy-cling without proper referencing was regarded as a violation of writerly ethics by contemporary critics and other professionals.

Furthermore, other writers of the time evaluated this matter in terms of literary merit linked to creativity. A major critic, Yuan Hongdao, leveled bit-ter criticism at the practice of copying from old texts, including classics. He contended, "[Stealing from previous works] is like chewing dung to find some residual good, like catching a fart in one's open mouth. . . . Remembering old and stale stories is called erudition, and those who can use hackneyed expres-sions are called poets."[17] Clearly, the merits of literary innovation and originality championed by Yuan and his fellow Gong'an School members directly motivated their disparagement of textual recycling. For them, such reproduction signified not a lack of ethical consciousness but rather a lack of merit and imagination. His comment also testifies to its widespread practice, which the broader public took for granted.

Some modern scholars have suggested that the majority of the late Ming pub-lic embraced this practice as a legitimate means of writing and publishing, and it was hardly considered dishonorable.[18] As for the advantages of such an approach, one late Ming popular novel, *Plum in a Golden Vase*, presents a helpful clue. Much of the contents of this novel were also transplanted from other publica-tions of the time—novels, dramas, and compendia of practical information; the book represents a pastiche of popular songs, jokes, scenes and arias from operas, and segments from earlier fiction of various forms. But there is no interest in or attempt to justify the editorial practice of cutting, pasting, modifying, renaming, and reassembling.[19] Robert Hegel has suggested that, just like poems composed of lines lifted from earlier verse, the recognition of familiar materials in *Plum in a*

Golden Vase, with their extended symbolic significance inserted into a new context, would have added to the enjoyment of educated readers.[20] Would it be too much of a logical stretch to claim that general readers of painting manuals might also have recognized the original sources of the quoted texts and been similarly delighted and at the same time reassured of their own status as knowledgeable elites?

So was it sheer plagiarism or a creative mode of writing? Either perspective, depending on one's reading of extant historical evidence, can lead to contradictory conclusions. Instead, it might be more useful to approach this conundrum from a pragmatic point of view. If textual recycling was really a universal practice in the late Ming, this suggests its high level of convenience and usefulness to publishers. What specifically were the merits of using old texts in the genre of painting manuals? On a basic level, this kind of practice must have saved Zhou Lüjing the trouble of creating a completely new body of ideas and texts. Furthermore, by incorporating established scholarship into his own writings, Zhou demonstrated his knowledge of the field and quickly managed to provide a more thorough, complete, and prestigious review of knowledge on art. Since *Painting Critique and the Sea of Art* offers no strikingly new ideas or discussion of critical issues of the time such as artistic originality, it appears that Zhou Lüjing's concern was to speak through the established terms of his predecessors, with his own language inserted between the statements of the old masters. He may have sacrificed individuality and originality in so doing, but he was able to position his work within a repository of established theories. By making this editorial choice, he not only underlined the importance of painting but also showed that its pedigree was as ancient and as noble as that of literature.

Fabricated Texts

Painting Critique and the Sea of Art ends with three summary pieces on landscape painting whose overall contents are similar to Zhou's composition discussed above. They recite the basics of landscape painting, such as the appropriate expression of seasons, the relative proportion of motifs in a scene, and explanations of technical terminology. Unlike other texts quoted in the volume, however, the names of these authors, three of China's most celebrated masters of the landscape genre, are specified: Jing Hao (act. 10th century), Li Cheng (919–967), and Wang Wei (701–761). The very inclusion of these names unexpectedly presents intriguing questions regarding the function of authorship in late Ming China.

First, none of these texts is verifiably by any of these three masters. Qing dynasty bibliographers noted that the textual characteristics of Wang Wei's "Summary on Landscape" (Shanshui jue) do not match those typical of his own period but are of a later date, namely, the Southern Song dynasty (1127–1279).[21] Second, this text did not appear anywhere until the late Ming period, when it was first printed in *National Bibliography of Classics* (Guoshi jingji zhi) of 1602 by Jiao Hong (1533–1612). Third, and even more intriguing, the modern scholar Yu Shaosong has observed that three other editions of this text quoted in other late Ming books—Zhan Jingfeng's *Appendix to a Recollection of Paintings by Master Wang* (Wangshi huayuan buyi), Tang Yin's *Album of Paintings from the Past and Present* (Gujin huapu), and a stone-block edition from Shaanxi—are all different in terms of content and length.[22] This implies that no established copy of this text existed even in the late Ming. Given these facts, it is difficult to confirm that the piece was composed during Wang Wei's time, let alone by the master's own hand.[23]

As for Jing Hao's "Summary on Landscape," this title appears in Liu Daochun's *Addendum to Records of Five Dynasties Masterpieces* (Wudai minghua buyi), Guo Ruoxu's *Experiences in Painting, Imperial Painting Catalogue of the Xuanhe Era* of the Song dynasty, and Tang Hou's *Examinations of Painting* (Huajian) of the Yuan dynasty. Although many of these earlier texts list Jing Hao as the author of this piece, it was not until the late Ming period that the body of its original text began to appear in various publications, including *Canon of Paintings, Recollection of Paintings by Master Wang* (Wangshi huayuan), and *Album of Paintings from the Past and Present*. The key to determining this text's authenticity is encoded in its compositional structure. In Zhan Jingfeng's *Appendix to a Recollection of Paintings by Master Wang*, the same Jing Hao text that appears in *Painting Critique and the Sea of Art* is printed under the title "An Ode to Landscape Painting" (Hua shanshui fu). Its compositional structure, however, is not strictly an "ode" (*fu*). Ode prose styles had changed over time, but irregular rhyming like that in Jing Hao's "Summary on Landscape" was not one of the styles commonly used in his lifetime. Furthermore, although its verses are arranged in parallel stanzas, the ode rhyming is broken in many places; thus, the text reads rather like doggerel. In addition to its stylistic defects, the text lacks artistic and literary competence: the effects of poor word choice and clumsy phrasing are only aggravated by the haphazard insertion of erudite vocabulary in various parts of the text. This is why Qing bibliographers concluded that it was a fabricated text by a later hand who had mastered neither decorum in writing nor knowledge of artistic theories.[24] This is not to suggest,

however, that Jing Hao had not written "Summary on Landscape"; instead, as Yu Shaosong has noted, it is more likely that the original text was lost, which motivated commercial writers of a later period to fabricate the lost text using other available writings.[25]

The last summary piece in the volume, Li Cheng's "Summary on Landscape," is no exception to this pattern. First, it is not cited in any bibliographical catalogues of the Song period. If Li Cheng had written something like this, considering his vaunted position in art history, it would be an odd historical omission in contemporaneous and later publications. Second, its content is almost identical to a text attributed to Li Chengsou, which has the same title but a preface dated to 1221. Li Chengsou's text was fabricated sometime in the late sixteenth century because it was published only in 1590 in *Recollection of Paintings by Master Wang*.[26] Perhaps, as Yu Shaosong cautiously suggests, the similarity between the names Li Cheng and Li Chengsou could have led to some publications confusing the two.[27] Therefore, we must conclude that none of these three summary pieces was written by the painting masters to whom they were attributed. As Xu Fuguan has identified, the genre of the "summary on landscape," which combined fabricated texts and the names of celebrated masters, seems to have been an invention of the Wanli period (1573–1620) in the late Ming.[28]

Late Ming scholars were notorious for manufacturing "old texts." In his study on fabricated texts, the modern scholar Zhang Xincheng counts a total of 1,104 such titles made throughout Chinese history.[29] Although the practice of forging texts began well before the beginning of the Common Era in China, it was during the late Ming dynasty that spurious publications were produced in massive numbers. Text manufacturing seems to have become a sort of eccentric intellectual hobby among late Ming scholars.[30] This was commonly accepted as a fact by Qing dynasty bibliographers, who criticized late Ming writers for deceiving the public.[31] Given this, it is not surprising to find that a Ming scholar, Hu Yinglin (1551–1618), conducted the first systematic research on textual fabrication and published his findings in *Authentic and Counterfeit Texts of the Four Categories* (Sibu zhengwei) in 1586. In this book, Hu identified more than one hundred titles as fabrications.[32] We may conclude that the three summaries on landscape in *Painting Critique and the Sea of Art* were simply some of those period products. Further, it is highly possible that Zhou Lüing was the original fabricator of these texts, since his painting manual predates all the above-mentioned works in which they appear.

Interestingly, these three pieces were included in other contemporary publications, but with slight changes to their titles, the names of their authors, and

even their contents from edition to edition. Jing Hao's "Summary on Landscape" in *Painting Critique and the Sea of Art* is also included in *Album of Paintings from the Past and Present* and *Canon of Paintings*, in which it bears the title "An Ode to Landscape" (Shanshui fu).[33] This slightly amended title is understandable editorially because the text is actually written (although poorly) as an ode. But the very same text also appears as Wang Wei's "Discussion of Landscape" (Shanshui lun) in Wang Shizhen's *Recollection of Paintings by Master Wang*. A single text now claims two different authors, never mind three different titles.

As for the Wang Wei and Li Cheng versions of "Summary on Landscape" in Zhou's manual, these two texts are almost identical to those printed in *Recollection of Paintings by Master Wang*. The names of the authors also remain unchanged, but the other publications of the time either changed the names of the authors or mixed up Li Cheng's and Wang Wei's texts. For example, *Album of Paintings from the Past and Present* takes the first forty-three characters of Wang Wei's "Summary on Landscape" and adds them to Li Cheng's but then lists Wang Wei as the author. The book handles Li Cheng's summary the same way, mixing its beginning with the body of Wang Wei's text. The text changes authors and contents from edition to edition. It is obviously pointless to ask which source is being truthful, since we now understand that these versions might simply be different editions of fabricated texts. This confronts us with multiple layers of issues: authorship, textual authenticity, and combinations of both.

How then can we understand this ugly mess? As Michel Foucault has noted, the function of the author is to characterize the existence, circulation, classification, and operation of certain discourses within a society. It is a form of authoritative property, which marks certain writing as a proven discourse.[34] In light of this, it becomes clear that the social consumption of fabricated texts was bolstered by attaching the names of famous authors to them. Those names announced the cultural legitimacy of a text, including the new summary prose pieces popularized in painting manuals. Obviously, the popular habits of textual fabrication and pastiche indicate that the historical authenticity of these summaries was of little interest to either publishers or readers. The function of an author in these examples is, quoting Roland Barthes, to furnish his or her texts with an "ultimate signified" that preserves the identification between author and text and thus perpetuates the independent identity and value of the writing.[35]

Their connection with the names of these three master artists, then, turned the texts into consumable objects of symbolic capital. Those names were stand-ins for authenticity, a quality that was amply rewarded as willing consumers purchased the books. Pierre Bourdieu once stated, "In fact, the use of language, the

manner as much as the substance of discourse, depends on *the social position of the speaker*, which governs the access he can have to the language of the institution, that is, to the *official*, *orthodox* and *legitimate* speech. It is the access to the legitimate instruments of expression, and therefore the participation in the authority of the institution, which makes all the difference."[36] Therefore, using the names of master artists as the authors of these writings in late Ming publications, in turn provides legitimacy for the form of the summary formula. In this way, a genre of writing based solely in the mechanics of pedagogy and practicum could assume the authority of a legitimate cultural product that owns its prestige as an institution.

Landscape Images in *Forest of Paintings*

As discussed in chapter 1, some of the images in *Forest of Painting* are formatted to deliver systematic information on diverse motifs, yet surviving pages also contain six engravings of full landscape paintings.[37] The historical importance of these landscape images lies in their being the first to be published in a painting manual, fully a century before the *Mustard Seed Garden Manual of Painting* of 1679, although its preface claims that it was the first manual to contain landscape illustrations. Unfortunately, little information survives that could indicate the origin of individual images in *Forest of Paintings*. We can only assume that they are based on the paintings of past masters that Zhou had studied at various collections as noted in the many commentaries in *Colophons of Recognition for Forest of Paintings*, including those of Liu Feng and Chen Jiru.[38] Although it is hard to pinpoint the artists or schools to which these rubbings refer, their compositions and use of pictorial motifs suggest some possible models.

One of the rubbings displays references to pictorial characteristics found in Northern Song monumental landscape paintings (fig. 2.1). It shows the soaring body of a mountain in its center, truncated mountaintops, a distant shore, houses tucked behind trees, and large trees on the front hills, the very features commonly found in the works of Song dynasty masters, including Guo Xi and Li Cheng. Some of the Yuan and Ming dynasty masters adopted this style. Among the works of these artists, one painting by Lu Guang—a Yuan master noted for following the manners of Huang Gongwang and Wu Zhen—shares a format and composition similar to that of the rubbing (fig. 2.2). It is also noteworthy that Lu Guang was a favorite of many late Ming literati, including Li Rihua and Dong Qichang, both of whom accorded Zhou Lüjing high levels of respect.[39] This does not necessarily mean, however, that Zhou consulted this specific artist's style,

2.1 Landscape image from *Forest of Paintings.*

since the monumental landscape style had long been admired and creatively revived by any number of artists through the ages.

The other landscape rubbings from *Forest of Paintings* also represent pictorial characteristics of more recent masters, mostly of the Yuan and Ming dynasties. One rubbing shows an empty pavilion under a pine tree, depicted in simple outline in a composition with an indeterminate open space reminiscent of the paintings of the Yuan master Ni Zan (fig. 2.3), but the brushstrokes used for the surfaces of the rocks, a combination of raindrop and ax-cut strokes, are hardly characteristic of Ni Zan's work. Another rubbing presents a couple of flat-topped mounds on the right, separated by water in the middle from the shore, bluffs, and rocks on the left (fig. 2.4). The truncated hills and the rather bland texture applied for the surface of the rocks and mountains suggest a reference to the pictorial

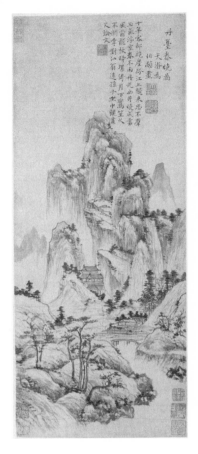

2.2 Lü Guang (ca. 1300–after 1371), *Spring Dawn over the Elixir Terrace*, ca. 1369. Ink on paper, 61.3 x 26 cm. C.C. Wang Collection, Metropolitan Museum of Art, New York.

idiom of the Yuan master Huang Gongwang. Yet in this rubbing, instead of a typically Yuan tripartite composition of hills in the foreground and distant mountains separated by a span of water extending horizontally through the mid-section, the water cuts the picture plane vertically into two spaces. Furthermore, its use of the bird's-eye-view perspective popular with late Ming masters was not common among Yuan painters. Thus, this rubbing might well have been based on a work by a late Ming master, if not Zhou himself, who combined a variety of traditional styles with his own interpretations.

Another rubbing, only half of which survives, provides a good example of this stylistic pastiche (fig. 2.5). Its pictorial formula resembles a painting by the late Ming master Wen Jia (fig. 2.6). The rubbing in *Forest of Paintings* and Wen's painting share a number of visual and compositional schemes: a couple of tall trees in the foreground covering half the picture plane, distant mountains visible across a vast expanse of water, and the high-rising mountain in the upper right

2.3 Landscape image from *Forest of Paintings*. **2.4** Landscape image from *Forest of Paintings*.

corner. Similar compositional schema are found in many other painters' work, however, especially the Wu School amateur artists, including Wu Zhen, Shen Zhou (1427–1509), and Wen Zhengming. Another half-page illustration (fig. 2.7) clearly shows its original subject matter, "The Red Cliff" (Chibi), and similarities with other paintings on the topic are beyond contest, as demonstrated in a work by Wen Zhenming (fig. 2.8). Although half of the rubbing is missing, the details available—the slanted rock above the water, the pine trees rooted into it, and the ripples hitting the rocks—strongly suggest that the illustrator tried to maintain the core motifs of the topic. At a minimum, it is clear that landscape rubbings in *Forest of Paintings* cover many distinctive styles that had developed over centuries.[40] This variety makes it difficult to pin down which artists or even which schools Zhou used as models. Furthermore, the small scale of the rubbings and their simplified strokes do not reveal enough information for the modern art historian to speculate productively about their precise origins.

And finally, there is the intriguing problem of the omission of these landscape images in *Grove of Paintings*, the companion work to *Forest of Paintings*. Most contents and illustrations are shared by both, but for some reason the landscape illustrations are not. The absence of these images leads to an entirely new series of discussions on late Ming cultural protocols within the publishing industry.

2.5 Landscape image from *Forest of Paintings*.

Illustrations and Editorial Statements

In contrast to its other lavishly illustrated volumes in *Grove of Paintings*, the volume on landscape paintings and general art theory, *Painting Critique and the Sea of Art*, does not feature any visual aids. Just as the chosen format or style of illustration may provide clues for the historian, the exclusion of features common in other publications may also offer leads for further research. In the case of *Grove of Paintings*, the omission of illustrations in the chapter on landscape must be understood as the choice of the publisher based on his understanding of the late Ming market and cultural protocols. The investigation of late Ming debates over the use of illustrations in books will prove helpful in uncovering just what was at stake in such a decision.

The development of the book industry in China reached a high point around the turn of the seventeenth century. By that time, illustrations were being

2.6 Wen Jia (1501–1583), *Landscape*, 1559. Location unknown, after the catalog of the National Fine Arts Exhibition of 1929.

incorporated into almost every genre of publication; apart from the classics and examination preparation manuals, most books featured illustrations. In popular literary genres, such as novels and dramas, illustrations were de rigueur for attracting a wide readership.[41] Despite the relatively high prices of illustrated books, their popularity and the demand for them expanded over time.[42] As the late Ming writer Wang Shizhen observed, "As for both classic and contemporary dramas in circulation today, no editions are printed without illustrations."[43] Even if we decline to take this claim literally, such a statement underscores how integral illustrations had become in reading practices at that time. Accordingly, publishers began to include self-reflexive comments on the merits and principles of illustration in "editorial statements" (*fanli*).

Often placed after the preface, editorial statements address such matters as the motives for publication and the work's merits, warn against plagiarism, and set forth the volume's contents one by one in a bulleted list. They also clarify technical and editorial features of the book, such as punctuation, page layout, or featured styles of calligraphy. Beyond this, publishers also manipulated editorial

2.7 Landscape image from *Forest of Paintings*. BnF, Curtis AC 9042, D7374.

2.8 Wen Zhengming (1470–1559), *The First Prose Poem on the Red Cliff*, 1558. Hanging scroll, ink on paper, 140.7 x 33 cm. Detroit Institute of Arts.

statements in order to advertise the superior quality of their publications.[44] Therefore, one of the main purposes of these statements was to provide practical information on format and styles in relation to the editorial principles informing the book. However, these claims and explanatory remarks, though prepared for a practical purpose, were by no means free of rhetorical charge or critical analysis. In editorial statements, publishers often described the reasons behind their choices, even going so far as to explain why they discarded alternative options. These statements can also be of interest because they reveal how editorial and design choices mediated between publishers and readers. One of the chief foci of negotiation was the relative authority of word over image. In China, as in Europe,

the priority of word over image had always been presumed, but this wisdom was called into question by the undeniable commercial success of illustrations. The old guard fought back by castigating the use of illustrations in books as "common," "philistine," or even "vulgar" (*su*). Book publishers then had to defend their turf. This battle was waged largely within the editorial statements that invariably accompanied these works.[45]

The Popularity of Illustrated Books

An anecdote regarding a professional writer of examination essays sheds considerable light on the popularity of book illustration and the newly emerging reading practices of the late Ming public. The writer in question is Chen Jitai (1567–1641). When Chen was a boy, he received an illustrated copy of *Romance of the Three Kingdoms* from his uncle. He became so enchanted with the book that he read it day and night without pause, even skipping meals. His mother could not put up with this, so she chastised her brother for giving such a book to her son, complaining that he had become obsessed with mere visual entertainment, such as pictures of mounted warriors fighting.[46] Though fragmentary, this story offers several hints regarding reading practices during the late Ming period. First, it seems to have been normal for family members to share illustrated popular books for pleasure reading. Second, novels were not merely read by adults but were available to different age groups, including young boys like Chen Jitai. Furthermore, Chen's mother apparently believed that her son was so engrossed in that novel because of its illustrations instead of its story. This suggests that there was a group of people who understood that illustration could be appreciated for its own value without much reference to the text.[47]

As the demand for illustrated books increased, publishers were eager to advertise their use of illustrations to readers. In fact, it is at this time that terms such as "fully illustrated," "beautifully illustrated," or "visually explained" begin to appear in book titles, presumably in hopes of improving sales.[48] Publishers adopted a range of strategies to enhance the value of illustrations. In some genres of popular literature, illustrations were placed together at the beginning of the book or even collected in a separate volume rather than being printed adjacent to the appropriate text. In addition, some publications featured an illustration on the front page.[49] For example, works by a well-known late Ming commercial publisher in Fujian, Yu Xiangdou (ca. 1550–after 1637), often include images of literati activities as frontispieces; this was a way of showing that the books' contents were grounded in elite culture and taste, thereby reinforcing their appeal to aspiring

aesthetes.[50] These formats suggest the independent status of illustrations, which could be appreciated for their own merits rather than as a mere enhancement of the text.[51]

At the same time, the artistic and social agency of the producers of book illustrations also expanded. One late Ming popular painting manual, *Canon of Paintings*, printed the names of the volume's illustrator, Cai Ruzuo, and carver, Huang Dechong, at the end of the preface. Because the great masters of painting in China had been signing their work for more than a thousand years, designating the illustrator and carver by name accorded them higher artistic status. Indeed, fine craftsmen and engravers would sign their work, as master painters would have signed theirs, imparting greater respect to the genre of popular literature.[52] This trend culminated in the participation of celebrated painters of the period in the production of book illustrations. The more prominent among these include such luminaries as Ding Yunpeng (1547–1621), Chen Hongshou (1598–1652), and Xiao Yuncong (1596–1673).[53]

Not surprisingly, claims about the quality of illustrations began to appear in the editorial statements of many illustrated books.[54] The eighth item listed in that section of *The Amorous History of Emperor Yang of Sui* (Sui Yangdi yanshi), published in 1631, reads,

> The decorative images one finds in other commercial publications only vaguely resemble the actual person. They are merely baubles offered for children's play. In this compilation we have especially sought famed calligraphers and accomplished artists to transmit the spirit of the subject through significant details and to fully exhaust its subtleties. Thus, when you open this publication, the [illustrated] person's individual emotions and charming demeanor seem to suddenly come alive. Isn't it like facing the works of [great masters like] Gu Kaizhi and Wu Daozi? Are they not like the beautiful works of the lyric masters? Are they not genuine treasures for a scholar's desk? [55]

In this passage, the publisher makes the explicit claim that the illustrations in his book are works of art in themselves. He reassures readers that he hired the finest calligraphers and painters, and he even compares his illustrations with the works of two classic masters of Chinese painting, Gu Kaizhi and Wu Daozi. Having been elevated to the status of art, the illustrations in this volume were purported to be appropriate for consumers of exacting taste.

It is worth noting, however, that the masters cited here were not the leading lights of contemporary painting, nor were they among the recognized literati

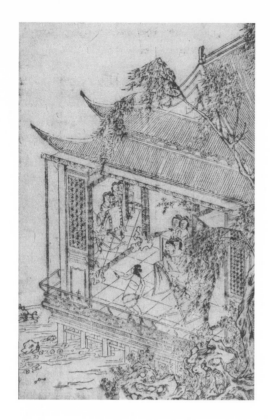

2.9 A page from *The Amorous History of Emperor of Yang of Sui*, Renruitang edition (1631). Harvard-Yenching Library Collection.

artists of the preceding nine centuries. Instead, the publisher cites the earliest recorded masters of the brush, the equivalent of a nineteenth-century European bookseller comparing his illustrations to the works of Masaccio rather than those of Théodore Géricault. This kind of attribution was fairly common at the time. Illustrations are accompanied by phrases such as "in the manner of Wu Daozi" or "in the manner of Zhou Fang"; however, the pictures thus attributed rarely show any credible stylistic affiliations with the works of the masters cited. As we can see in the page from *The Amorous History of Emperor Yang of Sui* (fig. 2.9), the thin and angled lines, the proportion of the figures to the architecture, and the bird's-eye-view perspective do not match the transmitted styles of either Gu Kaizhi or Wu Daozi. As some art historians have observed, this kind of attribution, though misleading, nonetheless implies that readers possessed some basic understanding of the artistic canon in China,[56] but readers with solid art historical knowledge would have noticed the discrepancies between the ascribed and actual styles. We can therefore conclude that in prints—unlike paintings—the level of visual fidelity to the attributed style was not the primary issue, either for the publishers or for the readers. It might be the case here, as Herbert Gans has

noted for other societies, that popular or middle-class culture has a tendency to exhibit more interest in the names of artists than in their actual works.[57] It would appear that the name value of famous artists was exploited in order to establish the publication's credentials or to provide the flavor of a cultured art practice for readers.

Furthermore, if publishers found their illustrations fit for certain functions not claimed in other illustrated publications, they missed no opportunity to promote those special features. In the Wanli edition of the Ming drama *Indigo Bridge and the Jade Pestle* (Lanqiao yuchu ji) by Yang Zhijiong, the sixth item in the editorial statements says, "The present story is illustrated scene by scene, as a convenience for [the actor] in applying makeup and selecting costumes."[58] Some illustrations in printed dramatic literature were in fact prepared for the practical purpose of providing a visual guide for acting, costume design, and stage arrangement.[59] Although it is also possible that these books were not used for the stated purpose, such works could have attracted a readership interested in diverse aspects of drama reading by emphasizing the vividness of the illustrations and their claimed link to actual stage performance.

Another interesting example of this kind can be found in the tenth article of the editorial statement in *Combined Edition of the Songs of Wu* (Wusao hebian), a collection of lyrics published in 1637. The publisher claims that the book's illustrations possess the same expressive power as genuine paintings and, like literati paintings, can express the unique thoughts and sentiments of the artist. He goes so far as to recommend them as perfect models that readers could study so as to create their own paintings.

> In publications of dramatic songs, illustrations first appeared in this book. This is hardly to delight the philistines. It has been said that there are paintings in poems and poems in paintings. Should you but open this book, it will immediately suit your sensibilities, naturally arousing your refined tastes. For this reason we have designed quite a few images, executed with great skill and utmost art. Following these images, readers can create their own paintings to express changes in their feelings.[60]

What is noteworthy here is that the images in the book are introduced not only as a supporting device for the text but also as pictorial models for the creation of paintings. Illustrations in this songbook show primarily images of women accompanied by their male lovers. In one image, a lady is sitting on a garden rock, gazing toward a distant shore, where a group of willow trees hangs over the

2.10 An illustration from *Combined Edition of the Songs of Wu*, 1637, 1: 52b–53a. National Library of China, Beijing.

arch of a bridge (fig. 2.10). A couplet selected from a song in the text is printed on the upper right side of the screen. It reads, "Drooping willows reflect the painted bridge; a small path is lost within the fragrant pasture." The image was prepared with the explicit intention of incorporating motifs evoked in the poem. Representing a poem in the book in pictorial format allowed readers to participate in the literati ethos equating poem and painting without the need for a great deal of learning or insight on their part. In this way, the images in the book functioned as a vehicle for expression that, like the lyrics, could provide readers with both artistic satisfaction and emotional catharsis.

Criticism of Illustrated Books

In his study of late Ming manuals of literati etiquette, Craig Clunas notes, "*Treatise on Superfluous Things* contains no pictures at all. Given the work's dependence on a socially structured-discourse of the 'elegant' and the 'vulgar,' this would seem to lend force to the notion that pictures are of themselves 'vulgar.'"[61]

While it would be misleading to imply that everyone in late Ming society regarded illustrations as common, vulgar, or philistine, this was certainly one position in the lively Ming cultural debate. One criticism of book illustration as a practice is found in *Five Assorted Offerings* (Wuzazu), a collection of instructions on elegant lifestyles written by Xie Zhaozhe (1567–1624).

> Publications nowadays, such as *Master Feng's Chronicle of Poetry* (Fengshi shiji), *Master Jiao's Assorted Encyclopedia* (Jiaoshi leilin), and other books printed in Xin'an, such as the *Philosophy of Zhuangzi* and the *Woes of the Departure* (Lisao), are made by extremely skilled hands in no way inferior to those of Song times. The publishers have also invested much in proofreading the texts, so errors are extremely rare. Yet the imprints of Mr. Ling of Wuxing were hurriedly printed for profit, without any revision and polishing of the text by professionals. It is no wonder there are so many typos in these books! Books such as the *Water Margin*, the *Story of the Western Chamber* (Xixiang ji), the *Romance of the Lute*, *Master Fang's Ink-Stick Catalogue* (Fangshi mopu), and *Master Cheng's Ink-Stick Collection* (Chengshi moyuan) are meticulously prepared, their workmanship is inspired and utterly admirable, [but] these are nothing but works designed to transmit the strange, mere entertainment for the ears and eyes—it is just a shame.[62]

Here, Xie Zhaozhe disapproved of the books published by Mr. Ling due to their lack of editorial polish. In his rush to make a quick profit, Mr. Ling seems to have sacrificed editorial standards. As for the illustrated books, although the quality of illustrations was excellent, they were dismissed as "mere entertainment for the ears and eyes," suggesting that they are not appropriate for the serious reader. Some of the books criticized here, such as *Master Fang's Ink-Stick Catalogue* and *Master Cheng's Ink-Stick Collection*, were commercial ink-stick catalogues. They are now regarded as among the best products of the printer's art from China, in terms of both their illustration quality and their exquisite designs. This fact, while illuminating the wide circulation of these commercial ink-stick catalogues in late Ming society, further suggests that these publications were not only used for marketing purpose but also enjoyed for leisurely reading by contemporary readers. Nevertheless, if Xie Zhaozhe chose these books as unworthy of serious attention, it would seem that no illustrations, however fine, could compete in his mind with the elegance of pure text.

Some publishers responded to such critiques by eliminating illustrations from their books. The fifth entry in the editorial statements of *Butterfly Dream* (Hudie

meng), a popular drama of the late Ming period, is a good example. The publisher of this drama defends the absence of illustrations in his book as follows:

> As for the practice of illustrating editions of plays, this is merely a device devised by those selling them. This play was written to provide leisurely enjoyment, not to make a profit. Since those eager to read this book are numerous, I printed it to save them the trouble of making copies by hand. But we made a point of not providing illustrations, to avoid being tasteless [*su*].[63]

Many un-illustrated books from the late Ming period also provided this kind of explanation for the absence of illustrations.[64] In this statement from *Butterfly Dream*, the publisher himself may have believed that illustrations were "vulgar" or "tasteless" as stated, or he may simply have been mindful of his target readers, those who did not wish to be accused of philistine taste. However, this was merely one among a wide range of possible views available to late Ming publishers and consumers.

It must be noted here that the real target of the criticism was not really book illustration itself. As Nicholas Mirzoeff notes, the source of the general antipathy of intellectuals to mass culture is not the medium itself but the people who enjoy it.[65] The debate over the book illustrations reflected conflicts of taste between different cultural groups. In this regard, the alleged philistinism of late Ming book illustrations was not only criticism of their format or usage, as claimed in some commentaries, but also of the users and advocates of book illustrations, those who challenged the literati's claim to having a monopoly on culture.

Therefore, what is most noteworthy in the emergence of a critique of book illustration is that it demonstrates the increased power of the general reading public, or those who favored book illustrations. As Dominic Strinati has argued, if a specific variant of the social discourse bemoans the advent of cultural democracy and criticizes mass culture in terms of elitist criteria of taste and discrimination, then it is the very power of the larger public, not the lack of it, that is emphasized, however little it is welcomed or celebrated.[66] In this observation, Strinati refers to a situation in which a so-called elite group fears the power of the less-lettered crowd. Such fear only increases as the public internalizes a debased form of high culture, thus forming a social group with potentially greater influence in society.[67] Therefore, the elevated level of criticism directed against illustrated books is firm evidence of the late Ming public's conspicuous presence and upgraded cultural agency, which it obtained through acquisition of a discounted form of high culture.

The growth of illustrated imprints argues against the simplistic notion that elite taste was being imposed upon a docile non-elite population. Although the reading public may accept generally the leadership of the dominant group, arguably this is because they have reasons of their own for doing so, not because they are ideologically subordinate or indoctrinated.[68] If Xie Zhaozhe felt compelled to criticize book illustrations, presumably this was because he recognized their cultural and commercial success. Accordingly, facing criticism of illustrated books, late Ming publishers found ways of elaborating on and adjusting the conflicting views and manipulating public taste to their advantage. Though not homogeneous in their cultural stances and levels of confidence, their responses to contemporary critiques further demonstrate the diversity and plurality of the late Ming public. There was plenty of room for negotiation between these extremes, with or without illustrations.

The Publisher's Dilemma

As shown in the editorial statements from *The Amorous History of Emperor Yang of Sui*, some publishers complimented themselves on the artistic quality of their illustrations. A deeper look into these notes uncovers a more complicated form of rhetoric. In the fourth item in the editorial statements in *Forgotten Tales of the True Way* (Chanzhen yishi), the following comment points to the conundrum late Ming publishers faced.

> Illustrations in books are like pictures for children. However, in this book words
> are used to portray the vicissitudes of the world. When the text is insufficient
> to get these across, then illustrations can be used to represent them. People in
> the past said, "There are paintings within poems." Now I say, "There are poems
> within paintings." When readers open this book, the sentiments of people,
> the principles of nature, cities and wildernesses, victory or defeat, poverty or
> prosperity, the capital city or the rural inn are completely available at a glance.
> Since in these illustrations the landscapes look real and the spirit of personages
> appears so vividly, we can call this the work of a marvelous hand in depiction.
> How could we refer to this as merely the craft of printing?[69]

This statement opens by denouncing the childish quality of book illustrations in general, hinting that they are inappropriate for readers of refined taste. It goes further still, advocating the primary status of the text: images are marginalized as mere supplements to it. All of this recognizes a dominant discourse in which image

is subordinate to word. However, the author then goes on to subvert this dogmatic view by placing the illustrations in his volume into a higher category than ordinary illustrations. Just as in the editorial statement in *The Amorous History of Emperor Yang of Sui*, the author here argues that these illustrations have an expressive power equal to that of fine art or literature, and so the illustrated images included in his book should be regarded as art in their own right. Thus, both publishers strove to distinguish their illustrations from those in other contemporaneous books. By separating their illustrations from those in the majority of other publications, the publishers of *Forgotten Tales of the True Way* and *The Amorous History of Emperor Yang of Sui* declared that their publications transcended the vulgar sort of illustrated book and should be classified as elegant (*ya*) artistic products.

Some other publishers claimed current taste was behind their decision to illustrate their books. One example is found in the ninth entry in the editorial statement in a Tianqi (1621–1627) edition of *Story of the Western Chamber*.

> This book is published for people of elegant taste and should be read as litera-
> ture, not as drama. Naturally, it could be published without illustrations; how-
> ever, since people love embellishment [pictures] and I was afraid there would
> be those who might judge the lack of illustration as a fault, I had an illustration
> prepared for each of the four lines of the title and topic of each act [within the
> cycle of five that constitutes the entire play] so as to compete [with other illus-
> trated publications].[70]

While the publisher reveals his awareness of high culture by belittling the status of illustrations, he explains his choice to include them as acquiescence to the taste of those readers who appreciate them. Apparently, his final production decision overrode his concern regarding criticisms of illustrations. What, then, is the significance of his choice? His finesse in working around the criticisms suggests the instability of cultural norms and the role of illustrated books as a site of contention within which alternative choices could be initiated and negotiated.

Similar types of commentaries, which appeal to the demands of the reader-ship for their authority, can be found in other contemporary books as well, and some of these make their point very explicitly. For example, the thirty-sixth item in the editorial statement in a 1614 edition of *Story of the Western Chamber* reads as follows:

> Illustrating books does not appear to be such an elegant thing. In old editions
> the illustrations are indeed coarse and labored, offending the senses. Since I

thought this edition might someday have a wide circulation, I had to follow the old customs but introduced some innovations. When I met Master Mao, a friend of mine from Wu County, he showed me a portrait of Oriole (Yingying) by Qian Gu copied by his wife, Ruyuan, in order to get a colophon for it from me. I wrote a quatrain, "On Behalf of Ms. Cui," followed by a prose poem titled "Charm to Last a Thousand Years." This was inscribed by Master Zhou Xia of the same county. Qian Gu is a famed artist of our period. Ruyuan's copy technique is truly exceptional and indeed surpassed Qian Gu's original work, so it can be aptly called "a fine work of the women's quarters." I also copied [this painting] and included it in this publication. As people say, it's hard to go against the tide; we may as well just go along with it.[71]

The rhetoric here is subtle. Just as in the above-mentioned edition of *Story of the Western Chamber*, this statement also notes the philistine nature of illustrations but then offers reasons for extolling the artistic quality of this edition's illustrations. In this manner, this book also establishes the artistic status of its illustrations as distinct from that of the majority of other illustrated publications. Furthermore, he notes that the original illustration in question was prepared by a well-known artist of the period, Qian Gu (1508–after 1574). Later it was copied by Master Mao's wife, and a colophon was added by the author of the editorial statements.[72]

The practice of adding a colophon is obviously adopted from literati practice. Indeed, the illustrations in this book reveal an obsession with landscape, a genre typical of scholarly art (fig. 2.11). The figures, however, are delineated in such an inexpressive and insignificant manner that they are reduced to mere decorative motifs in the landscape. This may reflect an emerging interest in landscape prints at that time and further suggests the desire of readers to incorporate the ideals of high culture into popular literature.[73] This statement ends by claiming it is inevitable that books will be illustrated despite the inelegance of the practice. Even with his avowed confidence in the artistic quality of his illustrations, the publisher also appeals to the commercial success of illustrations as a final authority vis-à-vis the criticisms leveled against them. He stresses that his decision to include illustrations was not his choice but rather was unavoidable, made in deference to the demands of the public based on their power in the marketplace.

The epitome of this type of argument is found in an edition of *Peony Pavilion* published in 1625, in which the ironies of the situation emerge even more clearly.

2.11 Illustration by Qian Gu (1508–after 1574), in *Story of the Western Chamber*, 1614. 21.5 x 14.3 cm. National Library of China, Beijing.

> Books of drama simply do not sell without illustrations, so I didn't mind
> putting illustrations in for the reader's pleasure. As people say, it's hard to go
> against the common [*su*] crowd, so we may as well just go along with it.[74]

This claim has much the same ending as the one in the 1614 edition of *Story of the Western Chamber*, yet due to its directness and brevity, the cultural agency of the public emerges here far more clearly. Furthermore, this author unabashedly accepts the value of entertainment. In addition, even the practice of pleasure-oriented reading finds approval without a hint of regret. In the end, a publisher's concern could be justified by an appeal to the authority of casual readers.

Regarding the relationship between publishers and their market, Roger Chartier made an insightful observation. He notes that publishing strategies depend on the extent and the character of the public that constitutes the book-maker's potential clientele at any moment in history. The decision to print a particular text and the choice of format and press run responded primarily to the numbers of prospective readers—or at least to the publisher's idea, accurate or

inaccurate, of that market.[75] This would seem to indicate significant instability in the cultural hegemony of the traditional elite class perceived as authoritative by so many publishers. Thus, we can now understand that both the greater reading public and elite readers in late Ming China exerted different levels of influence and hegemony over different groups of publishers and their products. We must understand that hegemony is not a singular phenomenon. Its status is constantly being created, challenged, defended, negotiated, and finally redefined. Hegemony provides a reason for struggle, and the process of cultural conflict provides opportunities to institute the ideas and values of subordinate groups. This is, as Raymond Williams has noted, why "a hegemony" circulates instead of "the hegemony." No hegemony can maintain a dominant role or avoid any challenge.[76] In this regard, we may hypothesize that the power prominent intellectuals held over standards of taste began to lose its dominant status as the public gained access to a culture—through consumption of printed works—that was not entirely dependent on intellectuals for its authenticity and its definition of worth. Apparently, to late Ming publishers, the interests of the general public and their taste became as important as those of the higher classes.

By studying late Ming painting manuals from this perspective, we can understand that they were also an important site of contention within which this kind of cultural conflict took place. In the preface to *Apprenticeship in the Painting Business*, Zhang Chun noted,

> [This painting manual] makes its readers forget their weariness and can even make those who enjoy it forget to eat. I sigh that the painters of our day, when they have an insight [on painting], try to hide it away for fear that people will find out about it or that it will be circulated among the public. They also do this because fellow artists might slander them. When they see Mr. Zou's book and know he shares [his insights] with the public, won't they be shamed? Can Master Zou's publication not be a generous endeavor?[77]

In this part of the preface, Zhang advertises the manual's merits in a rather exaggerated fashion and then voices his dissatisfaction with contemporary artists who try to keep their knowledge and experience confidential. This situation is easier to understand if we recall that the late Ming was a period when the literati's monopoly on artistic taste was at stake.[78] These painting manuals were handy textbooks: they could help a much broader public assume the appearance of people in command of literati cultural skills. And so their publication was sometimes seen as a threat to the traditionally dominant social group because

it challenged the intellectual's role as sole arbiter of artistic taste along with his monopoly or control of professional secrets. This suggests the remarkable level of cultural pressure put on those who published such works. Here, Zhang Chun counters such pressure with his claim that the publisher, Zou Dezhong, by offering his artistic insights and knowledge to the public in his painting manual, is acting in an entirely respectable manner.

Now to return to the question raised above: Why were illustrations absent from *Painting Critique* in *Grove of Paintings*? All the other chapters in the series are heavily illustrated, so readers might have wondered at this specific choice; however, the matter is not addressed anywhere in the writings of Zhou Lüjing. Nevertheless, high culture is precisely what his painting manuals claimed to offer aspiring socialites. This implies that considerations of the manuals' format and program could not escape the late Ming discourse of cultural legitimacy. With landscape painting recognized as a scholarly genre and perhaps held to higher standards because of its close association with literati art, the absence of illustrations in the volume on landscape painting was quite likely a specific decision made by a publisher whose cultural status could be damaged by permitting the landscape section to be tainted by the lowbrow blandishments of visual charm associated with illustration.

As already discussed, the soaring popularity of illustrations in books engendered debates over their cultural value. The most intriguing issue was, as indicated in Xie Zhaozhe's comments, that even illustrations of the best quality prepared by renowned masters did not escape criticism for being somehow philistine. Some editorial statements explained that the illustrations had been omitted so as to avoid the stain of lowbrow taste. For these publishers, illustrations, under any circumstances, are by definition vulgar or lowbrow. This suggests that the tendency to criticize illustrated books was ever present in the late Ming, regardless of their specific format or contents, including pictorial styles, craftsmanship, intended readership, and even print quality. Therefore, looking for definitions or criteria that would unambiguously classify such books as classy or contemptible is beside the point. Instead, understanding the hidden logic of criticisms against book illustration, and publishers' comments in defense of the same, requires closer examination of how the terms of elegance and philistinism were exercised in late Ming cultural discourse. In the process of negotiating the value of this new medium, we must target the rhetorical use of both high taste and low taste, a boundary that was subject to constant negotiation.

Rethinking Late Ming "Vulgarity"

The concepts *su* and *ya* have a long history in Chinese cultural and literary criticism. Before the Han period (206 B.C.E.–220 C.E.), the literary meaning of *ya* was "standard" or "elegant" (*zheng*), while *su* could mean "ordinary people" or "the general public," as in a term like "mundane" (*shisu*), which also means "secular" (*shijian*). Interestingly, the word *su* had little sense of the derogatory in its pre-Qin (221–206 B.C.E.) usages. It was not until the Wei-Jin period (220–420 C.E.) that *su* and *ya* together formed a hierarchical relationship designating a range of possibilities from vulgar to elegant.[79] This does not mean, however, that these terms had developed a mutually exclusive relationship. Although certain cultural forms or programs were often designated as either elegant or vulgar based on their functions and values, these categories were always relative rather than immutable. One man's vulgarity could be another man's elegance, since there was plenty of room for semantic modification and even interchangeability between the two.

Recently, historians have produced insightful studies on the cultural distinctions between different taste-groups in late Ming China. For example, Robert Hegel proposes the possibility that popular and literati novels differed in terms of their subject matter and the level of morality maintained in the text.[80] Grant Shen discovers different artistic standards among high- and low-level theatrical troupes.[81] These sorts of cultural distinction are a phenomenon of the late Ming period, and they are indeed a strong piece of evidence for the emergence of a multi-class society in China. Even so, cultural distinctions in the late Ming could be much more complicated than they first appear. For example, Julia Murray contends that during the late Ming, the life of Confucius was a popular theme for stone engravings and book illustrations, yet this topic was seldom, if ever, represented in a painting format.[82] Her observation elucidates that the subject matter or style of cultural products alone cannot determine the interrelationships between various social and cultural groups. What, then, could be an alternate way of understanding the complicated web of meaning and significance in discourses on the elegant and the vulgar?

Andrew Plaks aptly argues that late Ming literati artists asserted the authenticity of their paintings in terms of ideas rather than fixed formats or styles.[83] Originality and spontaneity were the major criteria for the evaluation of personality. Not only in art but also in literature and philosophy, literati critics widely praised the measure of liberation a work achieved from defined and conventional formula. For example, one of the most celebrated critics of the late Ming period,

Li Zhi (1527–1602), asserted that people must have a "childlike mind" (*tongxin*). With this idea, he emphasized a state of mind in which people were not restricted by previous knowledge or set rules. A phrase from Yuan Hongdao, a member of the Gong'an School, aptly summarizes these kinds of values. He professed that in terms of artistic creation and appreciation, his rule was "not to have any rules," a claim that permitted the breakdown of the style-based artistic tradition of the previous period.[84]

In this context, one item in the editorial statements in *A Critical Evaluation of Drama from the Hall of Distant Mountains* (Yuanshantang qupin), published by Qi Biaojia (1602–1645) in the early seventeenth century, provides a helpful prism for understanding the late Ming rules of art.

> Literati are [supposed to be] fond of change, so do not set up just one style and stick to it. One can change from a rich style to a more detached one, from a coarse [*su*] style to an elegant [*ya*] one, from a free style to a regulated one.[85]

Here, the taste of the true literatus is characterized by constantly changing styles, thus, the style of no style. Even the vulgar can be included within this cultural program. Instead of defining certain styles or formats as normative, the emphasis is on an attitude of greater generosity toward individual difference.

Wang Jide (ca. 1583–ca. 1623), a late Ming drama writer, also supported this view of style.

> Arias with humorous phrases are similar to Dongfang Shuo's witty sayings. If one lacks delicacy, excellence, and outstanding writing skills, or if one is not fated to have the perfect opportunity, it is difficult to write them as they should be. Although people might manage to write something, they will not create a masterpiece; neither can they even think of a sentence as good as Oil Peddler Zhang (Zhang Dayou). Thus, you have to use the vulgar to create elegance, so that with one word, it will win over everyone. Only this is truly wonderful![86]

Here, Wang Jide examines the difficulty of writing witty arias, noting that a vulgar phrase could be transformed into an elegant one if employed in a proper way. Although the expression is perceived as coarse, the blurred distinction between philistine and elegant cultures is what generates the humor. This shows that the nature of elegance lies in opportune uses rather than in any unalterable formula. For this reason, we should remember that the elegant and philistine cultures do not simply stand for the cultural programs of "high" and "popular" social

formations.[87] *Su* and *ya* were flexible items of cultural capital, which could be negotiated within and outside various cultural circles. The late Ming public was not debating the definition of the term *ya*, but its use. They used the term in order to enhance their cultural authority and influence. After all, what was at stake was the ownership of legitimate culture, and both literati critics and popular publishers laid claim to that ownership by rhetorically negotiating whether certain cultural objects or practices were elegant or philistine.

3

Portraits of the Characteristic

Wrestling is not a sport, it is a spectacle. It no longer matters whether the passion is genuine or not. . . . What the public wants is the image of passion, not the passion itself.

—Roland Barthes

ONE FEATURE THAT GIVES *GROVE OF PAINTINGS* GREAT HISTORICAL SIG-nificance is its inclusion of the work *Heavenly Forms and Exemplary Manners*, the first painting manual in Chinese history exclusively devoted to the genre of figure painting. Besides its early publication date, the importance of this manual lies in how it engaged contemporary society and the culture at large. In its format, page layout, pictorial styles, subject matter, and textual instructions, *Heavenly Forms and Exemplary Manners* touches upon a wide spectrum of contemporary affairs—popular culture, fashion, lifestyles, lei-sure activities, and gender stereotypes—and represents a juncture where con-temporary social discourses blended into the program of art. Its illustrations functioned as cultural conduits through which meanings were produced and exchanged among members of late Ming society. This work was not simply a painting manual but a collection of texts and images that enabled the late Ming public to register, promote, contest, and, finally, negotiate its desire for artistic excellence, cultural supremacy, spontaneous and unique personality, and even erotic fetish.

Textual Collage: Copying or Writing?

Like *Painting Critique and the Sea of Art*, the first title in *Grove of Paintings*, the text of *Heavenly Forms and Exemplary Manners* transplanted a considerable portion of its contents from other writings on art and art history. As discussed in chapter 2, this line of practice indirectly accounts for the readership of these publications and helps modern art historians gauge the level of artistic knowledge that circulated among the late Ming reading class in general. A similar philological investigation into the texts of *Heavenly Forms and Exemplary Manners*, therefore, will provide opportunities to discover why Zhou Lüjing chose specific texts and how he organized them with his own writings into one coherent piece. In this sense, a study of the patched text in Zhou's figure painting manual can lead to a better understanding of how a certain style and program of figural icons came to be included in the manual and subsequently promoted as canonical to the late Ming art public.

The text of *Heavenly Forms and Exemplary Manners* begins with an explanation of the Tang dynasty artist Wu Daozi and his brushwork. The original body of this text is from Su Shi's colophon on a Wu Daozi painting to which Zhou Lüjing made slight yet meaningful changes.[1] Su Shi's colophon asserts that Wu Daozi's painting is as valuable as the poetry of Du Fu (712–770), the prose of Han Yu (768–824), and the calligraphy of Yan Zhenqing (709–785), each of which, the text claims, is a historical exemplar of its art. This assertion is followed by an explanation of and praise for Wu Daozi's unmatched brushwork and the exceptional style of his figure paintings. Toward the end, Su Shi notes his own ability to tell Wu's original works from counterfeits and the rarity of Wu's originals, one of which he had seen only in a collection of his contemporary, Shi Quanshu. As with other colophons, the date of composition closes the text. Besides the fact that this colophon was reproduced word for word in many other late Ming writings on art, the format of its text unmistakably identifies it as a colophon.[2] Thus, any reader familiar with art historical writings would have readily recognized the original source of the first section of this figure painting manual.

Interestingly, Zhou Lüjing made some obvious modifications. First, he deleted the final part of the colophon, in which Su proclaims his connoisseurship, mentions Shi Quanshu's collection, and ends with the date, thus hiding all the contextual clues to the piece's historical origin. Second, in addition to Wu Daozi, he names another artist, Cao Zhongda (act. 6th century), as a paragon of figure painting; Cao, the text notes, excelled in Buddhist and Daoist images executed in tight brushwork. The inclusion of this one name, however, would have spoiled

the parallelisms in Su Shi's original, in which only one name is mentioned for each genre. In order to solve this problem, Zhou Lüjing added names to make new pairs of examples for the other categories as well. For example, he matched Li Bai (701–762) with Du Fu for poetry, Liu Zongyuan (773–819) with Han Yu for prose, and Zhong You (151–230) with Wang Xizhi for calligraphy. It is notable that Zhou removed Yan Zhenqing entirely and registered a new pair of names as model calligraphers. As James Cahill has proposed, Ming critics usually did not directly relegate figure painting to a lower class, but when they spoke of it as an art devoted to the imitation of visible forms, that, for the Ming, was a virtual condemnation.[3] This might be why Zhou selectively used Su Shi's colophon, in which figure painting is promoted as equal to other areas of literati culture and leisure, that is, poetry, prose, and calligraphy. The text further suggests that readers of the manual are supposed to study only one style from Wu Daozi's and Cao Zhongda's styles of brushwork. This is followed by Cao Zhongda's biography and an explanation of his artistic style copied from Guo Ruoxu's *Experiences in Painting*.[4]

Why is Wu Daozi, among many other masters known for figure paintings, the focus here? This may have represented Zhou's own personal preference and allowed him to publicize his knowledge of Su Shi's colophon. Of course, Wu Daozi was celebrated for monochrome brushstrokes that run unbroken and smooth, nicknamed "iron wire" (*tiexian*). His reputation was a firmly established tradition in itself. This may be compared roughly to an early twentieth-century painting manual that takes Michelangelo and Raphael as models but does not mention Vincent van Gogh or Henri Matisse. By choosing Wu Daozi rather than more recent masters such as Li Gonglin (1049–1106), Dai Jin (1388–1462), or Tang Yin, Zhou could emphasize the ancient pedigree of figure painting while further perpetuating Wu's fame.

The promotion of figure painting is pushed further by subsequent sentences, which explain the basics of brushwork for rendering clothing. The text stresses that painting is based on the technical principles of calligraphy; thus, people who want to learn painting should study brushwork first, just as calligraphers learn standard script before they learn cursive writing. Here again, phrases from Guo Ruoxu's *Experiences in Painting* are tipped in selectively. Guo's original notes, "The brushwork for patterns of clothing [as well as trees and rocks] is completely derived from calligraphy."[5] Zhou Lüjing's version has dropped the "trees and rocks" in order to maintain its focus on the volume's subject matter, figure painting. Many other writings on art in Chinese history have drawn this analogy between painting and calligraphy. For example, Guo Xi's *Lofty Record of Forests and Streams* (Linquan gaozhi) notes that "learning painting is no different

from learning calligraphy."[6] In his *Compendium of Comments from the Studio of the Four Friends* (Siyouzhai congshuo), He Liangjun also observes, "Calligraphy and painting share a single origin. Painting is one of the six calligraphic styles."[7] Similar claims also appear in many late Ming texts, including Li Rihua's *Miscellaneous Gatherings at the Purple Peach Pavilion* (Zitaoxuan zazhui), in which Li remarks, "As I often mention, it is imperative to learn calligraphy to paint; only then will you be capable of brushwork."[8] Such expressions clearly had become formulaic by the late Ming period.

The next statements discuss the suitable representation of different social classes. Pictorial art should deliver people's social status, occupation, ethnicity, religion, age, and gender via their precise expression. This advice is quoted from Guo Ruoxu's text and had also been copied in many other texts almost word for word.[9] Noteworthy here is the well-defined formula that delimits social order and historical reality in visual representations and beyond. Current scholarship finds that this attitude grew out of a philosophical trend in Guo's period, Song dynasty Neo-Confucianism, which placed great emphasis on the close observation of nature as well as observance of the social order.[10] Zhou Lüjing himself was not likely to have been particularly mindful of this Song dynasty philosophical trend, but this passage demonstrates a tendency toward adherence to artistic norms based on the principles of things.[11] Instead of simply revisiting an earlier knowledge system, however, Zhou added his own words in his efforts to elaborate further on how these images depicted by the rules can summon subjective and emotional values.[12] He elucidates the settings, poses, and activities of scholars in paintings, many of which are illustrated in images included in the latter part of the volume: "sitting alone on the plain," "strolling along the shore," and "gazing at distant gorges." Some of these images are described in terms of the feelings they evoke. One example reads, "The image of a scholar sitting alone shows that his heart can forget the secular world; a long whistle signifies he has hidden remorse that goes beyond the sensory world. Drawing a country wife and an old man leading a child by the hand shows the shared feelings of villagers."[13] In coupling a certain figural motif with a set way of perceiving it emotionally, such instruction provided both a guide from which painters could choose a theme representative of their feelings of the moment and guidance on how to read individual figural motifs in a painting. It may be said that the rules of artifice the manual dictates challenge the freedom of the viewer's response. But the real goal of such instructions was to help readers apprehend and convey emotion, and the manual assists by identifying conventional scenes and expected emotional responses to them.

Toward the end of this part, Zhou adds more of his own perspectives. He recommends not making the screen "busy," which he criticizes as typical of philistine taste. He even dictates that readers learn only one style instead of embracing a wide range of artistic styles. This opinion also appears in other contemporary writings. For example, He Liangjun declares, "Painters have their own lineage, and they don't mix different styles."[14] However, this is somewhat different from the claims of an earlier period. For example, in his treatise on landscape painting, Han Zhuo's text from the eleventh century states, "Painters nowadays tend to stick to one school; thus, most of them do not understand the accomplishments of the various famous traditions. Although there are able men of wide acquaintance with the various traditions, few of them are deeply conversant with a particular tradition."[15] Here, Han argues for a balance of breadth and in-depth mastery. A similar view is expressed by Guo Xi, who announces, "The great man and the virtuoso will not limit himself to one school but will cull and compare, discuss, and investigate, until he is able to establish his own school. . . . Narrow specialization has from ancient times been a fault. It is like harping on one note or playing on one string."[16] Therefore, Zhou's suggestion obviously contradicts the teachings of the old masters. In light of these views from a previous era, Zhou's choice seems calculated not to overwhelm the general readers of his manual, most of whom might not have been familiar with even one school of artistic expression.

The remainder of the text provides more technical advice on how to express individual figural motifs and their details. A list of eighteen techniques for rendering clothing include, like earlier examples of such lists, the names and simple descriptions of types of brushwork.[17] Many of these are noted to have been developed by well-known masters of previous periods including Cao Zhongda, Zhou Wenju (fl. 942–961), Zhang Xuan (fl. 713–741), Gu Kaizhi, Ma Yuan (ca. 1165–1225), Liang Kai (act. 13th century), Yan Hui (act. late 13th–early 14th century), and Wu Daozi. This is another indication of the use and the readership of the manual. Without the detailed explanations and illustrations of each type of brushwork, readers would have learned no more than a few key words. Zhou then lists eleven different viewpoints for figure painting (an illustration from the section on art in *Assembled Illustrations of the Three Talents* [Sancai tuhui] is shown in fig. 3.1). *Heavenly Forms and Exemplary Manners* further emphasizes that frontal, rear, fourth, sixth, and seventh views are used more often, and among these, the rear view is used least. It also dictates that the frontal view is suitable only for religious portraits and warns against its common use for figures in landscape paintings, as it will make the painting look awkward and unsophisticated.

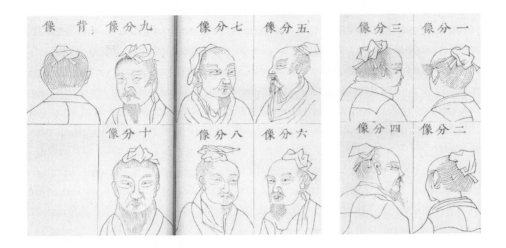

3.1 Viewing angles for portraiture from *Assembled Illustrations of the Three Talents*, 1607, renshi, 4:29a–30a. Each page, 22.8 x 13.7 cm. National Library of China, Beijing.

An explanation of how to draw individual body parts—eyes, mouth, ears, nose, beard, feet, and hands—finishes the text. Each explanation is brief yet provides supposedly useful information on how to draw or appreciate bodily features in painting. For example, the text proposes that, in paintings, ears are supposed to be manly and thick with a clear outline; the nose should be high and stout so as to resemble those of the ancients; the eyes should be balanced in order to have full elegance and suggest perseverance; and both sides of the mouth are to be lifted a bit so that a smile can naturally appear. As for the hands, they are to be rendered according to people's gender, age, and status. The hands of emperors, ministers, recluses, beauties, and boys should be represented as delicate, while those of farmers, loggers, and warriors would look powerful and weathered. The text ends by explaining the proportions of the body in terms of the size of a hand depicted in the painting: the face should be twice as big as the palm; a foot is twice as big as a hand; the body is supposed to be three times taller than the depicted hand of a seated figure but seven times taller for a standing figure. While this part of the instructions defines what a painted figure should look like, it also epitomizes the function of late Ming painting manuals, which coached readers equally in skills needed for informed viewing and those required for painting.

In sum, *Heavenly Forms and Exemplary Manners* shows a modicum of editorial planning. Its contents cover programs necessary for understanding figure

painting, using both known texts of the past and some of Zhou's own ideas. The text's focus on the basics and its minimal discussion of theoretical issues also point to its target readership and use. Complicated painting practice is often reduced to simple lists of terms, and the text emphasizes not only "how" to paint but also "what" to know and remember. Some of its contents reveal considerable discrepancy with other writings on art and art history, while its attachment of the terms "philistine" and "elegant" to certain styles or expressions makes it a strongly didactic guide. Similar to more recent European drawing manuals, Zhou's work provides the minimum knowledge necessary for discussion of figure paintings rather than for actual practice.[18] His silently copied (or plagiarized, by modern standards) compendium of previous knowledge delivers "style" as a device for transmitting basic information about how to read rather than how to create figure paintings. This observation suggests that the social use of painting manuals in late Ming China involved a display of artistic knowledge in conversation that was just as or even more important than the display of painting skill. Taking this into consideration, Zhou's textbook for figure painting may be understood as one that was clearly designed for the new readership of the time and which sought the essential elements of artistic knowledge, perhaps like those village art lovers depicted in Zhang Lu's painting (see plate 2, fig. I.2).

The Organization and Format of Images

Heavenly Forms and Exemplary Manners contains thirty-six full-page individual figure images along with six pages of small figural motifs at the end of the volume. Most of the individual images can be roughly classified by subject matter and sources of origin, but it is difficult to draw clear lines between them. The images have different cultural references and literary sources; some simply illustrate literati leisure in general, while others refer to specific historical occasions. Some images were chosen from among common motifs in paintings, and others illustrate stories that had rarely been represented in visual format before. Each image is independently depicted with no indication of time sequence or semantic correlation between them. The absence of an overarching rule of organization makes their selection by the publisher appear haphazard. This apparent confusion will be resolved, however, as we consider the multiple layers of meanings and functions encoded into their pictorial styles, formats, subject matter, and organization.

Without exception, all images in the volume share a couple of pictorial features. First, all are rendered in the "ink outline" (*baimiao*) technique. This style was first attributed to the Tang dynasty artist Wu Daozi, whose brushwork is

introduced and promoted as a canonical model in the textual portion of the manual. Next, the figures are consistently rendered against a blank background. Only the captions next to the figures break up the vacant space; thus, the reader's gaze is driven directly to and focused on the figures and their actions on each page.[19] These overall format decisions effectively domesticate the images of all the different subjects in the volume and make them a coherent, stylistically homogeneous group. Therefore, the images are organized not according to a narrative paradigm but by a kind of archival one that constrains interpretation of their rhetorical functions. As Allan Sekula has argued in his study of nineteenth-century European and American photography, even circumstantial and idiosyncratic images could be transformed into the typical and emblematic if their representative mode is manipulated or they are put into a coherent filing system.[20] Regardless of the differences in subject matter and the absence of logical links among the individual images, this formatting, universally applied, designates the images as falling within an authorized repository of icons.

The dominant presentational scheme of line-drawn figures on a blank surface is also common to various genres of Chinese visual art. As early as the Han dynasty, funerary engravings used this visual format for representing and highlighting Confucian exemplars. Later, it achieved its classic form at the Tang court, where it was used to present iconic or historical figures, as in the paintings by Yan Liben (d. 673) and Chen Hong (act. 8th century).[21] In Yan's painting (see plate 5), the old tradition of didactic art, with historical figures serving as moral and political exemplars, represents the last ruler of Chen (r. 583–589) and Emperor Wu of the Northern Zhou (r. 561–578). Ruling in the south and the north around the same time, these two men represented two kinds of failure a ruler must overcome. The Chen emperor, refined but undetermined, gave in to sensual pleasures and witnessed the fall of his dynasty; the Zhou emperor, cruel and violent, persecuted Buddhists and lost his mandate. Thus, the two portraits clearly convey a political message.[22] The painting as a whole, a series of such figures, is a history of the rise and fall of previous dynasties, providing the Tang emperor with a mirror in which to consider his own moral and political conduct. Its hand-scroll format was often used to depict narrative sequences. However, the images in this painting appear to be placed in rather vague pictorial schema; each one is depicted against a blank ground and has few sequential or semantic relationships with adjacent images. Thus, the rhetorical function of the scenes unfolds largely one by one, which mostly highlights a single image at a time. This pictorial strategy emphasizes the didactic and pedagogical aspect of a work and was deployed in many images that link moral and intellectual accomplishments

3.2 Portrait of Yan Hui from *Eulogies and Portraits of Confucius and Seventy-two Disciples*. Rubbing of incised stone tablet in Kongmiao, Hangzhou. After Huang Yongquan, Li Gonglin, plate 3.

to the men depicted within the frame. The portraits of Confucius and the seventy-two Disciples erected at the imperial university of the Southern Song period are a notable example. The venerable Confucian icons both affirm the tangible existence of the ancient paragons and project the values they represent in visible form, as in the portrait of Yan Hui in this set of the illustrations (fig. 3.2). These figures were meant to function as role models for all later students, as pictorial reminders of proper behavior and attitudes.[23]

This format was often used in wood-block-printed guidebooks on musical instruments, martial arts, and antiques, such as *Exploitation of the Works of Nature* (Tiangong kaiwu), *Illustrated Collection of Antiquities* (Bogu tulu) (fig. 3.3), and the various materia medica works. In these publications, images rendered as specimens in ink lines on a blank ground were visual aids or models for close study; they presented a purportedly clear and true rendering of each topic, whether antiques, practical science, pharmaceuticals, or the individual moves of martial arts. Many illustrations of romantic imagination and sexual desire also rely on this format; dozens of late Ming popular novels and dramas feature portraits of beautiful women at the beginning of a volume as emblems of passionate love or objects for sensual appreciation. One striking example, found in various editions of *Story of the Western Chamber*, is the portrait of Oriole (Yingying), the heroine of this popular romance (fig. 3.4). While presenting her body and pose as a sign of pure love and passion, the image further excites the sensual interest of

3.3 A page from *Illustrated Collection of Antiquities of the Xuanhe Era*, Revised and Expanded by Boruzhai,1588, 2:2a. 25 x 15.5 cm. East Asian Library and the Gest Collection, Princeton University.

readers, who would be attracted to her even before her story is narrated. Therefore, *Heavenly Forms and Exemplary Manners* seems to deploy a pictorial formula and format long familiar and in common use among the various new kinds of publications in Ming China.

Finally, we might also consider the manual's physical format, the printed book itself. Printed texts and pictures in general are vested with a certain authority owing to contents that can be reproduced exactly. The multiplicity of print media, however, could also generate a sense of triteness, insubstantiality, and a consequent ephemeral quality, all of which relegate them to low status relative to other categories of visual art. They nevertheless often compensated for this lack of status by their sheer number, which gained a certain institutional weight of its own by implying the public's seal of approval, extending as far and wide as copies were disseminated.[24] Obviously, printed books were the objects and means of bibliographical rationalization and cultural institutionalization; they retained a higher level of prestige and accessibility as vehicles of wider public discourse. Thus, *Heavenly Forms and Exemplary Manners* is an archive of figural images organized under an institutional category designed for the goal of preserving and conserving them.

Except for the four images of women at the end of the volume, the remaining thirty-two images of male literati share a vague semantic relevance to one another, with only rough planning or links among them. Based on their subject matter and origins, the illustrations can be categorized into four types: scholars

in nature, literati leisure and cultural activity, libertines and drinking, and love and women. This rather loose classification is called for since it is difficult to identify specific subjects strictly with one category. Still, even this rough categorical system will help clarify the overall organization of the volume and help tease out the concealed narratives of the images.

Scholars in Nature

Images titled "Sitting by running water" (*linliu*), "Washing one's feet" (*zhuozu*), "Listening to the waterfall (or stream)" (*tingquan*), "Gazing at water" (*guanshui*), "Gazing at the waterfall" (*guanquan*), "Strolling around" (*changyang*), "Taking a walk" (*sanbu*), "Quiet resting" (*jingqi*), "Enjoying the moon" (*wangyue*), "Leaning on a tree" (*yishu*), "Leaning on a rock," (*pingshi*), and "Picking *lingzhi*" (*caizhi*) represent scholars' pastimes or their retirement in nature. Many of these are almost pictorial clichés that appear in numerous Chinese paintings; thus, their meanings must have been well understood by contemporary viewers.[25] Beyond the pictorial tradition, however, the theme of a carefree lifestyle "in retirement" would have resonated in the late Ming, when a large number of educated men sought ways of justifying their (in)voluntary leisure. Formal employment had become extremely hard to secure due to unprecedented competition for official positions.

Some of these images, then, make unambiguous reference to the lifestyle imposed on those unsuccessful candidates. "Quiet resting" and "Picking *lingzhi*" (fig. 3.5) depict themes symbolizing the untrammeled life in nature.[26] The latter in particular has a specific origin in history. Four scholars, Lord Dongyuan (Dongyuan gong), Master Jiaoli (Jiaoli xiansheng), Lord Xiahuang (Xiahuang gong), and Qi Liji went deep into the mountains to escape the unjust and harsh governance of the Qin dynasty. The legend records that they survived on the *lingzhi* mushroom alone. The following Han dynasty poem memorializes their story:

> In desolate high mountains and winding deep gorges,
> Violet *lingzhi* mushrooms can relieve my hunger.
> The peaceful age of Yao and Shun is long gone—where can I find a home?
> Sitting in a carriage of four with high parasol, worries are still great.
> As for the fear that the prominent and noble inspire,
> Better the freedom of the poor and humble.[27]

This topic announces the unswerving integrity of upright scholars and their insouciant lifestyle. These four scholar-officials were portrayed as unhesitating in

3.4 Portrait of Oriole (Yingying), in *Northern Romance of the Western Chamber*, 1610. National Library of China, Beijing.

giving up their privilege and wealth, which they could retain only by submitting to the constant anxiety of service under a cruel ruler. In the later literary tradition, the theme of living on *lingzhi* mushrooms in the mountains became a key metaphor for the choice to withdraw from corrupt political life, social privileges, and power.

A similar meaning is also projected in "Washing one's feet," which depicts a scholar cleaning his feet in a stream, and "Sitting by water" (fig. 3.6). The act of cleansing the feet represents the purity and integrity the scholar seeks and is to be distinguished from the actions of people occupied with worldly affairs.[28] This subject matter appears in a number of paintings throughout Chinese history. Shen Zhou's landscape (see plate 6) at the Capital Museum, Beijing, is an example. In this scene, a man sits by the side of a stream dangling his feet in the water. The larger scale of the mountains and trees towering over him dramatizes the presence of the figure in nature and also spotlights the act of washing the feet. The clarity of the water appears to be reflected in the rock's crystal azure color, which further reverberates with the mind of the gentleman. The moment, the action, and his mind are quietly described in the colophon at the upper left corner.

River water being clean and rippled, runs through eternity.
I have nothing in my possession; contemplating, I sit on the islet.

3.5 "Picking lingzhi," from *Heavenly Forms and Exemplary Manners*, 14a. 19.9 x 13.9 cm. Library of Congress, Washington, D.C.

3.6 "Sitting by water," from *Heavenly Forms and Exemplary Manners*, 7b.

Both feet break the vast world [reflected on the water's surface]; a stone can be
 as valuable as the entire world.
Life is about satisfaction, and I seek nothing else.

The poem voices the communication between nature and the man. Water as a motif suggests the unsullied quality of the depicted body and vision and offers escape from the moral and visual chaos of both urban life and official duties.

Such images are also catalogued in other illustrations in the volume such as "Listening to the waterfall (or stream)," "Gazing at water," and "Gazing at the waterfall." In these images, water is the medium for dusting off worldly desires. "Gazing at the waterfall" (fig. 3.7) shows two scholars sitting on rocks, looking into the air. The waterfall is not shown but is inserted by means of the scholars' fixed gaze. Their firmly closed lips and relaxed yet poised postures suggest enchanted admiration and a silent moment shared between men and nature and between friends. This subject of looking at water has a long pedigree in East Asian art and literature. One of the earliest images of this subject is found on the

3.7 "Gazing at the waterfall," from Heavenly Forms and Exemplary Manners, 17b.

decorated plectrum of a guitar now housed in the Shōsōin, Japan (figs. 3.8a, 3.8b). In this image, two scholars sit on a spit of land; behind them, a pool extends back to a waterfall that drops between overhanging cliffs. The figure on the left, sitting in front of an inkstone, turns his head to look at the waterfall. The brush and the book he is holding in the air vividly deliver his state of mind as an unplanned glance at the waterfall leaves him entirely captivated. Both figures appear speechless and engrossed in the spectacle. Enchanted, they can't look away.[29]

While many of the images in *Heavenly Forms and Exemplary Manners* are stock figural motifs for landscape paintings, another, in addition to "Picking *lingzhi*," appears to have been drawn from a historical figure and his recorded manner. "Strolling around" (fig. 3.9) and "Taking a walk" present their figures on a ramble, another generic free-time activity of the scholar-recluse. However, the pictorialization of the figure in "Strolling around" is especially noteworthy. Here, the figure's sheer cap, mobile stance, trailing robes and sashes, and distant gaze match the iconographic features of Tao Yuanming (365–427), the exemplary scholar-recluse who voluntarily retired from his official position in order to escape the artifice of politics and pursue a poor, yet carefree life in his hometown. Tao was also a heavy drinker and claimed that he sought literary inspiration from inebriation; to him, drinking was another way of attaining and displaying freedom and spontaneity. As Martin Powers has aptly concluded, Tao's cultural

3.8a A guitar, Shōsōin, Nara, Japan, 8th century.

3.8b "Men sitting and looking at a waterfall," on plectrum guard of a guitar. Drawing reproduced from the exhibition catalogue for *50th Exhibition of Shōsōin Treasures* (Nara National Museum, 1998), 75.

authority stemmed from his "naturalness" (*ziran*), which derived from his actions and lifestyle and became synonymous with individual freedom; wealth and officialdom, in contrast, were treated as artifice.[30]

As early as the Northern Song dynasty (960–1127), a craze for this maverick poet, who was celebrated as a literary genius and a man of spontaneity, spread among the literati public,[31] and Tao's image had been produced repeatedly through the ages.[32] One example, the painting *Tao Yuanming Returning to Seclusion* (fig. 3.10) at the National Palace Museum in Taipei, a work attributed to the Song dynasty master Li Gonglin, precisely transcribes these pictorial

3.9 "Strolling around," from *Heavenly Forms and Exemplary Manners*, 10b.

characteristics. In one scene in this long hand-scroll painting, which shows Tao standing on a rocky hill and leaning against a pine tree, every detail of his figure—his scholar's cap, flying robes, walking stance, beard, and distant gaze—unmistakably matches those in *Heavenly Forms and Exemplary Manners*.[33] Thus, even though the manual's caption identifies only the action taken by the figure depicted, it would not have been at all challenging for Zhou's contemporaries to guess that figure's identity. Furthermore, during the late Ming, the so-called cult of Tao grew quite popular among the wider public. Zhou Lüjing himself was a fan and claimed that he was a successor to Tao Yuanming. He even composed dozens of poems as responses to Tao's originals.[34] Apparently, the personality cult of Tao Yuanming and his visual representations had spread beyond tolerable limits for certain critics. A late Ming art collector and connoisseur, Zhang Chou (1577–1643), recorded that Li Gonglin's painting *Tao Yuanming Returning Home* had been copied no less than a thousand times, which he, Zhang, found unbearable and even nauseating.[35]

As Tao's legend grew, the very glamour of the literati elite began to be incorporated into other contemporary public illustrations of unrelated subjects. One example, the late Ming medical reference book *Subtle Discourse on Nurturing Life* (Shanbu yisheng weilun) by Li Zhongzi (1588–1655), now housed at the East Asian Library and the Gest Collection at Princeton University, shows a bearded figure with exposed upper body, scholar's cap, outstretched arm, ambling posture, and

3.10 Li Gonglin (ca. 1041–1106), detail of *Tao Yuanming Returning to Seclusion*. Hand scroll, ink on paper, 33.7 x 908.2 cm. National Palace Museum, Taipei.

flying robes (fig. 3.11), an unmistakable reference to Tao Yuanming's pictorial traits in Li Gonglin's painting and Zhou's *Heavenly Forms and Exemplary Manners*. But the original identity of the figure thus portrayed is not addressed, and the image functions only as part of an anonymous medical illustration. As Roland Barthes has noted, representations of fashion not only copy reality but also circulate fashion as a meaningful currency of power.[36] In this regard, the reproduced image of Tao Yuanming's body and garb provides important evidence of the fluid communication between media that allowed this icon to be transformed into a motif in a painting manual and even recycled in other genres of illustration.

The Culture and Leisure of the Late Ming Literati

Some figures in *Heavenly Forms and Exemplary Manners* present other cultural and leisure activities of the literati. These include "Playing the zither" (*gutong*), "Carrying a zither" (*xieqin*), "Holding a duster" (*fuzhu*), "Waving a fan" (*huishan*), "Presenting socks" (*rangli*), "Conversing about metaphysics" (*tanxuan*), "Reading books" (*guanshu*), "Writing on a rock" (*tibi*), "Searching for a phrase" (*suoju*),

3.11 An illustration from *Subtle Discourse on Nurturing Life*, 2: 22a. East Asian Library and the Gest Collection, Princeton University.

"Calling a boy-attendant" (*hutong*), "Meditative pose" (*fuzuo*), "Turning around" (*huishou*), and "Talking face-to-face" (*wuyu*). Many of the images in this category come from specific historical and literary sources, which facilitates the study of their cultural message and rhetorical effects in the late Ming context. For example, "Holding a duster," "Waving a fan," "Conversing about metaphysics," and "Presenting socks" illustrate themes that originated in Wei-Jin aristocratic culture.

"Holding a duster" (fig. 3.12) shows a scholar holding a yak-hair duster. The scholar's duster, as the modern historian Yu Jiaxi has suggested, was a Wei-Jin invention; no record of it predates the period of the Three Kingdoms (220–265).[37] Wei-Jin intellectuals would hold a duster as they conversed about "metaphysics" (*tanxuan*), and many of the celebrated scholars of the time were described as casually carrying one around. A quote from *A New Account of Tales of the World* (Shishuo xinyu), a collection of witty remarks, characterizations, and anecdotes about Wei-Jin elites, reads, "Wang Yifu's countenance was neat and fetching, and he was wonderfully good at talking about abstruse subjects. He always clutched a deer-tail duster with a white jade handle, which could [almost] not be distinguished from his hand."[38] This kind of social promotion and valorization essentially identified the object with its holder's display of intellectual capabilities and erudition.

Similarly, the feather fan shown in "Waving a fan" (fig. 3.13) was also known for its use in "pure conversation" (*qingtan*), a form of philosophical discourse popular among Wei-Jin intellectuals.[39] The most recognized example of its use

3.12 "Holding a duster," from *Heavenly Forms and Exemplary Manners*, 19b.

is found in representations of the famous imaginary meeting between the bodhisattva Manjusri (Wenshu) and Vimalakirti (Weimo), a most knowledgeable layman.[40] In this scene, Vimalakirti is always depicted with a fan, while the bodhisattva carries the wand called *ruyi* (see plates 7, 8). In his discussion of the Vimalakirti-Manjusri scene, Édouard Chavannes reads the fan and the wand as symbols of debate. He interprets Manjusri's wand as a "discussion stick" (*tanbing*) signifying the holder's intellectual power and eloquence.[41] Thus, the *ruyi*, feather fan, and deer-tail duster, all emblematic of discussion, fall into the generic category of discussion stick, the sign of status and articulation.[42] Although the *ruyi* is not mentioned in any of the captions in *Heavenly Forms and Exemplary Manners*, three of its illustrations—"Strolling around," "Calling a boy-attendant," and "Conversing about metaphysics" (fig. 3.14)—register scholars holding a *ruyi*, the device symbolizing the heavenly and extraordinary knowledge and insights of the bodhisattva Manjusri.

These elite accessories signifying intellectual capacity appear to have caught the interest of the wider public in subsequent periods, when people actually carried them in daily life. The hair duster in particular became a trendy item among the general public. A Qing scholar, Zhao Yi (1727–1814), once noted,

> People of the Six Dynasties period held a yak-hair duster whenever they were
> involved in pure conversation. In the beginning, it was used only for pure talk,

3.13 "Waving a fan," from *Heavenly Forms and Exemplary Manners*, 9b.

but it soon was used commonly, and finally it came to be regarded as an elegant object of celebrities. Thus, people always held one even though they were not engaged in conversation.[43]

Besides their symbolic meanings, which had been established by virtue of their representation in earlier art, these items became stylish accessories among members of the educated public who sought to display their culture and taste. The Yuan scholar Tao Zongyi had already claimed that a real literatus was supposed to own and display a *ruyi* along with a zither and a flute in his studio.[44]

The late Ming public likewise played with these objects, which had become a must-have item for anyone who wanted to claim elite status. Both the *ruyi* and the duster are discussed in detail in most of the late Ming literati etiquette manuals, such as *Eight Treatises on the Nurturing of Life* (Zunsheng bajian) by Gao Lian, *Desultory Remarks on Furnishing the Abode of the Retired Scholar* (Kaopan yushi) by Tu Long, and *Superfluous Things* (Zhangwu zhi) by Wen Zhenheng (1585–1645), all of which treat both items similarly. The text in *Superfluous Things* discusses their wide acceptance as well as the author's concern regarding their proper use.

People in the past used yak-hair dusters for pure talk. But if someone nowadays uses it when he greets his guests, it makes me feel like throwing up. However, if

3.14 "Conversing about metaphysics," from *Heavenly Forms and Exemplary Manners*, 18a.

it is hung on the studio wall alone and has an old jade grip with white hair and green silk for the duster, it shows elegant taste. If it is made of natural bamboo strips and old wisteria vine, although it has a shiny surface, it is not suitable for use.[45]

Considering the nature of *Superfluous Things*, a textbook promoting elegant living for the middling class, this admonition is suggestive of the cultural protocols surrounding the suitable use of a duster in late Ming China. Obviously, Wen Zhenheng approves of owning a duster of certain styles and materials for display in one's studio but not for use in daily life. Ironically, this warning offers evidence that many people in the late Ming presumably carried a duster at social functions and occasions, which gave rise to Wen's complaint against their trivialization and excessive popularization. It is not surprising, then, that the motif of scholars holding a duster—along with the motifs of a zither, a *ruyi*, and a sword—were almost ubiquitous in late Ming paintings and registered across different graphic media.[46] As these Wei-Jin cultural objects circulated and were consumed, their fashionable currency in daily life was further institutionalized in the visual arts. This suggests that some figures in *Heavenly Forms and Exemplary Manners* were more than simply graphic items in a catalogue of the same; they also mirrored people's habits, thus further complicating the linkages between the manual and society at large.

Emulation of Wei-Jin manners in the late Ming carried over even to a peculiar pattern of dialogue. The illustration "Conversing about metaphysics" shows one literatus seated in a meditation pose.[47] A second man sitting nearby leans toward him in a casual way. It is not known where this composition originated, and if not for the caption, viewers might not find its meaning straightforward. Neither of the figures seems to speak, and we can only speculate that the two men are involved in some sort of communication because the man on the left is looking at the person on the right, who holds a *ruyi*, the discussion stick. The practice "conversing about metaphysics" is also known as "pure conversation" and is a distinct form of conversation in which parties discuss issues while following certain rules and protocols.

Although previous scholarship emphasized the Daoist aspects of this Wei-Jin practice, since words such as "the Way" (*dao*) and "metaphysical subtlety" (*xuanmiao*) frequently appear in its texts, this form of conversation represented not only a general philosophical attitude but also a sort of social activity based on dialectics and rhetoric.[48] In this conversational form, the discussants' intelligence, knowledge, creativity, talent, temper, and intention were supposedly delivered not only in their speech but also through their dress, facial expressions, attitude, voice, and gestures.[49] As Lu Xun once explained, Wei-Jin aristocrats and intellectuals who wanted to exercise social and cultural superiority were expected to have mastered the rhetoric of metaphysics; otherwise, they would not have qualified as "intellectual celebrities" (*mingshi*).[50] "Conversing about metaphysics" was thus a cultured form of leisure and entertainment for Wei-Jin elites, and, more importantly, it was bounded by rules of etiquette critical to literati socialization at that time.[51] Like discussion sticks, this specific form of dialogue also became popular among a wider audience in the late Ming. Qing scholars had this to say about the revival of this manner of conversation at that time:

> Before the end of Zhengde (1506–1521) and Jiajing (1522–1566) periods, [the writings of literati] maintained simplicity without being frivolous, although most of them sought extra meanings from writings of Song and Yuan styles. [However,] after the Longqing (1567–1572) and Wanli (1573–1620) eras, doom was approaching and customs deteriorated day by day. People who practiced Daoism insolently called themselves eminent elders and lectured on Chan Buddhism. The mountain hermits (*shanren*), competitively extolling Chen Jiru, regarded deceitful words as abstruse and sublime. In the name of "pure conversation," they spoke only debauchery. Some studied [writings and philosophy of] the Jin (265–420) and Liu Song (421–479) periods in vain. The others followed

the literary custom of the Southern Qi (479–502) and Liang (502–557) dynasties, making only embellished sentences in gaudy and philistine style. Now that writing became an easy business, people were competitively devoted to composing. More and more hideous writings appeared every day, and outlandish remarks piled up madly. People who sought true excellence and could avoid falling in with the contemptible crowd were not even two or three out of ten.[52]

This comment singles out for criticism imitators of the Wei-Jin conversational fashion and their shallow understanding of the custom. In the eyes of Qing scholars, many late Ming writers adopted the complicated metaphysical dialogue of the Wei-Jin but without mastering the core ideas of the practice, and their speech and writing were perceived to be the superficial renderings of florid sophistry.

One illustration in *Heavenly Forms and Exemplary Manners* seems to reflect a similar superficiality in its emulation of Wei-Jin culture. The theme of "presenting socks" came from a unique custom of the Wei-Jin period, when people presented a respected elder with a pair of socks and shoes on the day of the winter solstice. This practice was meant to express good wishes—specifically, that the old person would escape the clutches of the king of hell and enjoy a long life.[53] No known literary sources suggest that this custom was practiced after the Wei-Jin period, and there is no known painting of this subject from any era of history. Nevertheless, the *Heavenly Forms and Exemplary Manners* illustration shows three standing figures looking at one another rather indeterminately (fig. 3.15). There is no obvious presentation, and none of the figures appears to be the elderly recipient. It is questionable whether the image faithfully illustrates this subject matter or whether the illustrator understood the content of the practice. What remains is a rather generic grouping of three figures with a caption that presumably defines their actions, but no further evidence. The image, like others in the volume, is supposed to refer specifically to the Wei and Jin dynasties.

The mapping of graphic icons in *Heavenly Forms and Exemplary Manners* to actual social practices of its time may apply to many other images in the volume as well. Another good example is a group of images highlighting a particular musical instrument. "Playing the zither" (fig. 3.16) and "Carrying a zither" (fig. 3.17) represent scholars playing or traveling with a zither. A scholar playing the zither was one of most popular motifs in landscape painting. The zither as an object represented the literary mind, musical talent, artistic sensibility, personal freedom, intellectual capability, moral superiority, and therefore elite status. It was established unequivocally as the instrument commanding and conveying the utmost musical and cultural merit. This is related to the long-standing cultural

3.15 *"Presenting socks,"* from *Heavenly Forms and Exemplary Manners*, 22a.

value of the zither as a "civilized and civilizing instrument of special importance" among Chinese elites.[54] It was symbolic of the aesthete and of triumph over the limitations of ordinary men.

As explained elsewhere, late Ming illustrated novels and dramas often represent scholars with a zither boy even though the accompanying text never describes the latter's presence.[55] Thus, the representation of scholars with musical instruments was an established cliché of the time, which further implies that playing the zither was identified with the literati in the popular mind. The zither was an important symbol of elite status, and its representation and display were treated in a number of etiquette manuals. In his *Superfluous Things*, Wen Zhenheng advocated the building of special studios for playing the zither.[56] Setting aside a special space for musical performance encouraged a semipublic experience of music, wherein guests and friends would gather and appreciate the music together while closing the gap between the private action of music making and the shared entertainment of listening.[57] Even if a zither studio was not used for performance, it represented, at minimum, a perhaps ostentatious demonstration of the owner's musical enthusiasms and his dedication to the zither and its music. Wen further noted that a true literatus must have a zither hanging in his studio, whether or not he could play it.[58] This is a striking comment. This book, which supposedly champions legitimate cultural consumption, does not promote the original function of the musical instrument; instead, it states that ownership is enough to prove

3.16 "Playing the zither," from *Heavenly Forms and Exemplary Manners*, 7a.

readers' cultural acumen and social status. In this way, the zither was transformed into a visual trace that reflected its owner's subjectivity and knowledge.

"Reading books" and "Searching for a phrase" both show scholars involved in reading or writing. These activities, of course, function as synecdoche for literati culture in general, and thus these motifs introduce the basics of literati culture to readers of the manual.[59] A similar topic, "Writing on a rock" (fig. 3.18), shows a scholar inscribing a poem on a rock, while a young attendant stands beside him holding the inkstone. The scholar appears to be jotting down the poem on a stone for fear he might lose his momentary inspiration. The origin of this motif has been often attributed to paintings of the Elegant Gathering in the Western Garden (Xiyuan yaji), and a work by Qiu Ying (ca. 1494–1552) (see plate 9) is one example. On this occasion, while other members of the gathering were engaged in various types of cultural leisure, Mi Fu is noted to have written a poem on a rock wall, a unique action occupying real space and time; however, the practice of writing on rock walls definitely predates Mi Fu. "Poetry written on a rock or wall" (*tibishi*) first emerged as a genre during the Wei-Jin period and came fully into vogue during the Tang.[60] Over time, it developed its own programs of production in line with its media, location, and procedures.

Writing in situ expresses a writer's spontaneity; contents are improvised in order to valorize the place while describing the writer's mental and emotional state at the moment of writing.[61] However, as Robert Harrist has identified, such

携
琴

3.17 "Carrying a zither," from *Heavenly Forms and Exemplary Manners,* 14b.

texts were not randomly inscribed graffiti; rather, in most cases they were carefully located in line with geomorphic formations, and their contents responded to other inscriptions at that spot.[62] This suggests the existence of a protocol to be followed when composing a literary work in place. It also required a certain level of knowledge and sensitivity that informed the selection of location and calligraphic style.[63] As Luo Zongtao has emphasized, such spontaneous poetry was often found on the walls of temples, postal stations, guest houses, and public offices rather than private residences.[64] Therefore, poetry inscribed on a wall became a genre of public art by which the writer could demonstrate his talent, cultural awareness, and presence in a certain location.

During the Song period, the popularity of such poetry was not as conspicuous as during the Tang dynasty; however, leading scholars of the time such as Su Shi, Lu You (1125–1210), and Xin Qiji (1140–1207) wrote on rock faces at famous spots and were admired for it.[65] This practice once again caught on among the public in late Ming society. One cultural critic of the period, Yuan Hongdao, reported as follows:

3.18 "Writing on a rock," from *Heavenly Forms and Exemplary Manners*, 15a.

The Tianmen of Qiyun is astonishingly beautiful. The only thing that vexed me was that inscribed stone tablets filled the area below the cliff. The Hui [Anhui] people love to make inscriptions, and this is a bad habit. Local officials helped this practice develop into a vogue. Every piece of white rock is filled with red characters, which made me gasp in fury. I say there are standard legal punishments for those who appropriate the resources of mountains and dig mines illegally, so why is there no law prohibiting vulgar scholars from contaminating the spirit of the mountains? Buddha says that all evil deeds will be recompensed with evil. This [making inscriptions on the mountains] is just as evil as murder and robbery, and yet Buddha did not mention it.[66]

Inscribed poetry, generally written in ink, inevitably was ephemeral due to its outdoor location, weather, and time; poems were permanently preserved only by being engraved (an expensive proposition) and thus becoming firmly attached to a specific location. Yuan Hongdao's criticism of the practice by the general public announces its great popularity.[67] Even nowadays it is not difficult to locate late Ming writings on cliffs at many locations in southeastern China. For example,

the note written and permanently inscribed by a certain Ma Qianyuan, a Buddhist temple manager from Nanjing, was to commemorate his visit to the summit of Mount Tai in 1560 (see plate 10). In this regard, the illustration "Writing on a rock" demonstrates another conjunction between the painting manual and the cultural practice of the time and testifies as well to the rapid popularization of literati arts among a larger public.

Libertines and the Rhetoric of Spontaneity

Heavenly Forms and Exemplary Manners includes five illustrations of drinking scenes and drunken scholars: "Chanting when drunk" (*zuiyin*), "Passing the wineglass" (*chuanbei*), "Drinking up" (*fubai*), "Wasted" (*maotao*), and "Smashed" (*mingding*). These images suggest a range of intriguing questions. First, why did the author count such activities among notable literati endeavors? Next, what are the literary and visual sources of the images? Third, why are they included in a painting manual? Finally, what kinds of cultural value did they transmit to readers? The act of drinking per se is an ordinary scene from daily life, yet being extremely drunk is regarded as social misconduct across different cultures and times. Wine-drinking manuals published in the late Ming also warn against excessive drinking. For example, a colophon to a drinker's manual by Zhong Xing (1574–1624, *jinshi* 1609) notes, "A good drinker behaves just as usual, because his spirit is always at ease. . . . It is misery indeed to succumb to the enfeebling addiction of drink, yet how can anyone know the pleasure of drinking if he sinks into lethargy or yells to himself in a stupor? Only those who are superb in the art of sobriety know how to stay away from the torture of drinking and to indulge in its pleasure."[68] His warning against overdrinking is a sound and sincere message for ordinary members of society, but it might also reflect the situation of the time, when indulgent and extravagant enjoyment of wine and liquor was recognized as a serious social ill. Regardless of the true intention here, drinking, even to extreme inebriation, was, to the late Ming public, a form of meaningful action and was registered as such in contemporary writings and social codes. The inebriated appearance and minds of these figures in the manual show, in fact, another face of the cultural heroes who are also rationalized in the space of painting manuals.

"Passing the wineglass" literally means offering a cup of wine to someone. In *Heavenly Forms and Exemplary Manners*, a man offers a cup on a plate to a second person, who appears to be unaware of it (fig. 3.19). With eyes closed and hands clasping his left knee, he is already too drunk to be keenly aware of his

environment. As shown in this image, people customarily used only one cup at a party and passed it around among the participants. The Tang poet Du Fu noted, "In the past, on the Chongyang Festival [the ninth day of the ninth month], I passed the cup and did not decline it from others."[69] This act of sharing a wine cup was still practiced in late Ming China, and in certain areas of contemporary East Asia as well, as a sign of friendship and trust among friends. For example, in a poem written as a farewell, the Ming painter Wen Zhengming related, "Many friends gathered east of the capital to see me off; I stop my horse to drink the wine passed to me, to [better] withstand the north wind of the winter."[70] In this poem, the physical warmth from the wine is a metaphor for the heartwarming moment shared between Wen and his friends. Thus, offering and accepting a cup of wine was social courtesy and became a kind of rule among literati. Among the six rules of one literati club, Assembly of Delighted Elders (Yilaohui), organized in 1588, the third states that all members should control the pace of their drinking; nevertheless, it is not recommended that they reject wine offered to them by other members.[71]

"Drinking up" (fig. 3.20) might be the scene that follows the act depicted in "Passing the wineglass." It, too, represents two men sitting face-to-face. Here, while one man watches, the other drinks from a large cup. The gesture of the person drinking—his upper body leaning backward as his left hand supports his body—suggests that he is trying to drain the glass. His disheveled clothing

and exposed chest and stomach may imply that it is not the first glass he has drained. The depiction of his boozy state makes an interesting contrast with the somewhat stern and neat pose of the person sitting before him, who seems to be watching over the other man as he drinks. Interestingly, this pictorial expression closely matches the historical anecdote from which the term "drinking up" originated: The Han dynasty scholar Liu Xiang noted that Marquis Wen of Wei County once hosted a large party with much food and wine. Hoping to make sure that everyone enjoyed this gathering to the maximum, he came up with a plan to get everyone drunk. For that, he appointed Gongsheng buren as party overseer and told him to press a large cup of wine as a penalty on anyone who did not drain his cup at each toast. Later, this came to mean excessive drinking.[72] Thus, this image may represent Gongsheng buren watching as the other fellow drains the penalty cup.

The most striking images of drunken scholars in *Heavenly Forms and Exemplary Manners* are "Wasted" (fig. 3.21) and "Smashed" (fig. 3.22), which deliver very explicit images of inebriation. Both show intoxicated scholars. In "Wasted," a man with his upper body exposed and eyes closed waves his arms in the air. He seems to be trying to dance or moving his body in drunken excitement. A boy-attendant, smiling and thus seemingly amused by this scene, is bringing him another cup, which can only worsen his condition. "Smashed" shows a scholar trying to get to his feet with the help of his boy-attendant. His closed eyes and

3.21 "Wasted," from *Heavenly Forms and Exemplary Manners*, 21a.

3.22 "Smashed," from *Heavenly Forms and Exemplary Manners*, 21b.

slack body illustrate his mental and physical stupor after a long, heavy bout of drinking. He has obviously lost consciousness and control. The last image of this kind is "Chanting Drunk" (fig. 3.23), which shows a man with his upper torso exposed, swaying backward while staring aimlessly into the air. The wine cup next to him implies the reason for this condition.[73] The rather humorous features of these images make it tempting to read them as mockery or as an allegory of moral defects as in the works of William Hogarth (1697–1764). In the literary tradition, however, the theme of drinking wine celebrates the man of principle who voluntarily retires from a world of restrictions, renouncing the guaranteed path to a distinguished career.[74]

Throughout Chinese history, excessive drinking had been extolled as an appropriate means to spontaneity for literati. The Tang poet Yuan Zhen (779–831) said, "If half drunk, he can show his natural manner; when completely drunk, he can return to the great harmony!"[75] A contemporary, Yao He (779–846), intoned, "When you have wine, drink until you get completely drunk. When you meet with flowers, enjoy them to the full."[76] These records in the literary tradition suggest that getting drunk was promoted as a way of achieving contentment and personal freedom, thus engaging one's true identity. No surprise, then, that there is

no lack of literary records from the late Ming period extolling the joys of drunkenness. Along with many other late Ming literati, He Liangjun advocated the necessity of drinking.

> Chen Xuan (fl. late 6th century) once said, "Better to go one thousand days without a drink than to drink and not get drunk." This is nonsense! If I don't drink every day, my skin and body feel parched and stuffed. On the contrary, if I get smashed every day, I will be also seriously lethargic and sluggish. So I drink a small amount daily but get completely smashed every five days. [In this way,] I can balance my drinking.[77]

This statement suggests control and moderation but does not discourage occasional and even regular complete intoxication. As Craig Clunas has noted, a large portion of the surviving porcelain from the late Ming was designed for the storage or consumption of alcoholic drinks, which provides physical evidence of the importance of wine drinking in society at large.[78]

Drunken scholars have appeared in various artworks throughout Chinese history. For example, a Song dynasty master artist, Li Gonglin, is noted to have painted *Drunken Scholars of the Jin Dynasty* (Jinxian tu), while paintings with the titles *Drunken Guest* (Zuike tu) and *Drunken Scholars* (Zui xueshi tu) are recorded from as early as the Tang dynasty.[79] A particularly interesting example

is the work by Zhou Wei (act. ca. 1368–1390), *Tao Yuanming Returning Home Drunk* (plate 11). This painting, now housed in the National Palace Museum in Taipei, is very close to the image "Smashed" in *Heavenly Forms and Exemplary Manners*. Along with the blank background, details such as Tao's cap, exposed upper body, and thick beard in ink-outline technique all match with the figure in the painting. Among the dozens of collectors' seals on the painting, four are those of Xiang Yuanbian, a famous collector of the late Ming and patron of Zhou Lüjing.[80] Thus, Zhou might have had opportunities to see this painting and could have used it as a model for his painting manual.[81] And, as noted above, the theme of Tao Yuanming returning home drunk was painted again and again over the centuries. Of particular note in this regard are the values projected by Tao and his time in literati cultural discourse.

Tao Yuanming and the qualities of being natural and independent were taken even further by Tao's contemporaries. The stories of these cultural heroes are recorded in *A New Account of Tales of the World* by Liu Yiqing (403–444), a literary sketch recording the words and deeds of scholar-bureaucrats such as moral conduct, speech, government affairs, literature, light slander, and so on. It is a record of the words and deeds of idle talkers from the Eastern Han (25–220) to the Eastern Jin dynasty (317–420). This book frequently offers lines such as "Wine is just the thing to make every man naturally remote from the world" and "Wine is just the thing to naturally draw a man up and set him in a transcendent place."[82] The men in *A New Account of Tales of the World* drank heavily to exhibit their disdain for the conservative worldview and lifestyle. The link between man's inner potency and the power of wine provided Wei-Jin intellectuals an excuse for indulging themselves. The purpose of this licit pleasure was to forget worldly affairs and indulge in pure exhilaration. Among Wei-Jin elites, even indulgence in drugs was openly admired and practiced, not simply because people of the period were morally weak, but, rather, because taking drugs was regarded as a way of expressing personal freedom and naturalness. This practice became fashionable among wealthy intellectuals who could afford the high cost of drugs at that time.[83] The sensibilities and behavior of these eccentrics and libertines appealed greatly to the late Ming public.

The late Ming can be considered the peak of popularity for Wei-Jin culture delivered via *A New Account of Tales of the World*. By one count, of twenty-six different titles that imitate the style and content of *A New Account of Tales of the World* in subsequent Chinese history, two-thirds were published in the Jiangnan area during the late Ming period.[84] As Cao Zhengyong noted in his preface to *Pure Words* (Qingyan) by Zheng Zhongkui (fl. 1615–1634) published in 1617, in

the Jiajing (1522–1566) and Longqing (1567–1572) reigns, only a few scholars were aware of *A New Account of Tales of the World*; however, after the publication of Wang Shizhen's *Supplement to A New Account of Tales of the World* (Shishuo xinyu bu) in 1585, it suddenly caught fire.[85] Prefaces and postscripts to various imitations of this book claim that these works belong to a great tradition of historical documentation, valorizing the odd behavior of past and contemporary figures as outstandingly original and therefore a model of social and cultural excellence.[86]

It has been suggested that late Ming scholars were motivated to write imitations of *A New Account of Tales of the World* because they desired to prove their erudition and literary proficiency after having failed the civil service examinations,[87] yet we still need to ask why these scholars chose this specific work from among all the choices available to them. Part of the reason lies in its unconventional literary style, which not only provided Ming literati with a vehicle for attacking the narrowness of scholarship demanded in preparation for the government exams but also gave them an opportunity to collect, classify, and portray the diverse and colorful personalities of Wei-Jin intellectuals and their bizarre behavior. This introduced a new ideal type after which Ming intellectuals shaped their own identities. In this way, the Wei-Jin literary, intellectual, and behavioral tradition became a sanctuary within which new, wild values could be freely discussed and openly celebrated.[88]

A modern scholar, Yoshikawa Kōjirō, points out that late Ming literati differentiated themselves from the general public by their bizarre and extraordinary behavior.[89] Similar to the early modern English dandy, yet unlike the ideal gentleman, late Ming intellectuals distinguished themselves through a particular system of fashionable display. They practiced insolence and incivility and cultivated attitudes of self-centered individualism. What they sought was status and class privilege without obligations.[90] Thus, following this line of explanation, indulgence in the extremes of carnal pleasure could be reproduced as the mark of a true literatus. In Ming society, the pleasures of drinking, luxury, and sex were openly favored, and members of the literati vaunted eccentric displays of personality and originality.[91] "Leisure spent in sensual pleasure" (*fengliu*) became a watchword of the lifestyles of this type of elite. Scholars such as Li Rihua, Tu Long (1543–1605), Yuan Hongdao, and Li Kaixian (1502–1568) openly discussed their excessive drinking, sexual desire, promiscuous lifestyle, potency, and even venereal infections. As Martin Huang cautiously suggests, suffering from venereal disease was not necessarily regarded as a humiliation or dishonor among the overly "romantic" literati of the time.[92] He further explains, "The late Ming

revalorization of desire was much more than an attempt to assert the priority of desire during an age known for its cultural pluralism. It is probably true that never before in Chinese history were people so openly fascinated with desire and so eager to experience it in different forms and so anxious to discuss these experiences."[93] But others, such as Xie Zhaozhe, criticized this trend and argued that there should be limits to what can be considered a good life spent in leisure.[94] Many late Ming scholars, however, chose to pursue individuality, freedom, and anti-conservatism, the same values they supposed had been championed by Wei-Jin elites.

Taking all these factors into consideration, it is not surprising that drinking had become an important part of social life in late Ming China. Drinking societies were organized, and special playing cards for drinking games came into vogue.[95] Many books published in the late Ming introduced the basics and protocols of drinking, such as the history of wine, occasions for drinking, drinking companions, various kinds of wine cups, different varieties of wine, and wine appreciation. These publications include *Guide to Drinking* (Jiupu) by Xu Ju, *History of Wine* (Jiushi) by Feng Shihua, *Rules of Decorum in Drinking* (Shangzheng) by Yuan Hongdao, and *Drinkers' Digest* (Jiugai) by Shen Shen. In his preface to *Rules of Decorum in Drinking*, a small pamphlet written in 1607, Yuan Hongdao claims that he wrote it for the benefit of those lousy drinkers in his literati association, the Grape Society (Putaoshe). It is a collection of anecdotes about the quality of wines, the history of goblets, and suggestions on how to enjoy drinking on different occasions; thus, readers could learn about interesting topics on which to converse while drinking.[96] Additionally, representations of drinking scholars appeared in other genres of the visual arts: porcelains, woodcarvings, and even book illustrations. People were not only generous about drinking; overindulgence in drink could earn one the honor of being a known libertine, a new ideal elite of the period.

Nevertheless, the promotion of spontaneity in painting manuals points to an irresolvable irony. In her study of late Ming imitations of *A New Account of Tales of the World*, Li Wai-yee has noted that this genre contains the paradoxical idea of a "rhetoric of spontaneity." Its contents point to the direct continuity between self and expression by describing bizarre yet original attributes; however, the stylistic and narrative patterns that appear repeatedly in these stories suggest that these attributes also became matters of convention, artifice, and control.[97] Similarly, in *Heavenly Forms and Exemplary Manners*, images referring to spontaneity are presented in a set format, copy formulaic motifs, and are also collected as a set group. Ironically, this very effort fed on the dream of being natural and the disapproval

of predefined norms, both ideals favored by the late Ming public. In this sense, *Heavenly Forms and Exemplary Manners* is deeply ironic, since it reconstitutes a social ideal as a product in line with the very strategy it claims to disparage.

How to Paint or How to Behave: Literati Gatherings and Painting Manuals

Zhou Lüjing is noted to have produced many stone-block-printed pictures such as *Orchid Pavilion Gathering, Eighteen Arhats, Eighteen Sages of the Lotus Society, Portraits of Jin Dynasty Intellectuals,* and many others depicting historical figures in ink-line technique.[98] Unfortunately, none of these images survive; however, there are reasons to believe that some of the figural images in *Heavenly Forms and Exemplary Manners* could be the same ones originally prepared for the representation of these historical figures. One bit of support for this assertion is the fact that images in the bird-and-flower painting sections of *Forest of Paintings* appear in both its stone and wood-block editions. Furthermore, textual descriptions of possible source images, such as *Eighteen Sages of the Lotus Society* (Lianshe shibaxian tu), show considerable similarity to the images preserved in *Heavenly Forms and Exemplary Manners. Miscellaneous Jottings of the Old Man from Jie'an* (Jie'an laoren manbi) by Li Xu (1505–1593) includes an extensive description of Li Gonglin's painting of this subject.[99] Noteworthy in this work is the textual record of the activities of the people depicted in the painting. Many of the cartouches used in *Heavenly Forms and Exemplary Manners* also appear in this text, including "carrying a fan," "holding a duster," "leaning on a rock," "carrying a *ruyi*," "sitting on the shore," "gazing at the waterfall," and "washing the feet." So some of the images in the manual must have been made with historical figures, their actions, and the values they represented in mind. Many of these motifs were direct or modified reproductions of paintings of literati gatherings.

As discussed above, many of the images in *Heavenly Forms and Exemplary Manners* were based on the gestures, activities, and fashions of Wei-Jin intellectuals. The exemplar of the men of the time, known as the Seven Sages of the Bamboo Grove (Zhulin qixian), wished to escape the disorder, corruption, and stifling atmosphere of court life during the politically fraught third century. They gathered in a bamboo grove near the house of Xi Kang (223–262) in Shanyang (in Henan), where they enjoyed, as praised in their works, a simple rustic fellowship. This contrasted pointedly with the politics at court. The Seven Sages stressed the enjoyment of ale, personal freedom, spontaneity, and celebration of nature. In one of the earliest representations of them, found in a Wei-Jin tomb

excavated in the Nanjing area, each figure is located next to a tree and is accompanied by personal accoutrements: wine bowls, musical instruments, *ruyi*, and fur mats (fig. 3.24).[100] The sages are shown playing the zither, lolling about, whistling, drinking, and even sitting in a drugged stupor. Part raunchy immoral slackers, carousing and defying all propriety, part serious and contemplative men who defied the conventions of Confucian morality, these figures were the epitome of rebellious Wei-Jin intellectuals.[101] Detrich Seckel has defined the Seven Sages in the Nanjing mural as the earliest extant "character portrait" of a social ideal—the defiant yet cultivated gentleman of the Wei-Jin period.[102] It is unlikely that Zhou Lüjing was consciously following the style of this specific mural, yet his fascination with their time is incontestable. His nephew, Li Rihua, stated that Zhou had portraits of Wei-Jin intellectuals on his studio wall.[103] The Seven Sages of the Bamboo Grove were likewise one of the most popular themes among late Ming professional artists.[104] Thus, Zhou's portrayal of these third-century celebrities in his art manual clearly is meant to panegyrize their lifestyles, period, and culture.

Adulation for Wei-Jin intellectual culture was further developed by another celebrated group of scholars of the fourth century. Many images in *Heavenly Forms and Exemplary Manners* directly copy a representation of the Orchid Pavilion Gathering (Lanting yaji), a famed outing attended by forty-one literati that occurred in Wang Xizhi's garden in 353. This literary convocation was held in celebration of the annual Spring Purification Festival. There, the scholars bathed, sang, drank wine, and relaxed along a meandering stream. As a sort of competition and entertainment, wine cups were floated down the stream and guests were asked to compose a poem before a cup passed their seats. If they failed to do so, they had to drain the cup. Twenty-six guests composed at least one poem, and their poetry was gathered in a volume to which Wang Xizhi wrote an introduction in 324 characters. In the course of the party, as a result of this drinking game, several participants became intoxicated. Marked by the preponderance of artistic talent among the guests, the originality of their poetry, and the spontaneity of their drunken minds, this gathering and its participants became a celebrated cultural icon in elite circles. Soon, Wang Xizhi's calligraphy in this preface was canonized as the standard, and the party has been venerated over the centuries in literature, painting, and the decorative arts. By the end of the Song period, editions of Wang's preface already numbered more than one hundred, which explains the influence of the Orchid Pavilion Gathering in early modern China.[105]

The Song dynasty painter Li Gonglin is recorded as having been the first to paint this topic, and his work was soon inscribed in stone by a Southern Song

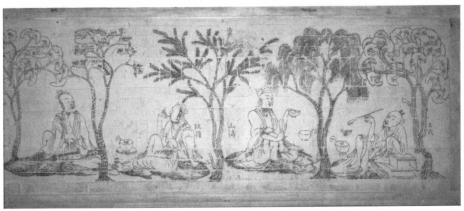

3.24 Rubbing of "The Seven Sages of the Bamboo Grove and Rong Qiqi," Eastern Jin dynasty (317–420). Molded-brick relief from a tomb in Nanjing, Jiangsu, 80 x 240 cm. Photo: James Cahill.

poet, Zeng Hongfu, in 1241.[106] A record from the Yuan dynasty notes that an amateur art lover produced another stone-block edition.[107] As discussed in chapter 1, the practice of engraving calligraphy and painting on stone blocks began in the Song, with the production of the ten-volume *Model Calligraphy from the Imperial Archives of the Chunhua Era* sponsored by the Song emperor Taizong. This project was an imperial attempt to preserve "model calligraphy" (*fatie*). The writings and paintings so incised were considered to have the highest artistic value, high enough to warrant their preservation in the eternal solidity of stone. Thus, the existence of stone-block editions of Li Gonglin's *Orchid Pavilion Gathering* suggests the painting's cultural aura and value among the literati. Although Li Gonglin's original is not extant, three copies of stone-block editions survive from the Ming period.

3.25 "Dancing sleeves," from *Heavenly Forms and Exemplary Manners*, 9b.

Among these copies, two were sponsored by a Ming prince, Zhu Youdun (1379–1439), grandson of the first Ming emperor, Taizu (1328–1398). One copy is now housed at the Anhui Provincial Museum. Another, smaller than the first, is kept at the National Library of China. A third copy, sponsored by Prince Yi, Wanghuang daoren, in 1592 is now part of the Muban Foundation collection in London.[108] These copies all differ in size and minor details but show almost the same layout in the expression of the figures and background. Zhou Lüjing also produced his own edition of this stone-block print. It is not known whether Zhou followed Li Gonglin's composition as the others did,[109] but the significant degree of resemblance between some images in *Heavenly Forms and Exemplary Manners* and late Ming rubbings of the *Orchid Pavilion Gathering* is suggestive.

At least five images in Zhou's manual were obviously copied from the rubbing of Li Gonglin's *Orchid Pavilion Gathering*. The images "Passing the wineglass" (see fig. 3.19), "Wasted" (see fig. 3.21), "Smashed" (see fig. 3.22), "Chanting drunk" (see fig. 3.23), and "Dancing sleeves" (*wuxiu*) (fig. 3.25) are unquestionably direct reproductions of the portraits of Qiu Mao (fig. 3.26a), Xie Teng (fig. 3.26b), Kong Sheng (fig. 3.26c), Yang Mo (fig. 3.26d), and Yu Yun (fig. 3.26e) in the rubbing. The visual similarity is beyond question, and it seems obvious that Zhou consulted the rubbing, the only difference being that in his manual, the names of the participants at the Orchid Pavilion Gathering have been replaced with captions defining their activities.[110] The identities of the original figures are completely

a. Qiu Mao b. Xie Teng

c. Kong Sheng d. Yang Mo e. Yu Yun

3.26 Illustration of the Orchid Pavilion Gathering, Prince Yi (Yiwang) edition, 1592. Hand scroll, rubbing of incised stone plate on paper, height 32.7 cm. Courtesy of Muban Foundation, London.

effaced. The purpose here does not seem to be commemoration of individual participants. Zhou simply adapted these iconic figures to serve as models in his manual. However, in Zhou's days, the Orchid Pavilion Gathering and the actions of its participants elicited meanings beyond their pictorial representations.

Parties that emulated the Orchid Pavilion Gathering were apparently in vogue during the Ming dynasty. A Ming official, Du Mu (1458–1525), left records from 1507 noting that the local commoners of Nanjing enjoyed playing drinking games with floating cups on a water channel.[111] In addition, a literati gathering, Society of a Small Blissful Land (Xiao Yingzhou she), established by Zhu Po in 1542, gathered at Leisurely Spring (Yuchun), a private garden owned by a member, Xu Xian. There, the group enjoyed drinking and writing poetry, complete with floating wine cups; the event was depicted by a local artist, Chen Xun.[112]

3.27 Oyster Stone Pavilion, Shilla Dynasty (57 BCE– 935 CE), Kyŏngju, Korea. Photo by author.

Furthermore, women also practiced this fashion. In his description of West Lake in Beijing, Yuan Zhongdao wrote, "Every year, at the peak of summer, blooming hibiscus rims the lake like silk brocade. In the fragrant breeze, women sit by the water floating wine cups. What an amazing scene!"[113] These stories inform us how widely the practice was enjoyed in Ming society.

Some wealthy people of the time even went to the trouble of installing artificial water channels solely to reenact the Orchid Pavilion Gathering. This vogue even extended beyond Chinese culture. An early example of a cup-floating setting is found in Oyster Stone Pavilion (Posŏkjŏng) (fig. 3.27), a site built in the later years of the Shilla dynasty (57 B.C.E.–935 C.E.) in Korea. Here, the water channel is made up of elaborately carved stones in general imitation of the natural stream in Wang Xizhi's garden. Such artificial channels soon became a fixed element of garden design. A technical architecture manual of the Song dynasty, *Treatise on Architectural Methods* (Yingzao fashi), gives instructions for installing such a channel, defining the size, shape, depth, and width in detail.[114] The

3.28 Drinking party scene, detail from *Garden of the Hall of Encircled Jade*, ca. 1610. 24.3 x 1470 cm. After a 1990 reproduction by Beijing Renmin meishu chubanshe.

Song poet Huang Tingjian is known to have built such a water feature at his mountain estate in Yibin, Sichuan. The private country estate of late Ming professional publisher Wang Tingna (ca. 1569–1628), the Hall of Encircled Jade (Huancuitang), was completed around 1600 in Xiuning, Anhui. An illustration of the garden shows a group of scholars sitting around a table in which a water channel has been installed (fig. 3.28).[115] This craze for social functions based on the Orchid Pavilion Gathering naturally drew the ire of intellectuals of the time, such as Yuan Hongdao.

> The Orchid Pavilion Gathering in the past occurred by a brook in the mountains, and wine cups were floated along its winding streams of clear water. Nowadays, people choose plain ground and install a small artificial channel. Such poseurs don't understand things; this is as bad as it gets![116]

This comment suggests that in Ming times the Orchid Pavilion Gathering had once again been revived and transformed into a program of popular leisure. In

3.29 Illustration of the Orchid Pavilion Gathering from *Master Cheng's Ink-Stick Collection*, 1606, 5:1b–2a. Approximately 24.7 x 15 cm. University of California, Berkeley, Library.

this regard, it is not surprising to find that its visual representations also saturated Ming society.

The dozens of paintings of the Orchid Pavilion Gathering produced in the late Ming include works by Wen Zhengming, Qian Gu, Ding Yunpeng, Qiu Ying, and Sheng Maoye (ca. 1594–ca. 1640).[117] This image is also found in *Master Cheng's Ink-Stick Collection*, a late Ming commercial ink-stick catalogue, which suggests its broad incorporation into the realm of objects of daily use (fig. 3.29). A late Ming wine bowl makes a similar indication: it shows two seated men facing each other as a boy-attendant places wine cups on a stream of water (see plate 12). The clumsy drawing and coloring of the bowl show it to be a low-end product, made for general consumers of the time.

As the Orchid Pavilion Gathering—or at least the party scenes with floating cups—had become a popular cultural icon, its pictorial motifs were also transferred to or superimposed onto other story lines. For example, in "The Seven Sages of the Bamboo Grove" in *Master Cheng's Ink-Stick Collection* (fig. 3.30), the

3.30 "The Seven Sages of the Bamboo Grove," in *Master Cheng's Ink-Stick Collection*, 6:12b.

sages are shown playing chess and playing and listening to the zither as depicted elsewhere, but, strikingly, there are also floating wine cups nearby, the quintessential characteristic of the Orchid Pavilion Gathering. This image testifies to the dominance of the Orchid Pavilion Gathering and its physical traces in late Ming society and visual culture. Such images may represent the Ming era "Cult of the Orchid Pavilion," a term coined by Richard Strassberg.[118] The recycled images of the Orchid Pavilion Gathering in *Heavenly Forms and Exemplary Manners*, in this sense, not only glorify this historical event and its participants but also draw traces of popularized literati culture across media.

One last issue concludes this discussion of literati images in *Heavenly Forms and Exemplary Manners*. That is, what do we know about the authenticity of both the Seven Sages and the Orchid Pavilion Gathering? Did they actually exist? Even though the answer is probably "no," should it make any difference regarding our or the late Ming public's reception of their portrayals? Another historical gathering offers some clues to the answer.

One day in the year 1087, sixteen prominent scholars assembled at the Western Garden of Wang Shen (ca. 1036–after 1104), the son-in-law of Emperor Yingzong (r. 1064–1067). They amused themselves writing poetry, painting, and playing

music in the outdoor setting. A painter at the scene who was also a member of the group, Li Gonglin, is noted to have made a pictorial record of the event. Later, this gathering of eminent Song literati, the so-called Elegant Gathering in the Western Garden, became established as another hallmark of scholarly culture and lore. In fact, this theme was depicted by dozens of painters of the early modern era, including Liu Songnian (1174–1224), Qiao Zhongchang (act. early 12th century), Cao Xi (act. early 17th century), You Qiu (ca. 1525–1580), and Qiu Ying. A painting by Qiu Ying, now housed at the National Palace Museum in Taipei, is a typical example of this subject. It shows the expected activities: scholars playing the lute, writing calligraphy, and inscribing a poem on a rock surface (see plate 9). Some of these images are reproduced in *Heavenly Forms and Exemplary Manners*, and they illuminate another possible function of the figure painting manual.

In a paper published in 1968, Ellen Laing elaborated her reasons for being skeptical about whether the Elegant Gathering in the Western Garden represents historical fact. She noted that, first, no literary or historical record of this gathering appeared until the fourteenth century. Second, Mi Fu's description of the gathering is not included in any bibliographical record before the late sixteenth century. Third, no art historical record mentions Li Gonglin's treatment of this theme or copies by other painters until the fourteenth century. Fourth, names of the participants differ from text to text. In sum, Laing has proposed that the Elegant Gathering in the Western Garden was no more than an imaginary meeting of cultural paragons of the past.[119] The historical authenticity of the other two gatherings, the Seven Sages of the Bamboo Grove and the Orchid Pavilion Gathering, has also been questioned based on very convincing grounds.[120] It is noteworthy that doubts about the authenticity of the Elegant Gathering in the Western Garden had already been raised by the late Ming intellectuals Wang Shizhen and Sun Gong.[121] However, the historical facticity of the meeting was of no interest to the majority of the late Ming public. The vogue for such gatherings obviously grew because people enjoyed these cultural activities and admired the fashions, attitudes, and lifestyles depicted in literature and paintings.

As I Juo-fen has suggested, investigation into the issue of the gathering's historical truth does nothing to help modern historians understand late Ming society; instead, it would be more fruitful to focus on the gathering's historical significance and cultural meaning in order to reconstruct the social webs of significance built around it.[122] We should remember that this subject combined a bit of history and imagination, and the border between them was not set in stone. The discovery of the past and its invention may become completely indistinguishable.

It is historical reconfiguration that defines the functions and effects of images circulated at a given moment in history. Thus, the Elegant Gathering in the Western Garden (like the Seven Sages of the Bamboo Grove and the Orchid Pavilion Gathering) stands at a juncture of fiction and the historical moment, something between the quasi-historical and the quasi-fictive. It is a reenactment of the past, the ultimate teleos of historical imagination. In this sense, Mi Fu's comment at the end of Li Gonglin's painting of the Elegant Gathering in the Western Garden highlights a less obvious function of the images reproduced in *Heavenly Forms and Exemplary Manners*:

> The pure and splendid pleasures of the human world cannot exceed this [Elegant Gathering in the Western Garden]! Alas! How can those who eagerly seek mundane success but don't understand that [they should] withdraw [from their official positions] easily attain this? Su Shi and the other sixteen [participants of this gathering] expressed themselves in writings. They were all broadly learned and possessed great acumen, excellence in rhetoric, subtlety in composition, love of antiquity, and they enjoyed wide repute. They have the qualities of the hero, the gallant, and the extraordinary [man] as well as the eminence of a high priest and heavenly beings. Superior and sublime as such, their names prevail across the entire world. People of later generations cannot merely look at the painting; they can also emulate these men.[123]

So these images are offered not simply for visual entertainment or appreciation; they are also a guide to the behavioral protocols of the historic gentleman. The images of these reputable scholars constituted pictorial role models. Zhou Lüjing's figure painting manual was very much a collection of such images, in which cultural celebrities and their actions were selected, assembled, stylized, and finally glorified; the refiguration of the figural in *Heavenly Forms and Exemplary Manners* represents a reenactment via the work's stylistic and pictorial formatting. Through this process, celebrated scholars of the past, their gatherings, and their activities were glorified in this archive of images and so established as a canon. These were the very images after which late Ming literati-wannabes tried to establish their own identities. In this way, the figure painting manual not only taught them how and what to paint; it also advised how, through specific forms of behavior, they could realize their dream of being authentic litterateurs.

4

Icons of Love and Marginality

Woman's virtue is man's greatest invention.
—Cornelia Otis Skinner (1909–1979)

O F THE THIRTY-SIX FIGURE IMAGES IN *HEAVENLY MODELS AND EXEMPLARY Manners*, only four are women. These are all placed at the end of the volume, which both declares the subordinate value of women as subject matter in late Ming art and points to women's marginality in society and cultural production more generally. Representations of the female body in the volume disclose their close ties to larger gender-related discourses, such as women's social status, literacy, talent, love, and romantic fantasy. In nineteenth-century England, certain qualities such as delicacy, sexual passivity, domesticity, and capricious emotionality were defined as feminine values and publicly presented as such in art and literature.[1] This pattern was evident in late Ming China as well. The images of women from visual media of the time reveal that women's role and status were exposed to a constant process of definition and redefinition via challenge and negotiation. Similar to the literati culture discussed in chapter 3, female bodies also prove to be more than simple pictorial motifs; they engage with contemporaneous literature and other textual evidence that defined women's roles and agency in society.

4.1 "Pounding clothes," from *Heavenly Forms and Exemplary Manners*, 24a.

Love Lost and Heart Broken

Most of the female images in *Heavenly Models and Exemplary Manners* portray women in love, yet their lovers are usually absent, and thus they pine for them "with unrelieved sadness." Like traditional Chinese poetry written in a female voice, the women depicted in the manual project an appealing emotional vulnerability. Their love takes the form of amorous reverie, daydreaming, fantasy, and morbid brooding, experiences shared by female viewers; ironically, it can also function as the object of male fantasy. The lovesick women and their sadness in both literary and visual conventions of the late Ming proved to be a major interest and concern among men.

The image "Pounding clothes" (*daoyi*) (fig. 4.1) provides a good example. In it, an elderly woman sits in front of a pounding stone with a cup of water for spraying the cloth next to her. Her listless body and closed eyes suggest emotional suffering; she appears to be frozen in the midst of a stroke of the pounding club. The conventional meaning of the "pounding clothes" theme is that a woman's lover is far away, specifically, stationed on the frontier with the army. She pounds clothes, worrying that he might not have enough warm clothing. This was an

4.2 Qiu Ying (ca. 1494–1552), *Pounding Clothes*. Hanging scroll, ink on paper, 95.2 x 28 cm. Nanjing Museum. After *Sōgen Minshin meiga taikan* (Tokyo: Otsuka Kogeisha, 1931), vol. 1, plate 110.

established motif in painting and literature long before the late Ming, and many painters are noted to have worked on it, including Zhou Wenju (ca. 917–ca. 975), Lu Tanwei (act. 460s–early 6th century), Mou Yi (ca. 1178–ca. 1243), and Zhou Fang (ca. 730–ca. 800).[2] It was also a common motif in late Ming paintings. One Ming master artist, Qiu Ying, left at least a couple of paintings on this topic, while two of his contemporaries, Tang Yin and Guo Xu (b. 1456), also created multiple paintings of this subject matter.[3] One of Qiu Ying's paintings, *Pounding Clothes* (fig. 4.2), includes five poems added by his contemporaries. The one on the right, written by Zhou Shi, a medical doctor who lived in Kunshan in the late sixteenth century, dramatizes the theme.

> Pounding the winter clothes, tears streak my face.
> The autumn mountains have already seen frost.
> With irresolvable grief, my body is empty, a mere shadow;
> And I cannot reach Liaoyang even in my lonely dreams.

In my empty room on an autumn night, it's hard to quiet my thoughts;
Across the thousands of miles between us, my heart's banner is pulled by
 the bright moon.
Most clear is the fact that beauty fades easily;
My everlasting resentment at our separation merges into the sound of
 pounding.[4]

This poem contains the classic literary allusions associated with the "pounding clothes" theme: frost, autumn, night, distance, dreams, the women's quarters, the moon, physical beauty, and the sound of pounding. The meaning of the poem depends on its symbolic lexicon: the word for "pounding" has the erotic connotation of a lover, and the woman in this poem is beating the silk/love all night. The chill suggests not only the cooling of the romance but also the declining beauty of the woman; autumn implies a time of desertion.[5] The pounding is her heartbeat, the soundtrack to her yearning and her despair over their time apart. Qiu Ying's painting shows a woman seated alone under a catalpa tree who turns her head to gaze into the distance. She appears to have paused to sigh and savor some passionate memory of her missing love. The empty background swallows the diminishing resonance of the pounding. The silence hovers as her mind wanders during the interrupted action.

The image in *Heavenly Models and Exemplary Manners* raises an intriguing question: Why does it present an elderly woman, unlike most paintings of the subject, which tend to depict an attractive young lady? The image of a motherly figure pounding clothes is also found in *Picturing One Hundred Poems* (Baiyong tupu), an illustrated album of romantic poetry by scholar-artist Gu Zhengyi, which was published in 1597.[6] The illustration "Autumnal Pounding Stone" (Qiuzhen) (fig. 4.3), which accompanies the poem, shows the moon in the upper left corner, a lit candle in the studio, and a traveler's lantern outside the gate, making this an evening scene.[7] As children play in the garden, the woman sits on a low stool pounding clothes. Falling leaves indicate the season is autumn. Its colophon reads,

Time flies and autumn clouds darken at the end of day;
The west wind reminds me to send new clothes.
On the pounding stone the pure dew is getting cold;
Fine silks are pounded into delicate frost.
The beat of pounding makes insects twitter;
The sound hurries the leaves off the trees.

4.3 "Autumnal Pounding Stone," in *Gu Zhengyi's Picturing One Hundred Poems*, 1596, 1: 12b. Peking University Rare Book Collection.

Can you hear the sound in the air, my dear?

Cold moon is also missing you.[8]

Analyzing this subject across many literary genres, Wang Ningzhang interprets it thusly: First, it represents autumnal emotion, which is linked to sadness, aging, and nostalgia. Second, the setting is usually night, thus hinting that the sound would be heard by other people in the quiet evening. Third, the sound of pounding arouses the romantic imagination and nostalgia for homeland and mother.[9] In this sense, the elderly woman in "Pounding clothes" in *Heavenly Models and Exemplary Manners* may be read in multiple ways—as an old lady missing her youth and beauty, a rejected love, or a mother, all of which engage readers' sentimentality and nostalgia.

"Taming a parrot" (*tiaoying*) (fig. 4.4) conveys a similar message about women's loneliness and yearning. The record on the earliest painting of this subject describes a painting from the Five Dynasties or the early Song period that depicts a bird perched on an apricot branch as a beauty leans against a flat rock holding a flower.[10] The image in *Heavenly Models and Exemplary Manners* follows a slightly

4.4 "Taming a parrot," from *Heavenly Forms and Exemplary Manners*, 23b.

different composition. Here, a lady stands holding a willow branch and the parrot perches on a flat-topped rock. The woman appears to be teaching the bird some phrases for fun, a leisure activity often labeled specifically female in traditional China. Wen Zhenheng's *Superfluous Things* prescribes the companionship of parrots for women, but the same was not considered suitable for male scholars.[11] Art historical records list Tang painter Zhou Fang as the one who originated this trope, but no surviving painting on the theme predates the late Ming or early Qing.[12] Interestingly, Zhou Lüjing's contemporary and one of his patrons, Wang Shizhen, possessed such a painting attributed to Zhou Fang. Wang recorded the Tang poem on which the painting was based.

> On an apricot branch sits the green-dress girl [parrot];
> I freely chat about life in the palace with her.
> Just afraid that in my haste, [she] hasn't got it down,
> I teach again the phrase, "I'm thinking of you, my lord."[13]

4.5 "Lamenting the parrot," from *Picturing One Hundred Poems*, 1:17b.

The poem refers to a palace lady who cherishes her love for the emperor yet is unsuccessful at attracting his attention. The parrot is her only company. Her limited life in the palace is figured in the domesticated parrot.

Besides appearing in paintings by traditional masters, this motif was reproduced in other public media of the time. Gu Zhengyi's *Picturing One Hundred Poems* lists two similar pairs of images and colophons. One of them, titled "Lamenting the Parrot" (Dao yingwu), reads as follows:

> Elevated to the spirit world, I sigh over her intelligence;
> Her fetching voice is suddenly silent.
> I call her name, but already there is no response,
> But the recitation of Buddhist prayer continues.
> As for this fragrant rice, how sad to see the food you left;
> As for your golden cage, how wrenching that it now hangs empty.
> You have suddenly deserted my boudoir—
> Who will again accompany this beauty?[14]

The accompanying illustration (fig. 4.5) shows a seated lady staring at an empty bird swing, symbolizing the loss of the only companion who shared her innermost

4.6 Chen Hongshou (1598–1652), "A Beauty and a Parrot," in the *Story of the Western Chamber,* illustration no. 20. Each page, 20.5 x 14.5 cm. National Library of China, Beijing.

feelings. Another example in an edition of *Story of the Western Chamber* illustrated by a late Ming master, Chen Hongshou (1598–1652), shows a lady sitting next to a parrot chained to a swing (fig. 4.6).[15] The inscription reads, "How can one's forehead show so many wrinkles [i.e., worry]?" which suggests women's agonies in love and life. The illustration includes a delicate and elegant interior space with orchids in a porcelain vase and a bonsai (Ch. *penzai*) pine. Unlike this orderly and neat environment, her mind appears to be so distracted and agitated that she cannot concentrate on the book opened on the table.

Two other images of women not included in *Heavenly Models and Exemplary Manners* appear in *Canon of Paintings* and other late Ming painting manuals. The first is of a female dancer. Accounts and images of women dancing often appear in other print media of the period, and most of them note the dancer's indescribable beauty.[16] This could redound to the popularized literati culture of the time, when many successful officials and merchants sponsored local singing groups for operatic performance.[17] The second image shows a lady holding a rabbit and looking into the night sky from under a banana leaf (fig. 4.7); the caption on the left reads, "Jade hare and autumnal fragrance" (Yutu qiuxiang). Records of the jade-rabbit theme appear in some sources. The meaning of this scene is

4.7 "Jade hare and autumnal fragrance," from *Canon of Paintings*, Yibaitang edition, 1607, 1:15b. East Asian Library and the Gest Collection, Princeton University.

4.8 "Pounding ink at the Moon Palace," from *Master Cheng's Ink-Stick Collection*, 2:38b.

related to the old Chinese legend of Chang'e.[18] Chang'e was the daughter of the Heavenly God, Diku, and the wife of the archer Hou Yi. One day, she stole her husband's elixir, a gift from the Queen Mother of the West (Xiwangmu), and fled to the moon.[19] Although she attained her goal of becoming an immortal, she was punished, condemned to an eternity of loneliness without love and companionship. Living alone and repenting her actions, she vainly tried to reconstruct the elixir's formula as a way of seeking her husband's forgiveness. She is accompanied only by a hare who forever pounds the medicine of immortality beside a cassia tree.[20] Chang'e's loneliness and sadness were often a motif for Chinese poets. The Tang dynasty poet Li Shangyin (ca. 813–ca. 858), for example, once chanted,

> Lamp's shadow deepens on the *yunmu* stone screen;
> Dawn's star gradually sinks over the Long River.

4.9 *"Jade pestle and heavenly frost," from*
Master Cheng's Ink-Stick Collection. 11:4b.

Chang'e should now regret having stolen the magic herb;
In the azure sea of the sky, her heart weeps night after night.[21]

This story is cited in various literary creations. In the Ming edition of *Story of the Western Chamber*, for instance, the female heroine Oriole is compared to Chang'e for her beauty.[22] This story and its representation also appear in other publications of the period, including *Master Cheng's Ink-Stick Collection*, in which the image of Chang'e and the elixir-pounding rabbit appears twice (figs. 4.8, 4.9). Interestingly, unlike the first image in the volume, which depicts the young and beautiful Chang'e, the second image depicts her as an old lady, thus suggesting the long period of time she has spent trying to recover the elixir and dramatizing her life of regret.

Therefore, whether she is pounding clothes, keeping company with a parrot, or regretting past actions, the sole cause of a woman's sorrow and loneliness is the

absence of a lover. Ironically, her absent lover is the silent recipient and observer of her anguish. These literary and pictorial story lines make us believe that curing the woman's broken heart is beyond what she can even imagine. Typically, she simply accepts reality and becomes docile in the face of her fate. Her frustration might have provided a degree of emotional catharsis for viewers, but at the same time, it was packaged and offered up for romantic consumption. For fellow female viewers, it might evoke a sense of empathy; for men, it also played to fantasies and desires inspired by her very sadness.

Taking Action

If the above illustrations depict women as passive and feeble, as figures who can only suffer over lost love, another image in *Heavenly Models and Exemplary Manners* presents a less discussed aspect of the period's gender stereotyping. This motif seems to contradict other female imagery since it refers to women taking a more active role in seeking out and finding love. Still, the core trope remains the same (the proper identity of women with love), and the amorous imagination is again unmistakably at play. The image "Writing on a leaf" (*tiye*) (fig. 4.10) shows a woman seated on a rock with her legs crossed. Cupping her chin in her left hand, she holds a writing brush in her right. She appears to be searching for inspiration for a poem that she will presumably write down on the leaf beside her. Her expression is blank as she contemplates, searching deeply for the words. She must find just the right words because leaves provide a limited writing surface. This image probably captures the very moment when she is poised to dash off a description of her emotions on the leaf.

One painting on this topic, now at the Freer Gallery of Art in Washington, D.C. (see plate 13), is attributed to the school of Qiu Ying. It shows a woman wearing an elaborate silk dress holding a brush and a red leaf.[23] Her billowing robes signify an outdoor setting as well as refer to her spontaneous and passionate feelings, which contrast usefully with her steady gaze, fixed on the red leaf. Other than this work, there are few surviving paintings on this topic, but various Ming records make references to colophons written on such paintings, which suggests its established status as subject matter before the Ming period.[24] All variations on the theme of a beauty with a red leaf include *A Beauty and a Red Leaf* (Meiren hongye tu), *A Red Leaf and a Noble Lady* (Hongye shinü tu), *A Beauty Writing on a Red Leaf* (Meiren shu hongye tu), *Writing a Poem on a Red Leaf* (Hongye tishi tu), *Writing a Poem on a Leaf in the Tang Palace* (Tanggong tiye tu), and *A Red Leaf* (Hongye tu).[25]

4.10 "Writing on a leaf," from *Heavenly Forms and Exemplary Manners,* 24b.

Similar to most figure images in Zhou's manual, this motif derived from specific narratives. Over the course of early modern Chinese history, a variety of printing houses published stories of women writing poems on leaves and sending them off in the water or wind. A romantic drama, *Catalpa Leaf* (Wutongye), published by Guquzhai during the Wanli period, is one example. The illustration in this edition (fig. 4.11) shows a lady sitting on a rock with a catalpa leaf in her hand, a composition almost identical to the one in *Heavenly Models and Exemplary Manners.* The story goes that during the Tang dynasty, a young court lady longed for a life outside the confines of the palace. One day, she placed a poem about her loneliness written on a catalpa leaf on a water channel in the palace; it was carried out of the palace, and by chance a scholar who had come to the capital to take the government examination picked it up. Enamored with the poem, he cherished the leaf and stored it in his stationery box. The lady eventually was able to leave the palace and marry that same scholar. It was only later that she discovered her leaf-poem in her husband's possession.[26] Thus, the leaf signifies

4.11 Image of "Woman writing a poem on a leaf," from *Catalpa Leaf*, Guquzhai edition, Wanli period (1572–1620), 8a. 20.4 x 14 cm. National Library of China, Beijing.

that their meeting was destined, not a coincidence. The word for "catalpa tree" (*wutong* 梧桐), under which she wrote the poem, puns with the expression "we together" (*wutong* 吾同) and so symbolizes looking for one's significant other.[27] The poem she wrote reads as follows:

Why does the water run so fast, while my days inside the palace pass so slowly?
My love is written on this leaf; may it reach somebody.[28]

The poem contrasts her lonely and boring life in the palace with the excitement and passion symbolized by the fast-running water. Her life at court, which deprives her of freedom and a chance for love, forces her to look for an outlet for her feelings.

This story must have gained a level of popularity among late Ming romance readers, since many different versions of it circulated.[29] In one of them, a scholar of the Tang period, Ren Jitu, left his wife, Li Yunying, to help a friend perform a job for the provincial government. In the meanwhile, the An Lushan rebellion broke out, and Li Yunying was captured by government soldiers. Thanks to an official who adopted her as his stepdaughter, Yunying was able to escape danger.

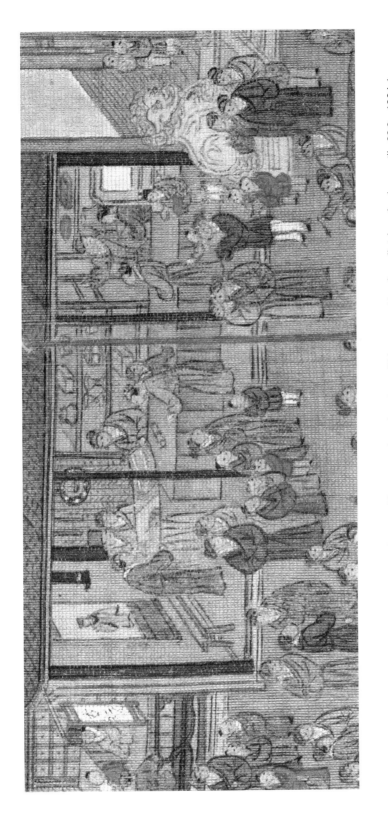

PLATE 1 Anonymous, detail of *Spring Festival on the River* (Qingming shanghe tu), ca. 17th century. Hand scroll, ink and color on silk, 29.8 x 1004.6 cm. Metropolitan Museum of Art, New York, Rogers Fund 11.170.

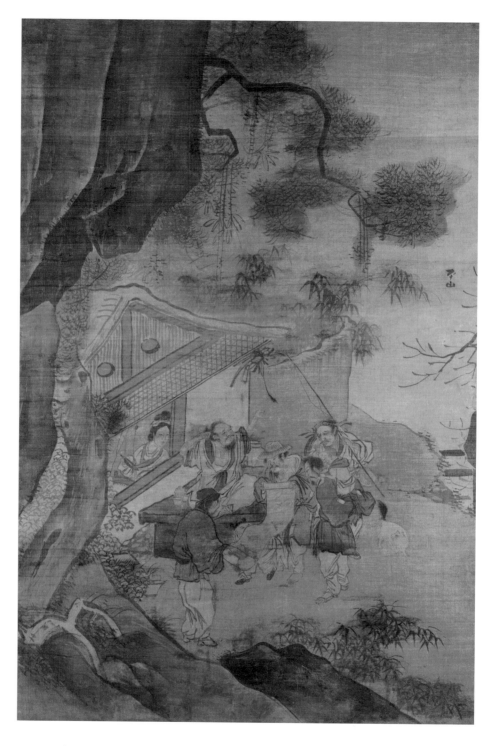

PLATE 2 Zhang Lu (ca. 1490–1563), *Studying a Painting*, ca. 16th century. Hanging scroll, ink and color on silk, 148.9 x 98.7 cm. Metropolitan Museum of Art, New York.

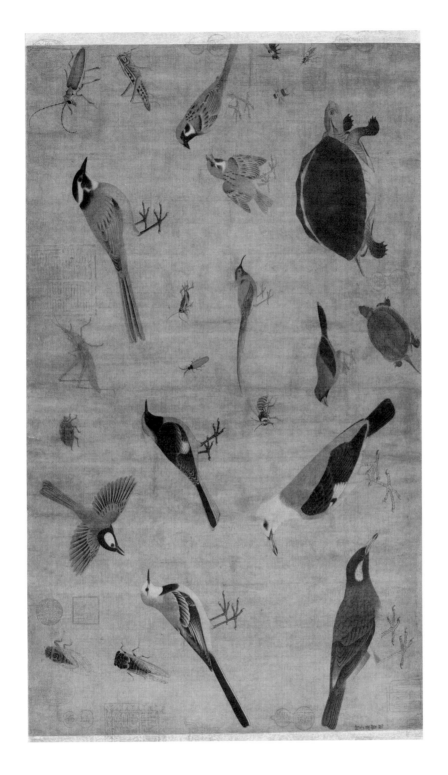

PLATE 3 Huang Quan (903–965), *Sketches of Birds and Insects*, ca. 960. Hand scroll, ink and color on silk, 41.5 x 70 cm. National Palace Museum, Beijing.

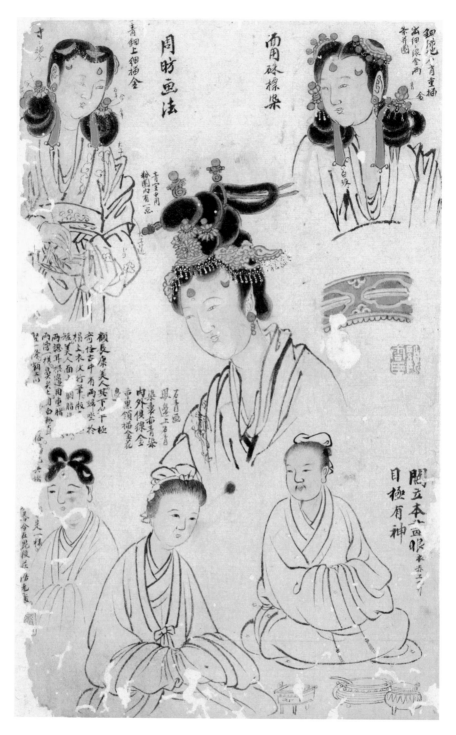

PLATE 4 Gu Jianlong (1606–ca. 1687), figure studies of five women and one man in *Sketches after the Old Masters*, mid-17th century. Album leaf, colors and ink on paper, 36.8 x 29.2 cm. The Nelson-Atkins Museum of Art, William Rockhill Nelson Trust, 59-24/45.

PLATE 5 Attributed to Yan Liben (ca. 601–673), detail of *Emperors of the Successive Dynasties*, second half of the 7th century. Hand scroll, ink and color on silk, 51.3 x 531 cm. Museum of Fine Arts, Boston, Denman Waldo Ross Collection.

PLATE 6 Shen Zhou (1427–1509), *Washing Feet under the Catalpa Tree*. Hanging scroll, ink and color on silk, 97.5 x 199 cm. Capital Museum, Beijing.

PLATE 7 Vimilakirti, detail of mural in Dunhuang Cave 103, mid-8th century. Interior, east wall. Courtesy of Dunhuang Research Institute.

PLATE 8 Manjusri (Wenshu), Yulin Cave no. 25. Interior, east wall of main chamber. Courtesy of Dunhuang Research Institute.

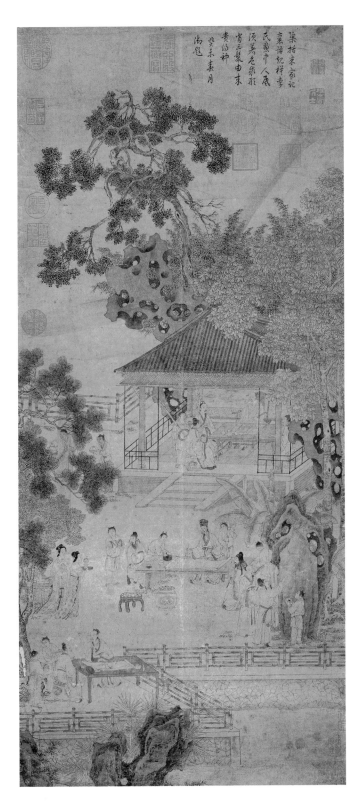

集括未審記
袁诗紀祥李
氏菊中人辰
須芳老飛形
肖三歲由末
貴陽神
嵗末表月
尚题

PLATE 9 Qiu Ying (ca. 1494–1552), *Elegant Gathering in the Western Garden*. Hanging scroll, ink and color on paper, 20.1 x 38.9 cm. National Palace Museum, Taipei.

PLATE 10 Stone inscriptions at Mount Tai in Shandong. Photo: Robert Harrist.

PLATE 11 Zhou Wei (early Ming), *Tao Yuanming Returning Home Drunk*. Album leaf, ink on paper, 24.9 x 25. 4 cm. National Palace Museum, Taipei.

PLATE 12 Late Ming wine bowl, with "Literati gathering with floating wine cups." Private collection of Mr. Liu Qinghua, Beijing.

PLATE 13 School of Qiu Ying (ca. 1494–1552), *Writing on a Leaf*, ca. 16th century. Hanging scroll, ink and color on silk, 126.7 x 69.7 cm. Freer Gallery of Art, Smithsonian Institution, Washington, D.C., Gift of Charles Lang Freer, F 1917.335.

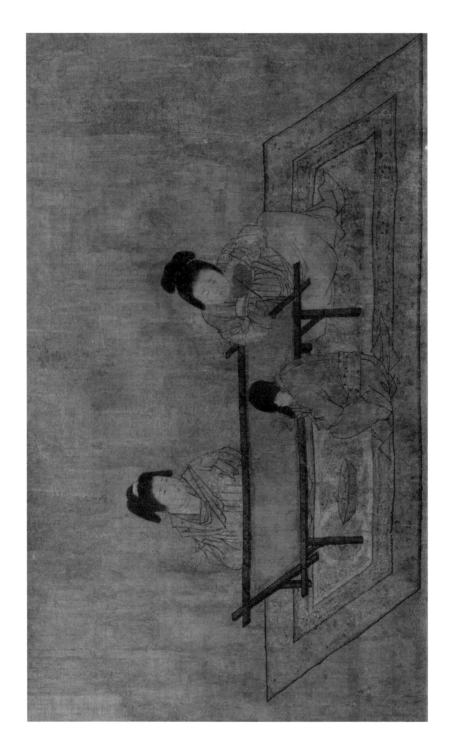

PLATE 14 Attributed to Zhou Fang (ca. 730–ca. 800), detail of *Tired of Embroidery*. Hand scroll, ink and color on silk, 33.3 x 205 cm. National Palace Museum, Beijing.

PLATE 15 Attributed to Zhou Fang (ca. 730–ca. 800), *Tired of Embroidery*. Album leaf, ink and color on silk, 21 x 29 cm. Freer Gallery of Art, Smithsonian Institution, Washington, D.C., Gift of Charles Lang Freer, F. 1916.75.

PLATE 16 Chen Hongshou (1598–1652), landscape, early 17th century. Album leaf, ink and color on silk, 21 x 15.2 cm. University Art Museum, Berkeley, California.

Ren Jitu, not knowing this, tried in vain to locate his wife when he returned, but she was nowhere to be found, since she had left with her stepfather to avoid the commotion. Ren Jitu again set out to find his wife. One day, he arrived at a Buddhist temple, extremely tired and heartbroken, and wrote a poem on the wall expressing how he missed his wife. Coincidentally, Yunying was staying at the same temple. In response to that poem, having no idea that its author was her husband, she wrote a poem on a catalpa leaf, which was carried off by the wind. Fate again connected them when Ren Jitu picked up the inscribed leaf. A few years later, he won first place in the imperial exam. Watching his celebration parade from a distant pavilion, Li Yunying recognized him, and they were finally reunited. The poem Yunying wrote on the leaf reads:

> I wipe my kingfisher jewelry and knit my brows, because of melancholy
> and the pain in my heart.
> Holding a writing brush, I descend into the courtyard and write the words
> "thinking of you."
> But I don't sign it, nor did I write it on paper.
> Inscribed on an autumn leaf, may it fly along with the autumn wind.
> Under heaven there is a man of passion dying of love for me.
> Under heaven those without passion don't understand love's longing.
> Those with passion or those without, who knows where the leaf will
> land? [30]

Just as in other versions of the story, the leaf links two lovers and manifests their longing for each other. The catalpa leaf here is also a medium of emotional transmission, but unlike in the other stories, it has flown through the air, without a set path like a water channel, and the heroine specifies the recipient of the poem.

Similar images were reproduced in many print media works, such as *Collection of Songs in the Northern Mode* (Beigong ciji), *Assorted Dramas of the Past* (Guzaju), and *Women Scholars by the Window of Green Gauze* (Lüchuang nüshi). The illustration (fig. 4.12) included in *Collection of Songs in the Northern Mode*, an anthology of lyrics published in 1604, is placed at the beginning of the chapter, "Emotions of the Inner Quarters" (Guiqing). Here, in a garden setting, a lady under a catalpa tree languidly gazes out onto the night landscape. One hand is raised to her chin, the standard pose of a lovelorn lady. As is common in poetic and pictorial metaphors for a lovesick woman, here too, she is depicted in an isolated space that prevents communication. Such paintings often picture women

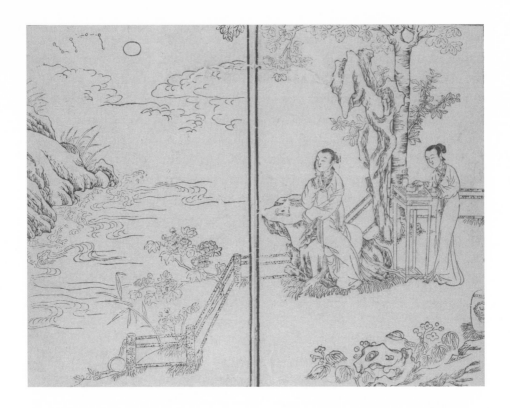

4.12 Image of "Woman writing a poem on a leaf," from *A Collection of Songs in the Northern Mode*, 1604, 6:1b–2a. Harvard-Yenching Library.

surrounded by steep cliffs, thick trees, or high compound walls, a situation that partitions them and thus underscores their seclusion and solitude.[31] Furthermore, the placement of the illustrations in this book is noteworthy. All are grouped together at the beginning of the book, but none has any relationship to the book's text. The inclusion of images at the beginning of volume, a phenomenon common in various illustrated literatures, offers selected images as an independent genre of appreciation. These were album leaves provided to prime readers' emotional and sentimental subjectivity. In this regard, the publisher must have chosen this specific image to represent the topic "women's emotion," and it thus functions as a frontispiece introducing the chapter's overarching theme. The story of writing on a leaf was emblematic of love and romance and would presumably have been understood as such by the late Ming reading public.

Even given the information presented here, the images of women in *Heavenly Models and Exemplary Manners* may not deliver any sense of eroticism and sensuality to modern readers. Nevertheless, in traditional Chinese paintings, as

John Hay has insightfully noted, eroticism and sexual fetish were manifested in the array of environments and women's fashions.[32] For example, certain plants were associated with types of beautiful women; the physical characteristics of the flowering plum, appreciated in literature as "plain elegance," paralleled depictions of solitary, delicate ladies arrayed in light-colored garb. A banana plant by a natural garden rock also functioned as a device that resonated with the idea of romance.[33] The garden rock on which all the heroines of "Writing on a leaf" sit is a place identified with spontaneity and the uncontrolled emotions that were commonly associated with naturalness.[34] Originally linked with the uncorrupted and natural minds of scholars, garden rocks extend their qualities to the personal emotions of the women who are seated on them. However, this environmental setting valorizing "the spontaneous woman" sharply contradicts the restricted agency of women in Ming society.

As Paul Ropp has noted, the late Ming definition of "proper womanhood" probably discouraged frankness.[35] Open display of personal feelings was not quite in line with the social standard imposed on women in a male-dominated society. This tells us little about Chinese culture, however, since women all over the early modern world were similarly discouraged.[36] The question for the historian is, what means were available to women to negotiate greater agency in the arena of personal expression? Clearly, literary conventions offered one vehicle for the conveyance of emotion. To a certain degree, this may be why Li Yunying and other heroines in the "writing on a leaf" stories choose a leaf (a natural vehicle) by which to give free rein to their emotions.[37] As soon as they release the leaf into the water or the air, the proof of their identity as authors disappears.

This explanation, then, highlights a higher level of irony around women's agency in late Ming China. In many Chinese *literary* traditions, it was women who expressed their feelings more explicitly than their male counterparts, or that was the claim; in traditional Chinese poetry, certainly, male literati often masqueraded as women in order to express love and loneliness. In popular love stories of the time, women characters are far more determined than their men in pursuing passion in the face of arranged marriages and other social injustices.[38] When approached by men, however, these women never turn down their appeals, or they go to extreme measures to seek and accept the male lover. For example, in *Peony Pavilion*, the epitome of the late Ming love story, the heroine Du Liniang is the one who first expresses her inner emotions and even sexual frustration.[39] She eventually dies of love for a man she never gets to meet, even though it was a definite failure of filial piety to die young, before her parents. But in his preface to *Peony Pavilion*, the author Tang Xianzu extols Du Liniang's

behavior, praising her for breaking with traditional values so that she could real-
ize her love.

> To be as Bridal Du is truly to have known love [*qing*]. Love's source is unknown,
> yet it grows ever deeper. The living may die of it; by its power the dead live
> again. Love is not love at its fullest if one who lives is unwilling to die for it, or if
> it cannot restore to life one who has so died.[40]

Tang acclaims Du's love and the extreme path she takes to prove it. Yet would
a male hero in the story meet with similar kudos for committing suicide? The
social system had double standards when it came to proper female roles: one
as daughter, the other as lover. Tang's voice valorizes the second role, which, if
pursued by males in a similar way, would have gotten a different reception from
readers of the time. In late Ming fictional reality, women were always available,
always exposed to the male gaze, and, in a sense, always presenting themselves as
objects of romantic consumption.

Women's Talent: Virtuous or Virulent?

The double standards around women's roles were projected and tested further in
another realm of social norms. As briefly noted in the introduction, in the late
Ming, there emerged an unprecedented number of talented women who were
published authors, poets, painters, calligraphers, or musicians—and who were
able to form relationships of true compatibility and mutual respect with contem-
porary male literati. Some 3,500 female poets were known to have been published
during the Ming-Qing period alone. However, this rapid emergence of women as
creators of culture made some of their male counterparts uneasy. One illustra-
tion in *Heavenly Models and Exemplary Manners*, being tangentially related to
the issue of female talent, provides clues as to how this problematic came into
play in its complex layers of social semantics.

The image "Tired of embroidering" (*juanxiu*) (fig. 4.13) shows a woman lean-
ing on an embroidery frame. Her hands are covered by the long sleeves of her
robe, not holding a needle and working. Her closed eyes imply a state of deep
thought. The embroidery frame, on which a spool is idly set, provides support
for the lady's listless body; it also appears to be a substitute comfort for her lonely
heart. As the caption suggests, she is taking a break from her household labors
at embroidery, a theme that inspired many poets and painters in Chinese history
and whose most well-known locus is a ninth-century poem by Bai Juyi (772–846).

4.13 "Tired of embroidering," from *Heavenly Forms and Exemplary Manners*, 23a.

> Wearily leaning on an embroidery frame, melancholic and listless,
> Languidly, a green ribbon hangs from coiled hair.
> In Liaoyang, spring is ending and still no news;
> I sit before the night-enclosing magnolia as the sun sinks in the west.[41]

The poem makes clear that the lady's weariness is not the result of her hard labor but because of her heartbreaking yearning for her lover. Even after a season has passed, there is no news of her lover returning. The poem conveys her melancholic longing while valorizing women's loyalty to their lovers and husbands. Her suffering from steadfast love figures her unswerving faith, and, ironically, this image of the suffering woman at once suggests emotional catharsis, sensual fantasy, and gender inequality.

This poetic theme had been visualized in paintings by many artists through the ages. *Tired of Embroidery*, a painting of uncertain date (though attributed to a Tang master, Zhou Fang) at the National Palace Museum in Beijing (see plate 14), may be one of its earliest representations. In this painting, the lady seated at the right end of an embroidery table is staring aimlessly at its frame. Her posture, leaning on the frame with her hand tucked in her sleeve, general listlessness, and absent-minded gaze contrast sharply with the other two women, who are silently

working away at their embroidery. Another painting with the same title, at the Freer Gallery of Art in Washington, D.C., is also attributed to Zhou Fang (see plate 15).[42] While a piece of cloth has been placed across the table, the lady is looking into the air with her arms tucked in her sleeves. The similarity between these paintings and the printed image in *Heavenly Models and Exemplary Manners* is convincing evidence that Zhou Lüjing adapted an existing work for his manual. A painting of this theme by a Southern Tang (937–975) painter, Zhou Wenju, was still extant in the late Ming.[43] This work is noted as having belonged to the collection of Yan Shifan (1513–1565) and later Han Shineng (1528–1598), which Zhang Chou had a chance to study and on which he left his observations. Zhang Chou further noted that three or four paintings on this topic, all identical, existed and might all be originals.[44] Historical documents of the Song and Yuan note dozens of paintings with the same title, which suggests the subject's prestige among artists and patrons throughout Chinese history.[45]

The Ming master Tang Yin also left a color painting of the topic dated to 1513, for which he consulted a similar painting by a Yuan master, Zhao Mengfu. Zhou Lüjing supposedly had access to this work via his social connections since it was in the collection of Wang Shimao (1536–1588), Zhou's friend and patron. The piece is noted to have borne the following inscription:

Evening has arrived and the fragrance of magnolia fills the garden;
A beauty stops embroidering, suppressing her feelings.
One hundred flowers embroidered, all fresh and delicate;
Only a pair of mandarin ducks are left unfinished.[46]

The basic meaning of the lines is similar to that of Bai Juyi's poem, but this poem gives more explicit voice to the woman's love and desire. While the flowers in the garden and the embroidery figure her femininity and beauty, the unfinished pair of ducks vividly conveys her unrealized love and frustration. Both in literature and in painting, then, this image carried romantic meaning. This same theme, however, in the social discourse of female identity and talent, took on an unexpected new sense.

In late Ming China, as in Victorian England, the accomplished woman was an object of conspicuous exhibition, a means whereby a family proclaimed its wealth and status.[47] This new social phenomenon invited a range of opinions from contemporary men. One group of scholars advocated the display of women's literary and artistic talents. These included Li Zhi and Feng Menglong, who insisted that talent could coexist with female beauty and virtue. The latter even noted that if a

woman had no talent, her virtue was not complete.[48] Other scholars, though sympathetic to the idea of women's talent, claimed that women's physical attractions were more important. Xie Zhaozhe noted that when it came to women, beauty was first and wisdom came second. He further held that women's talents and knowledge are not even worth discussing; women are to be appreciated for their physical beauty.[49] Obviously, this dismissal of women's talents reflects tensions in a society in which the number of educated women was conspicuously on the rise.

An even stronger objection to women's education surfaced in a popular phrase in late Ming China, "A woman lacking talent is virtuous."[50] By opposing women's virtue, their most important moral value, to their education and talent, this phrase obviously launched a menacing warning against women demonstrating any cultural accomplishment. However, such thinking discouraged not women's education or talent per se but the public "display" of the same. Subscribed to by both men and women, this view construed a woman's talents and virtues to be mutually exclusive and suggested that an advanced literary and cultural education was detrimental to her moral cultivation. There is no doubt that this new view of women, when it first developed in late Ming society, did encourage many women to challenge existing social and cultural forces. Some Ming women bitterly attacked this type of gender inequality. Educated women had begun to reject the submissive silence of domesticity by taking up poetry writing and publishing as legitimate pursuits. In pursuit of her identity as a poet, for instance, Xu Yuan (1560–1620) announced in her poetry that she would abandon her needlework for the sake of her literary interests. Even so, most women in late imperial China did not engage in cultural struggles formed along gender lines. Instead, as Kang-i Sun Chang has demonstrated, many women writers, in an attempt to conform to the Confucian ideal of female virtue, burned their poems in order to reaffirm their virtue rather than their talent. They must have felt immense pressure to prove that they did not neglect their household duties in spite of their poetry-writing activities. Altogether, this range of responses suggests the weight of the social code against women's participation in male-dominated cultural activities.[51]

In late Ming literature, the works of many women authors bore the titles "Poems Composed after Embroidery" (Xiuyu cao) or "Poems Composed after Weaving" (Zhiyu cao). A modern scholar, Hu Wenkai, records more than 170 such titles published by Ming and Qing women poets.[52] Women authors, mindful of the protocols of modesty, were likely to have adopted such titles, signaling readers that their works were not serious but composed only during leisure hours after the completion of domestic duties. Nevertheless, they might also have chosen this theme as a coded announcement of dissent. A comment by the

ambitious late Ming woman writer-painter Liang Yisu (fl. 1644) reflects such a mix of attitudes.

> Our "boudoir poetry" (i.e., women's poetry), compared with the work of male poets, is more difficult to write. Male poets can travel at will to beautiful scenic places and can see and experience a lot; moreover, in criticizing or showing anger, they can speak freely without restraint. So the songs they write can be heroic and expansive. But for women, things are different: our feet dare not cross the threshold; we do not see beyond our immediate neighborhood. Even if we have some insight, it must be "proper"; if our compositions are written without restraint, we will be seen as inelegant and vulgar. If Zhu Shuzhen (fl. ca. 1131) could not escape such charges, what about us lesser poets? So when we write about our feelings and dispositions, we cannot write too freely or directly. We must instead write deliberately and indirectly, with sweet refined taste, so our writings readily become soft and weak.[53]

Her statement, although defending certain styles and content of poetry written by female writers, sounds an obvious note of sarcasm and bitterness at the considerable social and creative restrictions with which women artists had to contend. Such comments reveal that literary activity was not prohibited among women—certainly not relative to other parts of Eurasia at that time—but that the issue of female literary expression remained a site of negotiation and debate. Therefore, for male and female members of late Ming society, the theme "tired of embroidery" carried differing functions and nuances. Literary and pictorial representations of this theme connoted for men the eroticism and obsession of female love, but for late Ming women, it provided an acceptable vehicle for the display of their talents and accomplishment. Summing up the artistic, literary, and historical context, this theme may have represented women's love, passion, and faithfulness, but it also came to exemplify the dilemma educated women faced and their dissent.

Icons of Love and Passion: Women's Dilemma in Late Ming China

Most of the images representing women in *Heavenly Models and Exemplary Manners* were based on paintings from the past or were related to stereotypical portrayals of women featured in contemporary print culture. This process, the representation of women both in art and in literature, was productive to the degree that it satisfied the male gaze—desires around the female body, romantic fantasy,

and patriarchy. However, conflicting attitudes lie just behind these images. As Katherine Carlitz has demonstrated, even the illustrations in late Ming editions of the Han dynasty classic *Biographies of Notable Women* (Lienü zhuan) were meant to present women simultaneously as icons of virtue and objects of sensuous enjoyment. The same publishing house reused an image of a woman registered as a model of virtue in *Biographies of Notable Women* as a lovesick lady in not-so-pious romantic plays.[54] This complication is often viewed today as a negation of female agency and the reduction of the female body to a desirable object. In fact, it was based on the conflation of two different yet complementary ideas. Late Ming literati culture went from conceiving desire as a negative to celebrating it positively as a species of intense emotion; at the same time, the idea of "woman" was reduced from a powerful emblem of loyalty to an object of sensual connoisseurship.[55] Susan Mann and Dorothy Ko have both described the Ming and Qing market for young women, which guaranteed that a young widow's in-laws or even her own parents could readily find a new "buyer" for her.[56] Thus, under the right circumstances, a woman's body could be treated literally as tradable merchandise.

Contemporary publications also reached a similar watershed. For example, in *One Hundred Beauties of the Wu Region* (Wuji baimei), a late Ming work on Nanjing courtesans, dozens of women are ranked by their literary talent and physical beauty.[57] According to the estimate of literatus Xie Zhaozhe, courtesans were omnipresent in Ming society, numbering in the hundreds or thousands in each big city; they could even be found in remote areas.[58] The textual and pictorial contents of *One Hundred Beauties of the Wu Region*, such as "Spring Inebriated" (fig. 4.14), include sexually explicit material, like other pornographic novels and sex guides available on the Ming market.[59] Obviously, this book was published for male literati under the cover of women's art and literature. To a certain degree, this reflects the late Ming tendency to blur the distinction between *yu* (carnal desire) and *qing* (emotional love), thus camouflaging male sexual desire as true love.

Qing was one of the most powerful cultural watchwords of the late Ming period. Born from personal love and passion, it is human emotion free of sexual desire. It is also the untainted source of familial responsibility and social morals, and as such becomes the sole paradigm of human relationships.[60] The emphasis on *qing* in literature and art was also a challenge to the Cheng-Zhu school of Neo-Confucianism, the mainstream philosophy of the time, which emphasized the logical analysis of natural harmony and social order. Thus, the priority of *qing* provided a new paradigm for society, since it placed a higher value

4.14 "Spring inebriated" (Zuichun tu), from *One Hundred Beauties of the Wu Region*, 1607, 1:3b. 21.5 x 13.2 cm. National Library of China, Beijing.

on individual sensitivity.[61] It was even interpreted as the source of all the other human feelings and values, such as reason (*li*), morality (*jiao*), filial piety (*xiao*), loyalty (*zhong*), and integrity (*jie*).[62] Feng Menglong once noted in his *Anatomy of Love* (Qingshi),

> Values like loyalty, filial piety, faith, and integrity, if they come from logic and reason, take personal effort, yet if they arise from *qing*, they are utterly genuine. . . . Contemporary scholars only know reason is the controlled mode of *qing*, [but] who understands that *qing* is the essence of reason?[63]

Here, Feng Menglong fixes *qing* at the center of philosophical reasoning. Personal emotion was elevated from its once marginal position of subjective discourse to the head of an entire value system. However, the predominance of *qing* ironically underscores its ultimate banality. *Qing*, repeatedly trumpeted in most popular literature, quickly became, as Dorothy Ko has noted, a cliché as both word and concept.

As the so-called cult of *qing* reached its apex, the cult of fidelity took simultaneous hold of society and culture. T'ien Ju-k'ang's statistical analysis shows the unprecedentedly large numbers of lifelong widows and widow suicides listed in Ming local histories.[64] Biographies of faithful women were published by the thousands in late Ming times. They can be found in epitaphs and short anecdotal sketches, local gazetteers, and the collected literary works of published scholars. Even popular pornographic novels such as *Wild History of the Embroidered Couch* (Xiuta yeshi) of 1597, while presenting a sexual fantasy of promiscuity, bizarre intercourse, and licentious escapades, promotes the virtuous widow and filial virgin as cult icons, thus entrapping women in the binary of either chastity or lasciviousness.[65] This paradox, however, is in fact built on the compatibility of literary and social tropes. Physical beauty and intense dedication to traditional values blurred the boundaries between stories of regulation and stories of romantic love. In stories centered on the canonical topos of widowhood, an emphasis on emotion came to be seen as positive. Even the conservative scholar Lü Kun (1536–1618), who saw *qing* in society as dangerously disruptive, admitted that widows who committed suicide simply to follow their husbands in death were dying not for "righteousness" (*yi*) but for "passion" (*qing*).[66] Late Ming culture was a tangle of irony and paradox that produced a flood of publications on both pornography and women's moral education.[67]

Therefore, we can see that women's images in *Heavenly Models and Exemplary Manners* are deeply rooted in the cultural soil of late Ming society and were tailored to male desires, voyeurism, and fantasies about women's behavior and inner feelings. In this sense, women's images in painting manuals and other popular prints satisfied the fantasy for sensual yet faithful, and thus ideal, women and, in so doing, provided an outlet for male obsessions with the romantic imagination in the guise of higher art and elegant taste. The effect was a form of erotica that provided discreet sensual pleasure to discerning viewers.[68]

Whether it was successful or not, *Heavenly Models and Exemplary Manners* remained an important touchstone for the late Ming middle class's dream of being artistic and sentimental. Readers learned from the painting manual not only how and what to paint in the female figure genre; that public was also invested in and invited to enjoy these images of talented and virtuous beauty, which they could valorize and even fall in love with.

5

The Art of Being Artistic

I consider originality as canon.

—Dong Qichang

S
ECTIONS ON BAMBOO, PLUM, ORCHID, AND BIRD-AND-FLOWER PAINTING
follow those on landscape and figure painting in *Grove of Paintings*.
Information in these chapters continues to be delivered via system-
atic and simplified pedagogical formulas. They use the concise summary form
as their primary teaching tool, and their pictorial guidance complements and
builds from this reader-friendly mnemonic device. Thus, in their textual and
pictorial aspects, these volumes of *Grove of Paintings* are clearly designed to
expedite readers' acquisition of painting skill and knowledge. Nevertheless,
the artistic formulas in them also address the subjective domain of the image-
making process, providing guidance by which readers can pictorialize their
personal emotions via the arrangement of certain motifs. One by-product is
an unavoidable irony—that personalization can be engineered via artificial
formulas.

Interestingly, as painting manuals encoded systems of expression in peda-
gogical devices, leading critics of the period promoted new artistic paradigms
such as "individuality" and "originality," precisely the opposite of culturally
approved artifice and uniformity. To a definitive degree, the new artistic agen-
das advocated by contemporary intellectuals must be understood as a conscious
response to the seasoned and manneristic programs of art making popularized
by the manuals. This suggests that late Ming painting manuals were a medium

that both highbrows and lowbrows paid attention to, an important cultural catalyst for the paradigm shift seen in late Ming art circles.

Standardization and Fixation of the Message

Like the chapters on landscape and figure paintings in *Forest of Paintings* and *Grove of Paintings*, much of the contents on still-life painting draw heavily from texts of earlier periods. A big difference, however, is that most of these are not reedited but are exact transcriptions of the originals and specify the names of their authors. For example, in *Shadows over the Hills of the Qi River* (Qiyuan xiaoying), the chapter on bamboo painting, most of the content is copied from Li Kan's *A Detailed Treatise on Bamboo* and cites Li Kan as the sole author of that content.[1] Similarly, many of the guidelines in *Dreaming of the Mountain of Floating Silk* (Luofu huanzhi), Zhou's manual of plum-flower painting, cite Yang Wujiu as their original author. Thus, in terms of their texts, still-life sections in *Grove of Paintings* do not differ substantially from the publications they copied; however, these sections do push their material further by presenting it in many new programs.

Most noteworthy is these programs' extensive reliance on a combination of pedagogical devices. First is the summary formula called *jue*. The summary form provides the basics of painting, laying the foundation for the reader's learning process and expediting understanding and memorization. Second, visual guides are presented in an idiom familiar to general readers. This includes configurations of Chinese characters combined into pictorial motifs and a step-by-step account of drawing. Third, dozens or even hundreds of pictorial models are given, so readers can broaden their graphic vocabularies or consult the manual as a kind of pattern book. In addition, many of these pictorial examples are accompanied by captions that define and explain the meanings of their motifs. Finally, the still-life sections all provide examples of inappropriate configurations and poor compositions; these help clearly define what is proper and what should be avoided in the practice of art. Altogether, these programs manifest a high level of mechanical simplicity and artifice intended to facilitate the reader's learning process.

The summary formula is used in every single category on still-life paintings in *Grove of Paintings*. One, included in *Dreaming of the Mountain of Floating Silk* and supposedly written by Zhou Lüjing himself, nicely illustrates the rhetoric and typical contents of this form. This text was reproduced word for word in the *Mustard Seed Garden Manual of Painting* of 1679 without specifying *Grove of Paintings* as its source, which suggests the recognized merits and expanded currency of Zhou's formulation in later periods.

5.1 "Things to avoid in bamboo paintings" (Huazhu suoji), in *Shadows over the Hills of the Qi River*, 66b–67a.

In painting the plum tree, there are Five Essentials to be kept in mind. First, the trunk should be old and gnarled, showing its age. Second, the main branches should twist while growing widely. Third, its branches should be clearly defined, with great care given to the way that they connect as well as to the unity that they form. Fourth, the tips of the branches should look strong, noble, and robust. Fifth, the blossoms should be original and lovely. In painting the plum, there are also things to be avoided. Above all, one must avoid wielding a brush that is not true, a point frequently discussed by the ancients. [Other points to be avoided are] flowers without calyxes, old branches without knots, whole branches without spaces, young trees with too many thorns, too few branches with too many blossoms, tips of branches not in the form of stag horns, a trunk not properly rooted or meaninglessly coiled, blossoms and branches without arrangement, young branches with moss on them, tips of branches all drawn in the same style, old trees that are not venerable, young trees that are not fresh. . . . If any of these faults is present, the whole effect will be spoiled.[2]

While listing the basics of painting plum trees and flowers, Zhou's summary draws a clear dichotomy between what is appropriate and what is not. The formula leaves no gray zones in its explanations: if a certain motif is to be rendered by

5.2 Pictorial motifs of plum petals, from *Dreaming of the Mountain of Floating Silk*, 76b.

readers, it must be done within the perimeter of the rules. There is little room for individual imagination. Marc Chagall and Claude Monet would have been judged terrible artists according to these restrictions. Such general formulas are further developed in the illustrations. *Shadows over the Hills of the Qi River* also offers many examples of tasteless bamboo paintings along with captions pinpointing their faults; these include a bamboo leaf that resembles a nail head, a *xiao* character (小), or a *ge* character (个) and a branch that looks like a drum, two branches growing parallel, or branches arranged symmetrically that look like a drum table (fig. 5.1). By this formula, the manual helpfully compares the flaws in common characters and objects based on their textual and pictorial similarities, another witty innovation meant to assist readers' understanding and memorization.[3]

A similar strategy is used for the sample images in *Dreaming of the Mountain of Floating Silk*. Pictorial motifs expressively labeled "peppercorn," "smiling dimples," "monkey ear," "mouse whiskers," "bee whiskers," "deer horns," "child's face," and "rat tails" provide visual cues for the rendering of buds, blossoms, stamens, and branches (fig. 5.2). This system was not new with Zhou Lüjing's manuals, since such labels were conventions supposedly dating back to the Song dynasty. One of the earlier examples is found in two poems composed by Zhao Mengjian (1199–1264) in the mid-thirteenth century. They constitute the earliest datable treatise on how to paint the "ink plum" and achieved wide circulation.[4]

5.3 A summary song and its illustrations, from *Dreaming of the Mountain of Floating Silk,* 75b–76a.

This text, known as Zhao Mengjian's *Plum Guide* (Meipu), likewise characterizes the features of plum flowers using the terms "peppercorns," "smiling dimples," "deer horns," "rat tails," and so on. In addition, as Maggie Bickford has suggested, these names seem to have been initially used in an anonymous, undated "typological manual" (*taipu*) that may stand behind Song Boren's book and were later incorporated into Wu Taisu's *Pine Studio Plum Painting Manual* (Songzhai meipu).[5] The purpose of these morphologically descriptive names and instructions in verse was clearly to assist novice painters in learning the conventions that constitute the formal vocabulary of plum painting.[6]

An example in the plum painting section may highlight the pedagogical formula in *Grove of Paintings*. Here, a brief summary song is accompanied by a group of images providing examples of items noted in the text. This lyrical digest was meant to help readers *memorize* the contents by repeated chanting. The song's lyrics lay out the many different types of plum flowers found in paintings and are followed by graphic representations of the same in succeeding pages. Most interesting is the transformation of simple Chinese characters into pictorial configurations of plum petals. Figure 5.3 shows this transformation of the characters

yu 余, *huo* 火, *er* 尒, and *shi* 示 listed in the summary.[7] The text literally duplicates the image, and vice versa, at both the semiotic and the semantic level. These two signs are co-operative, that is, the two heterogeneous units of character and image essentially give up their distinct spaces. Thus, they are not only contiguous but also "homogenized" as they are in the rebus, which fuses words and images in a single act of writing and drawing. The image is no longer explained by the words but instead is illustrated by one character. The beauty of this is that anyone who recognized these simple characters could easily learn at least a few different plum-blossom motifs, and any literate person who read this summary song and looked at the illustrations could instantly become a successful novice painter or at least command basic technical knowledge of plum painting.

This didactic principle has a notable parallel in early modern European pedagogy on drawing. Leon Battista Alberti (1404–1472) recommended the same method, whereby his pupils were to apply the skills of writing to the learning of drawing. Starting from individual letters of the alphabet, people learn how to group individual characters to produce a word and then finally to form a sentence by following custom and grammar. Alberti noted that students of painting should learn in a similar manner: starting from the outlining of surfaces, proceeding to the positioning of the subject on the screen, and finally achieving the ability to finish the image. The comparison between learning to write and learning to draw is repeated in many European drawing manuals, which pegs this method to what may be termed *ut grammatica pictura*.[8] A similar pattern of device is registered in the first page of illustrations in *Chirping and Flying in a Spring Valley* (fig. 5.4). Like the paint-by-numbers kits of the modern period, this page presents a foolproof step-by-step guide to the process of drawing a bird, starting with the beak and then on to the eye, the full head, back, claws, and feathers. This graphic explanation of painting birds lacks any textual explanation and instead epitomizes how illustration might serve as a stand-alone teaching tool.[9]

Another important feature found in all the chapters on still life in *Grove of Paintings* is the ready-made motif, numbering from dozens to even hundreds in some chapters. In *Chirping and Flying in a Spring Valley*, for example, the step-by-step guide for rendering a bird is followed by illustrations of various types of birds in different settings and poses. Some of them are paired, while others are single. They are chirping, watching or swallowing prey, preening, sitting on a branch, or playing. In this section's brief text, Zhou Lüjing notes that the images are copied from the paintings of Song and Yuan dynasty masters, including Huang Quan, Wang Yuan, the Huizong emperor, and Qian Xuan.[10] Interestingly, one motif in this volume, showing the pose "flying down" (*guzhuishi*) (fig.

5.4 Pictorial guide for painting a bird, from *Chirping and Flying in a Spring Valley*, 24b–25a.

5.5), very nearly replicates the pose of a bird in a Song painting (fig. 5.6). The size of the birds against a blank background and the accompanying captions giving the pose and gesture suggest that these images are formatted specifically as ready-mades and the manuals could thus also serve as pattern books.[11] The bird images as well as the illustrations of insects and small animals (fig. 5.7) could be transplanted into any composition, as the reader wished. Such sample images are also found in the other chapters of *Grove of Painting*. In *Lingering Beauty of the Nine Fields*, for example, dozens of orchid flowers are arranged according to type without any textual explanation of their meanings (fig. 5.8). Taken altogether, the still-life chapters form a comprehensive collection of formal variations based on the careful and thorough observation of nature and earlier paintings; the resulting model drawings could save the novice time, work, and creative effort.

In all the other chapters of *Grove of Paintings*, textual guides are more or at least equally as important as such graphic guides in terms of the relative amount of space devoted to them. But in *Chirping and Flying in a Spring Valley*, only a couple of pages are devoted to text, while the remainder is devoted to model images. It would be useful to consider the peculiar cultural status of bird-and-flower

paintings in traditional China. The absence of illustrations in *Painting Critique and the Sea of Art*, the section on landscape painting, is possibly due to cultural protocols of the period, since book illustrations were not considered a legitimate medium for this holy grail of literati art. In contrast, the bird-and-flower genre tended to be categorized as suitable subject matter for women and artisans, people with presumably less education and interest in textual representations.

As Craig Clunas has noted, late Ming women artists rarely painted landscapes, the most prestigious artistic subject; instead, they excelled in the painting of flowers and insects.[12] While some wives and daughters of scholar families, such as Huang Jieling (act. 1650s), Fu Daokun (dates unknown), and Ma Xianqing (1469–1538), still painted landscapes, the majority of late Ming female painters from ordinary families had to cope with this long-entrenched cultural prejudice. Wen Shu (1595–1634), a professional painter and housewife, for instance, focused mostly on flower and insect paintings. Interestingly, contemporary courtesans appear to have enjoyed a bit more freedom in their selection of subject matter. Two courtesan painters, Ma Shouzhen (1548–1604) and Xue Susu (ca. 1573–1620), both specialized in genres favored by male literati, such as ink landscape and bamboo. In terms of style, their paintings of flowers and plants in the garden

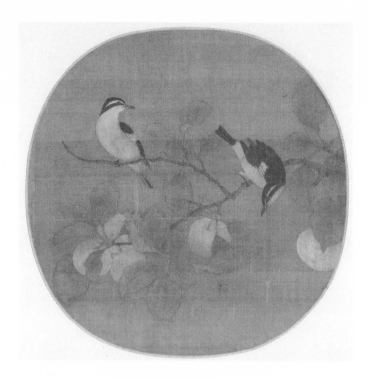

5.6 Artist unknown, Birds on a Peach Branch, ca. 12th century. Album leaf, ink and color on silk, 24.8 x 25.7 cm. Cleveland Museum of Art.

were less orderly and focused on the individual character of each element, while housewives tended to depict these subjects in a relatively elaborate manner. Furthermore, courtesan artists left many colophons and poems on their paintings, but other women left very few, thus masking any literary creativity.[13] This kind of social restriction was also common in Victorian England, where women were allowed to display their talent only in areas like flower painting, a genre deemed unimportant and purely decorative.[14] This suggests that the programs of *Chirping and Flying in a Spring Valley* were more or less determined by the manual's expected readership, an audience whose taste and level of education made pictorial guides seem appropriate and sufficient.

Personalized Nature

Some images in the painting manuals are specially designed to carry poetic implications; these include the conditions of one's environment, a painter's personal emotions, or the metaphorical messages conveyed by certain objects.

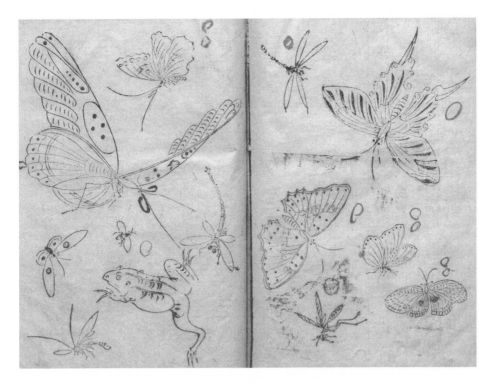

5.7 Pictorial motifs of insects and animals from *Chirping and Flying in a Spring Valley*, 45a–46b.

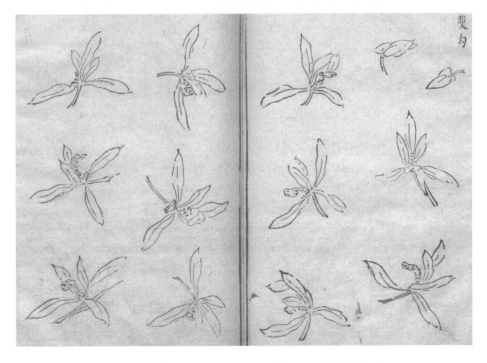

5.8 Pictorial motifs of orchids from *Lingering Beauty of the Nine Fields*, 7b–8a.

5.9 "Meeting the wind," from *Lingering Beauty of the Nine Fields*, 7a.

5.10 "After a long rain," from *Lingering Beauty of the Nine Fields*, 7a.

For example, the images "Meeting the wind" (*yingfeng*) and "After a long rain" (*jiuyu*) in *Lingering Beauty of the Nine Fields* present weather conditions that have specific effects on the potently symbolic orchid blossom. "Meeting the wind" (fig. 5.9) shows the petals and stems of the orchid flower bent fully horizontal and visually insinuates the presence and power of an outside force, in this case, the wind. Similarly, the figure "After a long rain" (fig. 5.10) shows an orchid flower drooping under the weight of water retained on its petals. The pictorial representation of weather effects in the rendering of certain motifs was discussed in painting texts as early as the Song dynasty. For example, in Han Zhuo's *A Pure and Complete Collection of Landscape*, rain and snow are categorized in terms of their traits or the environments in which they occur, such

5.11 "Containing dew," from *Lingering Beauty of the Nine Fields*, 5b.

5.12 "Emitting fragrance," from *Lingering Beauty of the Nine Fields*, 4b.

as the time of day, season, direction, and location. Modifying labels such as "driving rain," "showers," "night rain," and "clearing after rain" in Han Zhuo's writing convey the specific qualities of these elements. Han explained that since wind has no visible traits itself, it must be represented through the arrangement of objects in nature.[15]

In other examples, however, motifs are presented not as passive receptacles of outside forces but as agents with their own strength, motivation, and feelings—in short, as independent beings possessing their own consciousness and physical strength. For example, "Containing dew" (*hanlou*) and "Emitting fragrance" (*tuxiang*), illustrations of motifs in *Lingering Beauty of the Nine Fields* (figs. 5.11, 5.12), represent the physical postures of orchid flowers as if these expressed a kind of will. The specific terms used in the description of their poses—"holding" (*han*)

and "spitting" (*tu*)—suggest the idea that the orchid possesses an active and conscious identity and is capable of making choices followed by certain actions. This personification is rooted in a long-established literary tradition, in which the orchid symbolizes unappreciated virtue or beauty because, in the wild, it grows in inaccessible areas.[16] The rhetoric of personification may even portray natural objects as venerable entities taking resolute action to maintain ethical standards or achieve moral perfection and social order. For example, a paragraph in Li Kan's *A Detailed Treatise on Bamboo* highlights the bamboo's consciousness of the moral and social order.

> Bamboo is neither a grass nor a tree, not disordered or variegated. Although they grow in different places, they are always consistent in form. Those that grow separately nonetheless maintain a distinction between young and old; those that grow in a rhizome enjoy the relations between father and son. Dense but not fussy, thinly spaced but not shallow, they fill the space simply and silently; connecting with the spirit subtly and genuinely, they can be compared to the impeccable sages. [Therefore] a painting [of bamboo] in a hanging scroll format can be compared to the portraits of past worthies of wise and thoughtful demeanor, so it will inspire respect in viewers.[17]

Here, Li Kan's text not only suggests that bamboo possesses a will and consciousness as well as virtue equal to that of the sages; his comments further describe how bamboo habits replicate human relationships, such as those between father and son and between the old and the young, thus portraying them as entities that communicate, share feelings, and respect each other. John Ruskin (1819–1900), in his 1856 work *Modern Painters*, called this process of humanizing nature or objects the "pathetic fallacy." The aim of the pathetic fallacy was "to signify any description of inanimate natural objects that ascribes to them human capabilities, sensations, and emotions."[18] In a broader sense, this anthropomorphic equation is a form of personification, a rhetorical figure, and thus a legitimate poetic device.

In traditional Chinese poetry, the pathetic fallacy is usually reserved for moments of heightened emotion. One image in *Dreaming of the Mountain of Floating Silk*, captioned "Private conversation" (*siyu*) (fig. 5.13), is a good example of the process taken in a romantic direction. Here, two plum flowers on a twig face each other and appear to be talking to each other. Considering that the plum is the traditional metaphor for beauty and youth, we can read this as two lovers whispering intimately together. As early as the Six Dynasties, Xiao Gang's

5.13 "Private conversation," from *Dreaming of the Mountain of Floating Silk*, 81b.

"An Essay on the Plum Blossom" (Meihua fu) personified the plum flower as the palace lady. Beautiful and precious though such ladies may have been, they were also associated with melancholic thoughts of loneliness and transience as well as with tinges of nostalgia.[19] *Dreaming of the Mountain of Floating Silk* has plenty of images of this kind, such as "looking in the mirror" (*kuijing*), "gazing at each other" (*guanmian*), and "a flushed face" (*xiurong*). The use of plum flowers as a romantic figure was already well established in Song art and literature, but its full registration in the genre of painting manuals occurred in late Ming China.[20]

As an artistic genre, still-life paintings raise significant questions about what people in a given society and time wanted to see and imagine, or what was promoted as desirable or fascinating. In its subject matter, still life depends on the pleasure of looking that is initiated by the beholders' interest in the material world. As Norman Bryson and Richard Leppert have explained, still life is not simple representation of nature or objects. How and why an artist from a certain time and location depicts his or her subjects are not the random outcome of artistic production.

> Still life is a profound record of interests, yet it is never "objective" in its account and is all the more interesting and important for that reason. . . . In other words, still life is about the relation of the object world to the human subject who is unseen but imagined. Still life specially depends for its effects on an erotics—the desire and pleasure—of looking, triggered by the beholder's relation to the material world. "By default, what still life shows is the gaze. Since most of the objects in still life tend not to supply their own rationale for representation, what emerges when they are depicted is the act of representation as bestowed, unearned, as conferred, gratuitously, upon objects that exactly lack the power to summon representation." Still life privileges culture over nature . . . to the extent that nature is commonly sacrificed to culture.[21]

Thus, the painting manual's inclusion of many images that function as romantic metaphors suggests a cultural trend or force in society that created sensitivity to these figures and a desire to consume them. As discussed in chapter 4, iconic beauties from popular romantic stories were obvious candidates for depiction in manuals of figure paintings. If romanticizing women's love met the emotional desires of both genders in society, there were hundreds of contemporary dramas and novels that also valorized the image of the talented and sensitive gentleman; these romantic heroes were extremely well-educated, serious, and ambitious but could also whisper, sing, and promise undying love to their significant others. It is not a logical stretch to link these sensitive gentlemen with the sentimentalized motifs in the still-life manuals. Their talent is proven by their practice of art, while their romanticized paintings demonstrate their true sensitivity. Thus, the glorification of romantic icons signals another area of expressive virtuosity in late Ming society, one that required not only artistic skill and taste but also a certain (if not entirely romantic) sense and sensibility. The manuals most definitely addressed this concern by teaching their readers how to show inner emotion as pictorial idiom, to make the invisible visible.

However, there may be some critical fallacy inherent in this process of pictorial romanticization. The lyrical captions for the model drawings offer readers an opportunity to explore the relationship between text and image. "Private conversation," for instance, points readers to the correct register of interpretation and permits them to focus not simply their gaze but also their understanding of the image. The symbolic message encoded in the pictorial motif juxtaposed with the linguistic sign leads to both identification and interpretation; their juxtaposition narrows the relationship between the image and the totality of possible iconic messages. In other words, the caption helps readers decode the pictorial idioms and permits them to share the creator's gaze as well as his intended meaning. Here, the caption anchors the meaning, which controls the mechanism and erotics of the image.[22] Such inscriptions inject familiar readings into the space of the illustration and help readers understand how pictorial motifs permit viewers to project personal emotions. In this process, however, these programs make perhaps overly transparent the relationship between image and subjectivity for unsophisticated readers, since pictorial sign and text are virtually conflated. Ironically, in these programs, the reader's ability to customize pictorial motifs in order to express unique feelings is itself an illusion. Such formulaic teaching of sensibility makes it apparent that even the reader's subjectivity is completely dependent on the artifice and standardization registered in the manuals.

Adorno notes that a fundamental characteristic of popular music produced by the culture industry is its "standardization," even that part of the music in which an attempt is made to circumvent standards. This type of systematic and structural standardization aims for and generates standard reactions; thus, the process of translating the unique into a pattern is calculated, guided, and achieved within industrial cultural production. In the process, it can be said that the music is no longer offered for listeners; instead, individual listeners (many of whom believe themselves to be creative and spontaneous listeners) are repeatedly exposed to formulas that condition musical reflexes. Therefore, standardization in art—even when disguised as being "artistic"—is synonymous with "pseudo-individualization," in which the process of standardization is disguised by providing minor changes from song to song, thus focusing on the relationship between cultural products.[23]

Similarly, these images and their poetic captions in *Grove of Paintings* cannot help readers break out of the standardization inherent in their very method; instead, they can only try to cover up this illusion. As Gendron has noted in terms of cars, the use of style or pseudo-individualization such as the addition of a tail fin to a Cadillac distinguishes the vehicles from one another but can only mask the fact of its mass production, that is, its standardization.[24] Thus, these guidebooks to superior artistic taste and sentimental expression ironically deliver their contents in ways that run exactly counter to the idea of special knowledge and personal mastery pursued by their readers. Artistic, poetic, and romantic subjectivity, all qualities these manuals promise, remain, in the end, a tantalizing but unreachable goal within the forest of paintings.

Artistic Originality in the Age of Painting Manuals

We might conclude, then, that these late Ming painting manuals played little part in the artistic discourse and production of elite practitioners and theorizers. Imagining for a moment from our own context, would we expect leading art historians (e.g., T. J. Clark, Linda Nochlin, or Craig Clunas) to voluntarily choose to write reviews of the popular art guidebook series *Art for Dummies* or *Art History for Dummies*? Maybe this comparison would not hold if the readership of the late Ming manuals and the *Dummies* series turned out to be vastly different (which could be true to a certain degree). But in terms of the books' relationship with higher-taste knowledge groups of each period, their social and status identities appear to be quite similar. Consumers of late Ming painting manuals probably never heard of the debates about the Northern and Southern Schools, and

readers of *Art for Dummies* are less likely to possess detailed knowledge about postmodernism or conceptual art. Then what are we to make of the fact that late Ming master painters and critics were most likely aware of the contents and pictorial styles covered in the painting manuals and, even more surprisingly, that these publications may have played a part in changing the direction high art was to take in principle and in practice? This suggests that these manuals occupied a liminal zone between the middle and high class cultural arenas.

Walter Benjamin has argued that the "art for art's sake" movement in the latter half of the nineteenth century was a reaction to the commercialization of culture in Europe and the possible threats it posed to social elites' exclusive claim to art.[25] The commercialization and popularization of art apparently allowed the larger public to participate in the reception and appreciation of art and ultimately afforded them a role in the artistic arena. This also appears to have been the case in the late Ming art world. Both the large print runs of these painting manuals as well as cultural debates over their use in society implicitly testify to their prominent presence and influence in that day. It is very likely that these publications were seen as a serious threat to contemporary intellectuals, who harped on their exclusive ownership of artistic leisure. Late Ming highbrow art was working out a new paradigm for its claim to superiority, and the painting manuals, while not the only factor in this process, nonetheless had a significant impact on this movement. Many leading artists consciously tried not to follow the programs offered in the manuals, making a point of avoiding them and discovering something completely new.

Contemporary critics, including that unchallenged arbiter of artistic taste Dong Qichang, claimed that the modus operandi of true masters was to pursue and achieve distinctive and unique expressions. Dong noted, "When old masters wrote calligraphy, they did not follow established models. Instead, they always took originality [*qi*] as their canon."[26] He comments elsewhere, "In general, the divine paintings of the masters must have originality in their brushwork."[27] In these statements, he emphasizes the importance of originality, another value concept promoted within late Ming society. The term *qi* refers to a range of different meanings: bizarre, strange, different, eccentric, unusual, novel, marvelous, rare, shocking, and original.[28] In the late Ming, this term, as Bai Qianshen has clearly pointed out, was used rather loosely: "It could refer to an ideal quality in a person, to an unusual lifestyle, or to the eccentric behavior of a member of the elite used as a strategy to redefine his social standing during a period in which social relationships were fluid; it could refer to the exotic for the intellectually curious and in popular entertainment; it was an element of a literary and artistic

discourse that bespoke a new aesthetics; and it was used as an advertising ploy by commercial publishers."[29] He further elaborates that it was precisely the vagueness and openness of the term that created its innumerable possibilities.

In general, the term *qi* was used to describe anything innovative, in either commercial, intellectual, or artistic work. But it could have had a more definite rhetorical function: its creative and progressive aspects in late Ming art and literature were first acknowledged by Andrew Plaks. As he explains, the word *qi* carried positive and laudatory connotations in late Ming cultural criticism, in which it unequivocally indicated something completely new and ingenious and thus denoted a strongly positive valuation of the creative genius of writers and artists who were tagged with the term.[30] The semantics beyond its literal definition present the interpretive connotations of anti-normative, anti-traditional, and anti-conventional; thus, the term *qi* points to the faculty of true genius.

The promotion of *qi* is found in a number of late Ming writings. Yuan Hongdao, a wildly unconventional critic of the period, avidly promoted ingenuity, individuality, and thus originality in art and literature, as opposed to mechanical imitation of models from the past.[31]

A good artist learns from nature, not from any one person. A good student embraces the spirit, not the doctrines. A good master takes for his master not someone in the past, but the whole glorious creation. Take, for instance, the person who considers Li Tang (ca. 1050–1130) as his master. Does he try merely to learn the compositions and stroke techniques of Li Tang? Or should he not rather learn the spirit of Li Tang, the spirit of not wanting to be Han, or a Wei, or a man of the Six Dynasties? This is the right way to learn. It is said one can win a victory in a battle by "burning one's bridges," but one can also lose it by the same method and sometimes win by not burning them. Thus, to disobey the rules is sometimes the right way to follow the masters of the past. Many authors today condemn as new poetry whatever shows a [fresh] line that truly describes something, and when they observe the rules and patterns and borrow some superficial lines from others, they call it "restoration of the ancients." This is to follow the rules, but it has not the real beauty and charm of the ancient authors. It is the method of death.[32]

This comment clearly defines the changed role of artists; they are supposed to break away from established rules in art and found their own styles, which would distinguish their identities and secure their place in history. Thus, learning the style and formal habits of previous masters had become insufficient and inferior.[33]

In both their subject matter and their styles, many of the leading painters of the late Ming produced idiosyncratic work that distinguished them from previous and contemporary artists.[34] These examples include the surrealistic mountains and figures of Wu Bin (act. ca. 1573–1620) (fig. 5.14) and Chen Hongshou's reduction of landscape elements to abstract forms that nonetheless express an unprecedentedly intimate and personalized nature (see plate 16). Additional examples include Hongren's (1610–1664) distortion of general shapes and composition expressed in terse brushstrokes; Gong Xian's (1618–1689) extreme application of chiaroscuro in the manner of contemporary Western drawings; Li Shida's (ca. 1540–ca. 1620) chubby, round, and humorous figures; Zhang Hong's (1577–ca. 1652) use of Western perspectives as well as the bird's-eye view; Bada Shanren's (1626–1705) contemplative and psychopathic pictorial narrations; and Shitao's (1642–1707) eccentric use of color and ink and experiments in perspective and shaping, which completely challenge pictorial logic. These new artistic expressions display a heightened sense of individualized characteristics, but they are not mere stylistic aberrations. Instead, they signal a significant evolution in the role of artists in this period.[35]

Artistic originality was the new watchword, motto, and canon of the late Ming masters. Many contemporary critics left comments that questioned established styles from the past. For example, Li Rihua noted, "When a man looks at paintings, why should he confine himself within an established style?" Another painter, Yun Xiang (1568–1655), wrote, "What people have [in styles] I don't have, but I possess what others don't have." Furthermore, the priority of the Gong'an School theoreticians was to seek out originality in art and literature and to challenge established principles. Yuan Hongdao's famous dictum "Having no rule is my rule" (wufa weifa) well captures the spirit of the time.[36] Led by Yuan Hongdao and his brothers, the so-called Gong'an School advocated the ideas of Li Zhi, the iconoclastic Neo-Confucian thinker who promoted "authenticity" (zhen) and "originality" in art and literature. As a path to authenticity, the Gong'an School valorized the cultivation of a "childlike mind," which further paved the way for celebrating truthfulness as a characteristic. A famous statement by Li explains the relationship between authenticity and originality: "The best in literature always came from the childlike mind, and if the childlike mind continued to exist in this way, moral principles would not be practiced, received impressions would not stand up, and the writing of any age, any man, any form, any style, and any language would all be accepted as literature."[37] Here, the idea is that man's nature is originally pure and genuine, and thus people should follow wherever it spontaneously leads. If any type of didactic or pedagogical doctrine is imposed upon the innate childlike

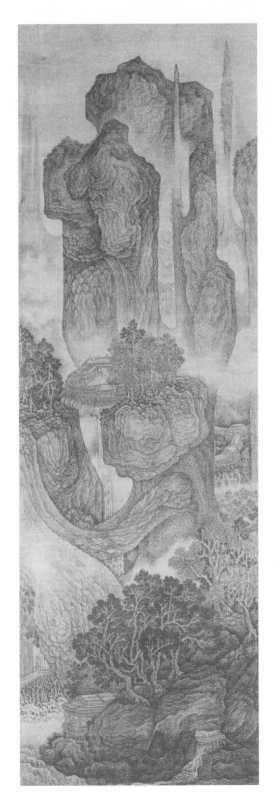

5.14 Wu Bin (act. ca. 1573–1620), *Steep Ravines and Flying Cascades*, before 1610. Hanging scroll, ink on silk, 252.7 x 82.1 cm. National Palace Museum, Taipei.

mind, the mind loses its capacity to create idiosyncratic works. Li Zhi claimed that this obstacle comes mainly from reading books and learning moral principles. Therefore, the childlike mind was, following Katharine Burnett's interpretation, "the fountainhead of innate, authentic or genuine (*zhen*) expression, and thus personal uniqueness," in other words, sincere originality in art and literature.[38]

In this regard, we can understand that the programs of the painting manuals—built on mechanical formulas, popular culture, and conventional pictorial motifs—ran in exact opposition to this new artistic paradigm. Thus, for sophisticated critics and artists, these manuals must have represented a repository of the age-old artistic expression from which they wanted to distance themselves. One contemporary writer, Zhao Huanguang (1559–1625), left a very revealing comment regarding the contradictions between artistic originality and the use of painting manuals.

> Amateur painters try to obtain famous painting manuals, and they are unhappy that genuine copies of these are difficult to obtain. I say, "Only if you *don't* use manuals can you attain authenticity in painting!" A guest responded, "If you say that is so, then how can you attain originality in brushwork?" I replied, "Only without manuals can I achieve originality. [If] you are looking to [paint] a branch that has originality, why can't you learn that from a tree? As for original rocks, why can't the mountains be our teacher?"[39]

While this comment explains the late Ming public's interest in painting manuals, it explicitly discourages their use, noting that the manuals cannot help novice painters achieve authenticity and originality in their work. Painting manuals at this point served as a medium regulating artistic communications between practitioners and audiences, and they revolutionized the ways in which artworks entered the public domain. Paintings by traditional masters, including Wu Zhen, Shen Zhou, and Wen Zhenming, now became widely known among the public thanks to these publications, but just so, their art came to be regarded as common and dated, if not completely obsolete. In this regard, it is not surprising that late Ming critics considered the founding fathers of early to mid-Ming literati art uncreative in their execution and derivative for following the old masters.[40]

A general comment by Dong Qichang discredits the pedagogical aims of the painting manuals while valorizing originality in art.

> When literati-scholars create paintings, they should use the methods for eccentric (*qi*) characters in the cursive and clerical scripts. Trees should look like bent

iron and mountains as if made of sand; you should avoid imitating that sac-charine, popular style, so you can achieve the flair of literati taste. If you don't follow this [advice], your work will lose its austere air and discipline, and you will fall into the hell of mere commercial painting, from which nothing can save you.[41]

Here, while promoting the primacy of literati art over that done by professionals, Dong discourages readers from relying on fast and easy formulas for learning artistic practice, precisely the prescriptions of late Ming painting manuals.[42] His comment further defines "literati art" as a program in pursuit of originality. The artistic guidelines promoting uniqueness and innovation are equivalent to the behavioral ideal for the elite class. Similar comments came from other leading critics of the time—Gao Lian, Fan Yunlin (1558–1641), and Tang Zhiqi (1579–1651) all valorized the link between literati flair and original forms in art.[43] For them, the outdated, well-known, and easy-to-master techniques and ideas of old no lon-ger provided a program suitable for true literati taste.

Paintings by the late Ming master Xu Wei (1521–1593) exemplify the artistic values pursued by early modern Chinese masters (fig. 5.15). The wild lines and shapes in his paintings are completely different from the pictorial styles found in contemporary painting manuals. His furious, unstoppable, and, most impor-tantly, unprecedented brushwork across the picture plane seems to epitomize the contemporary ideal of originality. Xu Wei himself once noted,

In my entire life, I have never consulted manuals on painting plum blossoms, I just trust my hand and the inspiration comes of itself.
 If you don't believe this, just watch how the myriads of trees put out their spring greens when the east breeze arrives.[44]

Here, Xu Wei is confident that his artistic inspiration is a natural phenomenon, like the change of seasons. As the warm spring breezes revitalize the frozen trees, his hand also unleashes the life force of the plum across the picture plane. Still, this comment also testifies to the wide acceptance of painting manuals in his time as well as the unfavorable opinion of them held by leading master painters. Xu made the conscious choice (or claims such) not to consult these manuals; therefore his art remained beyond the set or established practices, however use-ful, such publications promoted.

In sum, we should not underestimate the role of painting manuals in the field of cultural production in early modern China. Altogether, the zones of overlap

5.15 Xu Wei (1521–1593), detail of *Flower and Fruit*. Hand scroll, ink on paper. Jiangsu Provincial Museum, Nanjing.

between various cultural media, different classes, and the critical debate over the use of such manuals clearly show how these publications were engaged with taste-making mechanisms shared by both middlebrow and highbrow culture. At both levels, artistic talent permitted an increasingly affluent urban public to position itself more favorably in a society in which cultural finesse could translate into social access and power. In this process, painting textbooks, initially prepared to accommodate the tastes of a broader public, perhaps inevitably triggered the elevation of originality, which became the new artistic paradigm in late Ming society.

Coda

The Late Ming at the Crossroads

THIS BOOK SET OUT TO INVESTIGATE A RATHER SIMPLE QUESTION: WHY DID painting manuals suddenly become so popular in late Ming China? Wood-block printing technology, the use of illustrations in printed books, the genre of painting manuals, and the presence of a leisure class had all been part of the Chinese cultural scene well before the mid-sixteenth century. However, the emergence and rapid popularization of painting manuals at that historical moment are not a historical anomaly. Instead, they are clearly related to the transforming structures of both society and culture at large, which included the development of a market system and book industry. The audience for these books comprised the simply curious, landlords, shop owners, scholars, collectors of every stripe, and their sons and daughters. Through its active consumption of these publications, the emerging urban public unmistakably announced its presence and growing agency as a social class.

As Thorstein Veblen once noted, possession of wealth and power is not sufficient unless it is put in evidence.[1] As in our modern society, in late Ming China, growing numbers of successful urbanites found leisure to be an effective means of translating their economic accomplishment into a brand-new identity, that of an elegant elite. In a sense, leisure, and especially painting, functioned as an effective part-time occupation by which a person could publicize his or her cultural capital. The merit of painting, along with other types of artistic hobbies, was the assumed refinement it conferred on the practitioner. Artistic virtuosity signaled social distinction because it required not only wealth and knowledge but also a certain sensibility. Painting manuals offered tools that helped the aspiring art hobbyist negotiate an artistic persona and subjectivity, which could then be leveraged in

terms of class and power. Therefore, these painting manuals functioned not only as artistic or cultural tools but also as social and even practical devices, through which one's position in society could be displayed, claimed, and negotiated during a period when the definition of elite identity was open to debate.

What really matters about the social use of these manuals is that they inserted artistic theory and practice into public discourse. Their programs explained the practice and knowledge of painting by reference to individual motifs and encyclopedic entries, which facilitated the public's understanding of the secrets of art and democratized access to what had been the culture of the privileged few. A coherent mnemonic and cognitive system adopted for the description of techniques and methods not only disseminated this knowledge but also, and more importantly, rationalized artistic and aesthetic experience as a legitimate pursuit in people's daily lives. However, the format and programs of these manuals contain a series of schemata based mostly on partial, rather than comprehensive, ways of making and seeing images. Certain pedagogical devices in the volumes are overly simplified and details are sacrificed. In addition, the manuals also present many model images transposed from popular illustrations. These adjustments were designed to meet the expectations, needs, and visual literacy of the target readership. As a result, the manuals represent a critical disjuncture from the art practiced and favored by leading artists and critics of the time.

Interestingly, these manuals claimed that "literati taste" could be mastered by their readers. In reality, however, they proffered only the surface of higher arts and culture. Contemporary critics disparaged the manuals as being suitable only for philistine tastes and instead promoted the new paradigm of originality, or *qi*, in literati art and literature. For cultural elites, this was an effort to reclaim their turf and social status by reconstituting distinction in their art and thought. For readers of painting manuals, attaining literati flair in their painting was not necessarily an artistic norm but a social or behavioral ideal. The narratives in late Ming painting manuals perpetuated this ideal without fully resolving the contradictions introduced by their methods. It is not surprising, then, that late Ming cultural elites were more than a little skeptical of the elevation of "literati taste" by the larger public. A liberal critic of the time, Li Zhi, once noted,

No matter how clever the words, what have they to do with oneself? What else can there be but phony (*jia*) men speaking phony words, doing phony things, writing phony writings? Once the men become phonies, everything becomes phony. Thereafter if one speaks phony talk to the phonies, the phonies are pleased; if one does phony things as the phonies

do, the phonies are pleased; and if one discourses with the phonies through phony writings, the phonies are pleased. Everything is phony, and everyone is pleased.[2]

Li's condemnation of phoniness marks not only his dissatisfaction with contemporary art and literature but also his anguish over the unstable nature of elite identity. This passage clearly indicates his uneasiness with the inauthenticity of people's interest in art and literature as cultural capital and proof of elite status. It seems as if he is really asking, "Is your interest in art genuine?" which implies "Are you a real literatus?" Li's comment here definitely resonates with his promotion of the childlike mind—the sincere, untainted, and authentic source of inspiration and creation, which cannot be learned and thus cannot be forged.

Summing up, it becomes clear that the late Ming was a critical crossroads where the early modernity of society and culture was being formed and contested. All the innovative cultural ideas of authenticity, originality, individuality, and the childlike mind obviously coexisted with literati dissatisfaction and concerns over the popularization of art collecting and practice. They pushed back against phoniness, artificiality, and inauthenticity as rapid urbanization, increased literacy, a growing art market, a large number of how-to books (including painting manuals), and an emerging middle class became ever more conspicuous in Chinese society. A certain cause-and-effect dynamic was definitely in play.

Artistic originality was celebrated as art making itself no longer commanded its old prestige. What became ever more important was *how* one did it, that is, how one differentiated one's artistic taste from that of other art lovers, to prove one's exclusive superiority and rise above the majority of the public. The elite class had to create a new artistic and cultural program and styles by advocating individualistic or unique expressions not found in books on art or known traditions and schools. This was the elites' effort to "authenticate" their status in terms of art and culture. Easy access to traditional elite knowledge via print media evidently de-privileged the age-old turf of literati culture. Authenticity mattered most because it set new criteria by which to establish the qualifications of real elites and their culture. In this regard, the promotion of the childlike mind can be understood as a rhetorical machine that transported the compass of elite status to a more idealistic and mystified domain. It claimed that originality can be authentic only if it is created by an inherent talent and mind that lie beyond pedagogy or set rules offered in books. Thus, both "authenticity" and "originality," the two most important words of the late Ming cultural arena, are bound together in a tight circuit.

All in all, the situation in the arts clearly resonated with the pressures and contradictions of the multi-class society in late Ming China, where the popular equation between art and status was being contested and a new social semiotics was under negotiation. Different social classes, various artistic values, and the interaction between them, undeniably reveal the entangled roots of cultural and social negotiations in early modern China. Late Ming painting manuals as a product of the time represent an important process in Chinese history, one in which artistic discourse surfs on cultural and social discourses, and vice versa.

Appendix 1

Locations and Editions of Late Ming Painting Manuals

Note: Many bibliographic references, such as *Zhongguo shanben shumu* and *Zhongguo congshu zonglu*, contain misinformation regarding the whereabouts of original copies of late Ming painting manuals. The most common challenges I encountered during my research were the occasions when these rare items are not owned by the institutions or archives where they are recorded as being housed. The following publications are those whose locations I confirmed during my research.

Chen Meigong xiansheng dingzheng huapu (Painting manual revised by Master Chen Jiru)

> EIGHT-*JUAN* EDITION
> National Library of China (all illustrations are missing)

> FOUR-*JUAN* EDITION
> Chinese Department Library at Nanjing University

Chuanzhen miyao (Secrets of portraiture)

> *GEZHI CONGSHU* EDITION
> Shandong Provincial Library
> Institute for Research in Humanities, Kyoto University

> *BAIJIA MINGSHU* EDITION
> National Archives of Japan, Tokyo

Gao Song huapu (Painting manual of Gao Song)

> *Gao Song zhupu* (Gao Song's manual of bamboo)
> Peking University Library Rarebook Collection
> *Gao Song lingmaopu* (Gao Song's manual of birds-and-flowers)
> National Library of China
> *Gao Song jupu* (Gao Song's manual of chrysanthemum)
> National Library of China

Huafa dacheng (Great synthesis of the rules of painting)

> National Library of China, Beijing
> Shanghai Library (only *juan* 1 and 2)

Huafa xiaoxue (Elementary learning in the rules of painting)

> Shanghai Library

Huafa yaojue (Digest of the rules of painting)

> C.V. Starr East Asian Library, Columbia University
> National Archives of Japan (volumes on bamboo and orchid paintings missing)

Huasou (Grove of paintings) *in Yimen guangdu* (Extensive records from secluded doors)

> COMPLETE SETS
> National Archives of Japan, Tokyo (three copies)
> Maeda Ikutoku-kai, Tokyo
> Library of Congress, Washington, D.C.
> National Library of China, Beijing

> INCOMPLETE SETS
> National Library of China (three titles: *Huaping huihai, Huilin tishi,* and *Qiyuan xiaoyong*)
> Qinghua University Library (three titles: *Huaping huihai, Luofu huanzhi,* and *Huilin tizhi*)
> Kexueyuan (one title: *Huaping huihai*)
> Peking University Library (one title: *Chungu yingxiang*)
> Fudan University Library (hand-copied edition, date unknown)

Capital Library, Beijing (no titles from *Huasou*)
Central Library of China, Taipei (*Huasou* is replaced with *Yunlin shipu*)
East Asian Library and the Gest Collection, Princeton University (one title: *Huilin tizhi*)

Huilin (Forest of paintings)

INCOMPLETE SETS
Bibliothèque nationale de France, Paris (BnF)
Musée Guimet, Paris

Huishi zhimeng (Apprenticeship in the painting business)

HONG PIAN EDITION (MID-SIXTEENTH CENTURY)
Former Collection of Zhang Congyu: current location unknown; reprinted by Zhongguo shudian in 1960

GEZHI CONGSHU EDITION
Capital Library, Beijing
National Library of China, Beijing
Shandong Provincial Library
Columbia University, C.V. Starr East Asian Library

BAIJIA MINGSHU EDITION
Hosa Bunko, Nagoya
Maeda Ikutoku-kai, Tokyo

YOUYI SIJIA EDITION
Peking University Library Rare Book Collection

Liu Xuehu meipu (Liu Xuehu's plum painting manual)

WANG SIREN EDITION (EARLY SEVENTEENTH CENTURY)
Fudan University, Shanghai
Huadong Teacher's University, Shanghai
Fujian University
Tokyo Metropolitan Library

MOMIAO SHANFANG EDITION (1681)
National Library of China, Beijing
Zhejiang Provincial Library

Shanghai Library and twenty other locations in China and Japan

Meishi (History of the plum)

> National Library of China, Beijing
> Anhui Provincial Museum
> Library of Congress, Washington, D.C. (a few pages missing)

Tuhui zongyi (Canon of paintings)

> YIBAITANG EDITION
> East Asian Library and the Gest Collection, Princeton University
> C.V. Starr East Asian Library, Columbia University
> Shanghai Library
> Hosa Bunko, Nagoya

> MODIFIED YIBAITANG EDITION
> National Archives of Japan, Tokyo

> PIRATED YIBAITANG EDITION
> Harvard-Yenching Library
> New York Public Library
> Philadelphia Museum of Art Library (vols. 1, 2, 7, and 8 missing)
> Nanjing Library
> Peking University Library Rare Book Collection
> Renmin University Library, Beijing
> University of Tokyo Tōyō bunka kenkyūsō
> Eisei Bunko, Tokyo

> WENLINGE EDITION
> Shanghai Library

Yanxian sishi (Four keys to an ideal life)

> Shanghai Library (two copies)
> National Archive of Japan, Tokyo (three copies)
> Harvard-Yenching Library
> University of Tokyo General Library
> Hosa Bunko, Nagoya

Xiangxue linji (Forest in fragrant snow)

> National Library of China, Beijing
> Nanjing Library
> Maeda Ikutoku-kai, Tokyo

Xuezhai zhupu (Snow Studio bamboo guide)

> ZISUNGUAN EDITION (1608)
> National Library of China, Beijing
> Zhejiang Library

> WENBITANG EDITION (1618)
> National Library of Taiwan, Taipei

Appendix 2

Lost Manuals and Albums of the Ming Dynasty

Note: This list is not meant to be comprehensive, and additional titles of lost manuals and albums may be found in various bibliographical sources. I have excluded items known to be designed for personal use, such as handwritten or drawn works on paper and silk. For the titles and descriptions of such items, see Yu Shaosong, *Shuhua shulu jieti*, 634–57.

1. *Danya huapu* (Maroon cliff album/manual of painting) by Tang Su (1331–1374) of Shaoxing, Zhejiang. Tang Su was a calligrapher and painter who was especially known for landscape and rock paintings. For further information, see Xie Wei, *Zhongguo huaxue zhuzuo kaolu*, 283–84.

2. *Huapu* (Painting album/manual) by Zhang Ying (active ca. mid-15th century). Zhang was a self-taught painter known for his figure and bird-and-flower paintings. This title is listed in *Shanxi tongzhi*, 109:83.

4. *Huafa quanyu* (A grand palanquin of the rules of painting) by Zhu Guan'ou (active mid-16th century), a seventh-generation descendant of the Ming Taizu. This title is listed in *Qianqingtang shumu*, 391.

6. *Xiaoxia meipu* (Plum painting album/Manual of small evening glow) by Shen Xiang (1546–1628). This title is listed in the *Qianqingtang shumu*, 391. Shen Xiang studied plum painting under Liu Shiru, author of *Liu Xuehu meipu*. See Xie Wei, *Zhongguo huaxue zhuzuo kaolu*, 352–53.

7. *Youying lanpu* (Orchid album/manual of hidden excellence) by Shen Bin (active ca. 1573–1643). Shen painted orchids in the styles of Zhao Mengfu and Ni Zan. This work is known to be inscribed on stone plates. This title

is listed in multiple sources including Lan Ying and Xie Bin, *Tuhui bao-jian xuzuan*, 2:47–48, and *Guangyin renzhuan*, 423. See Xie Wei, *Zhongguo huaxue zhuzuo kaolu*, 399–400.

8. *Kongchen shihuapu* (Vain dusty album of poetry and paintings) by Hua Ao (active ca. 1484–1546). Hua was known for his painting skill. This work is listed in "*renwu zhuan*," in *Jinan fuzhi*. See Xie Wei, *Zhongguo huaxue zhuzuo kaolu*, 317.

9. *Lishi huapu* (Album/manual of Master Li) by Li Zhongheng (active ca. 1561–1623). Li is known as a poet and painter. It is listed in *Quanzhou fuzhi*, 63:3a. See Xie Wei, *Zhongguo huaxue zhuzuo kaolu*, 378.

10. *Gujin zhupu* (Album/manual of bamboo past and present) by Gui Changshi (1574–1645). This title is listed in Qu Yong, *Tieqin tongjianlou shumu*. See Xie Wei, *Zhongguo huaxue zhuzuo kaolu*, 401.

11. *Zhipu* (Album/manual of mushrooms). Author unknown. This title is noted in the list of household collections confiscated from the disgraced Ming minister Yan Fenyi. See Wu Yunjia, *Tianshui bingshanlu*, 296.

12. *Jupu* (Album/manual of chrysanthemums). Author unknown. See Wu Yunjia, *Tianshui bingshanlu*, 296.

Notes

Introduction

1 *Songzhai meipu* (Pine Studio plum manual) by Wu Taisu (ca. 1290–ca. 1359) and *Zhupu xianglu* (A detailed treatise on bamboo) by Li Kan (1245–ca. 1320) are two publications that contain chapters specifically designed to provide a pedagogical program on the painting practice, with texts accompanied by illustrations.

2 Li Rihua, *Zitaoxuan youzhui*, 1.

3 Shen Defu, *Wanli yehuobian*, 653.

4 Deng Tuo, *Yanshan yehua*, 466–69.

5 Ruan Pu, *Zhongguo huashi lunbian*, 241–46.

6 Li Rihua, *Zitaoxuan zazhui*, 25.

7 *Peiwenzhai shuhuapu*, 50:69a.

8 Chen Jiru, *Taiping qinghua*, 55. A similar comment is also in Zhu Mouyin, *Huashi huiyao*, 3:6a.

9 Jiang Tingxi, *Bowu huibian yishudian*, 485:28c.

10 *Peiwenzhai shuhuapu*, 50:77b.

11 Dong Qichang, *Huachanshi suibi*, 3:1a.

12 Meskill, *Gentlemanly Interests*, 2.

13 Ho Ping-ti, *Studies on the Population of China*, 261–64.

14 Evelyn Rawski, "Economic and Social Foundations," 3–5.

15 Ibid., 8, and Meskill, *Gentlemanly Interests*, 5.

16 For further discussion of this change, see Xia Xianchun, *Mingdai qing yu li de pengchuang*, 205–8.

17 See Wang Cheng-hua, "Guoyan fanhua," 50–51.

18 Chang Chun-shu and Shelly hsueh-lun Chang, *Crisis and Transformation*, 273–74.

19 Liang Fangzhong, *Zhongguo lidai hukou*, 346–58.

20 Chen Baoliang, *Mingdai shehui shenghuoshi*, 55.

21 The Ming originally continued the Yuan practice of registering certain households for special service as salt producers, soldiers, or artisans, but this system was replaced by one based on monetary payments. Goods obtained for Imperial Household use with corvée labor in the early Ming were later purchased through the private sector using taxes collected in the form of money. This loosened official hierarchy and the retreat of government from direct participation in the economy eventually increased social mobility. For more information, see Ping-ti Ho, *Ladder of Success in Imperial China*, 65.

22 Ibid., 49–153.

23 Wang Lanyin, "Mingdai zhi shexue,"
 42–102.

24 Brook, "Edifying Knowledge," 93–119.

25 Lucille Chia notes that the figure is even
 smaller than 11 percent in a countrywide
 survey. Although the survival rate of
 later publications would naturally be
 greater than that of earlier ones, there
 is still widespread agreement that the
 volume of printed works increased
 dramatically after 1500. See Lucille Chia,
 Printing for Profit, 152–53. This dramatic
 increase was in part related to decreased
 printing costs. As Inoue notes, the
 cost of wood-block carving in Suzhou
 fell by almost 90 percent between the
 thirteenth and the sixteenth century.
 See Inoue, "Shōshi shōko būnjin,"
 314–15. For a general explanation of book
 publishing in the late Ming period, see
 K.T. Wu, "Ming Printing and Print-
 ers," 203–60; Tsien Tsuen-hsuin, *Paper
 and Printing*; Oki, "Minmatsu kōnan ni
 okeru shuppan," 5.

26 Ko, *Teachers of the Inner Chambers*,
 53–65.

27 Meskill, *Cho'e Pu's Diary*, 155.

28 This book was compiled by Xu Guangqi,
 a Christian and a senior official in the
 Ministry of Rites. Among many ques-
 tions, the most intriguing is whether
 this peasant is actually reading or not.
 For further discussion, see McLaren,
 "Investigating Readership in Late-Impe-
 rial China," 104–6.

29 Wai-kam Ho, "Late Ming Literati," 31.
 For example, among the thirty-five
 printed chantefables from the late Ming
 period, twelve were by people with
 official degrees (including six *jinshi*)
 and fourteen were by commoners. See
 Fang Zhiyuan, *Mingdai chengshi yu
 shimin wenxue*, 221–23. Joseph McDer-
 mott also suggests that literati artists in
 the Suzhou area were immersed in the
 profit-making activities of selling and

 gifting their paintings. See McDermott,
 "The Art of Making a Living," 63–81.

30 Chen Guanghong, "Wan Ming Fujian
 diqu," 140–55.

31 Ko, *Teachers of the Inner Chambers*, 29.
 For social practices related to the publi-
 cation of women's writings, see Zeitlin,
 "Shared Dreams," 127–79; Lian Wen-
 ping, "Shishi keyou Nüxing de weizhi?"
 177–200.

32 Dorothy Ko suggests that the late Ming
 literacy rate did not exceed 10 percent of
 the entire population. See *Teachers of the
 Inner Chambers*, 35–37.

33 Liu Zhiqin, *Wan Ming shilun*, 140.

34 Ho Ping-ti, *Ladder of Success in Imperial
 China*, 182, and Lin Jiaohong, "Wan
 Ming Huizhou shangren," 40.

35 See Chang Chun-shu and Shelly hsueh-
 lun Chang, *Crisis and Transformation*,
 276.

36 Elman, "Political, Social, and Cultural,"
 18–22.

37 For this reason, Ho Ping-ti noted that they
 were mere "scholar-commoners." See *Lad-
 der of Success in Imperial China*, 35.

38 Regarding the corruption of the impe-
 rial exam during the late Ming period,
 see Liu Xiaodong, "Wan Ming kechang
 fengbian," 42–47.

39 Jie Zhao, "Ties That Bind," 142.

40 Ho Ping-ti, "Aspects of Social Mobility
 in China," 341.

41 Greenbaum, *Chen Jiru*, 22.

42 According to the custom of the Ming,
 shengyuan could be considered for being
 exempted from official duties only after
 six years of service, yet some of them
 bribed the clerks to get out of any pos-
 sible bureaucratic obligations. See Gui
 Zhuang, *Gui Zhuang ji*, 243.

43 Chen Baoliang, "Wan Ming shengyuan,"
 37.

44 Ibid., 36; Chen Guodong, "Kumiao yu
 fanrufu," 72–74.

45 Waltner, "Building on the Ladder of Suc-
 cess," 32–33.

46 Some scholarship of late imperial China often uses the term "gentry" to describe the moneyed elite class. However, the term typically refers to the noble class, whose social status was guaranteed by birth. Thus, as Ho Wai-kam has noted, in late imperial China, elite status was not hereditary and had to be reinforced or renewed by individuals of each generation. There was considerable social mobility involving every family member in the privileged upper stratum. To a definitive degree, there was no "gentry" (in the European model) in any period of early modern Chinese history. For further explanation, see Wai-kam Ho, "Late Ming Literati," 29.

47 Brook, "Family Continuity and Cultural Hegemony," 27–50.

48 See He Zongmei, *Mingmo Qingchu wenren*, 17–22. Guo Shaoyu collected information on 176 societies of the Ming dynasty. Most of these were also organized during the late Ming period. See Guo Shaoyu, "Mingdai wenren jieshe nianbiao," 498–610.

49 Gatherings for zither play were called "string societies" (*sishe*) or "zither associations" (*qinshe*). See Zhang Dai, *Tao'an mengyi*, 56–57, and Van Gulik, *Lore of the Chinese Lute*, 68–70.

50 For example, Wang Daokun organized at least two literati societies, Nanping Shishe (Southern Screen Poetry Society) in 1586 and Baiyushe (White Elm Club) in 1590. A close friend of his, Wang Shizhen, participated in both of these societies. Wang Shizhen further participated in many other clubs, including Qizishe (The Society of Seven Men). See Guo Shaoyu, "Mingdai wenren jieshe nianbiao," 522–65.

51 Brook, *Praying for Power*, 222.

52 In some cases, they produced pictorial accounts that commemorated their gatherings and even publicized them in book format, for example, an image showing a gathering hosted by the late Ming publisher Wang Tingna (fl. 1596). For further explanation of Wang Tingna and his group, see Berliner, "Wang Tingna and Illustrated Book Publishing," 67–75. In addition, one source notes a society called Xiao Yingzhou she (Society of a Small Blissful Land) established by Zhu Po in 1542, which commissioned a painting of its members together as a record and a souvenir. See Sheng Feng, *Jiahe zhengxian lu* (Original stories from Jiahe), 35:7b, 47:1b–2b. Furthermore, a visual record of the literati gathering was also a popular painting subject in Korea's Chosŏn dynasty (1392–1910). Participants in literati gatherings in Chosŏn Korea hired a professional painter to produce multiple copies of the scene of their gathering, which were distributed to all of the participants. Such paintings include written information on the date, place, and time of the gathering as well as participants' names and official degrees. For more information, see Ahn Hwi-joon, *Han'guk hoehwa ŭi chŏntong*, 381–89.

53 Chen Baoliang, *Zhongguo de she yu hui*, 333–41. Regarding the Cockfighting Society, see Kafalas, *In Limpid Dream*, 48.

54 *Huzhou fuzhi*, 94:12b–13a, and *Wuxing beizhi*, 29:7b.

55 For more information, see Lin Jiaohong, "Wan Ming Huizhou shangren," 37–47.

56 Throughout his *Wanxiangtang xiaopin* (Casual essays from the Hall of Enduring Fragrance), Chen Jiru also records many names of Huizhou merchants with whom he and his fellow literati associated. Regarding the Zhuxishe and Xilengshe, see Chen Baoliang, *Zhongguo de shi yu hui*, 282. For further historical cases of the friendship between literati and merchants as well as the elevated status of craftsmen and merchants through the arts and such friendships,

see Xia Xianchun, "Wan Ming wenshi yu shimin jieceng," 86–88.

57 Ts'ai Mei-fen, "Suzhou Gongyijia Zhou Danquan," 269–98.

58 A jade carver of the Chongzhen era (1636–1644), Huang Zhen was also celebrated not because of his superb carving skills but also because of his literary and spontaneous mind. See Qu Dajun, *Guangdong xinyu*, 369. For further discussion, see Xia Xianchun, *Mingdai qing yu li de pengzhuang*, 273–75.

59 Translation is from Ho Ping-ti, *Studies on the Population of China*, 73.

60 Despite the rise in the status of certain named artisans such as Hu Wenming and Lu Zigang, their fundamental social categorization remained formally a menial one throughout the dynasty. See Clunas, *Superfluous Things*, 147.

61 Wu Renshu, *Pinwei shuhua*, 128–47, and Meskill, *Gentlemanly Interests and Wealth*, 141–44.

62 However, this claim may in turn suggest that as early as the Tang period, a certain uneasiness may have existed regarding the practice of painting and calligraphy outside the privileged classes. Thus, this claim can perhaps be understood as an endeavor to firmly establish the nexus between art and high social status. This comment is also quoted in Han Zhuo, "Lun gujin huaxuezhe," in *Shanshui chunquan ji*, 99.

63 Cahill, *Painter's Practice*, 123.

64 Peterson, *Bitter Gourd*, 32.

65 Qian Bocheng, *Yuan Hongdao jianjiao*, 640.

66 Xie Zhaozhe, *Wuzazu*, 142–43. Translation is modified from Lin Yutang, *Chinese Theory of Art*, 128–29.

67 For example, a comment found in He Liangjun's *Siyouzhai congshuo* (Compendium of comments from the Studio of the Four Friends) notes that the majority of so-called *haoshizhe* (art lovers or hobbyists) of his time were the ignorant rich, who proudly hung dozens of paintings everywhere in their houses to show off yet understood nothing about the very basics of paintings. He Liangjun, *Siyouzhai congshuo*, 257–58. For similar comments by his contemporaries, see Tang Zhiqi, *Huishi weiyan*, 1:24b–25a, and Gao Lian, *Zunsheng bajian*, 493–96.

68 In her analytical study of the art collections of a literati artist Shen Zhou (1427–1509) and a successful merchant Wang Zhen (1424–1495), Kathlyn Liscomb has cautiously suggested that as early as the fifteenth century, the distinction between the literati and merchant classes, in terms of their artistic taste and knowledge, had become blurred. See Liscomb, "Social Status and Art Collecting," 111–36.

69 Clunas, *Superfluous Things*, 108.

70 See note 67.

71 "Huashe (Painting Society)," in Zhou Hui's *Erxu Jinling suoshi* (34a–36b) reads, "Shaogang's Wang Wenyao was good at painting and excels among the scholar-amateur artists. He was also an amateur art lover, collected many masterpieces of Song and Yuan period painting and calligraphy. He organized a painting society in Qinhuai. People who joined were all well-known scholars of the period. However, after Master Wang lost all his property, this came to an end. It is a pity that nobody continued this tradition."

A similar text is also found in Jiang Shaoshu, *Wushengshi shi*, 3:51. It appears that the society was solely organized and funded by Wang because his loss of property put an end to it. The modern scholar Zhuang Shen has suggested that the painting society was established in 1568, but this needs further investigation since this date is based on the hypothesis that Wang Wenyao lost his family assets during one of the major natural disasters

recorded for the period. However, the text only notes that he lost his house but does not explain how. See Zhuang Shen, "Mingdai zhongqi Nanjing diqu," 51–55.

72 Fan Lian, *Yunjian jumuchao*, 2:7a–b. Translation is from Meskill, *Gentlemanly Interests and Wealth*, 147. Yuan Hongdao also left a similar comment. See Qian Bocheng, *Yuan Hongdao jianjiao*, 460–61.

73 Zhou Hui, "Zhuangyuan nenghua (an exemplar of the state who knew how to paint)," in *Xu Jinling suoshi*, 40a.

74 Tang Hou, *Hualun*, 326–27.

75 Of the ninety-seven women artists of the Ming period, nine were literati women artists, fifty-six were classified as "beautiful women painters," nine were concubines, and twelve were famous courtesans.

76 Educated and cultured courtesans maintained close relationships with well-known scholars of the time. A courtesan-painter, Ma Shouzhen (1548–1605), had a lifelong friendship with Wang Zhideng (1535–1612). Other contemporary writers including Xu Wei (1521–93) and Zhou Tianqiu (1514–95) were also friends who composed complimentary poems for her. She was known for her literary talents and culture. As Tseng Yuho has pointed out, had she been just a famous courtesan and madam, those men would have had no reason to write for her. See Tseng, "Women Painters of the Ming Dynasty," 249–61.

77 For a detailed study of Shen Yixiu's homeschooling program, see Ko, "Pursuing Talent and Virtue," 23–24. *Wujiang xianzhi* (Wujiang county gazetteer) of 1684 notes that Shen had sixteen children, but Dorothy Ko writes that she could find only twelve names, which suggests that the rest did not survive past their first birthdays. See Ko, *Teachers of the Inner Chambers*, 187–88, 329.

78 Van Gulik, *Sexual Life in Ancient China*, 66.

79 Weidner, "Women in the History of Chinese Painting," 13. *Bencao* is an ancient illustrated pharmacopoeia revised and amplified in the late sixteenth century by Li Shizhen. His *Bencao gangmu* (Itemized outlines of materia medica), published in Nanjing in 1593, was a best seller, going through at least eight reprintings in the seventeenth century. A late Ming female artist, Wen Duanrong (1595–1634), copied the botanical specimens pictured in *Bencao* and further used its illustrations as models for her female students. See Laing, "Wives, Daughters, and Lovers," 32–33.

80 Ko, "Pursuing Talent and Virtue," 34.

81 Xu Yinglei, *Mingwenhai*, 253:21b.

82 See his biography written by Fang Zhaoying in Hummel, *Eminent Chinese of the Ch'ing Period*, 83–84. See also Nelson Wu, "Tung Ch'i-ch'ang (1555–1636)," 277–80.

83 See Zhang Dejian, *Mingdai shanren wenxue yanjiu*, 3–8.

84 "*Diecao*" (Pages of letters) in *Siku quanshu zongmu tiyao*, 2505b. A similar comment is also found at "Zengding *Yuhubing*" (Expanded and revised edition of *The Jade Jar Lid*), in *Siku quanshu zongmu tiyao*, 1744. It reads, "Mountain hermit writers flourished in the late Ming period, identified themselves with pure talk, and took pride in their elegance. This was a popular trend of the period."

85 Chen Wanyi, *Wan Ming xiaopin*, 57–59.

86 See Tan Yuanchun, "Nü shanren shuo" (Regarding female mountain hermits), in *Tan Yuanchun ji*, 789.

87 Xie Xingyao, *Kanyinzhai suibi*, 241.

88 See Yu Bian, *Shanqiao xiayu*, 8: 6b–7b; Huang Xingzeng (1490–1540), *Wufenglu*, 6b. For an explanation of this trend, see Chen Baoliang, "Wan Ming shengyuan," 38; McDermott, "The Art of Making a Living in Sixteenth-Century China," 73; Chen Wanyi, *Wan Ming xiaopin yu mingji wenren shenghuo*, 45.

89 Xue Gang, *Tianjuetang wenji*, 3:5a. Translation is mine. He further described ten different kinds of inelegant behavior of these fake mountain hermits. See ibid., 18:4a–6b.

90 A Ying, "Ming mo de fan shanren wenxue" (Late Ming anti–mountain hermit literature), in *Yehangji*, 103–6.

91 Xie Zhaoze, *Wuzazu*, 266. Similar comments are found in Li Zhi, *Fenshu*, 137; Shen Defu, *Wanli yehuobian*, 585. For a discussion of these texts, see De Bary, *Sources of Chinese Tradition*, 869.

92 Qian Xiyan, *Xixia*, 54–55.

93 "Culture and Snobbism," in Goodwin, ed., *Art and the Market*, 97–106.

94 Huang Jichi, "Mingdai zhongye wenren xingtai," 49.

95 Wu Chengxue, *Wan Ming xiaopin yanjiu*, 406; Chen Wanyi, *Wan Ming xiaopin yu mingji wenren shenghuo*, 46–47; Fan Lian, *Yunjian jumuchao*, 1:12b–13a.

96 Curatorial Note #1990.6. Metropolitan Museum of Art, New York.

1 / Genre and Biography

1 The literal meaning of *fenben* is "powder copy," referring to the pounce method of copying. Pricks made along the outlines of an original image were filled with powder against a blank wall or screen so as to leave the outline of the original image. This method was often used with religious wall paintings, including the murals of Dunhuang. For a detailed discussion of this method, see Fraser, "Formulas of Creativity," 189–224. Richard Barnhart translates *fenben* (used for a sketch) as "paper cartoon." See Barnhart, "The Return of the Academy," 345. Furthermore, artists serving at the Song Imperial Academy produced *fenben* as preliminary sketches that had to be approved by supervisors before they executed the final works. See Jang, "Issues of Public Service," 38–39.

2 Barnhart, "The Five Dynasties and the Song Period (907–1279)," 91.

3 Cahill, *Painter's Practice*, 88–95. For explanations regarding this image, see Wai-kam Ho, ed., *Century of Tung Ch'i-ch'ang*, 2:29.

4 See "*fenben*" in Xia Wenyan, *Tuhui baojian*, 2–3.

5 Vinograd, "Private Art and Public Knowledge," 194.

6 Bussotti, "The *Gushi huapu*," 33.

7 Bolten, *Method and Practice*, 11.

8 For more information, see Bickford, *Ink Plum*, 45–48.

9 Translation is from Lo Ch'ing, *Guide to Capturing a Plum Blossom*, entry no. 9.

10 Ibid., xii.

11 For biographical research on Huaguang, see Weng Tongwen, "Huaguang zhongren de shengping," 21–40.

12 Bickford, *Ink Plum*, 11. It may not be too much of a stretch to understand that much of these programs were, to a considerable degree, related to the Song dynasty's Neo-Confucianism; the ideology emphasized that the investigation of nature leading to the perfection of knowledge amounted to an ethical obligation that the artist study nature in its every aspect. This link may stay within the pedigree of sheer speculation; however, it is also noteworthy that much of the contents from these botanical manuals were indeed incorporated into the programs of the majority of later painting manuals.

13 Shimada, "Sōsai baifu teiyō," 96–118, and Bickford, *Ink Plum*, 186–87.

14 Yu Shaosong, *Shuhua shulu jieti*, 9:13a.

15 Bickford, *Ink Plum*, 188–96.

16 Translation is modified from Bickford, *Ink Plum*, 187–88. Another translation is found at Bush and Shih, *Early Chinese Texts on Painting*, 276–78.

17 However, from my correspondence with Prof. James Cahill (January 20, 2008), I learned that Rao Ziran's text could be

18 For a translation of this text, see Lippe, "Li K'an und seine 'Ausfürliche Beschreibung des Bambus,'" 1–35, 3/4:83–114, 5/6:166–83, and Sirén, *Chinese Paintings*, 4:39–42.

19 Cahill, *Hills beyond a River*, 159.

20 Cited and translated by Sirén, *Chinese Paintings*, 4:42.

21 In addition, as subject matter, bamboo must have had a special meaning for Li Kan. Toward the end of the Northern Song dynasty, ink bamboo and ink plum had become respected subjects for scholar-painters because both symbolized integrity and uprightness. During the Yuan period, these symbols took on a specially charged significance as literati artists often chose them to represent political resistance to the Mongol government. For example, Wang Mian left a colophon on one of his plum-flower paintings stating, "The flowers are clustered like ice and jade; even the Mongols' flute cannot blow them down." This practice of creating politically charged art can also be traced through other motifs. Paintings of orchids by Zheng Sixiao (ca. 1240–1310) and paintings of emaciated horses by Gong Kai (1222–1307) also carried sentiments of Song loyalism and nostalgia. See Cahill, *Hills beyond a River*, 15–37. Although Li Kan did not specifically admit his intention, he must have been mindful that his service to the Mongol government aroused strong antagonism among his fellow literati. Given this, he may well have chosen bamboo in order to demonstrate his quality as an upright scholar and publicize his consciousness.

22 For Puming's ink-orchid methods, see Kong Qi (act. mid-14th century), *Zhizheng zhiji*, 40–41; Chen Gaohua, *Yuandai huajia shiliao*, 499–500; Chu-tsing Li, "The Oberlin Orchid and the Problem of P'u Ming," 54–55. The instructions and injunctions of the surviving excerpt are similar to those in Li Kan's and Wu Taisu's works. Regarding Ni Zan's manual, see "Yuan Ni Zan Huapu," recorded in *Gugong shuhualu*, 6:20–23.

23 Yu Shaosong, *Shuhua shulu jieti*, 2:21a–21b.

24 Regarding Fonu, see Stanley-Baker, *Old Masters Reprinted*, 317.

25 For a detailed discussion of each album leaf, see Sungmi Li Han, "Wu Chen's Mo-chu P'u," and Hearn, "The Artist as Hero," 308–9.

26 A couple of *huapu* on bamboo appear to have existed before the publication of *Zhupu xianglu*. One of them is a *Zhupu* of three *juan* by a Northern Song scholar-official, Qian Yu (943–999). It is listed in *Songshi*, 13915. Yu Fu's *Lidai Zhongguo huaxue zhushu lumu* categorizes this *Zhupu* along with *Meihua xishenpu*, *Fancun meijupu*, Zhao Mengjian's *Meizhupu*, and Su Shi's "Lun huazhu"; however, it is unknown whether it was a textual guide for painting, an illustrated manual, or a botanical guide. In addition, *Zhejiang tongzhi* (197:4b or 524:365), Zhu Mouyin's *Huashi huiyao* (3:13b), and other records list *Zhupu*, a manual on painting bamboo compiled by the Song dynasty bamboo painter Ding Quan (ca. 1160–ca. 1224).

27 Both *Shuhua shulu jieti* and *Lidai Zhongguo huaxue zhushu lumu* record its title as *Huishi fameng* (Guidance on the matter of painting). This could be a simple typographical error, but it needs further verification.

28 *Qianqingtang shumu* (391) notes that the author of *Huishi zhimeng* is Zheng Dezhong. This name is found in Wang Fu's (1362–1416) *Wang Sheren shiji* (2:27a–27b), which contains prose dedicated to a medical doctor whose

name is Zheng Dezhong. But its contents concern mainly his excellent skills as a medical practitioner, and there is no discussion of his literary or artistic ability, so it is less likely this name refers to Zou Dezhong. This appears to be a simple typo by the compiler of *Qianqingtang shumu*.

29 *Hangzhou fuzhi*, 18:5a.

30 Li Xian, *Ming yitongzhi*, 27:33a.

31 *Jiangxi tongzhi*, 74:43b–44a.

32 Zou Dezhong, *Huishi zhimeng*, 41a.

33 Zhang Congyu was an eminent Shanghai collector. Yunhuizhai (Hidden Glow Studio) was his studio name; his collection is enshrined in *Yunhuizhai cang Tang Song yilai minghua ji* (Shanghai: Shanghai chuban gongsi, 1947). He somehow lost his assets, sold his collection (much of which came to the United States), and was invited by Zheng Zhenduo (1898–1958) to join him, along with Xu Bangda (b. 1911), as a kind of "people's connoisseur" in building a collection of Chinese paintings for the Palace Museum in Beijing. He died in jail during the Cultural Revolution. I thank Prof. James Cahill for sharing his knowledge of Zhang's life with me.

34 *Wanjuantang shumu* (Catalog of the Thousand-Volume Hall) by Zhu Mujie (1517–1586) lists Hong Pian's book collection catalog. Another catalog, *Wulin cangshu lu* (Records of book collection in Wulin) by Ding Shen (d. 1887), notes that he inherited the collection from his grandfather, Hong Zhong (*jinshi* 1475). See Zhu Mujie, *Wanjuantang shumu*, 2:13a; Ding Shen, *Wulin cangshu lu*, 44–45; Wang Guiping, *Zhongguo banben wenhua congshu: Jiakeben*, 90.

35 For the list of books he published, see Zhang Xiumin, *Zhongguo yinshua shi*, 365–66.

36 Wen Jia, *Tianshui bingshanlu*, 257.

37 The edition at Peking University is part of the larger series *Youyi sijia*. Copies housed at the National Library, Columbia University Library, and the Capital Library are part of *Gezhi congshu*. The *Baijia mingshu* edition is housed at the Dalian Library, the Shandong Provincial Library, and Lüdashi Library. Rare book catalogs, including *Zhongguo Shanben shumu*, *Zhongguo Congshu zonglu*, and *Zhongguo Huaxue zhuzuo kaolu*, note that dozens of libraries own Hu's *Huishi zhimeng*, yet many of the locations listed do not own this work. For an update on locations of this edition and other late Ming painting manuals, consult appendix 1 at the end of this book.

38 Zhang Chun's preface from the Hong Pian edition. Translation is mine.

39 A modern independent scholar, Wang Shuchun, notes that some of the book's contents are suitable only for professional artists. He points out that the subject matter, media, and techniques introduced in the volume are of concern mostly to professional artists rather than amateur or literati artists. See Wang Shucun, *Zhongguo minjian huajue*, 221–22.

40 This part of the text in *Huishi zhimeng* is reproduced in Wang Luoyu's (b. 1587) *Shanhuwang* (Coral nets) of 1643 almost word for word, which indicates its historical status as a source of artistic discourse for later periods. For the quoted text and its explanation, see Guo Yin, *Yuan Ming huihua meixue*, 149.

41 Zhang Yanyuan, *Lidai minghua ji*, 1:1a–1b. Translation is from Sirén, *Chinese on the Art of Painting*, 7. Another example of painting's didactic function is found in Tang Hou's discussion of Gu Hongzhong's *Night Revels of Han Xizhai*, in which he argues that this painting should be seen as a warning against carnal pleasure. See Tang, *Huajian* (Examinations of painting), 357.

42 Habermas, *Structural Transformation of the Public Sphere*, 14–26.

43 Zou Dezhong, *Huishi zhimeng*, 1a.

44 A similar explanation of coloring in painting is also found in Wang Yi's "Xiexiang mijue" (Summary of secrets in figure painting). Its text is recorded in Tao Zongyi, *Nancun chuogenglu*, 132–34.

45 See Han Ang, *Tuhui baojian xubian*, 128; Zhu Mouyin, *Huashi huiyao*, 4:55a–b; *Wen'an xianzhi*, 153/2: 607.

46 A Japanese scholar, Higuchi Hiroshi, notes that Gao Song's manual originally included sections on orchid and plum painting; thus, it treated a set of five different subjects. See Higuchi, *Chūgoku hanga shūsei kaisetsu*, 20. However, these two sections are not listed in any historical records.

47 Wang Siren, "Liu Xuehu meipu xu (Preface to *Liu Xuehu's Plum Painting Manual*)," *Liu Xuehu meipu*, 3a–3b.

48 Mote and Chu, *Calligraphy and the East Asian Book*, 141–42.

49 At the end of the first half-volume, there is a colophon written by Yan Maoyou dated 1634, which makes the publication history more complicated. The calligraphic style used for this colophon is different from the one in the manual, which indicates that the colophon was printed from new blocks and added to the existing edition.

50 All of the library catalogs and bibliographical research register another edition of this album after Wang Siren's publication in the Wanli period. One edition published in the mid-seventeenth century has a postface written by Zhou Lu at the end. There is another edition noted to have been printed in 1681 from a set of blocks owned by a studio called Momiao Shanfang (Mountain Atelier of Subtle Ink). Its frontispiece contains a printer's colophon stating that the text was reviewed by Zhong Wulin of Guizhi, Zhejiang. Some copies of this edition have another postface written by Sheng Zhenying. It appears, however, that they were all printed from the same blocks Wang Siren had prepared. First, all three editions are identical in their print size. Second, the new postfaces to the book appear to have simply been attached in additional pages at the end of the volume; their calligraphic styles are different from the main body of the text. Finally, the imprints are identical for all of these editions, even in places where the blocks were damaged (cracked, scuffed, or worn out). In sum, except for the four previously printed editions, the various editions of *Liu Xuehu meipu* published after 1595 were actually printed over time from the same set of blocks.

51 Although not designed by the original author, the Wanli edition of *Xu Wenzhang yigao*, a posthumous collection of Xu Wei's writings, also has his portrait. See Zheng Zhenduo, *Chatuben zhongguo wenxueshi*, 2:1033.

52 Zhang Junde notes that Zhou lived between 1549 and 1640. See Zhang Junde, "Zhou Lüjing de shengzunian ji qita," 268–72. However, this is based on rather poorly grounded speculation. A more solid historical record written by Zhou's nephew, Li Rihua, notes that Zhou was born in 1542. See Li, *Weishuixuan riji*, 125. Sheng Feng's *Jiahe zhengxian lu* (17:3b–4a) notes that Zhou died at the age of ninety-one. Thus, it is most reasonable to believe that he lived between 1542 and 1633.

53 See the commentaries written by Sun Guangzong and Chen Taijiao in *Huilin tizhi*.

54 *Jiaxing fuzhi* (1600), 505/4:1355.

55 Another edition of *Jiaxing fuzhi* published in 1879 notes that *Huilin* consists of sixteen chapters. See *Jiaxing fuzhi*, *Zhongguo fangzhi congshu*, 53/5:2480. *Zhejiang tongzhi* (247:22b) also provides different numbers, noting that both *Huilin* and *Huasou* are each composed of ten *juan*.

56 Guo Yingde, *Ming Qing chuanqi zonglu*, 1:171–72.

57 See the "Yiwen" (Artistic writings) chapter in *Jiaxing fuzhi* (1600). Of its one hundred half-page texts, fifty-five are Zhou's writing. Other contributors to the volume, including Wang Shizhen, Feng Mengzhen, and Yuan Huang, were well-known officials and writers.

58 Li Rihua, *Meixu xiansheng bielu*, *shang*:50b.

59 Ibid., 2:1b.

60 Ye Shusheng and Yu Minhui, *Ming Qing Jiangnan siren keshushi lue*, 20–88.

61 *Jiaxing fuzhi* (1600), 505/4:5–6. Similar explanations are also included in *Peiwenzhai shuhuapu*, 44:35a, and *Zhejiang tongzhi*, 179:11b.

62 Qian Yingjin, "*Meidian gaoxuan* xu" (Preface to *Writings of Plum Addict*), in Zhou Lüjing, *Meidian gaoxuan*, 1:2a.

63 Ibid., 1:2b.

64 See Huangfu Fang's preface to Zhou Lüjing's *Xianyun gao* (Notes by Idle Clouds).

65 *Jiaxing fuzhi* (1600), 504/5:1356.

66 Li Rihua, "*Meixu xiansheng bielu youxu*," *shang*:42a.

67 Ibid., 1:44b.

68 Dong Qichang, *Huachanshi suibi*, 2:15a.

69 Historical records note Zhou's travels to meet his friends in various cities. For example, in 1590, he visited Zhou Tianqiu in Suzhou with his friends to see an "album" (*tie*) and traveled to Songjiang to meet Chen Jiru in 1594. See Zhang Huijian, *Ming Qing Jiangsu wenren nianbiao*, 346, 359.

70 Wang Xianjie, *Meiwu yiqiong*, 3:54a. It was named after Tao Yuanming's *Donglin lianshe* (Lotus Society of the Eastern Woods) of the Eastern Jin period (386). Thus, this group was distinct from the Donglin political party organized in 1604. For Tao Yuanming's *Donglin lianshe*, see Chen Baoliang, *Zhongguo de shiyuhui*, 274.

71 Although their contents are not dedicatory comments for the publishers and their works, *Tangshi huapu* and *Lidai minggong huapu* contain hundreds of poems and biographies written by many literati and some publishers, including Dong Qichang, Chen Jiru, and Yang Erzeng. This must have helped sales of these manuals while publicizing the publisher's social network.

72 Clunas, *Superfluous Things*, 110. See also Mote and Chu, *Calligraphy and the East Asian Book*, 189–92.

73 Zhu Wanshu, "Li Zhuowu piping quben kao," 107–23.

74 Kobayashi, "Publishers and Their Huap'u," 174.

75 Guo Shaoyu, "Mingdai wenren jieshe nianbiao," 559–60. In addition, other contributors in *Huilin tizhi* also knew one another through social gatherings and the networks of contacts they maintained. For example, Wang Shizhen was friendly with Zhang Fengyi and Wang Xijue. He was a member of Nanping shishe with Wang Zhideng and Wang Daokun. Tang Wenxian (1549–1605) and Feng Mengzhen participated in the same lay association of a Buddhist temple. There are dozens of records testifying to the networks formed among the contributors to *Huilin tizhi*. For information on these, consult Zhu Yizun, *Jingzhiju shihua*, and Zhang Huijian, *Ming Qing Jiangsu wenren nianbiao*. Wen Jia also got along with various contemporary literati including Wang Zhideng, Wang Shizhen, and Zhang Fengyi, who also contributed to *Huilin tizhi*. For Wen Jia's social network, see Hyland, "Wen Chia and Suchou Literati."

76 Wright, "*Luoxuan biangu jianpu* and *Shizhuzhai jianpu*," 73–74.

77 *Huilin tizhi*, 14b–15a. Translation is mine.

78 Ibid., 7a–7b.

79 Ibid., 9b–10a.

80 Zheng Yan, *Meixu xiansheng bielu*, *xia*:58a. Translation is mine.

81 Furthermore, bibliographic records show considerable differences in their volume numbers. First, Wu Weizhen in *Huilin tizhi* notes that *Huilin* consists of eighteen *juan*, while Zhou's hometown gazetteer, *Jiaxing fuzhi* of 1600 (505/4:1356), notes that it has twenty *juan*. However, another edition of *Jiaxing fuzhi* compiled in 1879 notes that *Huilin* consists of sixteen *juan*. See *Jiaxing fuzhi* (1879), 53/5:2480. Another local gazetteer, *Zhejiang tongzhi* (247:22b), says *Huilin* and *Huasou* are both ten *juan*, while *Qianqingtang shumu* (391) notes that *Huilin* has sixteen *juan* and *Huasou* only nine *juan*. These differences in the volume numbers could have been caused by the publication of multiple editions of *Huilin* and *Huasou* or different compilation methods for each edition or could simply be mistakes in the later bibliographic record.

82 Musée Guimet in Paris and various private collections also own some fragmentary pages of *Huilin*. Regarding those housed at Musée Guimet, see Leisure and Cultural Services Department of Hong Kong and the Musée Guimet, *Huacai Bali 1730–1930*, 284–87. For the images and a general description of the BnF edition, see Burckhardt, *Chinesiche Steinabreibungen*, 15–18, and Monnet, *Chine: L'empire du trait*, 164–66.

83 For a translation of this part of the text, see Goepper, "Stone Rubbing," 259.

84 See Chun Shum, "Pictures of the Sage's Trace," 134, and Eugene Wang, *Treasures of the Yenching*, 207–8.

85 Modern scholars differ in their understanding of the material. Roger Goepper has noted it was initially printed from stone, while Amy McNair notes its production medium was wood blocks. See Goepper, "Stone Rubbing," 256, and

McNair, "The Engraved Model-Letters," 210. Some historical records note that the Song collection was originally printed from wood blocks; however, many late Ming writings, including comments in *Huilin tizhi*, understood *Chunhua getie* to be a product of stone rubbings. A Yuan dynasty scholar, Tao Zongyi, wrote that *Chunhua getie* was made "by order of his majesty inscribed on stone." However, *Chunhua getie* was originally made from wood-block prints and was transferred to stone only when the Song dynasty took over the Southern Tang and learned the method of using stone blocks for the preservation of model calligraphy. Emperor Taizong ordered an addendum to this *Chunhua getie* using stone blocks, which were later lost due to fire. See Tao Zongyi, *Nancun chuogenglu*, 73. A similar explanation is found in Wang Hongzhuan, *Shanzhi*, 52. Later, it simply became customary to define *Chunhua getie* as stone-block printed. See Zhong Wei and Shen Zhuanfeng, *Gumo xinyan*, 9.

86 For the explanation of the *Chunhua getie* and later Song engravings, see McNair, "The Engraved Model-Letters Compendia," 209–25; Tao Zongyi, *Nancun chuogenglu*, 73, 177–79; Shen Defu, *Wanli yehuobian*, 3:656.

87 Wu Hung, "On Rubbings," 33.

88 For the meanings and functions of *tie*, see Bai Qianshen, "Artistic and Intellectual Dimensions of Chinese Calligraphic Rubbings," 82–88.

89 McNair, "Engraved Calligraphy in China," 106–14. Furthermore, along with *Chunhua getie*, *Dingwu Lanting tie* also became a primary object of connoisseurship. Many personal writings and books on connoisseurship from the late Ming have sections on it, which indirectly suggests its cultural importance and popularity among the late Ming reading public. For examples,

see Wang Hongzhuan, *Shanzhi*, 22; Shen Defu, *Wanli yehuobian*, 3:656. Yang Dianxun, *Shike tiba suoyin*, lists seventy-one reproductions of the preface to *Lanting tie* through the ages.

90 See Qu Mianliang, *Zhongguo guji banke cidian*, 415. Blocks for *Huasou* were reported to have been carved by a professional, Cai Yuanxiang. See Higuchi, *Chūgoku hanga shūsei kaisetsu*, 20.

91 *Yimen guangdu* at the National Library of China, no. A01515.

92 One of the most complete sets of this work is at the National Library of China. This set has 105 of the 106 titles listed in the contents. The size of the publication differs in bibliographic data. *Qianqingtang shumu* (401) notes that it consists of 120 *juan*; *Zhejiang tongzhi* (246:45a) notes 114 *juan*; and *Siku quanshu zongmu* (1762) notes eighty-six titles and 126 *juan*.

93 Wang Zhongmin, *Zhongguo shanbenshu tiyao*, 418.

94 Zhu Yizun, *Jingzhiju shihua*, 723.

95 Zhou Yanwen, "Ming-Qing zhi ji congshu," 350–51.

96 "Gezhi congshu," in *Siku quanshu zongmu tiyao*, 1763.

97 "Yimen guangdu," in *Siku quanshu zongmu tiyao*, 1762.

98 Wang Zhongmin, *Zhongguo shanbenshu tiyao*, 418.

99 The engraver's name is Ye Xiuyai. Furthermore, *Qianqingtang shumu* (392) notes a *Huajia yaojue* in four *juan* written by an unknown author. Whether this title refers to the *Huafa yaojue* under discussion here is not certain. In addition, an original copy housed at the Columbia University Library has the title *Huafa wuzhong* on its cover, yet this title appears to have been added later. Another copy housed at the National Archives of Japan in Tokyo lacks the sections on bamboo and orchids.

100 The *Yimen guangdu* edition of *Huasou* is larger than the *Huafa yaojue* by at least 0.7 centimeters in its print size.

101 In two titles in *Huafa yaojue*, *Jiuwan yirong* and *Chungu yingxiang*, however, Zhou Lüjing's name is retained as author. Ming dynasty government authorities were trying to stop the piracy; however, they were more concerned about the textual exactness of the classics. The genre of popular literature was often not the focal point of their concern. A decree issued in 1532 by the Office of the Provincial Judge in Fujian noted, "The Five Classics and the Four Books are the most indispensable for students. The older editions were well printed; but now professional printers who aim at nothing but profits issue pocket editions in small print and with many errors. . . . This office deems it necessary that all works published in this province, for circulation over the whole of the empire, be carefully collated to rectify the errors committed by the printing establishment. . . . Anyone who disregards this regulation will be punished and will have his blocks destroyed. No leniency will be shown. All printers are required to file a statement promising to comply with this regulation." For the entire translation of the text, see K.T. Wu, "Ming Printing and Printers," 229–30.

102 Volkmar, "The Physician and the Plagiarists," 1–77.

103 In the mid-sixteenth century, Yibaitang had other names such as Shiyouzhai (Ten Friends Pavilion), Dashi Shanfang (Great Rock Mountain Cabin), and Yangshan Gushi Shanfang (Mountain Cabin of Master Gu of Yangshan). See Ye Shusheng and Yu Minhui, *Ming Qing Jiangnan siren keshushi lue*, 20–24. Yang Erzeng also had another publishing house, Caoxuanju (Green Sky Abode). A private publisher, Gu Yuanqing, also named his studio Yibaiting, but it is not

certain whether this referred to his own or Yang Erzeng's. See Cao Zhi, *Zhongguo guji banbenxue*, 321.

104 Kobayashi, "Chūgoku Kaigashi ni okeru hanga no igi," 123–35.

105 Xue Bing, *Zhongguo banben wenhua congshu: Chatuben*, 63. The popularity of book illustrations and other relevant issues is discussed in the second half of chapter 3.

106 Kobayashi, "Publishers and Their Huap'u," 178.

107 However, this change could have also been made by the original Yibaitang edition. One original Yibaitang edition housed at the National Archives of Japan in Tokyo also shows the bodhisattva with no boy-worshipper and the headdress different from that found in the other Yibaitang edition while most of the other physical features remain unaltered.

108 It is found in *Tuhui zongyi*, 2:1b–2a.

109 The two editions at the Peking University, the Yibaitang edition at the Shanghai Library, and the Wenlinge copies at the Shanghai Library and Harvard-Yenching Library are all different in terms of their front pages. The Spencer Collection has the same title page as one of the Peking University editions, but the frontispiece alone cannot be used to establish the various editions because publishers could (and often did) simply replace the frontispiece, while using same body of blocks, in order to claim authorship.

110 Rawski, *Education and Popular Literature*, 120. In Rawski's other article, the estimate is noted to be between sixteen thousand and twenty-six thousand. See Rawski, "Economic and Social Foundations," 20. We can assume that printings of the pirated and Wenlinge editions must have reached a significant volume in the late Ming period.

111 Kobayashi, "Chūgoku gafu," 106–23.

112 Some may suspect that Sun used the same set of blocks for this manual, but the size of the block is smaller than those of the Yibaitang and other editions of *Tuhui zongyi* by at least 0.5 centimeters.

113 The Nanjing University copy is not a fragment of the entire set. It was published as a complete series. Its frontispiece notes only two subjects, while the National Library edition specifies four subjects on its frontispiece.

114 Unlike *Yanxian sishi*, *Chen Meigong huapu* has no images of women, but they simply could have been left out during the binding process. Furthermore, the inscription "Yanxian sishi" printed on every page could also have been carved out for the *Chen Meigong huapu* printings.

115 Over the course of Ming history, sixty-two men were ennobled as regional princes, fifty of whom established princely domains in various locations. Among them, twenty-eight maintained their lineage and enfeoffed domains throughout the dynasty. The rest, who did not have sons or were deprived of their status because of some crime they committed, failed to maintain their lineages. For more information, see Wang Shoujia, "Shilun Mingdai de zongshi renkou," 85–89, and Zhao Yi, "Mingdai zongshi," 49–54.

116 Zhang Xiumin, *Zhongguo yinshua shi*, 402–24. Zhao Qian and Zhang Zhiqing note the number as about five hundred. See Zhao Qian and Zhang Zhiqing, "Book Publishing by the Princely Household," 110. Zhang Xiumin lists fourteen titles published by the Lu clan, but *Huafa dacheng* is not included in the list.

117 Mote and Chu, *Calligraphy and the East Asian Book*, 154.

118 *Huafa quanyu* is listed among the reference books for the compilation of *Huafa dacheng*. See *Huafa dacheng*, 1:4b–5a.

119 As for the meanings and the functions of these paintings, see Cahill, "Political Themes in Chinese Painting," 12–36.

120 Zhao Qian and Zhang Zhiqing, "Book Publishing by the Princely Household," 85–128.

121 Cao Zhi, *Zhongguo guji banbenxue*, 309–12, and Cao Zhi, *Zhongguo guji bianzhuanshi*, 297–98.

122 For a survey of Ming official bureaus that published books and the titles they produced, see Li Zhizhong, *Gudai banyin tonglun*, 217–44. The circulation of official publications was limited, and most were purchased by local academies as textbooks with financial support from the government; the prices of these books were higher than those of commercial publications. For more information, see Inoue, "Zōsho to dokusho," 422–27.

123 The Shanghai Library copy is printed in black ink instead of the dark blue ink used in the copy housed at the National Library of China. However, it is not known whether the difference was caused by a corruption of the pigment or whether this copy was originally printed in black.

124 In the section on figure painting, many of the religious figures were lifted from *Xian Fo qizong* and Zhou Lüjing's *Huilin*. The text on bird-and-flower painting is copied word for word from *Huilin*. There is a part explaining brushstrokes, along with images of the basic elements of painting. As Kobayashi Hiromitsu has suggested, these illustrations might have been taken from painted hand scrolls such as the "Scroll of Painting Methods" produced by Sun Tingyong of the fifteenth century. See Kobayashi, "Publishers and their *Hua-p'u*," 179–80. This format, however, had an earlier model in *Huishi zhimeng*, which was already in circulation by the fifteenth century.

125 Bickford, *Ink Plum*, 187.

126 Wang Yi's "Xiexiang mijue" of the Yuan dynasty delivers detailed discussion of technical issues in portrait painting. For a translation, see Franke, "Two Yuan Treatises," 27–32. Deng Chun's *Huaji* also has a special section on figures and portraits.

127 Ye Shusheng and Yu Minhui, *Ming Qing Jiangnan siren keshushi lue*, 138.

128 The human body was often seen as a micro-cosmos, a reflection of universal order. In this frame, the head was understood as heaven, the nose as a mountain peak, the blood as a river, hair as trees, and bone as stone. For a discussion of traditional texts on this matter, see Siggstedt, "Forms of Fate," 713–48.

129 These editions are housed at the National Library of China in Beijing.

130 For a discussion of physiognomy in late Ming popular literature, see Ogawa, *Nichiyō ruisho ni yoru*, chapter 3.

131 Wang Cheng-hua, "Shenghuo, zhishi yu wenhua shangpin," 1–85.

132 *Jiyazhai huapu* consists of six different albums: *Tangshi wuyan huapu* (A painting album of five-word Tang poetry), *Tangshi liuyan huapu* (A painting album of six-word Tang poetry), *Tangshi qiyan huapu* (A painting album of seven-word Tang poetry), *Caoben huashipu* (A poetry album of greens and flowers), *Meihua lanzhupu* (Album of plum, orchid, and bamboo), and *Muben huaniaopu* (Album of trees and birds). Later, *Minggong shanpu* (Album of fan paintings by masters) and *Gujin huapu* (Album of paintings from the past and present) were included in the series, which was retitled *Bazhong huapu* (Primer on eight varieties of painting).

133 See Clunas, *Pictures and Visuality*, 139–46, and Hegel, "Painting Manuals and the Illustration of Ming and Qing Popular Literature," 57–58.

2 / Words without Images

1 For their original sources, see Xie He, *Guhua pinlu* (Classification of ancient painters); Xia Wenyan, *Tuhui baojian*; Guo Ruoxu, *Tuhua jianwenzhi* (Experiences in painting), and Liu Daochun, *Shengchao minghua ping* (Critique of famous painters of our great dynasty). Rao Ziran's "Twelve Things to Avoid" is also known as "Shanshui jiafa" (Rules for landscape artists).

2 Several discussions of these rules have been published in English by the likes of James Cahill, Wen Fong, Osvald Sirén, Acker, and many others. See, in particular, Cahill, "Six Laws and How to Read Them," 372–81, and Soper, "Some Technical Terms," 163–73.

3 See Guo Ruoxu, *Tuhua jianwenzhi*, 28–31; Xia Wenyan, *Tuhui baojian*, 1.

4 Rao Ziran's text is translated in Sirén, *Chinese on the Art of Painting*, 114–18.

5 Part of Huang Gongwang's "Secrets of Landscape Painting" is translated in Cahill, *Hills beyond a River*, 86–88. As James Cahill has noted, Huang's text is not coherent and appears to have been prepared in a rather haphazard manner.

6 For further explanation, see Maeda, *Two Sung Texts on Chinese Painting*, 17, 37–38. The emphasis on seasonal expression can be dated back to Xie He, as his third rule, *yingwu xiangxing* (Fidelity to the object in portraying forms), concerns the approximation of the object. For further discussion on this, see Zhu Xuan, *Zhongguo shanshuihua meixue yanjiu*, 204–6.

7 Cahill, *Distant Mountains*, 3–30.

8 Its title is "Secrets of Landscape: Forty Rhymes." However, it only has thirty-nine rhymes.

9 Zhou Lüjing, *Huaping huihai*, 2:1a–2a. Translation is mine.

10 For further discussion of the use of wine by literati painters, see Sun Lijun, *Zhongguo de gudai shiren shenghuo*, 121–22, and Wang Yilun, *Danqingyin*, 2–27.

11 Shen Gua, *Mengxi bitan*, 72–73. Translation is mine. During the Ming period, this painting was in the collection of Yan Shifan's household. See Wu Yunjia, *Tianshui bingshanlu*, 226.

12 I could not locate this material in Zhang Yanyuan's *Lidai minghua ji*. It is possible that this assertion was in fact Shen Gua's own.

13 Fraser, *Performing the Visual*, 8–9.

14 Sirén, *Chinese on the Art of Painting*, 120.

15 Alford, *To Steal a Book Is an Elegant Offense*, 9–29.

16 Translation is from Volkmar, "The Physician and the Plagiarists," 17–18. Original text is in Taki Mototane (1789–1827), *Zhongguo yijikao*, 1043.

17 Translation is from Chou, *Yüan Hung-tao and the Kung-an School*, 103. Original text is in Yuan Hongdao, *Yuan Zhonglang quanji*, 34.

18 Liu Ninghui, "Tang Song tushu bianzuan xingtai," 322.

19 See Shang Wei, "The Making of the Everyday World," 63–92, and "Jin Ping Mei and Late Ming Print Culture," 193. This practice had its precedents in Song times. For example, Huang Tingjian incorporated the information listed in the *leishu* (encyclopedia) into his literary creations, which suggests that the printed knowledge shared by the educated public provided him with an alternative source of literary inspiration. See Zhao Feipeng, "Songdai shiren yu leishu," 207–19.

20 Hegel, *Reading Illustrated Fiction*, 38. For studies of the textual source materials in *Jinpingmei*, see Hu Wenbin, *Jin Ping Mei shulu*; Hanan, "Sources of the Chin p'ing mei," 23–67; Hanan, "The Text of Chin p'ing mei," 1–57; Carlitz, "Allusion to Drama in the Chin p'ing mei," 30–35; Carlitz, "Puns and Puzzles in Chin p'ing mei," 216–39.

21 This text is also known as "Huaxue mijue" (Digest of secrets in painting lessons).

22 Zhan's *Shuhuayuan buyi* edition is composed of 292 characters along with 62 more in the addendum; the *Gujin huapu* edition has 1,016 characters; and the Shaanxi edition is different from the other two editions. See Yu Shaosong, 9:10b.

23 See "Huaxue mijue," in *Siku quanshu zongmu tiyao*, 1511.

24 See "Hua shanshui fu," in *Siku quanshu zongmu tiyao*, 1484. Zhang Xincheng, *Weishu toangkao*, 929. Xu Fuguan has suggested that Jing Hao's *Bifa ji* (Notes on the method for the brush) could have been mistakenly titled *Shanshui jue* before the late Ming period. He observed that most of the bibliographical research conducted before the Ming period had noted *Shanshui jue* as the only work of Jing Hao. See Xu Fuguan, *Chungguk yesul chŏngsin*, 318–19.

25 Yu Shansong, *Shuhua shulu jieti*, 9:11a–b.

26 "Shanshui jue," in *Siku quanshu zongmu tiyao*, 1511.

27 Yu Shaosong, *Shuhua shulu jieti*, 9:11b–12a.

28 Xu Fuguan, *Chungguk yesul chŏngsin*, 319. Not only the writers from the previous period as seen in the genre of *shanshui jue* but also the names of contemporary luminaries were exploited for their cultural merits and attractions. The names of renowned writers and critics of the time, such as Dong Qichang, Tu Long, Chen Jiru, and Yuan Hongdao, were included in dozens of fabricated publications and presented as these works' original authors.

29 Zhang Xincheng, *Weishu tongkao*, chapter 1.

30 Ho Wai-kam, "Late Ming Literati," 24.

31 "Yulingzi," in *Siku quanshu zongmu tiyao*, 1648.

32 For a detailed discussion of Hu's research, see Yu Zhaopeng, *Zhongguo weishu daguan*, 34–36.

33 Many scholars doubt the authenticity of Tang Yin's *Gujin huapu*, pointing out its rather poor editing and contents extracted from previous sources. See Guo Yin, *Yuan Ming huihua meixue*, 75.

34 Foucault, "What Is an Author?" 121–30.

35 Barthes, "The Death of the Author," 142–48.

36 Bourdieu, *Language and Symbolic Power*, 109. Italics are mine.

37 It is very probable that there were more landscape images since other chapters in *Huilin* include dozens of illustrations.

38 *Huilin tizhi*, 2b–3a; 15b–16a.

39 Sirén, *Chinese Paintings*, 4:72.

40 There is one more landscape rubbing in *Huilin* that has a pictorial style close to works by the Yuan dynasty master Wang Meng. However, this rubbing appears to have been erroneously framed; the left and right halves of the rubbings are reversed, a mistake probably made by a handler of a later period.

41 For example, bibliographic studies on Ming editions of *Xixiang ji*, one of the most popular of all plays in Chinese history, show that a majority of its late Ming editions were illustrated. See Denda, *Minkan Gen zatsugeki Seishoki mokuroku*, and Ma Mengjing, "Ermu zhi wan," 251–56.

42 Lavishly illustrated books of the late Ming period, such as *Wuyan Tangshi huapu* (0.5 *liang* [ounce] of silver), *Lisao tu* (1 *liang*), and *Shiyu huapu* (0.8 *liang*) cost considerably more than the majority of unillustrated books. For book prices in late Ming China, see Inoue, "Zōsho to dokusho," 409–45; Yu Yaohua, *Zhongguo jiage shi*, 829; Chum Shum (Shen Jin), "Mingdai fangke tushu zhi liutong yu jiage," 101–18; Zhang Xiumin, *Zhongguo yinshua shi*, 518; Lucille Chia, *Printing for Profit*, 190–91.

43 Quoted in Zhang Xiumin, *Zhongguo yinshua shi*, 498.

44 Rolston, "Formal Aspects of Fiction Criticism," 59–60.

45 Not all the books printed in traditional China have these editorial comments. The examples quoted in this book are samples chosen from a wide range of texts commenting on the use of illustration in books, many of which are popular novels and dramas of the late Ming period. Interestingly, none of the contemporaneous painting manuals, a genre that typically includes the most illustrations, contains *fanli* items or comments on the use of illustrations.

46 The story is introduced in both Kin Bunkyō, *Sangokushi engi no seikai*, 84–85, and McLaren, "Popularizing the Romance of the Three Kingdoms," 165–85.

47 Lucille Chia has noted that illustrations could provide pleasure even to poor readers, regardless of how well they understood the text. See Lucille Chia, *Printing for Profit*, 247.

48 Zhang Xiumin, *Zhongguo yinshua shi*, 498–99.

49 This technique has a considerable pedigree, since it can be found in some illustrated storybooks published during the Yuan dynasty (1279–1368). See Hegel, *Reading Illustrated Fiction in Late Imperial China*, 219–20.

50 Zhang Xiumin, *Zhongguo yinshua shi*, 521; Kin Bunkyō, "Tang Binyin yu wan Ming shangye chuban," 82–83; Lucille Chia, *Printing for Profit*, 217.

51 This opinion was originally raised and discussed by Yao Dajuin and Michela Bussotti in the early 1990s and has been further developed by a group of scholars. For example, Lucille Chia notes that these grouped illustrations can be placed somewhere between a functional device for the explanation of the text and an artistic/aesthetic object for apprecia-

tion, which eventually would attract a clientele among the literati as well as the general public. Ma Meng-ching studied an edition of *Xixiang ji* published in 1640 by a commercial publishing house, Tianzhangge, which has all of its twenty-one images at the beginning of the text, thus separating illustration from text. Pointing out the illustrations' physical separation from the text as well as the vague internal relationships among them, she notes that the illustrations could be viewed as independent artistic album leaves. See Yao Dajuin, "The Pleasure of Reading Drama," 444–49; Bussotti, "The *Gushi huapu*," 21; Ma Meng-ching (Ma Mengjing), "Collecting Images for Illustrations"; and Lucille Chia, *Printing for Profit*, 215–17.

52 Hegel, *Reading Illustrated Fiction*, 192.

53 See Bao Zunpeng in Chang Bide, *Mingdai banhua xuan*, preface 1–2; and Wang Bomin, *Zhongguo Banhuashi*, 72–83. In addition, Jingchang (a government publishing house run by eunuchs) categorized laborers working in the printing house into nine categories. Among the 1,275 listed workmen, 76 were classified as illustrators (*huagong*). See Shen Shixing, *Minghuidian*, 189:25a–26b. This indicates that book illustration was firmly recognized as an independent and specialized task in the late Ming publishing industry.

54 In some other cases, the quantity of illustrations was as important as their quality. For example, an edition of *Shuihu zhuan* published by Yu Xiangdou of Fujian in 1594 notes, "There are many editions of *Shuihu zhuan* published by commercial publishers. There are dozens of them that are illustrated. But only my edition has illustrations of all the scenes. . . . Scholars who purchase this edition should keep Shuangfengtang in mind." Original text is quoted in Xue Bing, *Zhongguo banben wenhua congshu: Chatuben*, 35.

55 A different translation of this statement is in Nienhauser, "A Reading of the Poetic Captions," 20–21. Similar comments are also found in the preface of the Wanli edition of *Shanhai jing* (Classic of mountains and seas). For a translation, see Eugene Wang, *Treasures of the Yenching*, 186. Another similar article is found in the fifth *fanli* item of *Qinglou yunyu* (Stylish words from the pleasure quarters) published in 1616.

56 Scarlett Jang, "Form, Content, and Audience," 1–26, and Eugene Wang, *Treasures of the Yenching*, 190. Another important example can be found in one late Ming painting album, *Gushi huapu*. Many of the images included in this album, which was initially planned and printed to provide novice collectors with knowledge of old and rare early masters so as to prevent the purchase of counterfeits, nevertheless mistakenly (or even carelessly) includes many images without proper attribution. See Clunas, *Art in China*, 181. Also see Burnett, "A Discourse of Originality," 528–29.

57 Gans, *Popular Culture and High Culture*, 105.

58 Quoted in Cai Yi, *Zhongguo gudian xiqu xuba huibian*, 1302.

59 Denda Akira has proposed sorting out the genealogy of Ming editions of *Xixiang ji* by dividing it into two major categories: the stage edition group (those editions meant to be used in performances) and the desktop edition group (those editions meant only to be read). See Denda, "Manreki ban Seishōki," 93–106. Zheng Zhenduo proposed the idea that the folk style and exaggerated gestures in late Ming book illustration from Nanjing suggest that the format and the style of their illustrations were taken from coarse editions printed for actors. See Zheng Zhenduo's notes to volume 4 of *Zhongguo banhuashi tulu*.

60 Zhang Chushu and Zhang Xuchu, *Wusao hebian, fanli*:3a.

61 Clunas, *Pictures and Visuality in Early Modern China*, 55, and Clunas, *Superfluous Things*, 51–52.

62 Xie Zhaozhe, *Wuzazu*, 275. Translation is modified from Lucille Chia, *Printing for Profit*, 185.

63 Fifth *fanli* item of *Hudie meng*, quoted in Cai Yi, *Zhongguo gudian xiqu xuba huibian*, 1329.

64 A similar *fanli* item is also found in one late Ming edition of *Mudanting*: "Dramas competitively include illustrations so as to deliver the vivid action and appearance of the actors onstage. This is another trick of the commercial publishers. Tang Xianzu's drama naturally delivers the images in words. Drama is not for illustration; on the contrary, illustration exists for drama. How stupid people are! Shuai Ji (act. late Ming) once noted '*Mudanting* is for reading, not for stage acting.' This edition has no illustrations, because I don't want people to think drama is a visual entertainment." Original text is quoted in Mao Xiaotong, *Tang Xianzu yanjiu ziliao huibian*, 858.

65 Mirzoeff, *Introduction to Visual Culture*, 11.

66 Strinati, *Introduction to Theories of Popular Culture*, 9.

67 Unlike folk art, which is often a spontaneous or autonomous expression of a social group without the benefit of high culture, mass culture bridges different social groups despite its disinformation. See Macdonald, "A Theory of Mass Culture," 60.

68 Bourdieu, *Distinction*, 56–57.

69 Fourth *fanli* item in *Chanzhen yishi*, quoted in Huang Lin and Han Tongwen, eds., *Zhongguo lidai xiashuo lunzhu xuan*, 273.

70 Ninth *fanli* item, quoted in Cai Yi, *Zhongguo gudian xiqu xuba huibian*, 678.

71 Ibid., 664.

72 This demonstrates that book publication or preparation of book illustrations was a group effort involving various professionals. Furthermore, we can see that some women played active roles in the late Ming publishing industry, in this case, as an illustrator.

73 Yao Dajuin, "The Pleasure of Reading Drama," 445.

74 A similar remark is also found in the sixth *fanli* item of *Wuyu cuiya* (Fragments of refinement in Wu songs), published in 1616: "Pictures in books are only for visual embellishment, but they are hard to dispense with because ordinary people love them. [In this volume] exceptional painters express the relevant feelings of the themes and skilled carvers painstakingly work to present the images to the art lovers." Quoted in Cai Yi, *Zhongguo gudian xiqu xuba huibian*, 434.

75 Chartier, *Cultural Uses of Print*, 145.

76 Williams, *Problems in Materialism and Culture*, 37–38. Regarding the concept of "hegemony," I use this term here to mean a consensual control in the cultural production of a certain society, which maintains a status of legitimacy and power over subordinate classes. Hegemony implies consent of subordinates to the authority of the discourses of the dominant group in society. For more detailed discussion of this term, see Ransome, *Antonio Gramsci*, 150–55.

77 *Huishi zhimeng*, preface:2b.

78 Furthermore, the active commission and patronage of painting by late Ming merchants—a social group considered the lowest class in traditional Chinese society—even caused a shift in the representations of gardens in the work of many professional masters; they went from the once solemn refuge of the scholar-official to a lively place of family functions. See Laing, "From Sages to Revelers," 25–33.

79 Murakami, "Yasu kao," 423–41.

80 Similar to this approach, in his comparative research on three different editions of the play *White Rabbit* during the Ming period, Henry Zhao suggests that subcultural texts seem to have adhered more strictly to conservative morals than did culturally advanced editions. See Henry Zhao, "Subculturalness as Moral Paradox," 89–122. For Robert Hegel's remarks, see his "Distinguishing Levels of Audiences," 113–42.

81 Grant Shen, "Acting in the Private Theatre," 64–86. In this article, Shen notes that the private theaters of the literati class, unlike commercial troupes, who were concerned with profit, did not meet the wider public's standards of fashion and taste. Instead, they pursued innovations in stage acting and artistic perfection along with accuracy.

82 Murray, "Illustrations of the Life of Confucius," 73.

83 Plaks, "The Aesthetics of Irony," 487–500.

84 As a way of complimenting writings by his fellow townsman, Wang Lu, Yuan Hongdao noted, "His poetry has a rule in having no rules." Quoted in Xiong Lihui, *Yuan Zhonglang xiaopin*, 245. Following Li Zhi, Yuan Zhongdao also noted, "Most of his prose and poetry uniquely express his personal nature, and they are not restricted by conventions." This perspective appears to have been established as an influential trend in the late Ming in that even some conservative writers of the time did not always adhere to the styles of past masters. For example, although he was associated with those who took the past as a model, Li Mengyang (1473–1529) was not a die-hard believer in antique formalism. He was extremely fond of folk songs and regarded them as a continuation of the classical tradition. His intention was to initiate literary reform through

this concept instead of "holding onto the old" (*shoujiu*). See Chou Chih-P'ing, *Yüan Hung-tao and the Kung-an School*, 7–10.

85 Quoted in Cai Yi, *Zhongguo gudian xiqu xuba huibian*, 72.

86 Quoted in Wang Jide, *Wang Jide qulü*, 148–49. Zhang Dayou (Oil Peddler Zhang) was a street poet of the Tang dynasty who was known for his witty and humorous songs composed in vernacular language.

87 Popular culture is not necessarily a cultural territory of the low or popular class. Instead, it is a field where the various cultural tastes can be contested and negotiated. For more on the relationship between popular culture and class, see Hall, "Notes on Deconstructing 'The Popular,'" 227–40.

3 / Portraits of the Characteristic

1 For the original, see Su Shi, "Shu Wu Daozi huahou" (Comments on Wu Daozi's painting), in *Dongpo quanji*, 93:13b–14a.

2 This colophon is also published in Zhu Mu, *Gujin shiwen leiju, qianji*, 40:13b–14a, and Zhang Chou, *Qinghe shuhuafang*, 4a:12b–13a.

3 Cahill, *Distant Mountains*, 212.

4 Guo Ruoxu, *Tuhua jianwen zhi*, 33–35.

5 Ibid., 19–24.

6 Guo Xi and Guo Si, *Linquan gaozhi*, 9.

7 He Liangjun, *Siyouzhai congshuo*, 255.

8 For the texts of Li Rihua, see Yang Danian, *Zhongguo lidai hualun caiying*, 24. Similar comparisons appear in many other sources. For one example, see Tang Yin's remark quoted in Zhu Mouyin, *Huashi huiyao*, 5:21b–22a.

9 Guo Ruoxu, *Tuhua jianwen zhi*, 19–24; Xia Wenyan, *Tuhui baojian*, 1–2; Tao Zongyi, *Nancun Chuogenglu*, 216–17.

10 Regarding Song dynasty painting styles and their association with contemporary

philosophical trends, see Wen Fong, "Monumental Landscape Painting," 123–24.

11 A similarly categorical explanation of figure painting is also found in Han Zhuo's *Shanshui chunquan ji*. The text notes, "A confident recluse must have a different appearance from the old farmers and fishermen in the country towns." See Han Zhuo, *Shanshui chunquan ji*, 83.

12 This section of text appears to be Zhou's original writing, since it is not found in any other art historical work before the late Ming period. However, this doesn't guarantee its textual authenticity as he still could have learned this part from the verbal tradition of art practice or from a text that is no longer available. In a brief note attached to his punctuated text of *Tianxing daomao*, Yu Jianhua also expresses his suspicion that this part must be copied from unidentified source. See Yu Jianhua, *Zhongguo gudai hualun leibian*, 2:494–96. As Patrick Hanan has pointed out, the source materials could be uncertain because current scholarship has not been wide enough or simply because the original writings ceased to exist. It is probable that there are many other sources as yet unnoticed. A study of available sources could establish some foundation for defining what parts are, or are not, likely to be the author's own invention. See Hanan, "Sources of Chin P'ing Mei," 24–25.

13 Zhou Lüjing, *Tianxing daomao*, 3a. Translation is mine.

14 He Liangjun, *Siyouzhai congshuo*, 264.

15 Han Zhuo, *Shanshui chunquan ji*, 92. Translation is mine.

16 Translation is modified from Shio Sakanish, *Spirit of the Brush*, 33.

17 The earliest case of such a list is in *Huishi zhimeng* as explained in chapter 2 of this book. The same brushwork types are also listed in Wang Luoyu, *Shanhuwang*, 48:79a–79b. The only difference is that

Tianxing daomao registers the brush-work types in a slightly different order; the seventeenth and eighteenth types in Wang's lists were moved to the eleventh and twelfth positions, respectively, in *Tianxing daomao*. This rearrangement lists Wu Daozi's two examples in order, instead of setting them apart as numbers eleven and eighteen. Regarding the detailed description of each example and its expression, see Liu Fangru, "Gujin yiwen shiba miao," 48–57.

18 Bermingham, *Learning to Draw*, 47.

19 It is also noteworthy that late Ming painters often placed large figures in their landscape paintings. This format is often explained in term of late Ming perspectives toward life, which placed more serious emphasis on people's daily lives than on the natural world. In literature, this attitude was also reflected in the genre of *xiaopin* (informal essays), an invention of the late Ming literati, in which personal experiences in everyday life were treated as legitimate sources of literary inspiration. See Lin Mu, *Ming Qing wenrenhua xinchao*, 132–34.

20 Sekula, "The Body and the Archive," 17–18.

21 A similar format is found in a hand scroll from the Freer Gallery of Art (collection no. 11.526) representing individual anecdotes from Tao Yuanming's life. There are many other paintings of Tao Yuanming's life, which valorize his actions and personality. For these images and discussion of them, see Wang Yaoting, "Chen Hongshou bixia," 96–109, and Susan Nelson, "Catching Sight of South Mountain," 32–33.

22 Wu Hung, "The Origins of Chinese Painting," 61.

23 Murray, "The Hangzhou *Portraits of Confucius*," 10.

24 Talbot, "Prints and the Definitive Image," 199, and Ivins, *Prints and Visual Communication*, 3.

25 Cahill, *Compelling Image*, 122–23.

26 For the explanations of both terms, see *Hanyu dacidian*, 8:689 and 6:574.

27 For their stories, see Sima Qian, *Shiji*, 2045. Translation is mine.

28 The earliest record of *zhuozu* is in *Mengzi* (*Mencius*), 128. It notes, "If the water is clean, I can wash my cap strap; if dirty, I wash my feet." For further explanation, see Cahill, *Parting at the Shore*, 47, and Wai-Kam Ho, *Eight Dynasties of Chinese Painting*, 157.

29 This specific sitting-by-the-water mode is associated with the "mind-reclusion" idea of Xie Kun, a fourth-century official and "recluse at court," whose reclusive ideal became famous through Gu Kaizhi's portrait of him set amid mountains and streams. Later artists, including Zhao Mengfu (1254–1322), also left many portraits of Xie. See Shih Shou-chien, "The Landscape Painting of Frustrated Literati," 228–30.

30 Powers, "Love and Marriage in Song China," 53.

31 Ibid., 51–53. See also Brotherton, "Beyond the Written Word," 231, and Swartz, *Reading Tao Yuanming*, 145–211.

32 Susan Nelson, "Tao Yuanming's Sashes," 1–27.

33 The image of *yishu* (leaning on a tree) in *Tianxing daomao* also matches an image of the same motif in the Palace Museum scroll. Numerous paintings show a figure leaning on a tree. Many of them are Tao references, such as the painting *Tao Yuanming Coming Home* by Li Zai (d. 1431). However, this motif is not exclusively associated with Tao Yuanming. It also appears in paintings celebrating scholarly social networks, such as the Orchid Pavilion Gathering and the Elegant Gathering in the Western Garden.

34 More than fifty of these poems are introduced in Yuan Xingpei, *Tao Yuanming jijian zhu*, 686–726.

35 Zhang Chou, *Qinghe shuhuafang*, 8a:29b.

36 Barthes, *Fashion System*, 9–10.

37 Wang Nengxian, *Shishuo xinyu yanjiu*, 133.

38 Liu Yiqing, *New Account of Tales of the World*, 238.

39 Ning Jiayu, *Shishuo xinyu de shiren*, 206–15.

40 Regarding historical and iconographic explanation of this topic, see *Bunker*, "Early Chinese Representations of *Vimalakirti*," 28–49.

41 Chavannes, *Mission Archéologique dans la Chine Septentrionale*, pt. 2, 556.

42 Davidson, "The Origin and Early Use of the Ju-I," 247.

43 Zhao Yi, *Ershi'er shi zhaji*, 8:151–52. Translation is mine.

44 Tao Zongyi, *Nancun chuogenglu*, 255.

45 Wen Zhenheng, *Zhangwu zhi*, 54. Translation is mine.

46 Chen Xiasheng, "Jixiang ruyi," 64–66.

47 The images "Talking face-to-face" and "Seated firmly" (*panhuan*) in *Tianxing daomao* also deal with scholars involved in conversation or socializing. However, in some records, *panhuan* also means "strolling in nature." The biography of Tao Yuanming notes that he enjoyed a pine tree and loitered around it. See *Hanyu dacidian*, 7:1643. Tao Yuanming's biography in *Jinshu* (History of the Jin) records that he "stroked the old pine as he walked around [*panhuan*] it." See *Jinshu*, 2461.

48 Yu Yingshi, *Shi yu Zhongguo wenhua*, 297–300.

49 Tang Yiming, *Wei Jin qingtan*, 43–44, and Xiong Lihui, "Lüelun Wei Jin wenfeng," 111–14.

50 Lu Xun, *Zhongguo xiaoshuode lishi de bianqian*, 8–13, and Wang Nengxian, *Shishuo xinyu yanjiu*, 199.

51 Qian Mu, *Zhongguo xueshu sixiangshi luncong*, 3:187–88. This opinion was first suggested by Japanese scholars during the first half of the twentieth century. Based on the similarities between Confucian ideology and the *qingtan* rhetoric, Itano Chōhachi noted that *qingtan* was an expression of philosophical and ideological perspectives, not paradoxical sophistry as had been thought. See Itano, "Seidan no ichi kaishaku," 358–86. Utsunomiya Seikichi also notes that *qingtan* was a manner of dialogue that covered a wide range of subject matter such as academics, politics, military matters, and even socializing. See Utsunomiya, "Sesetsu shingo no jidai," 5–18.

52 "Xu Shuofu," in *Siku quanshu zongmu tiyao*, 1743.

53 See "Dongzhi," in Feng Feng, *Baixing minsu liyi daquan*.

54 DeWoskin, *A Song for One or Two*, 57, 78.

55 Park, "Instrument as Device," 136–48.

56 Van Gulik, *Lore of the Chinese Lute*, 67; Wen Zhenheng, *Zhangwu zhi*, 58.

57 Another kind of zither, the twenty-five-stringed *se*, was an accompanying or ensemble instrument, but it disappeared by the middle of the first millennium. See Bodman, *Chinese Musical Iconography*, 32–42.

58 Wen Zhenheng, *Zhangwu zhi*, 57–58.

59 The image of *suoju* in *Tianxing daomao* shows a scholar sitting on an animal skin by the shore while looking into the distance. A brush and an inkstone next to him signify that he is in the middle of seeking inspiration for writing. In *Tuhui zongyi*, the figure of *suoju* is accompanied by blooming chrysanthemums, a cup of wine, a brush, an inkstone, and an unrolled length of paper for writing in the background. Kobayashi Hiromitsu notes these visual traits are more than allusive to Tao Yuanming, who madly loved chrysanthemums and drinking. See Kobayshi, "Publishers and Their *Hua-p'u* in the Wanli Period," 174–76.

60 Wu Chengxue, "Lun tibishi," 5.

61 In some cases, *tibishi* was written when

the writer was drunk, and this was regarded as authentic spontaneity. Hou Kaijia, "Tibi shufa xingfei shishu," 5–8.

62 Harrist, "Reading Chinese Mountains," 64–69.

63 Wild calligraphic style called *kuangcao* (crazy handwriting) was often used for the genre of *tibishi*, which was regarded as the style of a free spirit. In one of his poems, the Tang poet Li Bai noted, "I face the rock wall, and the brush takes flight. In one stroke, I write several large characters." *Tibishi* has a public nature, since it was a way of displaying and disseminating one's work publicly. Thus, it was especially important before the Song when publishing had not yet taken off in China. See Zeitlin, "Disappearing Verses," 73–125.

64 Luo Zongtao, "Tangren tibishi chutan," 144–58.

65 The change was due to the development of paper and the book industry along with the emergence of Neo-Confucianism, which emphasized balance and order rather than individual spontaneity and freedom. See Hou Kaijia, "Tibi shufa xingfei shishu," 7.

66 Translation from Chou Chih-p'ing, *Yüan Hung-tao and the Kung-an School*, 108–9. For another English translation, see Chaves, *Pilgrims of the Clouds*, 101–2. Interestingly, on another occasion, Yuan Hongdao saw somebody inscribing a poem on the surface of a pagoda but did not launch any harsh criticism against this action. Instead, he worried about how quickly the inscription would be effaced by the wind and rain. See Chaves, *Pilgrims of the Clouds*, 33.

67 As early as the Northern Song dynasty, a literati critic, Huang Tingjian (1145–1105), claimed that direct engraving on the surface of a rock was a philistine practice of the past. He proposed that calligraphy must be written on paper before being transcribed onto stone.

68 Translation is from Yang Ye, *Vignettes from the Late Ming*, 66–67.

69 A late Ming scholar, Wang Sishi (1566–1648), noted, "From the phrase 'I passed my cup and did not decline those from others,' we can see that people sometimes used only one cup to share wine among all the participants." See Wang Sishi, *Duyi*, 5:25b.

70 For further explanation, see *Hanyu dacidian*, 11:1618.

71 See the third article in Zhang Han, "Yilaohui yue," in *Wulin Yilaohui shiji*, 3a.

72 *Hanyu dacidian*, 7:1240, and *Ciyuan*, 3:1798.

73 Zuiyin was also the nickname of the famous Tang dynasty poet Bai Juyi, who was often noted to have sought inspiration and creativity from drink. Bai Juyi called himself Mr. Drunk Chanter. See *Xin Tangshu*, 4304.

74 Hightower and Yeh, *Studies in Chinese Poetry*, 35.

75 *Quantangshi*, 4487.

76 *Hanyu dacidian*, 9:1394b–95a.

77 He Liangjun, *Siyouzhai congshu*, 302.

78 Clunas, *Empire of Great Brightness*, 145–46.

79 *Peiwenzhai shuhuapu*, 90:15a–15b, and Tang Hou, *Gujin huajian*, 349.

80 Xiang Yuanbin's seals on this painting are found at nos. 2, 56, 59, and 67 in Zheng Yinshu, *Xiang Yuanbian shuhua shoucang*, 102–3.

81 Similar images are also found in a painting of the same title by a Ming artist, Zhang Peng, in the Guangdong Provincial Museum and in Chen Hongshou's painting of the same title, now located in the Wuxi Municipal Museum Collection.

82 Translations are from Liu Yiqing, *New Account of Tales of the World*, 419, 421. Additional remarks of this kind are quoted in Wang Nengxian, *Shishuo xinyu yanjiu*, 157–58.

83 For the Wei-Jin scholars and drugs, see Lu Xun, "Wei Jin fengdu," 251–65. In addition, *Taiping guangji* (Extensive records of the Taiping era) notes a story about a commoner in the Wei period who pretended to be drugged in public. In truth he could not afford the drug, but he wanted to show people that he was following the fashion of the upper class. See Li Fang, *Taiping guangji*, 247:1b–2a.

84 Wang Nengxian, *Shishuo xinyu yanjiu*, 71–77. See also Qian Nanxiu, *Spirit and Self in Medieval China*, table 5, 194–95, and 247.

85 Cao Zhengyong's preface to Zheng Zhongkui, *Qingyan*, 1b.

86 Qian Nanxiu, *Spirit and Self in Medieval China*, 201.

87 Goodrich, "Ho Liang-chün," in *Dictionary of Ming Biography*, 515–18.

88 Qian Nanxiu, *Spirit and Self in Medieval China*, 273. Some of the late Ming gatherings openly proclaimed that they were based on models of the Wei–Jin periods. The most well-known literati gathering in Chinese history, the Orchid Pavilion Gathering, which is believed to have occurred in 343 CE, was repeatedly imitated, and these events were celebrated by late Ming scholars, for example, the Second Orchid Pavilion Society of the early Ming period and the Little Orchid Pavilion Society of the late Ming period. See He Zongmei, *Mingmo Qingchu wenren jieshe yanjiu*, 49–50.

89 Yoshikawa, *Yuan Ming shi gaishuo*, 113–15.

90 Regarding English dandies and their behavioral patterns, see Bermingham, *Learning to Draw*, 137–38.

91 See Guo Yinde, "Lun wan Ming Qingchu caizi jiaren xiqu xiaoshuo," 79.

92 Zhang Han (1510–1593) noted, "Human emotion regards overindulgence in sensual pleasure as delectable; in worldly fashion, overspending is seen to be respectable. Even though people went to extremes [in pursuing them], they are not conscious of it at all." See Zhang Han, *Songchuang mengyu*, 139. Yuan Hongdao also noted, "Some people in drinking and sex, others in music and opera, just follow where their hearts lead them; they do not care about anything else. Frustrated, they no longer care about their success or reputation." See Wu Chengxue, *Wan Ming xiaopin yanjiu*, 381.

93 As for the records of Tu Long and his sexual life, see Martin Huang, *Desire and Fictional Narrative*, 5–22.

94 Xie Zhaozhe denounces the pleasure derived from drinking and the company of courtesans as inappropriate pastimes and also argues that these represent a person's corrupted mind. For the original text of Xie's comments and explanations, see Mao Wenfang, *Wan Ming xianshang meixue*, 38.

95 Yuan Zhongdao organized a "drinking society" (*jiushe*) with about twenty friends. Its rules stipulated that the person who could drink the most was supposed to be the leader of the group. See Yuan Zhongdao, *Kexuezhai qianji*, 16:6a. Another drinking society called Lianhua jiushe (Lotus Flower Drinking Society) was organized by a *shengyuan*, Huang Yu, in 1462. See Huang Ang, *Xijinshi xiaolu*, 5:7b. Chen Baoliang further notes that drinking societies became even more popular during the Qing period; see Chen Baoliang, *Mingdai shehui shenghuoshi*, 25. For a general explanation of seventeenth-century drinking-game cards, see Bentley, "Authenticity in a New Key," 1–36.

96 Yuan Hongdao listed scores of books as indispensable sources of joy for those who truly enjoy drinking. The list starts with the Six Classics and ends with *Shuihu zhuan* and *Jinpingmei*. "Those who are not familiar with these books," says Yuan Hongdao, "will remain unat-

tractive and dull in conversation; they should not be considered true drinkers." For a more detailed discussion, see Chih-p'ing Chou, *Yüan Hung-tao and the Kung-an School*, 59–60.

97 Li Wai-yee, "The Rhetoric of Spontaneity," 32–52.

98 *Jiaxing fuzhi* (1600), *Zhongguo fangzhi congshu*, 505/4:1355–56.

99 Li Xu, *Jie'an laoren manbi*, 78–80.

100 The discovery of this brick tomb with portrait reliefs was first reported in 1960. In 1965 and 1968, two more tombs were found with partial traces of inscriptions and additional images of the Seven Sages. See Spiro, *Contemplating the Ancients*, chapter 3.

101 Loehr, "The Beginning of Portrait Painting in China," 211.

102 Seckel, "The Rise of Portraiture in Chinese Art," 15.

103 Li Rihua, *Meixu xiansheng bielu*, shang:4b.

104. One of the earliest examples of this subject in a painting format is a partially preserved painting by Sun Wei (9th century), from the Tang period, which is now in the Shanghai Museum. This painting shows four such figures: Shan Tao, seated and half naked, rests his hand on his knee; a seated Wang Rong holds a *ruyi* between his bare feet; holding a wine cup and turning away to throw up is Liu Ling; Ruan Ji laughs, waving a yak-hair duster. However, the state of preservation and the stylistic features suggest that the painting could well be a later copy of Sun's original. For further discussion of the painting, see Li Hongquan, *Wei Jin shenghuo lüeying*, 28.

105 Tao Zongyi reported 117 works in the collection of the Song emperor Lizong (r. 1225–1264). See his *Nancun chuogenglu*, 68.

106 Regarding Li Gonglin's painting and stone engravings, see Moss, *Emperor, Scholar, Artisan, Monk*, 32.

107 Huang Jin, *Wenxuanji*, 4:71a.

108 In addition to these three, Zhejiang Lanting Jinianguan has an edition of 1617. It could be a later rubbing of the Prince Yi edition. For a detailed description of these editions, see Ma Daokuo, "Zhu Youdun de Lanting taben," 73–77, and Yuan Yuhong, "Beijing tushuguan cang *Lantingtu*," 60, 94–96.

109 Zhao Mengfu's painting of the Orchid Pavilion Gathering housed at the National Palace Museum in Taipei is almost identical to the format, composition, and details of the rubbings. At the beginning of this hand-scroll painting, there is a seal of Xiang Yuanbian, Zhou Lüjing's friend and patron. Thus, it is likely that Zhou followed the traditional format of the Orchid Pavilion painting.

110 Song Lian (1310–1381), a Yuan scholar-official and imperial adviser, left a detailed record of the Orchid Pavilion Gathering painting. Some of his descriptions are quite different from what is written in *Tianxing daomao*. For example, regarding Xie Teng's image, which is labeled as "Wasted" in *Tianxing daomao*, Song Lian notes that Xie was tired and thus was stretching his arms out while yawning. As for Yu Yun's "Smashed" in *Tianxing daomao*, Song Lian notes he is being helped by a boy-attendant because of his old age. For a translation of Song Lian's record, see Moss, "Prince I's Lan-T'ing Ink Rubbing Compilation," a separate volume included in his *Emperor, Scholar, Artisan, Monk*.

111 Du Mu, *You Mingshan ji*, 25–26.

112 *Jiahe zhengxianlu*, 35:7b; 47:1b–2b.

113 Yuan Zhongdao, *Kexuezhai quanji*, 535.

114 Li Jie, *Yingzao fashi*, 3:9, 29:14–15. There is a Song example of this water channel at Chongfugong in Henan. A photograph of it is found in Liang Sicheng, *Yingzao fashi zhushi*, 1:79.

115 Regarding detailed explanations of the

floating cups and other objects in the Orchid Pavilion Gathering, see Lin Gongzu, "Qushui liushang hua shangsi," 16–33. For more information regarding Wang Tingna and his garden estate, see Xu Xiaoman, *Banhua*, 70–71,and Berliner, "Wang Tingna and Illustrated Book Publishing in Huizhou," 67–75.

116 Qian Bocheng, *Yuan Hongdao jianjiao*, 443–45.

117 James Cahill has pointed out that paintings of the Orchid Pavilion Gathering are not to the literati's artistic taste. He notes that along with Su Shi's "Red Cliff," and "The Elegant Gathering in the Western Garden," this theme was a favorite subject among Suzhou's professional masters. See Cahill, *Distant Mountains*, 35–36.

118 Strassberg, *Inscribed Landscape*, 63.

119 Laing, "Real or Ideal," 419–35. However, this opinion met with forceful opposition from a group of Chinese scholars including Xu Jianrong. See Xu Jianrong, "'Xiyuan yaji yu meishushixue," 5–21.

120 See Guo Moruo, "You Wang Xie muzhi de chutu lundao Lanting xu," 5–32. Regarding the controversies over the Orchid Pavilion Gathering preface, consult Hua Rende and Bai Qianshen, eds., *Lanting lunji*, and Wenwu chubanshe, ed., *Lanting lunbian*.

121 See Gao Musen, "Hanmo qiankun wen zhenwei," 103, and Laing, "Real or Ideal," 428–29.

122 I Juo-fen (Yi Ruofen), "Yizhuang lishi de gong'an: Xiyuan yaji," 221–68.

123 Text is quoted in Bian Yongyu, *Shigutang shuhua huikao*, 33:19a. Translation is mine. However, this text may well have been made up during the late Ming, as it is not found in any Song or Yuan sources.

4 / Icons of Love and Marginality

1 Vicinus, "Introduction: The Perfect Victorian Lady," x–xi.

2 *Tuhua jianwen zhi* (87) notes Zhang Mei's painting of this theme; *Peiwen yunfu* (306a) for Lu Tanwei; *Tuhua jianwen zhi* (124) and *Xuanhe huapu* (7:1b) record Zhou Wenju as the painter of this theme, while Dong You's *Guangchuan huaba* (6:7a) and Wang Luoyu's *Shanhuwang* (47:61b) note Zhou Fang's painting of same subject matter. In addition, Yang Shen's *Danqian zonglu* (Complete records on proofreading) notes that paintings of this topic from the Six Dynasties show two ladies standing face-to-face holding the pounding club. However, this composition is similar to the painting of the Huizong copy of Zhang Xuan's famous *Daolian tu* (Ladies preparing newly woven silk), currently housed at the Museum of Fine Arts, Boston.

3 Tang Yin's painting housed at the National Palace Museum in Taipei shows a lady sitting alone outdoors, pounding clothes. Its caption reads, "In the inner quarter of the palace, catalpa leaves cover the moon. A long autumn night, the sound of pounding comes from the palace. Why did she drop the feather fan? Autumn wind carries away her feelings." Guo Xu's work on this topic is housed at the University of Chicago Art Museum.

4 The other colophons on this painting are composed by Huangfu Chong, Huangfu Fang, and Huang Jishui (1509–1574). For their texts, see Wang Ningzhang, "Qiuhanyue yehua daoyi," 16–17.

5 Laing, "Erotic Themes and Romantic Heroines," 75–77.

6 *Baiyong tupu* has two extant copies. The one I consulted for this research is part of the Peking University Rare Book Collection. The National Library of China in Beijing has another copy, but it is badly damaged and none of its illustration pages survive.

7 An almost identical image appears in

Yougui ji (Inner quarters) published by Rongyutang (Hall of Generosity). This image also shows a woman pounding clothes in a garden. The format and detail are very close to those in *Baiyong tupu*. The caption reads, "The sound of the cold pounding stone delivers our feelings beyond the forest."

8 Gu Zhengyi, *Baiyong tupu*, 1:12b. Translation is mine.

9 Wang Ningzhang, "Qiuhanyue yehua daoyi," 10–12.

10 Wang Shizhen, *Yanzhou xugao*, 168:31a–b.

11 Wen Zhenheng, *Zhangwu zhi*, 25.

12 Wang Luoyu, *Shanhuwang*, 47:55b, and *Peiwenzhai shuhuapu*, 98:43b.

13 Wang Shizhen, *Yanzhou xugao*, 22:1a–b. Translation is mine. *Lidai tihuashi lei* (44:5a) notes that this theme was related to Yang guifei.

14 Gu Zhengyi, *Baiyong tupu*, 1:18a. The other illustration and poem is on 2:8b–9a.

15 Chen Hongshou also left a painting of this theme (ca. 1639), now housed at the Shanghai Museum. For a reproduction, see Weng Wango, *Chen Hongshou*, plate 130.

16 These works are *Huansha ji* (Washing silken gauze), *Kaipi yanyi* (The origins and development of heaven and earth), *Tang Minghuang qiuye wutongyu* (Autumn night of the Emperor Ming of Tang: Rain on the catalpa tree), and *Chajiu zhengqi* (Outstanding teas and wines).

17 Wang Anqi, "Mingdai de siren jiayue yu jiazhai yanju," 64–77.

18 Bian Yongyu, *Shigutang shuhua huikao*, 32:171a; Wang Yuxian, *Huishi Beikao*, 5a:41a; Hang Huai, *Shuangxi ji*, 5:15b.

19 *Huainanzi*, 6:10b. A different version of the story notes that she took the elixir to prevent it from being stolen by Hou Yi's protégé Peng Meng.

20 Stephen West and Wilt Idema note that in some traditions, Chang'e is actually transformed into a hare. See West and Idema, "Sexuality and Innocence," 32.

21 Translation is modified from James J.Y. Liu, *The Poems of Li Shangyin*, 99.

22 For the translation of the text, see West and Idema, "Sexuality and Innocence," 31–35.

23 Freer Gallery of Art storage note for item no. F1917.335.

24 See Cao Xuequan, *Shicang lidai shixuan*, 302:5b; Sun Xu, *Shaxiji*, 23:6b; Huang Zhongzhao, *Weixuan wenji*, 11:231b; Liu Ji, *Chengyibo wenji*, 5:43a.

25 *Lidai tihuashi lei*, 44:12b–13b.

26 *Hanyu dacidian* introduces five different examples of stories on the theme "writing on a leaf." All are based on stories from the Tang dynasty and introduce flowing water as a carrier of the letter, instead of the wind. See *Hanyu dacidian*, 12:328.

27 Laing, "Erotic Themes and Romantic Heroines," 77.

28 *Quantangshi*, 8967.

29 Qiao Mengfu, "Li Yunying fengsong wutongye," reprinted in *Xuxiu Siku quanshu*, 1703:146–55.

30 Ibid. Translation is mine.

31 Laing, "Erotic Themes and Romantic Heroines," 71.

32 See John Hay, "The Body Invisible in Chinese Art?" 43.

33 Laing, "Chinese Palace-Style Poetry,'" 284–95.

34 Powers, "Garden Rocks, Fractals and Freedom," 28–38.

35 Ropp, "Now Cease Painting Eyebrows, Don a Scholar's Cap and Pin," 87–88.

36 Carlitz, "Chastity, Pornography, and Early Modernity."

37 Although Confucian obligations were at the center of model family letters for wives, actual letters by late Ming women to their husbands reveal very little interest in family obligations. Instead, intellectual, literary, and artistic interests

predominate. The letter becomes a vehicle for expressing a woman's individual creativity and emotions. See Mann and Cheng, *Under Confucian Eyes*, 170.

38 See Yang Shuhui, *Appropriation and Representation*, 101. Late Ming *caizi jiaren* (scholar-beauty romance) literature insightfully mirrors a level of fictional reality. First, literary and artistic capabilities instead of adaptation to an institutional education lead to an successful official career through a government position; second, talent and the emotion were not bound to the conservative Confucian morality of the period, which limited the woman's status in society; finally, talent and sexuality were not mutually exclusive values and instead were regarded as complementary. See Guo Yingde, "Lun wan Ming Qing chu caizi jiaren xiqu," 71–80.

39 Zheng Peikai, "Wan Ming shidafu dui funü yishide zhuyi," 39.

40 See Tang Xianzu, *Mudantingji tici*, 1093. Translation is from Birch, *The Peony Pavilion*, ix.

41 Translation is modified from Blanchard, "Visualizing Love and Longing," 233.

42 Zhang Chou's *Qinghe shuhuafang* (6b:25a–b) notes that there was a painting of this subject by Zhou Wenju, a Southern Tang court painter, housed in Yan Fenyi's collection. It has an inscription on its left side saying, "In Liaoyang, spring is ending, but no news; night flowers bloom as the sun sets in the west." This colophon corresponds to the latter half of Bai Juyi's poem. In addition, Wang Luoyu, *Shanhuwang* (23:5a), Wen Jia, *Lingshantang shuhuaji* (832b), and Wu Yunjia, *Tianshui bingshanlu* (272) also record Zhou Wenju's work on this topic. There is also a record of Zhou Wenju's painting of "embroidery lady" (*xiunü*) in Zhou Mi (1232–1308), *Yunyan guoyanlu*, 347. Many other art historical sources record Zhou Fang's painting

on this topic. See Gao Shiqi, *Jiangcun shuhuamu*, 4:25a, and Peng Sunyu, *Songguitang quanji*, 31:7b.

43 One painting of this topic attributed to Zhou Wenju is reprinted in Sirén, *Chinese Painting*, plate 120.

44 Zhang Chou, *Qinghe shuhuafang*, 7a:26a.

45 A textual record from the Yuan dynasty notes a painting of this topic executed in "ink outline" (*baimiao*) technique. *Zhusu shanfang shiji* by Wuqiu Yan (2:3a) notes, "Fog shrouded grasses hug mist-like the jade hibiscus; The chirping bird is now silent, and the small courtyard empty. Who believes that a broken heart comes from dreaming of butterflies? Autumnal hues make me yearn for easterly breezes." In addition, there are more Yuan sources recording colophons written on paintings of this topic. See Qiu Yuan, *Jinyuanji*, 6:5b, and Yang Hongdao, *Xiaohengji*, 5:6a. In addition, *Lidai tihua shilei* (59:1a–b) lists several other colophons on this subject from the Song dynasty.

46 *Peiwenzhai shuhuapu*, 87:29b, and *Shanhuwang*, 40:9b.

47 Leppert, *Sight of Sound*, 63–90.

48 Li Zhi, *Fenshu*, 164–68, and Feng Menglong, "Guizhibu congxu," 504.

49 Xie Zhaozhe, *Wuzazu*, 157.

50 For the historical background of this phrase, see Chen Dongyuan, *Zhongguo funü shenghuoshi*, 188–202. Chen notes that this dictum is from the early Qing period, yet, as Chen Baoliang has proved, it was already existent during the late Ming period. See Chen Baoliang, *Mingdai shihui shenghuoshi*, 187–88.

51 See Kang-i Sun Chang, "Ming-Qing Women Poets," 250–55.

52 Hu Wenkai, *Lidai funü zhuzuo kao*, 1016–17, 1020–23.

53 Translated by Paul Ropp. See Ropp, "Now Cease Painting Eyebrows," 87.

54 Carlitz, "The Social Uses of Female Virtue," 128–41.

55 Carlitz, "Desire, Danger, and the Body," 104.

56 Mann, "Widows in the Kinship," 37–56, and Ko, "Toward a Social History of Women," 11–40. Here, Dorothy Ko notes that late Ming widows would be traded as concubines since widow remarriage was an agreed "contract" instead of an alliance.

57 Zhang Dai (1597–1679) recorded that although common prostitutes were ubiquitous and easily hired, a meeting with a famous courtesan could not be arranged without an intermediary: she was accessible only to the privileged few. See Zhang Dai, *Tao'an mengyi*, 85–86.

58 Xie Zhaozhe, *Wuzazu*, 163.

59 For books of this sort published during the Ming period, see van Gulik, *Sexual Life in Ancient China*, chapter 10.

60 Fu Chengzhou, "Feng Menglong li qing jiao xinshuo," 186–96.

61 There was a semantic link between Feng's idea and the "childlike mind" of Li Zhi and the Gong'an School, which emphasized unseasoned taste, originality, and spontaneity. They all initiated the liberation of subjectivity from conservatism or control. See Fang Sheng, "Lun Feng Menglong de 'Qingjiao' guan," 119–21.

62 Chen Wanyi, "Feng Menglong [Qingjiaoshuo] shilun," 303–7. Furthermore, C.T. Hsia has pointed out that the emphasis on "life," "love" (*qing*), and "dream" underscores the impact of the Neo-Confucian Taizhou School on Tang Xianzu's philosophy in general and his affirmation of *qing* in particular. Tang Xianzu was a student of Luo Rufang's (1515–1588) and a third-generation disciple of Wang Gen (1483–1541), the founder of the Taizhou School. See Hsia, *Classic Chinese Novel*, 276–79. However, Dorothy Ko interprets the cult of *qing* not as a philosophical abstraction but as a more general cultural product of the

time. She has noted, "Its true meaning has to be appreciated in the lives of those galvanized by its promise of a freer and happier life." See Ko, *Teachers of the Inner Chambers*, 79–82.

63 Feng Menglong, *Qingshi*, 82. Similar viewpoints are repeatedly noted in Feng's *Qingshi*. Another example: "Loyalty, filial piety, integrity, and righteousness in the world are all stimulated by *qing*." See *Qingshi*, 270.

64 T'ien Ju-k'ang, *Male Anxiety and Female Chastity*, 39–69.

65 Ka. F. Wong, "The Anatomy of Eroticism," 325–27.

66 Carlitz, "Desire, Danger, and the Body," 117–20.

67 These publications include *Nüjie* (Commandments for women) by Ban Zhao (d. 116 C.E.), *Nü Xiaojing* (Book of filial piety for women) by the wife of Chen Miao of the Tang dynasty, *Nü Lunyu* (The Analects of Confucius for women) by Song Ruohua, a consort of Emperor Dezong (r. 779–805), *Neixun* (Instruction for the inner chamber) by the empress of Emperor Chengzu (r. 1403–1424), and *Xinfupu* (Instructions for the new wife) by Lu Qi (b. 1614).

68 The difference between pornography and erotica is that the latter is more suggestive than explicit, producing a certain degree of sexual interest in the viewer rather than intense sexual excitement. See O'Neil, "(Re)Presentations of Eros," 68–71.

5 / The Art of Being Artistic

1 Some textual contents in *Qiyuan xiaoying* are also copied word for word from *Gao Song zhupu*. Although Gao Song's name is not specified as an author in the volume, as explained in the chapter 1 of this book, Zhou Lüjing admitted in *Huilin* that he used large portions of the program from Gao Song's manuals. 2

Translation is modified from Mai-mai Sze, *Way of Chinese Painting*, 410.

3 It is true that the simplicity of bamboo paintings may make them less difficult to execute effectively than landscape and figure paintings. This might be the reason bamboo paintings were often presented as gifts between scholars. As James Cahill has pointed out, paintings that could be used in the exchange of social courtesies may have encouraged artists to work more schematically and conventionally rather than doing works more truly indicative of personal feelings or artistic originality. See Cahill, *Painter's Practice*, 16–17.

4 *Lanpu* by Puming (ca. 1285–ca. 1351) is also composed of a short text of two hundred characters explaining the types, poses, and shapes of orchids as well as the kinds of brushwork used to achieve their expressions. Its text is reprinted in Kong Qi, *Zhizheng zhiji*, 40–41.

5 Bickford, "Stirring the Pot of State," 173–86.

6 Bickford, *Ink Plum*, 151.

7 The bamboo, with its simpler form consisting of conical shoots, a cylindrical stalk, ringed joints, and spear-shaped leaf blades, finds ready morphological analogues in calligraphy. However, the morphological and tactile complexity of the plum blossom does not so easily lend the flower to such treatment. See Bickford, *Ink Plum*, 9. Thus, this exercise appears to have required a certain level of creativity from Zhou Lüjing.

8 Bolten, *Method and Practice*, 192, 313.

9 The summary in *Chungu yingxiang* does not explain this step-by-step process of bird painting. It is noteworthy that this summary was copied in a contemporaneous practical encyclopedia, *Sancai tuhui*. Even the title of the series, *Huilin*, is transcribed without change.

10 *Chungu yingxiang*, 1b–2a. It was in the Song dynasty court that the genre of bird-and-flower paintings reached its initial apogee. In 1120, the Song court owned 2,776 paintings of this genre, which constituted more than twice the number of the next-largest categories, religious and landscape painting, in its collection. Their tradition was transmitted to the Ming period by Bian Wenjin (ca. 1356–ca. 1428) and his two successors, Lin Liang (1416–1480) and Lü Ji (b. 1477). They worked mostly in the established pictorial formulas and style of Song and Yuan academic and professional paintings. On Northern Song bird-and-flower painters and later traditions, see Barnhart, *Peach Blossom Spring*, 25–35.

11 Although not applicable to the images in *Chungu yingxiang*, the names of the birds or the titles of the paintings often carry special meanings. For example, *shuangying* (a pair of hawks) is a pun on "a pair of heroes," while *sixi* (the four magpies) can also mean "four happinesses." *Songmei* (pine and plum) puns with "to convey good wishes." Hawks are symbols of strength, and pines are symbols of endurance and longevity. Other examples are snow for hardship, magpies for happiness, and plum for beauty, intelligence, and talent. See Barnhart, *Peach Blossom Spring*, 207. Regarding such punning rebuses, see Eberhardt and Bartholomew, *Dictionary of Chinese Symbols*.

12 Clunas, *Art in China*, 160.

13 Tao Yongbai and Li Shi, *Shiluo de lishi*, 60–64.

14 Bermingham, *Learning to Draw*, 225.

15 For Han Zhuo's text and explanations of them, see Maeda, *Two Sung Texts on Chinese Painting*, 32–35.

16 A minister of the Chu kingdom and emblem of political loyalty, Qu Yuan (332–296 B.C.E.) often extolled the

orchid above all other flowers in his works. Its association with him has lent the flower additional—and ultimately its primary—meaning of loyalty. In the Southern Song period, however, the orchid, like most other flowers, personified female beauty, usually that of courtesans and neglected palace women. See Barnhart, *Peach Blossom Spring*, 35. The plum is often associated with the poet Lin Bu (967–1028), who cultivated plum trees and regarded the plum as his wife. This could be an example of imposing identity on a natural object. However, as Susan Nelson has noted, as symbols, such objects would also remain independent, and they often appear in contexts having nothing to do with their poet-patrons. See Nelson "Revisiting the Eastern Fence," 441.

17 Li Kan, *Zhupu xianglu*, 3:1b. Translation is mine. A similar comment is also found in Wu Taisu's *Songzhai meipu*. See Bickford, *Ink Plum*, 189.

18 Ruskin, *Modern Painters*, 200–218.

19 Ginger Hsü, "Incarnations of the Blossoming Plum," 25; Frankel, "Plum Tree," 88–90, 99–102; Bickford et al., *Bones of Jade*, 154–57. This romantic association of the plum and sensual love is also registered in *Fancun meipu*, the earliest botanical treatise devoted to flowering plum, by Fan Chengda (1126–1193). See Bickford, *Ink Plum*, 11.

20 A Song dynasty poet and painter, Yang Wujiu, also used these terms in his poetry as the semi-personification of the plum as a lovely woman or young girl, such as "fragrant heart" and "powdered face slightly flushed." See Bickford, *Ink Plum*, 137.

21 Leppert, *Art & the Committed Eye*, 43–44. Quotation in the text is from Bryson, *In Medusa's Gaze*, 6–7.

22 The theoretical framework of the illustration and its caption is borrowed from

Barthes, "Rhetoric of the Image," 32–51.

23 Adorno, *Culture Industry*, 25–36.

24 Gendron, "Theodor Adorno Meets the Cadillac," 18–36.

25 Benjamin, "The Work of Art in the Age of Mechanical Reproduction," 226–36.

26 Dong Qichang, *Huachanshi suibi*, 1:2a.

27 Dong Qichang, *Huazhi*, 1:81.

28 Regarding the discussion of the late Ming usage of *qi*, see Ching, "The Aesthetic of the Unusual and the Strange," 343–59.

29 Bai Qianshen, *Fu Shan's World*, 18.

30 Plaks, "Aesthetics of Irony," 487–500.

31 Ye Lang, *Zhongguo meixueshi dagang*, 336–56.

32 Translation is from Lin Yutang, *Chinese Theory of Art*, 126.

33 See Mao Wenfang, *Wan Ming xianshang meixue*, 51.

34 For an explanation of originality and *qi* in late Ming art and literature, see Burnett, "A Discourse of Originality," 522–58.

35 Plaks, "The Aesthetics of Irony," 495.

36 The earlier example of this idea is Wang Lü's (14th century) statement: "Belonging to no tradition is my tradition." See Guo Yin, *Yuan Ming huihua meixue*, 153–55.

37 De Bary, "Individualism and Humanitarianism in Late Ming Thought," 195–96.

38 Burnett, "A Discourse of Originality," 525.

39 Text is reprinted in Guo Yin, *Yuan Ming huihua meixue*, 86.

40 Burnett, "A Discourse of Originality," 540–41.

41 In addition, Dong Qichang made it clear that the painter must learn technique and then discard it, or seem to do so. Dong argued that "complete naturalness" is a more difficult goal than technical finish because naturalness in painting must be a genuine awkwardness reached only by transcending pro-

ficiency in one's artistic skill. See Dong Qichang, *Huachanshi Suibi*, 2:1a.

42 Many contemporary critics expressed similar opinions, in which they discouraged the use of learning aids. For example, in his *Huishi weiyan* (Subtle accounts on the practice of painting), Tang Zhiqi discourages the use of "study copies" (*fenben*). See Yang Danian, *Zhongguo lidai hualun caiying*, 37–39. Yuan Hongdao also noted, "The good painter learns from things, not from other painters. The good philosopher learns from his mind, not from some doctrine. The good poet learns from the myriad of images, not from writers of the past." Transla-

tion is from Chaves, "The Panoply of Images," 352.

43 Guo Yin, *Yuan Ming huihua meixue*, 125–26, 130–32, 166.

44 This text is a colophon written on a hand-scroll painting (ink on paper, 46.6 x 622.2 cm) now housed at the National Palace Museum in Beijing. For its image, see *Xu Wei*, fig. 32.

Coda

1 Veblen, *The Theory of the Leisure Class*, 28–75.

2 Li Zhi, *Fenshu*, 275–76. Translation is from De Bary, *Sources of Chinese Tradition*, 1:867–68.

Glossary

An Lushan 安祿山
antou jingshu 案頭靜書
Bada Shanren 八大山人
Bai Juyi 白居易
Baihua lanzhupu 百華蘭竹譜
Baijia mingshu 百家名書
baimiao 白描
Baiyong tupu 百咏圖譜
Baiyushe 白榆社
Ban Zhao 班昭
Baobianzhai 豹變齋
Baodingzhai 寶鼎齋
Bei Xixiang ji 北西廂記
Beigong ciji 北宮詞紀
bencao 本草
Bencao gangmu 本草綱目
Bian Wenjin 邊文進
bieye 別業
Bifa ji 筆法記
bigeng 筆耕
Bogu tulu 博古圖錄
bonsai (Ch. *penzai*) 盆栽
Boruzhai 泊如齋
cai 才
Cai Ruzuo 蔡汝佐
Cai Yuanxiang 蔡元襄
caizhi 採芝
caizi jiaren 才子佳人
Cao Xi 曹曦
Cao Zhao 曹昭
Cao Zhongda 曹仲達

Caoxuanju 草玄居
Chajiu zhengqi 茶酒爭奇
Chang'an 長安
Chang'e 嫦娥
changyang 徜徉
Chanzhen yishi 禪真逸史
Chao Wujiu 晁無咎
Chen Bangtai 陳邦泰
Chen Hong 陳閎
Chen Hongshou 陳洪綬
Chen Jiru 陳繼儒
Chen Jitai 陳際泰
Chen Meigong xiansheng dingzhen huapu 陳眉公先生訂正畫譜
Chen Miao 陳邈
Chen Taijiao 陳泰交
Chen Wenzhong 陳文仲
Chen Xuan 陳暄
Chen Xun 陳詢
Cheng Daxian 程大憲
Cheng Yunzhao 程允兆
Chengshi moyuan 程氏墨苑
Chengzu 成祖
Chibi 赤壁
Ch'oe P'u 崔溥
Chongfugong 崇福宮
Chongyang 重陽
Chongzhen 崇禎
Chongzhou 崇州
Chosǒn (Joseon) 朝鮮
chuanbei 傳盃

Chuanzhen miyao 傳真秘要
Chungu yingxiang 春谷嚶翔
Chunhua getie 淳化閣帖
congshu 叢書
Cuizhuzhai 翠竹齋
Cunyutang 存餘堂
Da Xixun 達奚珣
Dai Jin 戴進
Dai Kaizhi 戴凱之
Danqian zonglu 丹鉛总錄
Danya huapu 丹崖畫譜
dao 道
Dao yingwu 悼鸚鵡
Daolian tu 搗練圖
daoyi 搗衣
Dashi shanfang 大石山房
Dashi xiang 大士像
Deng Chun 鄧椿
Deng Tuo 鄧拓
Dezong (r. 779–805) 德宗
diaoying 調鸚
Diecao 牒草
Diku 帝嚳
Ding Quan 丁權
Ding Shen 丁申
Ding Yunpeng 丁雲鵬
Dingwu 定武
Dong Fen 董份
Dong Qichang 董其昌
Dongfang Shuo 東方朔
Donglin 東林
Donglin lianshe 東林蓮社
Dongyuan 東原
Dongyuan gong 東園公
doujishe 斗雞社
Douzhen quanshu 痘疹全書
Du Fu 杜甫
Du Liniang 杜麗娘
Du Mu 都穆
Du Qiong 杜瓊
Du Wan 杜綰
Ershiba zu shike 二十八祖石刻
Erxu Jinling suoshi 二續金陵瑣事
Fan Chengda 范成大
Fan Lian 范濂
fan shanren wenxue 反山人文學
Fan Yunlin 范允臨

fanben 藩本
fanche 翻車
Fancun meipu 范村梅譜
Fangshi mopu 方氏墨譜
fanli 凡例
fanwang 藩王
fatie 法帖
fenben 粉本
Feng Menglong 馮夢龍
Feng Mengzhen 馮夢楨
Feng Shihua 馮時化
fengliu 風流
Fengshi shiji 馮氏詩紀
Fenshu 焚書
Fonu 佛奴
Fu Daokun 傅道坤
fubai 浮白
Fujian 福建
fuzhu 拂塵
fuzuo 跌坐
Gao Lian 高濂
Gao Panlong 高攀龍
Gao Song 高松
Gao Song huapu 高松畫譜
Gao Song jupu 高松菊譜
Gao Song lingmaopu 高松翎毛譜
Gao Song zhupu 高松竹譜
Gao Wu 高武
gaoben 稿本
Gegu yaolun 格古要論
Geguzhai 格古齋
Gezhi congshu 格致叢書
Gong Kai 龔開
Gong Xian 龔賢
Gong'an 公安
Gongsheng buren 公乘不仁
Gu Bing 顧炳
Gu Hongzhong 顧閎中
Gu Jianlong 顧見龍
Gu Kaizhi 顧凱之
Gu Xiancheng 顧憲成
Gu Yuanqing 顧元慶
Gu Zhengyi 顧正誼
Guangling 廣陵
guanke 官刻
guanmian 觀面
guanquan 觀泉

guanshu 觀書	Hu Zhengyan 胡正言
guanshui 觀水	Hua Ao 華齩
Guanyin 觀音	*Hua shanshui fu* 畫山水賦
Guhua pinlu 古畫品錄	*Hua shanshui jue* 畫山水訣
Gui Changshi 歸昌世	*Huachanshi suibi* 畫禪室隨筆
Gui Youguang 歸有光	*Huafa dacheng* 畫法大成
Guiqing 閨情	*Huafa quanyu* 畫法全輿
Guiqu laici 歸去來辭	*Huafa wuzhong* 畫法五種
Gujin huapu 古今畫譜	*Huafa xiaoxue* 畫法小學
Gujin zhupu 古今竹譜	*Huafa yaojue* 畫法要訣
Guo Ruoxu 郭若虛	*huagao* 畫稿
Guo Tuotuo 郭橐駝	*huagong* 畫工
Guo Xi 郭熙	Huaguang 華光
Guo Xu 郭詡	*Huaguang meipu* 華光梅譜
Guo Zhongshu 郭忠恕	*Huajia yaojue* 畫家要訣
Guoshi jingji zhi 國史經籍志	*Hualun* 畫論
Guquzhai 顧曲齋	*Huamei quanpu* 畫梅全譜
Gushi huapu 顧氏畫譜	Huancuitang 環翠堂
Gushi fu 古石賦	Huang Changrui 黃長睿
gutong 鼓桐	Huang Dechong 黃德寵
Guwenqian 古文錢	Huang Fengchi 黃鳳池
Guzaju 古雜劇	Huang Gongwang 黃公望
guzhuishi 孤墜勢	Huang Jieling 黃皆令
han 含	Huang Jishui 黃姬水
Han (dynasty) 漢	Huang Jubao 黃居寶
Han Shineng 韓世能	Huang Lian 黃廉
Han Yu 韓愈	Huang Quan 黃荃
Han Zhuo 韓拙	Huang Tingjian 黃庭堅
Hangzhou 杭州	Huang Xingzeng 黃省曾
hanlou 含露	Huang Yuanjie 黃媛介
haoshizhe 好事者	Huang Zhen 黃貞
He Chuguang 何出光	Huangfu Chong 皇甫沖
He Jingming 何景明	Huangfu Fang 皇甫汸
He Liangjun 何良俊	Huangzhou 黃州
He Taoshi 和陶詩	*Huaping huhai* 畫評繪海
Hebei 河北	*huapu* 畫譜
Henan 河南	Huashan fu 華山賦
Hong Pian 洪楩	*huashe* 畫社
Hong Zhong 洪鍾	*Huashi* 畫史
Hongren 弘仁	Huashu lun 畫樹論
Hongye shinü tu 紅葉仕女圖	*Huasou* 畫藪
Hongye tishi tu 紅葉題詩圖	*Huaxue mijue* 畫學秘訣
Hongye tu 紅葉圖	Huazhu suoji 畫竹所忌
Hou Yi 后翼	*Hudie meng* 蝴蝶夢
houke 後刻	Huilin 繪林
Hu Wenhuan 胡文煥	*Huilin tizhi* 繪林題識
Hu Yinglin 胡應麟	*huishan* 揮扇

Huishi aolun 繪石奧論
Huishi fameng 繪事發蒙
Huishi zhimeng 繪事指蒙
huishou 回首
Huizhou 徽州
Huizhou fuzhi 徽州府志
hutong 呼僮
jia 假
jiafa 家法
Jiajing 嘉靖
Jiang Shaoshu 姜紹書
jiangmei 江梅
Jiangnan 江南
Jiangyang 建陽
jiao 教
Jiao Hong 焦竑
Jiaoli xiansheng 角里先生
Jiaoshi leilin 焦氏類林
Jiaxing 嘉興
jie 節
Jie'an laoren manbi 戒庵老人漫筆
Jieziyuan huazhuan 芥子園畫傳
Jin (dynasty) 晉
Jin Sheng 金聲
Jin Wan 金完
Jin'an 晉安
Jing Hao 荊浩
Jingchang 經廠
Jingcun jushi 靜存居士
jingqi 靜憩
Jingshan Shulin 荊山書林
Jinjianji 錦箋記
Jinling 金陵
Jinpingmei 金瓶梅
jinshi 進士
Jinshi huapu 金氏畫譜
Jinxian tu 晉賢圖
jisi 己巳
Jiugai 酒概
Jiupu 酒譜
jiushe 酒社
Jiushi 酒史
Jiuwan yirong 九畹遺容
jiuyu 久雨
Jiyazhai huapu 集雅齋畫譜
Jizhizhai 繼志齋
juan 卷

juanxiu 倦繡
jue 訣
jueshe 噱社
Jupu 菊譜
juren 舉人
Kaipi yanyi 開闢演義
Kaopan yushi 考槃餘事
Ke Jiusi 柯九思
Kong Sheng 孔盛
Kongchen shihuapu 空塵詩畫譜
koujue 口訣
kuangcao 狂草
kuhui 哭會
kuijing 窺鏡
Kunshan 昆山
Lan Ru 瀾如
Lan Ying 藍瑛
Lanpu 蘭譜
Lanqiao yuchu ji 藍橋玉杵記
Lanting tu 蘭亭圖
Lanting yaji 蘭亭雅集
leishu 類書
li 理
Li Bai 李白
Li Cheng 李成
Li Chengsou 李澄叟
Li E 厲鶚
Li Gonglin 李公麟
Li Kaixian 李開先
Li Kan 李衎
Li Mengyang 李夢陽
Li Panlong 李攀龍
Li Rihua 李日華
Li Shangyin 李商隱
Li Shida 李士達
Li Shizhen 李時珍
Li Sixun 李思訓
Li Tang 李唐
Li Yong 李邕
Li Yunying 李雲英
Li Zai 李在
Li Zhaodao 李昭道
Li Zhi 李贄
Li Zhongheng 李鍾衡
Li Zhongzi 李中梓
Li Zuowu Xiansheng Piping Huansha ji 李卓吾
　　先生批評浣紗記

Liang (dynasty) 梁
Liang Kai 梁楷
Liang Yisu 梁夷素
Lianhua jiushe 蓮花酒社
Lianshe shibaxian tu 蓮社十八賢圖
Liaoyang 遼陽
Lidai huaping 歷代畫評
Lidai minggong huapu 歷代名公畫譜
Lidai minghuaji 歷代名畫記
Lienü zhuan 烈女傳
Lin Bu 林逋
Lin Liang 林良
linliu 臨流
Linquan gaozhi 林泉高致
Lisao 離騷
Lishi huapu 李氏畫譜
Liu Daochun 劉道醇
Liu Feng 劉鳳
Liu Ling 劉伶
Liu Meizhi 劉美之
Liu Qinghua 劉清華
Liu Shiru 劉世儒
Liu Songnian 劉松年
Liu Xiang 劉向
Liu Xuehu meipu 劉雪湖梅譜
Liu Yiqing 劉義慶
Liu Zongyuan 柳宗元
Liuchang 六長
Liufa 六法
Liuyao 六要
Liuzhuang xiangfa 柳莊相法
Lizong 理宗
Longqing 隆慶
Lu Guang 陸廣
Lu Qi 陸圻
Lu Tanwei 陸探微
Lu Weichong 陸位崇
Lu You 陸游
Lun gujin huaxuezhe 論古今畫學者
Lun huazhu 論畫竹
Luo Rufang 羅汝芳
Luofu huanzhi 羅浮幻質
Luoguanzi tie 羅冠子帖
Luohan xiang 羅漢像
Luoxuan biangu jianpu 蘿軒變古箋譜
Lü Ji 呂紀
Lü Kun 呂坤

Lüchuang nüshi 綠窗女史
Ma Nancun 馬南村
Ma Qianyuan 馬乾元
Ma Shouzhen 馬守真
Ma Xianqing 馬閑卿
Ma Yuan 馬遠
Mao Kun 茅坤
maotao 酕醄
Mayi xiangfa 麻衣相法
Meidian 梅顛
Meihua baiyong 梅花百詠
Meihua fu 梅花賦
Meihua xishenpu 梅花喜神譜
Meipu 梅譜
Meiren hongye tu 美人紅葉圖
Meiren shu hongye tu 美人書紅葉圖
Meishi 梅史
Meiwu yiqiong 梅塢遺瓊
Meixu xiansheng bielu 梅墟先生別錄
Mi Fu 米芾
Ming (dynasty) 明
mingding 酩酊
mingshi 名士
Mo Shilong 莫是龍
Momiao Shanfang 墨妙山房
Mou Yi 牟益
Mozhupu 墨竹譜
Mudanting 牡丹停
Nan Song yuanhua lu 南宋院畫錄
Nanjing 南京
Nanping shishe 南屏詩社
Neixun 內訓
Ni Zan 倪瓚
Ning 寧
Ningbo 寧波
Nongzheng quanshu 農政全書
nufeishe 怒飛社
nü shanren 女山人
Nü shanren shuo 女山人說
Nü Lunyu 女論語
Nü Xiaojing 女孝經
Nüjie 女誡
Pan Zhiheng 潘之恒
panhuan 盤桓
Peiwenzhai shuhuapu 佩文齋書畫譜
Peng Meng 蓬蒙
Pingshantang 平山堂

pingshi 凭石
Pipa ji 琵琶記
Posŏkjŏng 鮑石亭
Puming 普明
Putaoshe 葡萄社
qi 氣
Qi Biaojia 祁彪佳
Qian Gu 錢穀
Qian Xuan 錢選
Qian Yingjin 錢應金
Qian Yu 錢昱
qianli tongxin 千里同心
Qianqingtang shumu 千頃堂書目
Qiao Zhongchang 喬仲常
Qi Liji 綺里季
qin 琴
Qinjing 禽經
Qing (dynasty) 清
qing (love) 情
Qinghuizhai 清繪齋
Qinglou yunyu 青樓韻語
Qingming shanghe tu 清明上河圖
Qingsenge 清森閣
Qingshi 情史
qingtan 清談
Qingxishe 青溪社
Qingyan 清言
Qinpu hebi 琴譜合璧
qinshe 琴社
Qiu Mao 丘杔
Qiu Ying 仇英
Qiuzhen 秋砧
Qiyuan xiaoying 淇園肖影
Qizishe 七子社
Qu Yuan 屈原
rangli 讓履
Rao Ziran 饒自然
Ren Jitu 任繼圖
Renruitang 人瑞堂
renshi 人事
Rong Qiqi 榮啟期
Rongyutang 容與堂
Ruan Ji 阮籍
ruyi 如意
Ruyuan 汝媛
Sanbing 三病
sanbu 散步

Sancai tuhui 三才圖會
Sang Zhenbai 桑貞白
Sanguo yanyi 三國演義
Sanpin 三品
se 瑟
Shaanxi 陝西
Shan Tao 山濤
Shanbu yisheng weilun 删補頤生微論
Shancai 善財
Shandong 山東
Shanghai 上海
shangjianjia 賞鑑家
Shangzheng 觴政
Shanhai jing 山海經
shanren 山人
Shanshui chunquan ji 山水純全集
Shanshui fu 山水賦
Shanshui jue 山水訣
Shanshui lun 山水論
Shanshui jiafa 山水家法
Shanyang 山陽
Shaoxing 紹興
Shen Bin 沈賓
Shen Defu 沈德符
Shen Gua 沈括
Shen Shen 沈沈
Shen Xiang 沈襄
Shen Yixiu 沈宜修
Shen Zhou 沈周
Sheng Maoye 盛茂曄
Sheng Zhenying 盛振英
Shengchao minghua ping 聖朝明畫評
Shengji tu 聖跡圖
shengyuan 生員
shexue 社學
Shi Guang 師曠
Shi Hui 施惠
Shi Quanshu 史全叔
Shidetang 世德堂
Shi'erji 十二忌
Shifu 石賦
Shihu jupu 石湖菊譜
Shihu meipu 石湖梅譜
shijian 世間
Shilla (dynasty) 新羅
Shiming 释名
Shishuo xinyu 世說新語

Shishuo xinyu bu 世說新語補

shisu 世俗

Shitao 石涛

Shiti tianwen 十體千文

Shiyouzhai 十友齋

Shiyu huapu 詩餘畫譜

Shizhuzhai shuhuapu 十竹齋書畫譜

shoujiu 守舊

Shu (kingdom) 蜀

Shu Wu Daozi huahou 書吳道子畫後

Shuai Ji 帥機

shufa 書法

Shuihu zhuan 水滸傳

Sibu zhengwei 四部正譌

Siku quanshu 四庫全書

Sima Guang 司馬光

sishe 絲社

Sisunguan 思蓀館

siyu 私語

Song (dynasty) 宋

Song Boren 宋伯仁

Song Ruohua 宋若華

Songjiang 松江

Songzhai meipu 松齋梅譜

su 俗

Su Shi 蘇軾

Sui Yangdi yanshi 隋煬帝艷史

Sun Guangzong 孫光宗

Sun Kehong 孫克弘

Sun Pixian 孫丕顯

Sun Tingyong 孫廷用

Sun Wei 孙位

suoju 索句

Suzhou 蘇州

Taiping qinghua 太平清話

taipu 態譜

Taizhou 泰州

Taizong 太宗

Taizu 太祖

Tan Yuanchun 譚元春

Tan Yuanchun ji 譚元春集

tanbing 談柄

Tang (dynasty) 唐

Tang Hou 湯后

Tang Jinchi 唐錦池

Tang Minghuang qiuye wutongyu 唐明皇秋夜
 梧桐雨

Tang Shuyu 湯漱玉

Tang Su 唐蕭

Tang Wenxian 唐文獻

Tang Xianzu 湯顯祖

Tang Yin 唐寅

Tang Zhengzhong 湯正仲

Tang Zhiqi 唐志契

Tanggong tiye tu 唐宮題葉圖

Tangshi huapu 唐詩畫譜

tanxuan 談玄

Tao Hongjing 陶弘景

Tao Yuanming 陶淵明

Tao Zongyi 陶宗儀

Tao'an mengyi 陶庵夢憶

Tianduge cangshu 天都閣藏書

Tiangong kaiwu 天工開物

Tianjuetang wenji 天爵堂文集

Tianqi 天啟

Tianxing daomao 天形道貌

Tianzhangge 天章閣

Tiaoxishe 苕溪社

tiaoying 調鸚

tibi 題壁

tibishi 題壁詩

tie 帖

tiexian 鐵線

tingquan 聽泉

Tingyun xiaozhi 停雲小志

tiye 題葉

tongfan zongshi 同藩宗室

tongxin 童心

tu 吐

Tu Long 屠隆

Tuhua jianwen zhi 圖畫見聞志

Tuhui baojian 圖繪寶鑑

Tuhui zongyi 圖繪宗彝

tuxiang 吐香

Wan Quan 萬全

Wang Anshi 王安石

Wang Chong 王寵

Wang Daokun 王道昆

Wang Gen 王艮

Wang Guixue 王貴學

Wang Jide 王驥德

Wang Lingyue 王靈嶽

Wang Lu 王輅

Wang Maoxiao 汪懋孝

Wang Meng 王蒙

Wang Mian 王冕

Wang Qi 王圻

Wang Rong 王戎

Wang Shen 王詵

Wang Shimao 王世懋

Wang Shizhen 王世貞

Wang Siren 王思任

Wang Siyi 王思義

Wang Tingna 汪廷訥

Wang Wei 王維

Wang Wenyao 王文耀

Wang Xianjie 王顯節

Wang Xianzhi 王獻之

Wang Xijue 王錫爵

Wang Xizhi 王羲之

Wang Yan 王偃

Wang Yi 王繹

Wang Yifu 王夷甫

Wang Yuan 王淵

Wang Zhen 王鎮

Wang Zhideng 王穉登

Wangchuan tu 輞川圖

Wanghuang daoren 王潢道人

Wangshi lanpu 王氏蘭譜

Wangshi huayuan 王氏畫苑

Wangshi shuhuayuan buyi 王氏書畫苑補益

wangyue 望月

Wanli 萬歷

Wanli yehuobian 萬曆野獲編

Wanxiangtang xiaopin 晚香堂小品

Weimo 維摩

Wen Duanrong 文端容

Wen Jia 文嘉

Wen Shu 文俶

Wen Zhengming 文徵明

Wen Zhenheng 文震亨

Wen'an 文安

Wenbitang 文璧堂

Weng Ang 翁昂

Wenlinge 文林閣

Wenshu 文殊

Wu Daozi 吳道子

Wu Taisu 吳太素

Wu Wei 吳偉

Wu Weizhen 吳惟貞

Wu Yanzi 吳岩子

Wu Zhen 吳鎮

Wudai minghua buyi 五代名畫補遺

wufa weifa 無法為法

Wuji baimei 吳姬百媚

Wujiang xianzhi 吳江縣志

Wulin 武林

Wulin cangshu lu 武林藏書錄

Wusao hebian 吳騷合編

Wushen shi shi 無聲詩史

Wutongye 梧桐葉

Wuxing 吳興

Wuxing beizhi 吳興備志

wuxiu 舞袖

wuyu 晤語

Wuyu cuiya 吳歈萃雅

Wuzazu 五雜俎

Xi Kang 嵇康

Xia Wenyan 夏文彥

Xiahuang gong 夏黃公

Xian Fo qizong 仙佛奇蹤

Xiang Yuanbian 項元汴

Xianglian shicao 香奩詩草

Xiangxue linji 香雪林集

Xianyun gao 閑雲稿

Xianyunguan 閒雲館

xiao 孝

Xiao Gang 蕭綱

Xiao Yuncong 蕭雲從

xiaopin 小品

Xiaoqiuguan 小酉館

Xiaoxia meipu 小霞梅譜

Xiao Yingzhou she 小瀛洲社

Xie An 謝安

Xie He 謝赫

Xie Kun 謝鯤

Xie Teng 謝藤

Xie Zhaozhe 謝肇淛

xieqin 攜琴

Xiexiang mijue 寫像秘訣

Xilingshe 西泠社

Xin Qiji 辛棄疾

Xin'an 新安

Xinfupu 新婦譜

Xinyiguan 辛夷館

xishen 喜神

Xiuning 休寧

xiunü 繡女

xiurong 羞容
Xiuta yeshi 繡榻野史
Xiuyu cao 繡餘草
Xiwangmu 西王母
Xixiang ji 西廂記
Xiyuan yaji 西園雅集
Xu Bangda 徐邦達
Xu Bo 徐勃
Xu Guangqi 徐光啟
Xu Jinling suoshi 續金陵瑣事
Xu Ju 徐炬
Xu Wei 徐渭
Xu Wenzhang yigao 徐文長逸稿
Xu Xi 徐熙
Xu Xian 徐咸
Xu Yinglei 徐應雷
Xu Yuan 徐媛
Xu Zhenqing 徐禎卿
Xu zhupu 續竹譜
Xuanhe 宣和
Xuanhe huapu 宣和畫譜
xuanmiao 玄妙
Xue Gang 薛岡
Xue Susu 薛素素
Xuezhai zhupu 雪齋竹譜
ya 雅
Yan Fenyi 嚴分宜
Yan Hui 顏輝
Yan Liben 閻立本
Yan Maoyou 顏茂猷
Yan Shifan 嚴世蕃
Yan Zhenqing 顏真卿
Yang Erzeng 楊爾曾
Yang Lun 揚掄
Yang Mo 楊模
Yang Shen 楊慎
Yang Wujiu 揚無咎
Yang Zhijiong 楊之炯
Yangshan Gushi shanfang 陽山顧氏山房
Yangzhou 揚州
yantian 硯田
Yanxian sishi 燕閒四適
Yao He 姚合
Ye Xiuyai 葉修崖
yi 義
Yibaitang 夷白堂
Yibin 宜賓

Yilaohui 怡老會
Yimen guangdu 夷門廣牘
yingfeng 迎風
yingwu xiangxing 應物象形
Yingying 鶯鶯
Yingzao fashi 營造法式
Yingzong 英宗
yishu 倚樹
Yiwang 益王
Yiwen 藝文
Yiyuan 藝苑
Yiyuzhi 異域志
Yongle dadian 永樂大典
Yongwushi 咏物詩
You Qiu 尤求
Yougui ji 幽閨記
Youyi sijia 游藝四家
Youying lanpu 幽英蘭譜
yu 慾
Yu Xiangdou 余象斗
Yu Yun 庾蘊
Yuan (dynasty) 元
Yuan Gong 袁珙
Yuan Hongdao 袁宏道
Yuan Huang 袁黃
Yuan Zhen 元積
Yuan Zhongche 袁忠徹
Yuan Zhongdao 袁中道
Yuanshantang qupin 遠山堂曲品
Yuchun 餘春
Yulantang 玉蘭堂
Yun Xiang 惲向
Yunhuizhai 韞輝齋
Yunjian jumuchao 雲間據目鈔
Yunjianhe 雲間鶴
Yunlin shipu 雲林石譜
Yutai huashi 玉臺畫史
Yutu qiuxiang 玉兔秋香
yuzhi 娛志
Zeng Hongfu 曾宏父
Zengding Yuhubing 增定玉壺冰
Zhan Jingfeng 詹景風
Zhang Chou 張丑
Zhang Chun 張春
Zhang Congyu 張聰玉
Zhang Dai 張岱
Zhang Dayou 張打油

Zhang Fei 張飛
Zhang Fengyi 張鳳翼
Zhang Han 張瀚
Zhang Hong 張宏
Zhang Jizhi 張即之
Zhang Lu 張路
Zhang Mei 張玫
Zhang Peng 張鵬
Zhang Quan 張銓
Zhang Xianyi 張獻翼
Zhang Xuan 張萱
Zhang Yanyuan 張彥遠
Zhang Ying 張英
Zhang Yu 張雨
Zhangwu zhi 長物志
Zhao Huanguang 趙宦光
Zhao Mengfu 趙孟頫
Zhao Mengjian 趙孟堅
Zhao Yi 趙翼
Zhao Zuo 趙左
Zhejiang 浙江
Zhejiang tongzhi 浙江通志
zhen 真
zheng 正
Zheng Dezhong 鄭德中
Zheng En 鄭熄
Zheng Qingfu 鄭卿甫
Zheng Sixiao 鄭思肖
Zheng Weizhong 鄭惟忠
Zheng Yanhan 鄭琰翰
Zheng Zhenduo 鄭振鐸
Zheng Zhongkui 鄭仲夔
Zhengde 正德
Zhepai 浙派
Zhipu 芝譜
Zhiyu cao 織餘草
zhong 忠
Zhong Wulin 鍾武林
Zhong Xing 鍾惺
Zhong You 鍾繇
Zhongfen Mingben 中峰明本
Zhongguo shudian 中國書店
Zhongren 仲仁
Zhongshu shu 種樹書
Zhou Banxiang 周般鄉
Zhou Danquan 周丹泉
Zhou Fang 周昉

Zhou Hui 周暉
Zhou Lu 周路
Zhou Lüjing 周履靖
Zhou Shi 周詩
Zhou Tianqiu 周天球
Zhou Wei 周位
Zhou Wenju 周文矩
Zhou Zhizhong 周致中
Zhoushi huilin 周氏繪林
Zhu Bingqi 朱秉器
Zhu Chenhao 朱宸濠
Zhu Cunjue 朱存爵
Zhu Dashao 朱大韶
Zhu Guan'ou 朱觀𤊽
Zhu Po 朱朴
Zhu Shouyong 朱壽鏞
Zhu Shuzhen 朱淑真
Zhu Xi 朱熹
Zhu Yipai 朱以派
Zhu Yiyai 朱頤崖
Zhu Youdun 朱有燉
Zhu Yuanzhang 朱元璋
Zhu Yunming 祝允明
Zhu Zhifan 朱之番
zhuangyuan 狀元
Zhuangyuan nenghua 狀元能畫
Zhuangzi 莊子
Zhuge Liang 諸葛亮
Zhuge Zhan 諸葛瞻
Zhulin qixian 竹林七賢
zhuozu 濯足
Zhupu 竹譜
Zhupu xianglu 竹譜詳錄
Zhushi wenfang 朱氏文房
Zhuxishe 竹西社
ziran 自然
Zisunguan 滋蓀官
Zitaoxuan youzhui 紫桃軒又綴
Zitaoxuan zazhui 紫桃軒雜綴
Zong Chen 宗臣
Zou Dezhong 鄒德中
Zui xueshi tu 醉學士圖
Zuichun tu 醉春圖
Zuike tu 醉客圖
zuimo 醉墨
zuiyin 醉吟
Zunsheng bajian 遵生八箋

Bibliography

East Asian Languages (Chinese, Japanese, and Korean)

A Ying 阿英. *Yehangji* 夜航集. 1935. Reprint, Beijing: Zhongguo wenlian chubanshe, 1993.

———. *Zhongguo lianhuan tuhua shihua* 中國連環圖畫史話. Beijing: Zhongguo gudian yishu chubanshe, 1957.

Ahn Hwi-joon 安輝濬. *Han'guk hoehwasa* 韓國繪畫史. Seoul: Iljisa, 1994.

Bian Yongyu 卞永譽. *Shigutang shuhua huikao* 式古堂書畫彙考. Reprinted in *Wenyuange Siku quanshu*, vols. 827–29.

Cai Yi 蔡毅. *Zhongguo gudian xiqu xuba huibian* 中國古典戲曲序跋彙編. Ji'nan: Qilu shushe, 1989.

Cao Xuequan 曹學佺. *Shicang lidai shixuan* 石倉歷代詩選. Reprinted in *Wenyuange Siku quanshu*, vols. 1387–1394.

Cao Zhi 曹之. *Zhongguo guji banbenxue* 中國古籍版本學. Wuhan: Wuhan daxue chubanshe, 2002.

———. *Zhongguo guji bianzhuanshi* 中國古籍編撰史. Wuhan: Wuhan daxue chubanshe, 1999.

Chang Bide 昌彼得. *Mingdai banhua xuan* 明代版畫選. Taipei: Guoli zhongyang tushuguan, 1969.

Chen Baoliang 陳寶良. "Mingdai shehui liutongxing chutan" 明代社會流通性初探. *Anhui shixue* 安徽史學 25 (2005):18–24.

———. *Mingdai shehui shenghuoshi* 明代社會生活史. Beijing: Zhongguo shihui kexue chubanshe, 2004.

———. "Mingdai wenren bianxi" 明代文人辨析. *Hanxue yanjiu* 漢學研究 19, no. 1 (2001): 187–218.

———. "Wan Ming shengyuan de qijin zhi feng ji qi shanrenhua" 晚明生員的弃巾之風及其山人化. *Shixue jikan* 史學集刊 2, no. 2 (May 2000): 34–39.

———. *Zhongguo de shi yu hui* 中國的社与会. Hangzhou: Zhejiang renmin chubanshe, 1996.

Chen Ci 陈辞. *Dong Qichang* 董其昌. Shijiazhuang: Hebei jiaoyu chubanshe, 2003.

Chen Dongyuan 陈东原. *Zhongguo funü shenghuoshi* 中国妇女生活史. 1937. Reprint, Beijing: Shangwuyin shuguan, 1998.

Chen Gaohua 陳高華. *Yuandai huajia shiliao* 元代畫家史料. Shanghai: Shanghai renmin chubanshe, 1980.

Chen Guanghong 陈广宏. "Wan Ming Fujian diqu de chengshi shiren" 晚明福建地区

的城市诗人. *Zhongxi xueshu* 中西学术 2 (1996): 140–55.

Chen Guodong 陳國棟. "Kumiao yu fanrufu: Mingmo Qingchu shengyuan cheng de shehuixing yuanzuo" 哭廟與焚儒服: 明末清初生員層的社會性动作. *Xin shixue* 新史学 3, no. 1 (1992): 72–74.

Chen Jiru 陳繼儒. *Taiping qinghua* 太平清話. Reprint, Beijing: Zhonghua shuju, 1985.

———. *Wanxiangtang xiaopin* 晚香堂小品. Reprint, Shanghai: Shanghai Zazhi chubanshe, 1936.

Chen Shaotang 陳少堂. *Wan Ming xiaopin lunxi* 晚明小品論析. Hong Kong: Powen shuju, 1981.

Chen Suowen 陳所聞. *Beigong ciji* 北宮詞紀. 1604.

Chen Wanyi 陳萬益. "Feng Menglong [Qingjiaoshuo] shilun" 馮夢龍 [情教說] 試論. *Hanxue Yanjiu* 漢學研究 6, no. 1 (1988): 297–308.

———. *Wan Ming xiaopin yu mingji wenren shenghuo* 晚明小品與明季文人生活. Taipei: Da'an chubanshe, 1988.

Chen Xiasheng 陳夏生. "Jixiang ruyi" 吉祥如意. *Gugong wenwu yuekan* 故宮文物月刊 143 (1995): 54–75.

Chen Xuewen 陳學文. *Ming Qing shiqi shangyeshu ji shangrenshu zhi yanjiu* 明清時期商業書及商人書之研究. Taipei: Zhonghua fazhan jijin guanli weiyuanhui, 1997.

Chen Zhuanxi 陈传席 and Tan Shengguang 谈晟广. *Tang Yin* 唐寅. Shijiazhuang: Hebei jiaoyu chubanshe, 2004.

Chum Shum (Shen Jin) 沈津. "Mingdai fangke tushu zhi liutong yu jiage" 明代坊刻圖書之流通與價格. *Guojia Tushuguan kan* 國家圖書館刊 1 (1996): 101–18.

Ciyuan 辭源. Beijing: Shangwuyin shuguan, 1988.

Denda Akira 傳田章. "Manreki ban Seishōki no keitō to sono seikaku" 萬歷版畫西廂記の系統とその性格. *Tōhōgaku* 31 (1965): 93–106.

———. *Minkan Gen zatsugeki Seishoki mokuroku* 明刊元雜刻西廂記目錄.

Revised edition, Tokyo: Kyūkō shōin, 1979.

Deng Chun 鄧椿. *Huaji* 畫繼. Reprint, Beijing: Renmin meishu chubanshe, 1963.

Deng Tuo 鄧拓 (aka Ma Nancun 馬南村). *Yanshan yehua* 燕山夜話. Beijing: Beijing chubanshe, 1979.

Ding Shen 丁申. *Wulin cangshu lu* 武林藏書錄. Reprint, Shanghai: Gudian wenxue chubanshe, 1957.

Dong Qichang 董其昌. Huachanshi *suibi* 畫禪室隨筆. Reprinted in *Biji Xiaoshuo daguan* 筆記小說大觀, vol. 7. Taipei: Xinxing shuju, 1962.

———. *Huazhi* 畫旨. Reprinted in *Hualun congkan* 畫論叢刊, vol. 1.

Dong You 董逌. *Guangchuan huaba* 廣川畫跋. Reprinted in *Wenyuange Siku quanshu*, vol. 813.

Du Mu 都穆. *You mingshanji* 游名山記. Reprinted in *Congshu jicheng chubian*, vol. 2999.

Fan Lian 范濂. *Yunjian jumuchao* 雲間據目鈔. Reprinted in *Biji Xiaoshuo daguan* 筆記小說大觀, vol. 1. Taipei: Xinxing shuju, 1962.

Fang Sheng 方胜. "Lun Feng Menglong de 'Qingjiao' guan" 论冯梦龙的 '情教' 观. *Wenxue Yichan* 文学遗产 4 (1985): 113–21.

Fang Zhiyuan 方志远. *Mingdai chengshi yu shimin wenxue* 明代城市与市民文学. Beijing: Zhonghua shuju, 2004.

Feng Feng 冯逢. *Baixing minsu liyi daquan* 百姓民俗礼仪大全. Beijing: Mangwen chubanshe, 2003.

Feng Menglong 馮夢龍. "Guizhibu congxu" 閨智部叢序. In *Zhinang quanji* 智囊全集. *Reprint, Nanjing: Jiangsu guji chubanshe, 1986.*

———. *Qingshi* 情史. 1621. *Reprinted in Feng Menglong quanji* 馮夢龍全集. *Shanghai: Shanghai guji chubanshe, 1993.*

Feng Pengsheng 冯鹏生. *Zhongguo muban shuiyin gaishuo* 中国木版水印概说. Beijing: Beijing daxue chubanshe, 1999.

Feng Youheng 馮幼衡. "Tang Yin shinühua de leixing yu yihan—Jiangnan diyi de fengliu caizi de guanggu chenai" 唐寅仕女

畫的類型與意涵—江南第一風流才子的曠古沉哀. *Gugong xueshu jikan* 故宮學術季刊 22, no. 3 (2005): 55-90.

Fu Chengzhou 傅承洲. "Feng Menglong li Qingjiao xinshuo" 冯梦龙立情教新说. In *Shoujie Mingdai wenxue guoji yantaohui lunwenji* 首届明代文学国际研讨会论文集, edited by He Yongkang 何永康 and Chen Shulu 陈书录, 186-96. Nanjing: Nanjing shifan daxue chubanshe, 2004.

Fu Yu 虞复, ed. *Lidai Zhongguo huaxue zhushu lumu* 歷代中國畫學著述錄目. Beijing: Chaohua meishu chubanshe, 1962.

Gao Lian 高濂. *Zunsheng bajian* 遵生八箋. Reprint, Chengdu: Bashu shushe, 1988.

Gao Musen 高木森. "Hanmo qiankun wen zhenwei qiuhao mingjianfei gongfu—Mingren [Jufu Xiyuan yajitu] zhi jianshang (shang)" 翰墨乾坤間真偽秋豪明鑒費工夫—明人[巨幅西園雅集圖]之鑒賞 (上). *Gugong wenwu yuekan* 故宮文物月刊 183 (1998): 90-110.

———. "Hanmo qiankun wen zhenwei qiuhao mingjianfei gongfu—Mingren [Jufu Xiyuan yajitu] zhi jianshang (xia)" 翰墨乾坤間真偽秋豪明鑒費工夫—明人[巨幅西園雅集圖]之鑒賞 (下). *Gugong wenwu yuekan* 故宮文物月刊 184 (1998): 54-73.

Gao Shiqi 高士奇. *Jiangcun shuhuamu* 江村書畫目. Reprint, Shanghai: Shanghai shuhua chubanshe, 2000.

Gu Zhengyi 顧正誼. *Baiyong tupu* 百詠圖譜. 1596.

Gugong shuhualu 故宮書畫錄. Taipei: Guoli zhongyang bowuyuan, 1956.

Gui Zhuang 歸莊. *Gui Zhuang ji* 歸莊集. Reprint, Shanghai: Shanghai guji chubanshe, 1984.

Guo Moruo 郭沫若. "You Wang Xie muzhi de chutu lundao Lanting xu de zhenwei" 由王谢墓志的出土论到兰亭序的真伪. *Wenwu* 文物 6 (1965): 5-32.

Guo Ruoxu 郭若虛. *Tuhua jianwen zhi* 圖畫見聞志. Reprinted in *Congshu jicheng chubian*, vol. 1648.

Guo Shaoyu 郭紹虞. "Mingdai wenren jieshe nianbiao" 明代文人結社年表. In *Zhaoyushi gudian wenxue lunji* 照隅室古典文學論集. Shanghai: Shanghai guji chubanshe, 1983.

———. *Zhongguo wenxue pipingshi* 中國文學批評史. Shanghai: Shanghai shudian, 1989.

Guo Si 郭思, comp. *Linquan gaozhi* 林泉高致. Reprint, Changsha: Hunan meishu chubanshe, 2003.

Guo Weiqu 郭味蕖. *Zhongguo banhua shilue* 中國版畫史略. Beijing: Renmin meishu chubanshe, 1962.

Guo Yin 郭因. *Yuan Ming huihua meixue* 元明繪畫美學. Taipei: Jinfeng chuban youxian gongsi, 1987.

Guo Yingde 郭英德. "Lun Wan Ming Qing chu caizi jiaren xiqu xiaoshuo de shenmei quwei" 論晚明清初才子佳人戲曲小說的審美趣味. *Wenxue yichan* 文學遺產 5 (1987): 71-80.

———. *Ming Qing chuanqi zonglu* 明清傳奇綜錄. Shijiazhuang: Hebei jiaoyu chubanshe, 1997.

Han Ang 韓昂. *Tuhui baojian xubian* 圖繪寶鑑續編. Reprint, Taipei: Shangwuyin shuguan, 1956.

Han Zhuo 韓拙. *Shanshui chunquan ji* 山水純全集. Reprinted in *Songren hualun* 宋人畫論. Changsha: Hunan meishu chubanshe, 2003.

Hang Huai 杭淮. *Shuangxi ji* 雙溪集. Reprinted in *Wenyuange Siku quanshu*, vol. 1266.

Hangzhou fuzhi 杭州府志. Reprinted in *Zhongguo fangzhi congshu: Huazhong* 中國方志叢書: 華中, vol. 199: 1-10.

Hanyu da cidian 漢語大辭典. By Luo Zhufeng 羅竹風. Shanghai: Shanghai cishu, 1986-1994.

Hayashi Tomoharu 林友春. *Kinsei Chūgoku kyōikushi kenkyū: Sono bunkyō seisaku to shomin kyōiku* 近世中國教育史研究: その文教政策と庶民 教育. Tokyo: Kokudōsha, 1958.

He Liangjun 何良俊. *Siyouzhai congshuo* 四友齋叢說. 1569. Reprint, Beijing: Zhonghua shuju, 1997.

He Zongmei 何宗美. *Mingmo Qingchu wenren jieshe yanjiu* 明末清初文人结社研究. Tianjin: Nankai daxue chubanshe, 2003.

Higuchi Hiroshi 樋口弘. *Chūgoku hanga shūsei kaisetsu*中國版畫集成解說. Tokyo: Mitō Shooku, 1967.

Hou Kaijia 侯开嘉. "Tibi shufa xingfei shishu" 題壁書法兴废史述. *Shufa yanjiu* 书法研究 5, no. 116 (1997): 5–8.

Hu Wenbin 胡文彬. *Jinpingmei shulu* 金瓶梅書錄. Shenyang: Liaoning renmin chubanshe, 1986.

Hu Wenkai 胡文楷. *Lidai funü zhuzuo kao* 歷代婦女著作考. Shanghai: Shanghai guji chubanshe, 1985.

Hua Rende 華人德 and Bai Qianshen 白謙慎, eds. *Lanting lunji* 蘭亭論集. Suzhou: Suzhou daxue chubanshe, 2000.

Huainanzi 淮南子. By Liu An 劉安. Reprint, Taipei: Zhonghua shuju, 1987.

Huang Jichi 黃繼持. "Mingdai zhongye wenren xingtai" 明代中葉文人型態. *Ming Qingshi jikan* 明清史集刊 1 (1985): 37–61.

Huang Lin 黃霖 and Han Tongwen 韓同文, eds. *Zhongguo lidai xiashuo lunzhu xuan* 中國歷代小說論著選. Nanchang: Jiangxi renmin chubanshe, 1982.

Huang Ang 黃卬. *Xijinshi xiaolu* 錫金識小錄. Reprinted in *Zhongguo fangzhi congshu: Huazhong* 中國方志叢書: 華中, vol. 426: 1–2.

Huang Jin 黃溍. *Wenxuanji* 文獻集. Reprinted in *Wenyuange Siku quanshu*, vol. 1209.

Huang Yongquan 黃涌泉. *Li Gonglin shengxiantu shike* 李公麟聖賢圖石刻. Beijing: Renmin meishu chubanshe, 1963.

Huang Xingzeng 黃省曾. *Wufenglu* 吳風錄. Reprint, Taipei: Wenyuan shuju, 1964.

Huang Zhongzhao 黃仲昭. *Weixuan wenji* 未軒文集. Reprinted in *Wenyuange Siku quanshu*, vol. 1254.

Huzhou fuzhi 湖州府志. Reprinted in *Zhongguo fangzhi congshu: Huazhong* 中國方志叢書: 華中, vol 54: 1–5.

I Juo-fen (Yi Ruofen) 衣若芬. "Yizhuang lishi de gong'an—Xiyuan yaji" 一樁歷史的公案—[西園雅集]. *Zhongguo wenzhe yanjiu jikan* 中國文哲研究集刊 10 (1997): 221–68.

Inoue Susumu 井上進. "Shōshi shōko būnjin" 書肆, 書賈, 文人. In *Chūka bunjin no seikatsu* 中華文人の生活, edited by Arai Ken 荒井健, 304–38. Tokyo: Heibonsha, 1994.

———. "Zōsho to dokusho" 藏書と讀書. *Tōhō gakuhō* 東方學報 62 (1990): 409–45.

Isobe Akira 磯部彰. "Minmatsu ni okeru 'Seiyūki' no shutaiteki juyōsō ni kansuru kenkyū—Mindai 'Kotennteki hakuwa shōsetsu' no dokushasō o meguru mondai ni tsuite" 明末における「西遊記」の主体的受容層に関する研究—明代「古典的白話小説」の読者層をめぐる問題について. *Shūkan Tōyōgaku* 集刊東洋学 40 (1980): 50–63.

Itano Chōhachi 板野長八. "Seidan no ichi kaishaku" 清談の一解釋. *Shigaku zasshi* 史學雜誌 50, no. 3 (March 1939): 25–55.

Jiang Shaoshu 姜紹書. *Wushengshi shi* 無聲詩史. Reprint, Tianjin: Tianjin guji chubanshe, 1997.

Jiang Tingxi 蔣廷錫 et al. *Bowu huibian yishudian* 博物彙編藝術典. Reprinted in *Gujin tushu jicheng*, vols. 541–52.

Jiangxi tongzhi 江西通志. Reprinted in *Wenyuange Siku quanshu*, vols. 513–18.

Jiaxing fuzhi 嘉興府志. (1600). Reprinted in *Zhongguo fangzhi congshu: Huazhong* 中國方志叢書: 華中, vol. 505: 1–6.

Jiaxing fuzhi 嘉興府志 (1879). Reprinted in *Zhongguo fangzhi congshu: Huazhong* 中國方志叢書: 華中, vol. 53: 1–5.

Jinshu 晉書. By Fang Xuanling 房玄齡 et al. Reprint, Beijing: Zhonghua shuju, 1974.

Kin Bunkyō 金民京. *Sangokushi engi no seikai* 三國志演義の世界. Tokyo: Tōhō shoten, 1993.

———. "Tang Binyin yu Wan Ming shangye chuban" 湯賓尹與晚明商業出版. In *Shibian yu weixin: Wan Ming yu Wan Qing de wenxue yishu* 世變與維新: 晚明與晚清的文學藝術國際學術研討會,

edited by Hu Xiaozhen 胡曉真, 79–101. Taipei: Academia Sinica, 2001.

———. "Wenxue dui richang shenghuode pipan—Ming Qing shiqing xiaoshuo de wenhua touguan" 文学对日常生活的批判—明清世情小说的文化透视. *Qiushi xuekan* 求是学刊 3 (1996): 11–14.

Kobata Atsushi 小葉田淳. *Chūsei Ni Shi tsūukō bōekishi no kenkyū* 中世日支通交留易史の研究. Tokyo: Tōkō Shoin, 1969.

Kobayashi Hiromitsu 小林宏光. "Chūgoku gafu no hakusai, honkoku to waseigafu no tanjo" 中国画譜の舶戴, 翻刻と和製画譜の誕生. In *Kinsei Nihon kaiga to gafu etehon ten*, vol. 2 近代日本繪画と画譜, 繪手本展 II, 106–23. Tokyo: Machida City Museum of Graphic Art, 1990.

———. "Chūgoku Kaigashi ni okeru hanga no igi: Koshigafu no miru rekidaimeiga fukusei wo megutte" 中国繪画史における版画の意義: 顧氏畫譜にみる歴代名画復製をめぐって. *Bijutsushi* 美術史 128 (1990): 123–35.

———. *Chūgoku no hanga: Tōdai kara Shindai made* 中国の版画: 唐代から清代まで. Tokyo: Tōshindō, 1995.

Kong Qi 孔齊. *Zhizheng zhiji* 至正直記. Reprint, Beijing: Zhonghua shuju, 1991.

Lan Ying 藍瑛 and Xie Bin 謝彬. *Tuhui baojian xuzuan* 圖繪寶鑑續纂. Reprinted in *Huashi congshu* 畫史叢書. Taipei: Wenshizhe chubanshe, 1974.

Leisure and Cultural Services Department of Hong Kong and the Musée Guimet. Exhibition catalogue: *Huacai Bali 1730–1930: Zhongguo jingshen Faguo pinwei* 華采巴黎: 中國精神 法國品味. Hong Kong: Hong Kong Museum of Art, 2008.

Li Fang 李昉 et al. *Taiping guangji* 太平廣記. Reprint, Beiping: Wenyoutang shufang, 1934.

Li Hongquan 李洪权. *Wei Jin shenghuo lüeying* 魏晋生活掠影. Shenyang: Shenyang chubanshe, 2002.

Li Jie 李誡. *Yingzao fashi* 營造法式. Reprint, Shanghai: Shangwuyin shuguan, 1929.

Li Kan 李衎. *Zhupu xianglu* 竹譜詳錄. 1299.

Reprinted in *Baibu congshu jicheng*. Shanghai: Shangwuyin shuguan, 1932.

Li Rihua 李日華. *Meixu xiansheng bielu: Shang* 梅墟先生別錄:上. *Yimen guangdu* edition.

———. *Weishuixuan riji* 味水軒日記. Reprinted in *Beijing tushuguan guji zhenben congkan* 北京圖書館古籍真本叢刊, vol. 20.

———. *Zitaoxuan youzhui* 紫桃軒又綴. Reprint, Shanghai: Zhongyang shudian, 1935.

———. *Zitaoxuan zazhui* 紫桃軒雜綴. Reprint, Shanghai: Zhongyang shudian, 1935.

Li Xian 李賢. *Ming yitongzhi* 明一統志. Reprint, Taipei: Shangwuyin shuguan, 1977.

Li Xu 李詡. *Jie'an laoren manbi* 戒庵老人漫筆. Reprint, Beijing: Zhonghua shuju, 1997.

Li Yonglin 李永林. *Zhongguo gudai meishu jiaoyushi gang* 中国古代美术教育史纲. Nanning: Guangxi meishu chubanshe, 2001.

Li Zhi 李贄. *Fenshu* 焚書. 1598. Reprint, Beijing: Zhonghua shuju, 1974.

Li Zhizhong 李致忠. *Gudai banben tonglun* 古代版本通论. Beijing: Zijincheng chubanshe, 2000.

———. *Gudai banbenxue gailun* 古代版本学概论. Beijing: Beijing tushuguan chubanshe, 2003.

———. *Lidai keshu kaoshu* 历代刻书考述. Chengdu: Pashu shushi, 1990.

Lian Wenping 連文萍. "Shishi keyou nüxingde weizhi—yi liangbu Mingdai shihua wei lunshu zhongxin" 詩史可有女性的位置—以兩部明代詩話為論述中心. *Hanxue yanjiu* 漢學研究 17, no. 1 (1999): 177–200.

Liang Fangzhong 梁方仲. *Zhongguo lidai hukou, tiandi, tianfu tongji* 中国 历代 戶口, 田地, 田賦 统计. Shanghai: Shanghai renmin chubanshe, 1980.

Liang Sicheng 梁思成. *Yingzao fashi zhushi* 營造法式註釋. Beijing: Zhongguo jianzhu gongye, 1980.

Lidai tihuashi lei 歷代題畫詩類. By Kangxi 康

熙 Emperor and Chen Bangyan 陳邦彥. Reprinted in *Wenyuange Siku quanshu*, vols. 1435-1436.

Lin Gongzu 林恭祖. "Qushui liushang hua shangsi" 曲水流觴話上巳. *Gugong yuekan* 故宮文物月刊 4, no. 1 (1986): 16-33.

Lin Heyi 林鶴宜. "Wan Ming xiqu kanxing gaikuang" 晚明戲曲刊行概況. *Hanxue yanjiu* 漢學研究 9, no. 1 (1991): 287-328.

Lin Jiaohong 林皎宏. "Wan Ming Huizhou shangren de wenhua huodong" 晚明徽州商人的文化活動. *Jiuzhou xuekan* 九州學刊 6, no. 3 (1994): 35-60.

Lin Mu 林木. *Ming Qing wenrenhua xinchao* 明清文人画新潮. Shanghai: Shanghai renmin meishu chubanshe, 1991.

Liu Fangru 劉芳如. "Gujin yiwen shiba miao" 古今衣紋十八描. *Gugong yuekan* 故宮月刊 3, no. 8 (1985): 48-57.

Liu Guojun 劉國鈞. *Zhongguo gudai shuji shihua* 中國古代書籍史話. Beijing: Zhongguo qingnian chubanshe, 1979.

Liu Ji 劉基. *Chengyibo wenji* 誠意伯文集. Reprinted in *Wenyuange Siku quanshu*, vol. 1225.

Liu Ninghui 劉寧慧. "Tang Song tushubian xingtai de zhuanbian yu congshu shengchengzhi guanxi" 唐宋圖書編型態的轉變與叢書生成之關係. In *Haixia Liang'an: Gudian wenxianxue xueshu taolunhui lunwenji* 海峽兩岸: 古典文獻學 學術研討會論文集, 309-45. Shanghai: Shanghai guji chubanshe, 2002.

Liu Shangheng 劉尚恒. *Huizhou keshu yu cangshu* 徽州刻書與藏書. Yangzhou: Guangling shushe, 2003.

Liu Shiru 劉世儒. *Liu Xuehu meipu* 劉雪湖梅譜. 1595.

Liu Xiaodong 刘晓东. "Wan Ming kechang fengbian yu shiren keju xintai de yanbian" 晚明科场风变与士人科举心态的演变. *Ming Qing shi* 明清史 12 (December 2007): 42-47.

Liu Zhiqin 刘志琴. *Wan Ming shilun: Chongxin renshi moshi shuaibian* 晚明史论: 重新认识末世衰变. Nanchang: Jiangxi gaoxiao chubanshe, 2004.

Lu Xun 鲁迅. "Wei Jin fengdu ji wenzhang yu yao ji jiu zhi guanxi" 魏晋风度及文章与药及酒之关系. In *Lu Xun lunwenxue yu yishu* 鲁迅论文与艺术, edited by Wu Zimin 吴子敏, Xu Naixiang 徐泗翔, and Ma Liangchun 馬良春, 251-65. Beijing: Renmin daxue chubanshe, 1980.

———. *Zhongguo xiaoshuode lishi de bianqian* 中国小说的历史的变迁. Hong Kong: Zhongliu chubanshe, 1957.

Luo Shubao 罗树宝. *Zhongguo gudai yinshua shi tuce* 中国古代印刷史图册. Beijing: Wenwu chubanshe, 1998.

Luo Zongtao 羅宗濤. "Tangren tibishi chutan" 唐人題壁詩初探. *Zhonghua wenshi luncong* 中華文史論丛 47 (1991): 144-58.

Ma Daokuo 马道阔. "Zhu Youdun de Lanting taben" 朱有敦的兰亭图拓本. *Shufa yanjiu* 书法研究 1 (1984): 73-77.

Ma Jige 马季戈. *Zeng Jing yu Bochenpai* 曾鲸与波臣派. Jinan: Shandong meishu chubanshe, 2004.

Ma Meng-ching (Ma Mengjing) 馬孟晶. "Collecting Images for Illustrations." Paper presented at the symposium "Kunst in China: Sammlungen und Konzepte." 2003.

———. "Ermu zhi wan—Cong *Xixiang ji* banhua chatu lun Wan Ming chuban wenhua dui shijuexing zhi guanzhu" 耳目之玩 — 從 <西廂記> 版畫插圖論晚明出版文化對視覺性之關注. *Meishushi yanjiu jikan* 美術史研究集刊 13 (2002): 201-76.

Mao Wenfang 毛文芳. "Wan Ming [Kuangchan] tanlun" 晚明 [狂禪] 探論. *Hanxue yanjiu* 漢學研究 19, no. 2 (2001): 171-200.

———. *Wan Ming xianshang meixue* 晚明閒賞美學. Taipei: Taipei xuesheng shuju, 2000.

Mao Xiaotong 毛效同. *Tang Xianzu yanjiu ziliao huibian* 湯顯祖研究資料彙編. Shanghai: Shangahi guji chubanshe, 1986.

Murakami Tetsumi 村上哲見. "Yasukao" 雅俗考. In *Zhongguo dianji yu wenhua luncong*, vol. 4 中國典籍與文化論叢. Translated by Gu Xinyi 顾欣艺, 423-41. Beijing: Zhonghua shuju, 1997.

Nagasawa Kikuya 長澤規矩也. "Gencho shikokuhonpyo" 元朝四国本表. In *Tōyōshi ronsō: Ichimura hakushi koki kinen* 東洋史論叢: 市村博士古稀記念, edited by Ichimura hakushi koki kinen Tōyōshi ronsō kankōkai 市村博士古稀記念東洋史論叢刊行會, 775–811. Tokyo: Fuzanbō, 1933.

———. "Genkanbon koko meihyo shoko" 元刊本考古名初考. *Shoshigaku* 書誌学 2 (1934): 257–68.

———. *Wakansho no insatsu to sono rekishi* 和漢書の印刷とその歴史. Tokyo: Yoshikawa kobunkan, 1952.

Ning Jiayu 宁稼雨. *Shishuo xinyu de shiren jingshenshi yanjiu* <世说新语> 的士人精神史研究. Tianjin: Nankai daxue chubanshe, 2003.

Ogawa Yoichi 小川陽一. *Nichiyō ruisho ni yoru Min Shin shōsetsu no kenkyū* 日用類書による明清小說の研究. Tokyo: Kenbun shuppan, 1995.

Oki Yasushi 大木康. "Minmatsu kōnan ni okeru shuppan bunka no kenkyū" 明末江南における出版文化の研究. *Hiroshima daigaku bungakubu kiyō* 廣島大學文學部紀要 50, no. 1 (1991): 1–175.

———. *Minmatsu Kōnan no shuppan bunka* 明末江南の出版文化. Tokyo: Kenbun shuppan, 2004.

———. "Wan Ming suwenxue xingsheng de jingshen beijing" 晚明俗文學興盛的精神背景. *Shibian yu weixin—Wan Ming yu Wan Qing de wenxue yishu* 世變與維新—晚明與晚清的文學藝術, edited by Hu Xiaozhen 胡曉真, 103–26. Taipei: Zhongyang yanjiuyuan Zhongguo wenzhe yanjiusuo, 2001.

Peiwen yunfu 佩文韻府. By Kangxi 康熙 Emperor and Zhang Yushu 張玉書. Reprint, Shanghai: Shangwuyin shuguan, 1937.

Peiwenzhai shuhuapu 佩文齋書畫譜. By Wang Yuanqi 王原祁 et al. 1708. Reprinted in *Wenyuange Siku quanshu*, vols. 819–23.

Peng Sunyu 彭遜遹. *Songguitang quanji* 松桂堂全集. Reprinted in *Wenyuange Siku quanshu*, vol. 1317.

Qian Bocheng 錢伯城, comp. *Yuan Hongdao jianjiao* 袁宏道集箋校. Shanghai: Shanghai guji chubanshe, 1981.

Qian Mu 錢穆. *Zhongguo xueshu sixiangshi luncong* 中國學術思想史論叢. Taipei: Dongda tushu gongsi, 1985.

Qian Xiyan 錢希言. *Xixia* 戲瑕. Reprint, Beijing: Zhonghua shuju, 1985.

Qianqingtang shumu 千頃堂書目. By Huang Yuji 黃虞稷 et al. Reprint, Shanghai: Shanghai guji chubanshe, 2001.

Qiao Mengfu 喬夢符. "Li Yunying fengsong wutongye" 李雲英風送梧桐葉. Reprinted in *Xuxiu Siku quanshu*, 1703:146–55.

Qiu Yuan 仇遠. *Jinyuanji* 金淵集. Reprinted in *Wenyuange Siku quanshu*, vol. 1198.

Qu Dajun 屈大均. *Guangdong xinyu* 廣東新語. Reprint, Beijing: Zhonghua shuju, 1985.

Qu Mianliang 瞿冕良. *Zhongguo guji banke cidian* 中国古籍版刻辞典. Jinan: Qilu shushe, 1999.

Qu Yong 瞿鏞. *Tieqin tongjianlou shumu* 鐵琴銅劍樓書目. 1897.

Quantangshi 全唐詩. Compiled by Peng Dingjiu 彭定求 et al. Reprint, Beijing: Zhonghua shuju, 1960.

Ruan Pu 阮璞. *Zhongguo huashi lunbian* 中國畫史論辨. Shanxi: Shanxi renmin meishu chubanshe, 1993.

Sakai Tadao 酒井忠夫. *Chūgoku zensho no kenkyū* 中國善書の研究. Tokyo: Kōbundō, 1960.

Shanxi tongzhi 山西通志. Reprint, Beijing: Zhonghua shuju, 1990.

Shen Defu 沈德符. *Wanli yehuobian* 萬曆野獲編. Reprint, Beijing: Zhonghua shuju, 2004.

Shen Gua 沈括. *Mengxi bitan* 梦溪笔谈. Reprinted in *Sibu congkan: Guangbian*, vol. 28.

Shen Shixing 申時行 et al. *Minghuidian* 明會典. Reprint, Beijing: Zhonghua shuju, 1989.

Sheng Feng 盛楓. *Jiahe zhengxian lu* 嘉禾徵獻

錄. Reprint, Yangzhou: Jiangsu Guangling guji keyin, 1989.

Shi Li 石莉. *Wen Zhengming* 文徵明. Shijiazhuang: Hebei jiaoyu chubanshe, 2003.

Shi Tingyong 施廷鏞. *Zhongguo guji banben gaiyao* 中國古籍版本概要. Tianjin: Tianjin guji chubanshe, 1987.

Shōsōin ten: 50th 正倉院展: 第50回. Nara: Nara kokuritsu hakubutsukan, 1998.

Shimada Shūjirō 島田修二朗. "Sōsai baifu teiyō" 松齋梅譜提要. *Bunka* 文化 20, no. 2 (1956): 96–118.

Shimada Kenji 島田虔次. *Chūgoku ni okeru kindai shii no zasetsu* 中國における近代思維の挫折. Tokyo: Chikuma shobō, 1949.

Siku quanshu zongmu tiyao 四庫全書總目提要. By Ji Yun 紀昀, Yong Rong 永瑢, et al. Reprint, Beijing: Zhonghua shuju, 1997.

Sima Qian 司馬遷. *Shiji* 史記. Reprint, Beijing: Zhonghua shuju, 1987.

Songshi 宋史. By Tuo Tuo 脫脫 et al. Reprint, Beijing: Zhonghua shuju, 1977.

Su Shi 蘇軾. *Dongpo quanji* 東坡全集. Reprinted in *Wenyuange Siku quanshu*, vols. 1107–1108.

Sun Lijun 孙立郡. *Zhongguo de gudai shiren shenghuo* 中国古代的士人生活. Beijing: Shangwuyin shuguan, 2003.

Sun Xu 孫緒. *Shaxiji* 沙溪集. Reprinted in *Wenyuange Siku quanshu*, vol. 1264.

Suzuki Tadashi 鈴木正. "Mindai sanjin kō" 明代山人考. In *Mindaishi ronsō: Shimizu hakushi tsuitō kinen* 明代史論叢: 清水博士追悼記念, edited by Shimizu hakushi tsuitō kinen Mindaishi ronsō hensan iinkai 清水博士追悼記念明代史論叢編纂委員会, 357–88. Tokyo: Daian, 1962.

Taki Mototane 丹波元胤. *Zhongguo yijikao* 中国医籍考. 1819. Reprint, Beijing: Renmin weisheng chubanshe, 1983.

Tan Yuanchun 譚元春. *Tan Yuanchun ji* 譚元春集. Reprint, Shanghai: Shanghai guji chubanshe, 1998.

Tang Hou 湯垕. *Gujin huajian* 古今畫鑒. Reprinted in *Yuandai shuhualun* 元代书画论. Changsha: Hunan meishu chubanshe, 2002.

———. *Hualun* 畫論. Reprinted in *Yuandai shuhualun* 元代书画论. Changsha: Hunan meishu chubanshe, 2002.

Tang Xianzu 湯顯祖. *Mudanting ji tici* 牡丹亭記提詞. In *Tang Xianzu ji* 湯顯祖集. Reprint, Taipei: Hongshi chubanshe, 1975.

Tang Yiming 唐翼明. *Wei Jin Qingtan* 魏晉清談. Taipei: Dongda chubanshe, 1992.

Tang Zhiqi 唐志契. *Huishi weiyan* 繪事微言. Reprint, Taipei: Shangwuyin shuguan, 1981.

Tao Yongbai 陶咏白 and Li Shi 李湜. *Shiluo de lishi: Zhongguo nüxing huihuashi* 失落的歷史: 中國女性繪畫史. Changsha: Hunan meishu chubanshe, 2000.

Tao Zongyi 陶宗儀. *Nancun chuogenglu* 南村輟耕錄. Reprint, Beijing: Zhonghua shuju, 2004.

Ts'ai Mei-fen (Cai Meifen) 蔡玫芬. "Suzhou Gongyijia Zhou Danquan ji qi Shidai" 蘇州工藝家周丹泉及其時代. In *Quyu yu Wangluo: Jin qiannian lai Zhongguo meishushi yanjiu guoji xueshu yantaohui lunwenji* 區域與網絡: 近千年來中國美術史研究國際學術研討會論文集, 269–98. Taipei: National Taiwan University, 2001.

Utsunomiya Kiyoyoshi 宇都宮清吉. "Sesetsu shingo no jidai" 世說新語の時代. *Tōhō gakuhō* 東方學報 10, no. 2 (1939): 10–25.

Wang Anqi 王安祈. "Mingdai de siren jiayue yu jiazhai yanju" 明代的私人家樂與家宅演劇. *Gugong wenwu yuekan* 故宮文物月刊 84 (1983): 64–77.

Wang Bomin 王伯敏. *Zhongguo banhua tongshi* 中国版画通史. Shijiazhuang: Hebei meishu chubanshe, 2002.

———. *Zhongguo banhuashi* 中国版画史. Shanghai: Shanghai renmin meishu chubanshe, 1961.

Wang Cheng-hua (Wang Zhenghua) 王正華. "Guoyan fanhua: Wan Ming chengshitu, chengshiguan yu wenhua xiaofei de yanjiu" 過眼繁華: 晚明城市圖、城市觀與文化消費的研究. In *Zhongguo de chengshi shenghuo* 中國的城市生活, edited by Li

Hsiao-t'i (Li Xiaoti) 李孝悌, 1–57. Taipei: Lianjing, 2005.

———. "Shenghuo, zhishi yu wenhua shangpin: Wan Ming Fujianban riyong leishu yu qi shuhuamen" 生活與文化商品: 晚明福建版 <日用類書> 與其書畫門. *Zhongyang yanjiusuo Jindaishi yanjiusuo jikan* 中央研究所 近代史研究所集刊 41 (2003): 1–85.

Wang Ermin 王爾敏. *Ming Qing shehui wenhua shengtai* 明清社會文化生態. Taipei: Shangwuyin shuguan, 1997.

———. *Ming Qing shidai shumin wenhua shenghuo* 明清時代庶民文化生活. Taipei: Zhongyang yanjiuyuan jindaishi yanjiusuo, 1996.

Wang Fu 王紱. *Wang Sheren shiji* 王舍人詩集. Reprint, Taipei: Shangwuyin shuguan, 1978.

Wang Guiping 王桂平. *Zhongguo banben wenhua congshu: Jiakeben* 中國版本文化叢書: 家刻本. Nanjing: Jiangsu guji chubanshe, 2002.

Wang Hongtai 王鴻泰. "Ming Qing wenren shenghuo yu shangwan wenhua" 明清文人生活與賞玩文化. Paper presented at the International Symposium, Antiquarianism and Novelty: Art Appreciation in Ming and Qing China 玩古/賞新—明清的賞玩文化. Taipei, National Palace Museum, 2004.

Wang Hongzhuan 王弘撰. *Shanzhi* 山志. Reprint, Beijing: Zhonghua shuju, 1999.

Wang Jide 王驥德. *Wang Jide qulü* 王驥德曲律. Edited by Chen Duo 陳多 and Ye Changhai 葉長海. Changsha: Hunan renmin chubanshe, 1983.

Wang Kaixuan 王凱旋 and Li Hongquan 李洪权. *Ming Qing shenghuo lüeying* 明清生活掠影. Shenyang: Shenyang chubanshe, 2001.

Wang Lanyin 王蘭蔭. "Mingdai zhi shexue" 明代之社學. *Shida yuekan* 師大月刊 5, no. 4 (1935): 42–102.

Wang Luoyu 汪珂玉. *Shanhuwang* 珊瑚網. Reprinted in *Wenyuange Siku quanshu*, vol. 818.

Wang Nengxian 王能宪. *Shishuo xinyu yanjiu* 世说新语研究. Nanjing: Jiansu guji chubanshe, 1992.

Wang Ningzhang 王寧章. "Qiuhanyue yehua daoyi—cong Tang Bohu *Daoyitu* shuoqi" 秋寒月夜話搗衣 — 從唐伯虎 <搗衣圖> 說起. *Gugong wenwu yuekan* 故宮文物月刊 222 (1991): 4–18.

Wang Shizhen 王世貞. *Wangshi huayuan* 王氏畫苑. 1590.

———. *Yanzhou xugao* 弇州續稿. Reprinted in *Wenyuange Siku quanshu*, vols. 1282–1284.

Wang Shoujia 玉守稼. "Shilun Mingdai de zongshi renkou wenti" 试论明代的宗室人口问题. *Zhongguoshi yanjiu* 中国史研究 45, no. 1 (1990): 85–89.

Wang Shucun 王樹村. *Zhongguo minjian huajue* 中國民間畫訣. Beijing: Beijing gongyi meishu chubanshe, 2003.

Wang Sishi 王嗣奭. *Duyi* 杜臆. Reprinted in *Xuxiu Siku quanshu*, vol. 1307.

Wang Xianjie 汪顯節. *Meiwu yiqiong* 梅塢貽瓊. Reprinted in *Congshu jicheng chubian*, vols. 1705–1706.

Wang Yaoting 王耀庭. "Chen Hongshou bixia de Yuanming yizhi" 陳洪綬筆下的淵明逸致. *Gugong wenwu yuekan* 故宮文物月刊 95 (1983): 96–109.

Wang Yilun 王益論. *Danqingyin* 丹青引. Guangzhou: Yuanyishe, 1949.

Wang Yuxian 王毓賢. *Huishi beikao* 繪事備考. Reprinted in *Wenyuange Siku quanshu*, vol. 826.

Wang Zhongmin 王重民. *A Descriptive Catalogue of Rare Chinese Books in the Library of Congress* 國會圖書館藏中國山本書錄. Washington, D.C.: Library of Congress, 1937.

———. *Zhongguo shanbenshu tiyao* 中國善本書提要. Shanghai: Shanghai guji chubanshe, 1983.

Wen Jia 文嘉. *Lingshantang shuhuaji* 鈐山堂書畫記. Reprinted in *Zhongguo shuhua quanshu*, 3:829–34.

Wen Zhenheng 文震亨. *Zhangwu zhi* 長物志. Reprinted in *Congshu jicheng chubian*, vol. 1508.

Wen'an xianzhi 文安縣志. Reprinted in
Zhongguo fangzhi congshu: Huabei 中國方
志叢書: 華北, vol. 153: 1–3.

Weng Tongwen 翁同文. "Huaguang zhongren
de shengping yu momei chuqi de fazhan"
花光仲仁的生平與墨梅初期的發展.
Gugong jikan 故宮季刊 9, no. 3 (1975):
21–40.

Weng Wango H. C. Chen Hongshou: His Life
and Art. Shanghai: Shanghai renmin
chubanshe, 1997.

Wenwu chubanshe 文物出版社, ed. Lanting
lunbian 兰亭论辨. Beijing: Wenwu
chubanshe, 1973.

Wu Chengxue 吳承學. "Lun tibishi—jianji
xiangguan de shige zhizuo yu chuanbo
xingshi" 论题壁诗—兼及相关的诗歌制
作与传播形式. Wenxue yichan 文学遗产 4
(1994): 4–13.

———. Wan Ming xiaopin yanjiu 晚明小品研
究. Nanjing: Jiangsu guji chubanshe, 1998.

Wu Huifang 吳蕙芳. Wanbao quanshu: Ming
Qing shiqi de minjian shenghuo shilu 萬寶
全書: 明清時期的民間生活實錄. Taipei:
Guoli zhengzhi daxue lishi xuexi, 2001.

Wu Pi-yong 吳璧雍. "Cong fangke dao
daoyin—Wan Ming yinshua shiye de
xianxiang zhi yi" 從彷刻到盜印—晚明
印刷事業的現象之一. Paper presented
at the International Symposium,
Antiquarianism and Novelty: Art
Appreciation in Ming and Ch'ing China.
National Palace Museum, Taipei, 2004.

Wu Renshu 武仁恕. Pinwei shuhua: Wan
Ming de xiaofei shehui yu shidafu 品味
奢華: 晚明的消費社會與士大夫. Taipei:
Zhongyang yanjiuyuan, 2007.

Wu Taisu 吳太素. Songzhai meipu 松齋梅譜.
Compiled by Shimada Shūjirō 島田修二
郎. Hiroshima: Hiroshima shiritsu chūō
toshokan, 1989.

Wu Yunjia 吳允嘉. Tianshui bingshanlu 天
水冰山錄. Reprinted in Congshu jicheng
chubian, vols. 1502–1504.

Wu Zhihe 吳智和. "Mingdai Suzhou shequ
xiangtu shenghuoshi juyu—yi wenren
jituan weili" 明代蘇州社區鄉土生活史

舉隅—以文人集團為例. In Fangzhixue
yu shequxiangtushi xueshu yantaohui
lunwenji 方志學與社區鄉土史學術研討
會論文集, 23–48. Taipei: Taiwan xuesheng
shuju, 1998.

Wuqiu Yan 吾丘衍 et al. Zhusu shanfang shiji
竹素山房詩集. Reprinted in Wenyuange
Siku quanshu, vol. 1195.

Wuxing beizhi 吳興備志. By Dong Sizhang 董
斯張. Reprinted in Siku quanshu zhenben
jiuji, vols. 156–59.

Xia Wenyan 夏文彥. Tuhui baojian 圖繪寶
鑑. Reprint, Taipei: Shangwuyin shuguan,
1956.

Xia Xianchun 夏咸淳. Mingdai qing yu li de
pengzhuang: Mingdai shilin xinshi 明代情
与理的碰撞: 明代士林心史. Hebei: Hebei
daxue chubanshe, 2001.

———. "Wan Ming wenshi yu shimin
jieceng" 晚明文士与市民阶层. Wenxue
yichan 文学遗产 2 (1994): 85–91.

Xie Shuishun 谢水顺 and Li Ting 李珽. Fujian
gudai keshu 福建古代刻书. Fujian: Fujian
renmin chubanshe, 1997.

Xie Wei 谢巍. Zhongguo huaxue zhuzuo kaolu
中国画学著作考录. Shanghai: Shanghai
shuhua chubanshe, 1998.

Xie Xingyao 谢兴尧. Kanyinzhai suibi 堪
隐斋随笔. Shenyang: Liaoning jiaoyu
chubanshe, 1995.

Xie Zhaozhe 謝肇淛. Wuzazu 五雜組.
Reprint, Shenyang: Liaoning jiaoyu
chubanshe, 2001.

Xin Tangshu 新唐書. By Song Qi 宋祁 and
Ouyang Xiu 歐陽修. Reprint, Beijing:
Zhonghua shuju, 1994.

Xiong Lihui 熊礼汇. "Lüelun Wei Jin wenfeng
shanbian de wenhua dongyin" 略论魏晋
文风嬗变的文化动因. Renwen luncong 人
文论丛 (1998): 101–18.

———, ed. Yuan Zhonglang xiaopin 袁中朗
小品. Beijing: Wenhua yishu chubanshe,
1996.

Xu Fuguan 徐復觀. Chungguk yesul chŏngsin
중국예술정신. Translated by Kwon
Dŏk-Ju 권덕주. Seoul: Tongmunsŏn, 1990.

Xu Fuming 徐扶明. Mudanting yanjiu ziliao

kaoshi 牡丹亭研究資料考釋. Shanghai: Shanghai guji chubanshe, 1987.

———. "Zang Maoxun yu Yuanqu xuan" 臧懋循與元曲選. In *Yuan zaju lunji* 元雜劇論集, edited by Li Xiusheng 李修生, Li Zhenyu 李真渝, and Hou Guangfu 侯光复, 1:142–49. Tianjin: Baihua wenyi chubanshe, 1985.

Xu Hui 许辉, Qiu Min 邱敏, and Hu Axiang 胡阿祥. *Liuchao wenhua* 六朝文化. Nanjing: Jiangsu guji chubanshe, 2001.

Xu Jianrong 徐建融. "'Xiyuan yaji' yu meishu shixue—dui yizhong ge'an yanjiu fangfa de pipan" "西园雅集"与美术史学—对一种个案研究方法的批判. *Duoyun* 朵云 4 (1993): 5–21.

Xu Shuofang 徐朔方. *Yuanqu xuanjia Zang Maoxun* 元曲选家臧懋循. Beijing: Zhongguo xiqu chubanshe, 1985.

Xu Wei 徐渭. Hangzhou: Zhejiang renmin chubanshe, 1989.

Xu Xiaoman 徐小蛮. *Banhua* 版画. Shanghai: Shanghai guji chubanshe, 1997.

Xu Yinglei 徐應雷. *Mingwenhai* 明文海. Reprint, Taipei: Shangwuyin shuguan, 1981.

Xuanhe huapu 宣和畫譜. Reprinted in *Wenyuange Siku quanshu*, vol. 813.

Xue Bing 薛冰. *Zhongguo banben wenhua congshu: Chatuben* 中國版本文化叢書: 插圖本. Nanjing: Jiangsu guji chubanshe, 2002.

Xue Gang 薛岡. *Tianjuetang wenji* 天爵堂文集. Reprint, Beijing: Beijing chubanshe, 1997.

Yang Danian 楊大年. *Zhongguo lidai hualun caiying* 中國歷代畫論采英. Henan: Henan renmin chubanshe, 1984.

Yang Dianxun 楊殿珣. *Shike tiba suoyin* 石刻題跋索引. Beijing: Shangwuyin shuguan, 1990.

Yang Guoli 楊郭禮. "Cong yinjiu yishi kan Lanting wenwu" 從飲酒儀式看蘭停文物. *Gugong wenwu yuekan* 故宮文物月刊 4, no. 1 (1986): 46–53.

Yang Hongdao 楊弘道. *Xiaohengji* 小亨集. Reprinted in *Wenyuange Siku quanshu*, vol. 1198.

Yang Jong-Guk 梁鍾國. *Songdae sadaebu sahwi yong* 宋代士大夫社會研究. Seoul: Samjiwon, 1996.

Yang Shen 楊慎. *Danqian zonglu* 丹鉛总錄. Reprinted in *Wenyuange Siku quanshu*, vol. 855.

Yang Shengxin 杨绳信. *Zhongguo banke zonglu* 中国版刻综录. Xi'an: Shanxi renmin chubanshe, 1987.

Yang Yong'an 楊永安. "Cong *Jinpingmei* shuzhong chufa yiguancha Ming zhongye yige pianduan zhi yinshi jiage" 從 <金瓶梅> 書中出發以觀察明中葉一個片斷之飲食價格. In *Mingshi guankui zagao* 明史管窺雜稿, 151–90. Hong Kong: Xianfeng chubanshe, 1987.

Ye Dehui 葉德輝. *Shulin qinghua* 書林清話. 1911. Reprint, Beijing: Guji chubanshe, 1957.

Ye Lang 叶朗. *Zhongguo meixueshi dagang* 中国美学史大纲. Shanghai: Shanghai renmin chubanshe, 2001.

Ye Ming 葉銘. *Guangyin renzhuan* 廣印人傳. Reprint, Taipei: Wenshizhe chubanshe, 1997.

Ye Shusheng 叶树声 and Yu Minhui 余敏辉. *Ming Qing Jiangnan siren keshushi lue* 明清江南私人刻书史略. Hefei: Anhui daxue chubanshe, 2002.

Yoshikawa Kōjirō 吉川幸次郎. *Yuan Ming shi gaishuo* 元明詩概說. Translated by Zheng Qingmao 鄭清茂. Taipei: Youshi wenhua shiye gongsi, 1986.

Yu Bian 俞弁. *Shanqiao xiayu* 山樵暇語. Shanghai: Shangwuyin shuguan, 1917.

Yu Jianhua 俞劍華. *Zhongguo gudai hualun leibian* 中國古代畫論類編. Beijing: Renmin meishu chubanshe, 1998.

Yu Shaosong 余紹宋. *Shuhua shulu jieti* 書畫書錄解題. 1932. Reprint, Beijing: Beijing tushuguan chubanshe, 2003.

Yu Yaohua 余耀华. *Zhongguo jiage shi* 中国价格史. Beijing: Zhongguo wujia chubanshe, 2000.

Yu Yingshi 余英時. *Shi yu Zhongguo wenhua* 士与中国文化. Shanghai: Shanghai guji chubanshe, 2003.

Yu Zhaopeng 俞兆鵬. *Zhongguo weishu daguan* 中國偽書大觀. Nanchang: Jiangxi Jiaoyu chubanshe, 1998.

Yuan Hongdao 袁宏道. *Yuan Zhonglang quanji* 袁中朗全集. Compiled by Liu Dajie 劉大杰. Shanghai: Shidai shuju, 1934.

Yuan Xingpei 袁行霈. *Tao Yuanming ji jianzhu* 陶淵明集箋注. Beijing: Zhonghua shuju, 2003.

Yuan Yuhong 袁玉红. "Beijing tushuguan cang *Lanting tu taben qianshuo*" 北京图书馆藏兰亭图拓本浅说. *Beijing tushuguan guankan* 北京图书馆馆刊 1 (1998): 60, 94–96.

Yuan Zhongdao 袁中道. *Kexuezhai qianji* 珂雪齋前集. Reprinted in *Xuxiu siku quanshu*, vol. 1375.

Zhan Jingfeng 詹景風. *Wangshi shuhua yuan buyi* 王氏畫苑補益.

Zhang Chou 張丑. *Qinghe shuhuafang* 清河書畫舫. Reprinted in *Wenyuange Siku quanshu* edition, vol. 817.

———. *Shuhua jianwen biao* 書畫見聞表. Reprinted in *Wenyuange Siku quanshu*, vol. 817.

Zhang Chushu 張楚叔 and Zhang Xuchu 張旭初. *Wusao hebian* 吳騷合編. 1637.

Zhang Dai 張岱. *Tao'an mengyi* 陶庵夢憶. Reprint, Beijing: Zuojia chubanshe, 1994.

Zhang Dejian 張德建. *Mingdai shanren wenxue yanjiu* 明代山人文學研究. Changsha: Hunan renmin chubanshe, 2005.

Zhang Han 張瀚. *Songchuang mengyu* 松窗夢語. Reprint, Beijing: Zhonghua shuju, 1985.

———. *Wulin Yilaohui shiji* 武林怡老會詩集. Reprinted in *Congshu jicheng xubian*, vol. 154.

Zhang Huijian 張慧劍. *Ming Qing Jiangsu wenren nianbiao* 明清江蘇文人年表. Shanghai: Shanghai guji chubanshe, 1986.

Zhang Junde 张军德. "Zhou Lüjing de shengzunian ji qita" 周履靖的生卒年及其他. *Xiqu yanjiu* 戏曲研究 28 (1988): 268–72.

Zhang Qiya 張啟亞. "Zhongguo huaniaohua de yanliu yu biange" 中國花鳥畫的衍流與變革. In *Nanjing bowuyuancang huaniaohua xuanji* 南京博物院藏花鳥畫選集. Hong Kong: Daye gongsi, 1992.

Zhang Xincheng 張心澂. *Weishu tongkao* 偽書通考. Shanghai: Shanghai shudian chubanshe, 1998.

Zhang Xiumin 張秀民. *Zhongguo yinshua shi* 中國印刷史. Shanghai, Shanghai renmin chubanshe, 1989.

Zhang Yanyuan 張彥遠. *Lidai minghua ji* 歷代名畫記. Reprint, Taipei: Yiwen, 1965.

Zhao Feipeng 趙飛鵬. "Songdai shiren yu leishu—yi Huang Tingjian wei li 宋代詩人與類書—以黃庭堅為例. In *Haixia Liang'an: Gudian wenxianxue xueshu yantaohui lunwenji* 海峽兩岸: 古典文獻學 學術研討會論文集, 207–19. Shanghai: Shanghai guji chubanshe, 2002.

Zhao Yi 趙翼. *Ershi'er shi zhaji* 二十二史劄記. Reprinted in *Congshu jicheng chubian*, vols. 3543–3552.

Zhao Yi 赵毅. "Mingdai zongshi de shangye huodong ji shehui yingxiang" 明代宗室的商业活动及社会影响. *Zhongguoshi yanjiu* 中国史研究 41, no. 1 (1989): 49–54.

Zhao Yi 赵毅 and Luan Fan 栾凡. *Ershi shiji Mingshi yanjiu zongshu* 20 世纪明史研究综述. Changchun: Dongbei shifan daxue chubanshe, 2002.

Zhejiang tongzhi 浙江通志. Reprinted in *Wenyuange Siku quanshu*, vols. 519–26.

Zheng Peikai 鄭培凱. "Wan Ming shidafu dui funü yishi de zhuyi" 晚明士大夫對婦女意識的注意. *Jiuzhou xuekan* 九州學刊 6, no. 2 (1994): 27–43.

Zheng Yan 鄭琰. *Meixu xiansheng bielu: Xia* 梅墟先生別錄: 下.

Zheng Yan 郑岩. *Wei Jin Nanbeichao bihuamu yanjiu* 魏晉南北朝壁画墓研究. Beijing: Wenwu chubanshe, 2002.

Zheng Yinshu 鄭銀淑. *Xiang Yuanbian shuhua shoucang* 項元汴書畫收藏. MA thesis. Taipei: Zhongguo wenhua daxue, 1983.

Zheng Zhenduo 鄭振鐸. *Chatuben zhongguo wenxueshi* 插圖本中國文學史. Reprint,

Shanghai: Shanghai renmin chubanshe, 2005.

———, comp. *Zhongguo banhua shi tulu* 中國版畫史圖錄. Shanghai: Zhongguo banhuashi she, 1940–1942.

Zheng Zhongkui 鄭仲夔. *Qingyan* 清言. Reprinted in *Siku quanshu cunmu congshu*, vol. 244.

Zhong Wei 仲威 and Shen Chuanfeng 沈传凤. *Gumo xinyan: Chunhua getie zonghengtan* 古墨新研:《淳化阁帖》纵横谈. Shanghai: Shanghai shudian chubanshe, 2003.

Zhongguo congshu zonglu 中國叢書綜錄. By Shanghai tushuguan. 1959. Reprint, Shanghai: Shanghai guji chubanshe and Xinhua shudian, 1986.

Zhongguo guji shanben shumu 中國古籍善本書目. By Zhongguo guji shanben shumu bianji weiyuanhui. Reprint, Shanghai: Shanghai guji chubanshe: Xinhua shudian, 1989–1998.

Zhou Hui 周暉. *Erxu Jinling suoshi* 二續金陵瑣事. 1610.

———. *Xu Jinling suoshi* 續金陵瑣事. 1610.

Zhou Lüjing 周履靖. *Meidian gaoxuan* 梅顛稿選. Reprinted in *Siku quanshu cunmu congshu: Jibu*, vol. 187.

———. *Yimen guangdu* 夷門廣牘. 1597. Reprint, Beijing: Dongda chubanshe, 1997.

Zhou Mi 周密. *Yunyan guoyanlu* 雲煙過眼錄. Reprinted in *Huapin congshu* 畫品叢書. Shanghai: Shanghai renmin meishu, 1982.

Zhou Wu 周芜. *Huipai banhuashi lunji* 徽派版畫史論集. Hebei: Anhui renmin chubanshe, 1983.

———. *Zhongguo banhuashi tulu* 中國版畫史圖錄. Shanghai: Shanghai renmin meishu chubanshe, 1988.

Zhou Xinhui 周心慧. *Xinbian Zhongguo banhuashi tulu* 新编中国版画史图录. Beijing: Xueyuan chubanshe, 1998.

———. *Zhongguo gubanhua tongshi* 中国古版画通史. Beijing: Xueyuan chubanshe, 2000.

———. *Zhongguo gudai banke banhuashi lunji* 中国古代版刻版画史论集. Beijing: Xueyuan chubanshe, 1998.

Zhou Yanwen 周彥文. "Ming Qing zhi ji congshu yu shangye jizhide duiying guanxi" 明清之際叢書與商業機制的對應關係. In *Haixia Liang'an: Gudian wenxianxue xueshu yantaohui lunwenji* 海峽兩岸: 古典文獻學 學術研討會論文集, 346–56. Shanghai: Shanghai guji chubanshe, 2002.

Zhu Mouyin 朱謀垔. *Huashi huiyao* 畫史會要. Reprinted in *Siku quanshu: Zhenben erji*, vols. 201–2.

Zhu Mu 祝穆. *Gujin shiwen leiju* 古今事文類聚. Reprinted in *Wenyuange Siku quanshu*, vols. 925–29.

Zhu Mujie 朱睦㮮. *Wanjuantang shumu* 萬卷堂書目. Reprinted in *Xuxiu Siku quanshu*, 919:451–89.

Zhu Wanshu 朱万曙. "Li Zhuowu piping quben kao" 李卓吾批評曲本考. *Wenxian Jikan* 文獻季刊 no. 3 (2002): 107–23.

———. "Mingdai de minjian shiren: Yi Huizhou wei li" 明代的民间诗人: 以徽州为例. In *Shoujie Mingdai wenxue guoji yantaohui lunwenji* 首届明代文学国际研讨会论文集, edited by He Yongkang 何永康 and Chen Shulu 陈书录, 381–93. Nanjing: Nanjing shifan daxue chubanshe, 2004.

Zhu Xuan 朱玄. *Zhongguo shanshuihua meixue yanjiu* 中國山水畫美學研究. Taipei: Xuesheng shuju, 1997.

Zhu Yizun 朱彝尊. *Jingzhiju shihua* 静志居詩話. Reprint, Beijing: Renmin wenxue chubanshe, 1990.

Zhuang Shen 莊申. "Mingdai zhongqi Nanjing diqu de shishe yu huashe" 明代中期南京地區的詩社與畫社. *Gugong xueshu jikan* 故宮學術季刊 14, no.3 (1997): 1–64.

Western Languages

Adorno, Theodor. *The Culture Industry: Selected Essays on Mass Culture*. Edited by J. M. Bernstein. London: Routledge, 1991.

———. "On Popular Music." *Studies in Philosophy and Social Science* 9 (1941): 17–48.

Alford, William P. *To Steal a Book Is an Elegant Offense: Intellectual Property Law*

in Chinese Civilization. Stanford, Calif.: Stanford University Press, 1995.

Alsop, Joseph. *Rare Art Traditions: History of Art Collecting and Its Linked Phenomenon*. New York: Harper and Row, 1982.

Appadurai, Arjun, ed. *The Social Life of Things: Commodities in Cultural Perspective*. Cambridge: Cambridge University Press, 2001.

Bai Qianshen. "Artistic and Intellectual Dimensions of Chinese Calligraphic Rubbings: Some Examples from the Collection of Robert Hartfield Ellsworth." *Orientations* 30, no. 3 (March 1999): 82–88.

———. *Fu Shan's World: The Transformation of Chinese Calligraphy in the Seventeenth Century*. Cambridge and London: Harvard University Asia Center, 2003.

Barnhart, Richard. "The Five Dynasties and the Song Period (907–1279)." In *Three Thousand Years of Chinese Painting*, 87–137. New Haven and London: Yale University Press.

———. *Painters of the Great Ming: The Imperial Court and the Zhe School*. Dallas: Dallas Museum of Art, 1993.

———. *Peach Blossom Spring: Gardens and Flowers in Chinese Painting*. New York: Metropolitan Museum of Art, 1983.

———. "The Return of the Academy." In *Possessing the Past: Treasures from the National Palace Museum, Taipei*, edited by Wen Fong and James Watt, 335–67. New York: Metropolitan Museum of Art, 1996.

Barthes, Roland. *The Fashion System*. Translated by Matthew Ward and Richard Howard. Berkeley: University of California Press, 1983.

———. *Image—Music—Text*. Translated by Stephen Heath. New York: Hill and Wang, 1998.

Bartholomew, Terese Tse. *Myths and Rebuses in Chinese Art*. San Francisco: Asian Art Museum, 1988.

Bell, Catherine. "A Precious Raft to Save the World—The Interaction of Scriptural Traditions and Printing in a Chinese Morality Book." *Late Imperial China* 17 (June 1996): 158–200.

Benjamin, Walter. "The Work of Art in the Age of Mechanical Reproduction." In *Illuminations: Essays and Reflections*, edited by Hannah Arendt and translated by Harry Zohn, 217–51. New York: Schocken Books, 1968.

Bentley, Tamara. "Authenticity in a New Key: Chen Hongshou's Figurative Oeuvre, 'Authentic Emotion' and the Late Ming Market." Ph.D. diss., University of Michigan, 2000.

Berliner, Nancy. "Wang Tingna and Illustrated Book Publishing in Huizhou." *Orientations* 25, no. 1 (January 1994): 67–75.

Bermingham, Ann. *Learning to Draw: Studies in the Cultural History of a Polite and Useful Art*. New Haven, Conn.: Yale University Press, 2000.

Bickford, Maggie. *Ink Plum: The Making of a Chinese Scholar-Painting Genre*. New York: Cambridge University Press, 1996.

———. "Stirring the Pot of State: The Sung Picture Book *Mei-Hua Hsi-Shen P'u* and Its Implications for Yuan Scholar-Painting." *Asia Major* 6, no. 2 (1993): 169–225.

Bickford, Maggie, et al. *Bones of Jade, Soul of Ice*. New Haven, Conn.: Yale University Art Gallery, 1985.

Birch, Cyril. *The Peony Pavilion: Mudan ting*. Bloomington: Indiana University Press, 2002.

Blanchard, Lara. "Visualizing Love and Longing in Song Dynasty Paintings of Women." Ph.D. diss., University of Michigan, Ann Arbor, 2000.

Bodman, Helene Dunn. *Chinese Musical Iconography: A History of Musical Instruments Depicted in Chinese Art*. Taipei: Asia-Pacific Cultural Center, 1987.

Bolten, Jaap. *Method and Practice: Dutch and Flemish Drawing Books, 1600–1750*. Landau: Edition PVA, 1985.

Bordo, Susan. "The Body and the Reproduction of Femininity." In *Writing on the*

Body: Female Embodiment and Feminist Theory, edited by Katie Conboy, Nadia Medina, and Sarah Stanbury, 13–33. New York: Columbia University Press, 1997.

Bourdieu, Alain. "Books of Emblems on the Public Stage: Côté jardin and côté cour." In The Culture of Print: Power and the Uses of Print in Early Europe, edited by Roger Chartier and translated by Lydia G. Cochrane, 261–89. London: Polity, 1987.

Bourdieu, Pierre. Distinction: A Social Critique of the Judgement of Taste. Translated by Richard Nice. Cambridge, Mass.: Harvard University Press, 1998.

———. The Field of Cultural Production: Essays on Art and Literature. Translated and edited by Randal Johnson. New York: Columbia University Press, 1993.

———. Language and Symbolic Power. Translated by Gino Raymond and Matthew Adamson. Cambridge, Mass.: Harvard University Press, 1991.

Brokaw, Cynthia. "Commercial Publishing in Late Imperial China: The Zou and Ma Family Business of Sibao, Fujian." Late Imperial China 17 (June 1996): 49–92.

Brook, Timothy. "Censorship in Eighteenth-Century China: A View from the Book Trade." Canadian Journal of History 23, no. 2 (August 1988): 177–96.

———. Confusions of Pleasure: Commerce and Culture in Ming China. Berkeley: University of California Press, 1998.

———. "Edifying Knowledge: The Building of School Libraries in Ming China." Late Imperial China 17 (June 1996): 93–119.

———. "Family Continuity and Cultural Hegemony: The Gentry of Ningbo, 1368–1911." In Chinese Local Elites and Patterns of Dominance, edited by Joseph W. Esherick and Mary Buckus Rankin, 27–50. Berkeley: University of California Press, 1990.

———. "The Merchant Networks in 16th-Century China: A Discussion and Translation of Zhang Han's 'On Merchants.'" Journal of the Economic and Social History of the Orient 24, no. 2 (1981): 165–214.

———. Praying for Power: Buddhism and the Formation of Gentry Society in Late-Ming China. Cambridge, Mass.: Harvard University, 1993.

———. "Profit and Righteousness in Chinese Economic Culture." In Culture and Economy: The Shaping of Capitalism in Eastern Asia, edited by Timoth Brook and Hy V. Luong, 27–44. Ann Arbor: University of Michigan Press, 1993.

Brotherton, Elizabeth. "Beyond the Written Word: Li Gonglin's Illustrations to Tao Yuanming's Returning Home." Artibus Asiae 59, no. 3/4 (2000): 225–63.

Bryson, Norman. In Medusa's Gaze: Still Life Paintings from Upstate New York Museums. Rochester, N.Y.: Memorial Art Gallery of the University of Rochester, 1991

Bunker, Emma C. "Early Chinese Representations of Vimalakirti." Artibus Asiae 30, no. 1 (1968): 28–49.

Burckhardt, Erwin. Chinesiche Steinabreibungen. Munich: Hirmer Verlag München, 1961.

Burnett, Katherine. "A Discourse of Originality in Late Ming Chinese Painting Criticism." Art History 24, no. 4 (November 2000): 522–58.

Bush, Susan. Chinese Literati on Painting: Su Shih (1037–1101) to Tung Ch'i-ch'ang (1555–1636). Cambridge, Mass.: Harvard University Press, 1971.

———, ed. Theories of the Arts in China. Princeton, N.J.: Princeton University Press, 1983.

Bush, Susan, and Hsio-yen Shih. Early Chinese Texts on Painting. Cambridge, Mass.: Harvard-Yenching Institute, 1985.

Bussotti, Michela. "The Gushi huapu, a Ming Dynasty Wood-Block Masterpiece in the Naples National Library." Ming Qing Yanjiu 17 (1995): 11–44.

Cahill, James. The Compelling Image: Nature and Style in Seventeenth-Century Chinese Painting. Cambridge, Mass.: Harvard University Press, 1982.

———. *The Distant Mountains: Chinese Painting of the Late Ming Dynasty, 1570–1644*. New York: Weatherhill, 1982.

———. *Hills beyond a River: Chinese Painting of the Yuan Dynasty, 1270–1368*. New York: Weatherhill, 1976.

———. *The Painter's Practice: How Artists Lived and Worked in Traditional China*. New York: Columbia University Press, 1994.

———. *Parting at the Shore: Chinese Painting of the Early and Middle Ming Dynasty, 1368–1580*. New York: Weatherhill, 1977.

———. *The Restless Landscape: Chinese Painting of the Late Ming Period*. Berkeley, Calif.: University Museum, 1971.

———, ed. *Shadows of Mt. Huang: Chinese Painting and Printing of the Anhui School*, Berkeley: University Art Museum, 1981.

———. "Six Laws and How to Read Them." *Ars Orientalis* 4 (1961): 372–81.

———. *Three Alternative Histories of Chinese Painting*. Lawrence, Kans.: Spencer Museum, 1988.

Carlitz, Katherine. "Allusion to Drama in the *Chin p'ing mei*." *Ming Studies* 6 (1978): 30–35.

———. "Chastity, Pornography, and 'Early Modernity' in England and China, 1500–1640." Paper presented at the conference Comparative Early Modernities: 1100–1800, University of Michigan, April 17–18, 2009.

———. "Desire and Writing in the Late Ming Play 'Parrot Island.'" In *Writing Women in Late Imperial China*, edited by Ellen Widmer and Kang-i Sun Chang, 101–30. Stanford, Calif.: Stanford University, 1997.

———. "Desire, Danger, and the Body: Stories of Women's Virtue in Late Ming China." In *Engendering China: Women, Culture, and the State*, edited by Christina K. Gilmartin, 101–25. Cambridge, Mass.: Harvard University Press, 1994.

———. "Puns and Puzzles in *Chin p'ing mei*: A Look at Chapter 27." *T'oung Pao* 67 (1981): 216–39.

———. "The Social Uses of Female Virtue in Late Ming Editions of *Lienüzhuan*." *Late Imperial China* 12, no. 2 (1991): 117–52.

Carter, Thomas. *The Invention of Printing in China and Its Spread Westward*. New York: Columbia University Press, 1925.

Chang Chun-shu and Shelley Hsueh-lun Chang. *Crisis and Transformation in Seventeenth-Century China*. Ann Arbor: University of Michigan Press, 1998.

Chang Kang-i Sun. *The Late-Ming Poet Ch'en Tzu-lung: Crises of Love and Loyalism*. New Haven, Conn.: Yale University Press, 1991.

———. "Ming-Qing Women Poets and the Notions of 'Talent' and 'Morality.'" In *Culture & State in Chinese History: Conventions, Accommodations, and Critiques*, edited by Theodore Huters, R. Bin Wong, and Pauline Yu, 236–58. Stanford, Calif.: Stanford University Press, 1997.

Chartier, Roger. *The Cultural Uses of Print in Early Modern France*. Princeton, N.J.: Princeton University Press, 1987.

———, ed. *The Culture of Print: Power and the Uses of Print in Early Modern Europe*. Translated by Linda Cochrane. Princeton, N.J.: Princeton University Press, 1987.

Chau, David H.S. "Woodblock Printing, an Essential Medium of Culture Inheritance on Chinese History." *Journal of the Hong Kong Branch of the Royal Asiatic Society* 18 (1978): 175–89.

Chavannes, Édouard. *Mission Archéologique dans la Chine Septentrionale*. Paris, 1915.

Chaves, Jonathan. "The Panoply of Images: A Reconsideration of the Literary Theory of the Kung-an School." In *Theories of the Arts in China*, edited by Susan Bush and Christian Murck, 341–64. Princeton, N.J.: Princeton University Press, 1983.

———. *Pilgrims of the Clouds—Poems and Essays by Yüan Hung-tao and His Brothers*. New York: Weatherhill, 1978.

Cherniack, Susan. "Book Culture and Textual Transmission in Sung China." *Harvard Journal of Asiatic Studies* 54, no. 1 (1994): 5–125.

Chia, Lucille. "Book Emporium: The Development of the Jianyang Book Trade, Song-Yuan." *Late Imperial China* 17 (June 1996): 10–48.

———. *Printing for Profit: The Commercial Publisher of Jianyang, Fujian (11–17th Centuries)*. Cambridge, Mass.: Harvard University Asia Center, 2002.

Chin, Sandi, and Cheng-chi (Ginger) Hsü. "Anhui Merchant Culture and Patronage." In *Shadows of Mt. Huang: Chinese Painting and Printing of the Anhui Province*, edited by James Cahill, 19–24. Berkeley, Calif.: University Art Museum, 1981.

Ching, Dora C.Y. "The Aesthetic of the Unusual and the Strange in Seventeenth-Century Calligraphy." In *The Embodied Image*, edited by Robert Harrist, 342–59. New York: Harry N. Abrams, 1999.

Chou Chih-P'ing. *Yüan Hung-tao and the Kung-an School*. Cambridge: Cambridge University Press, 1988.

Chow, Kai-wing. "Writing for Success: Printing, Examinations and Intellectual Change in Late Ming China." *Late Imperial China* 25 (1996): 120–57.

Chun Shum (Shen Jin). "Pictures of the Sage's Trace: *A Preliminary Investigation of the Editions* of *Shengji tu*." *East Asian Library Journal* 10, no. 1 (Spring 2001): 129–75.

Claypool, Lisa R. "Figuring the Body: Painting Manuals in Late Ming Imperial China." Ph.D. diss., Stanford University, 2001.

Clunas, Craig. *Empire of Great Brightness*. Honolulu: University of Hawaii Press, 2007.

———. *Fruitful Sites: Garden Culture in Ming Dynasty China*. Durham, N.C.: Duke University Press, 1996.

———. *Pictures and Visuality in Early Modern China*. Princeton, N.J.: Princeton University Press, 1997.

———. *Superfluous Things: Material Culture and Social Status in Early Modern China*. Cambridge: Polity Press, 1991.

Crow, Thomas. *Painters and Public Life in Eighteenth-Century Paris*. New Haven, Conn.: Yale University Press, 1987.

Davidson, LeRoy J. "The Origin and Early Use of the Ju-I." *Artibus Asiae* 13 (1950): 239–49.

De Bary, William Theodore. "Individualism and Humanitarianism in Late Ming Thought." In *Self and Society in Ming Thought*, edited by Wm. Theodore de Bary, 145–247. New York: Columbia University Press, 1970.

De Bary, Theodore, Irene Bloom, Joseph Lufrano, and Wing-tsit Chan, eds. *Sources of Chinese Tradition*. New York: Columbia University Press, 1960.

De Certeau, Michel. *The Practice of Everyday Life*. Translated by Steven Rendall. Berkeley: University of California Press, 1984.

De Marchi, Neil, and Hans J. van Miegroet. "Pricing Invention: 'Originals,' 'Copies,' and Their Relative Value in Seventeenth Century Netherlandish Art Markets." In *Economics of the Arts: Selected Essays*, edited by Victor A. Ginsburgh, 27–70. Amsterdam: Elsevier, 1996.

Delbanco, Dawn Ho. "Illustrated Books of the Ming Dynasty." *Orientations* 12, no. 11 (November 1981): 23–37.

———. "Nanking and the Mustard Seed Painting Manual." Ph.D. diss., Harvard University, 1981.

———. "The Romance of the Western Chamber: Min Qiji's Album in Cologne." *Orientations* 14, no. 6 (June 1983): 12–23.

DeWoskin, Kenneth. *A Song for One or Two: Music and the Concept of Art in Early China*. Ann Arbor: Center for Chinese Studies, University of Michigan, 1982.

Eberhardt, Wolfram. *A Dictionary of Chinese Symbols: Hidden Symbols in Chinese Life and Thoughts*. London and New York: Routledge & Kegan Paul, 1986.

Edgren, Sören. "I.V. Gillis and the Spencer Collection." *The Gest Library Journal* 6, no. 2 (1993): 5–29.

Edwards, Richard. *The Art of Wen Cheng-ming*

(1470–1559). Ann Arbor: University of Michigan Press, 1976.

Elman, A. Benjamin. *A Cultural History of Civil Examination in Late Imperial China.* Berkeley: University of California Press, 2000.

———. *Education and Society in Late Imperial China, 1600–1900.* Berkeley: University of California Press, 1994.

———. "Political, Social, and Cultural Reproduction via Civil Service Examination in Late Imperial China." *The Journal of Asian Studies* 50, no. 1 (1991): 7–28.

Farrer, Anne S. "The Shui-hu chuan: A Study in the Development of Late Ming Woodblock Illustration." Ph.D. diss., The School of Oriental and African Studies, London, 1984.

Franke, Herbert. "Two Yüan Treatises on the Technique of Portrait Painting." *Oriental Art* 3, no. 1 (1950): 27–32.

Frankel, Hans. "Plum Tree in Chinese Poetry." *Asiatische Studien* 6 (1952): 88–115.

Fraser, Sarah. "Formulas of Creativity: Artist's Sketches and Techniques of Copying at Dunhuang." *Artibus Asiae* 59, no. 3/4 (2000): 189–224.

———. *Performing the Visual: The Practice of Buddhist Wall Painting in China and Central Asia, 618–960.* Stanford, Calif.: Stanford University Press, 2004.

Foucault, Michel. "What Is an Author?" In *Language, Counter-Memory, Practice,* translated by Donald F. Bouchard and Sherry Simon, 113–38. Ithaca, N.Y.: Cornell University Press, 1977.

Furth, Charlotte. *A Flourishing Yin: Gender in China's Medical History, 960–1665.* Berkeley: University of California Press, 1999.

Gans, Herbert J. *Popular Culture and High Culture: An Analysis and Evaluation of Taste.* New York: Basic Books, 1999.

Gendron, Bernard. "Theodor Adorno Meets the Cadillacs." In *Studies in Entertainment: Critical Approaches to Mass Culture,* edited by Tania Modleski, 18–36. Bloomington and Indianapolis: Indiana University Press, 1986.

Goepper, Roger. "Stone Rubbing." In *Chinese Art,* vol. 3, edited by Werner Speiser, Roger Goepper, and Jean Fribourg, 245–72. New York: Universe Books, 1965.

Goodrich, Luther Carrington. *Dictionary of Ming Biography.* New York: Columbia University Press, 1976.

Goodwin, Craufurd D., ed. *Art and the Market: Roger Fry on Commerce in Art.* Ann Arbor: University of Michigan Press, 1998.

Gramsci, Antonio. *Selections from the Prison Notebooks.* Edited and translated by Quintin Hoare and Geoffrey Nowell Smith. London: Lawrence and Wishart, 1971.

Greenbaum, Jamie. *Chen Jiru (1558–1639): The Development and Subsequent Uses of Literary Personae.* Leiden, Netherlands: Brill Academic, 2007.

Habermas, Jürgen. *The Structural Transformation of the Public Sphere: An Inquiry into a Category of Bourgeois Society.* Translated by Thomas Burger. Cambridge: M.I.T. Press, 1989.

Hall, Stuart. "Notes on Deconstructing 'The Popular.'" In *People's History and Socialist Theory,* edited by Raphael Samuel, 227–39. London: Routledge & Kegan Paul, 1981.

Han, Sungmi Li. "Wu Chen's 'Mo-chu P'u': Literati Painter's Manual on Ink Bamboo." Ph.D. diss., Princeton University, 1983.

Hanan, Patrick D. "Sources of the *Chin p'ing mei.*" *Asia Major* 10 (1963): 23–67.

———. "The Text of *Chin p'ing mei.*" *Asia Major* 9 (1962): 1–57.

Handlin-Smith, Joanna F. "Gardens in Ch'i Piao-chia's Social World: Wealth and Values in Late-Ming Kiangnan." *The Journal of Asian Studies* 51, no. 1 (February 1992): 55–81.

Harrist, Robert, ed. "Copies, All the Way Down: Notes on the Early Transmission of Calligraphy by Wang Xizhi." *East Asian Library Journal* 20, no. 1 (2001): 176–96.

———. *The Embodied Image: Chinese Calligraphy from the John B. Elliott Collection.* Princeton, N.J.: Princeton University Press, 1999.

————. *The Landscape of the Words: Stone Inscriptions from Early and Medieval China.* Seattle: University of Washington Press, 2008.

————. "Reading Chinese Mountains: Landscape and Calligraphy in China." *Orientations* (December 2000): 64–69.

Hay, John. "The Body Invisible in Chinese Art?" In *Body, Subject and Power in China*, edited by Angela Zito and Tani Barlow, 42–77. Chicago: University of Chicago Press, 1994.

Hearn, Maxwell K. "The Artist as Hero." In *Possessing the Past*, edited by Wen Fong and James C.Y. Watt, 299–323. New York: Metropolitan Museum of Art, 1996.

————. *Cultivated Landscapes: Chinese Paintings from the Collection of Marie-Hélène and Guy Weill.* New York: Yale University Press, 2002.

Hegel, Robert E. "Distinguishing Levels of Audiences for Ming-Ch'ing Vernacular Literature: A Case Study." In *Popular Culture in Late Imperial China*, edited by David Johnson, Andrew J. Nathan, Evelyn S. Rawski, 112–42. Berkeley: University of California Press, 1985.

————. *The Novel in Seventeenth-Century China.* New York: Columbia University, 1981.

————. "Painting Manuals and the Illustration of Ming and Qing Popular Literature." *The East Asian Library Journal* 10, no. 1 (Spring 2001): 53–84.

————. *Reading Illustrated Fiction in Late Imperial China.* Stanford, Calif.: Stanford University Press, 1998.

Hightower, James R., and Florence Chia-ying Yeh. *Studies in Chinese Poetry.* Cambridge, Mass.: Harvard University Asia Center, 1998.

Ho Ping-ti. "Aspects of Social Mobility in China, 1368–1911." *Comparative Studies in Society and History* 1, no. 4 (1959): 330–59.

————. *The Ladder of Success in Imperial China: Aspects of Social Mobility, 1368–1911.* New York: John Wiley & Sons, 1962.

————. *Studies on the Population of China, 1368–1953.* Cambridge, Mass.: Harvard University Press, 1959.

Ho Wai-kam. "Late Ming Literati: Their Social and Cultural Ambience." In *The Chinese Scholar's Studio: Artistic Life in the Late Ming Period*, edited by Chu-Tsing Li and James C.Y. Watt, 23–36. New York: Thames and Hudson, 1987.

————, ed. *The Century of Tung Ch'i-ch'ang.* Kansas City, Mo.: Nelson-Atkins Museum of Art; Seattle: University of Washington Press, 1992.

Ho Wai-kam et al. *Eight Dynasties of Chinese Painting: The Collection of the Nelson Gallery-Atkins Museum, Kansas City, and the Cleveland Museum of Art.* Cleveland: Cleveland Museum of Art, 1980.

Hou, Sharon Shih-jiuan. "Women's Literature." In *The Indiana Companion to Traditional Chinese Literature*, edited by William H. Nienhauser, Jr., 175–94. Bloomington: Indiana University Press, 1986.

Hsia, C.T. *The Classic Chinese Novel: A Critical Introduction.* New York: Columbia University Press, 1968.

Hsu Pi-ching. "Courtesans and Scholars in the Writings of Feng Menglong: Transcending Status and Gender." *Nan Nü* 2, no. 1 (2000): 40–77.

Hsu Wen-chin. "Fictional Scenes on Chinese Transitional Porcelain (1620– ca. 1683) and Their Sources of Decoration." *The Museum of Far Eastern Antiquities*, no. 58 (1986): 1–146.

Hsü, Cheng-chi Ginger. "Incarnations of the Blossoming Plum." *Ars Orientalis* 25 (1996): 23–45.

Hu, Phillip, ed. *Visible Traces: Rare Books and Special Collections from the National Library of China.* New York: Queens Borough Public Library, 2000.

Huang, Martin. *Desire and Fictional Narrative in Late Imperial China.* Cambridge, Mass.: Harvard University Press, 2001.

Hummel, Arthur, ed. *Eminent Chinese of the*

Ch'ing Period. Washington, D.C.: United States Printing Office, 1943–1944.

Hyland, Alice R.M. "Wen Chia and Suchou Literati." In *Artists and Patrons: Some Social and Economic Aspects of Chinese Painting*, edited by Chu-Tsing Li, 127–38. Lawrence: University of Kansas Press, 1989.

Ivins, William M., Jr. *Prints and Visual Communication*. New York: Da Capo, 1969.

Jang, Scarlette Ju-yu. "Form, Content, and Audience: A Common Theme in Painting and Woodblock-Printed Books of the Ming Dynasty." *Ars Orientalis* 27 (1997): 1–26.

———. "Issues of Public Service in the Themes of Chinese Court Painting." Ph.D. diss., University of California, Berkeley, 1989.

Jie Zhao, "Ties That Bind: The Craft of Political Networking in Late Ming China." *T'oung Pao* 86 (2000): 136–64.

Johns, Adrian. *The Nature of the Book: Print and Knowledge in the Making*. Chicago: University of Chicago Press, 1998.

Kafalas, Philip A. *In Limpid Dream: Nostalgia and Zhang Dai's Reminiscences of the Ming*. Norwalk, Conn.: EastBridge, 2007.

Ko, Dorothy. "Pursuing Talent and Virtue: Education and Women's Culture in Seventeenth- and Eighteenth-Century China." *Late Imperial China* 13, no. 1 (June 1992): 9–39.

———. *Teachers of the Inner Chambers: Women and Culture in Seventeenth-Century China*. Stanford, Calif.: Stanford University Press, 1994.

———. "Toward a Social History of Women in Seventeenth-Century China." Ph.D. diss., Stanford University, 1989.

Kobayashi Hiromitsu. "Publishers and Their *Hua-p'u* in the Wanli Period: The Development of the Comprehensive Painting Manual in the Late Ming." *Gugong xueshu jikan* 故宮學術季刊 22, no. 2 (2005): 167–98.

Kobayashi Hiromitsu and Samantha Sabin.

"The Great Age of Anhui Printing." In *Shadows of Mt. Huang: Chinese Painting and Printing of the Anhui Province*, edited by James Cahill, 25–33. Berkeley, Calif.: University Art Museum, 1981.

Kuo, Jason Chi-Sheng. "Hui-Chou Merchants as Art Patrons in the Late Sixteenth and Early Seventeenth Centuries." In *Artists and Patrons: Some Social and Economic Aspects of Chinese Painting*, edited by Chu-Tsing Li, 177–88. Lawrence: University of Kansas Press, 1989.

Laing, Ellen J. "Chinese Palace-Style Poetry and the Depiction of 'A Palace Beauty.'" *Art Bulletin* 72, no. 2 (June 1990): 284–95.

———. "Chou Tan-Ch'üan Is Chou Shih-Ch'en: A Report on a Ming Dynasty Potter Painter and Entrepreneur." *Oriental Art* 21, no. 3 (1975): 224–29.

———. "Erotic Themes and Romantic Heroines Depicted by Ch'iu Ying." *Archives of Asian Art* 49 (1996): 68–91.

———. "From Sages to Revellers: 17th-Century Transformations in Chinese Painting Subjects." *Oriental Art* 41, no. 1 (Spring 1995): 25–33.

———. "Real or Ideal: The Problem of the 'Elegant Gathering in the Western Garden' in Chinese Historical and Art Historical Records." *Journal of the American Oriental Society* 88, no. 3 (1968): 419–35.

———. "Sixteenth-Century Patterns of Art Patronage: Qiu Ying and the Xiang Family." *Journal of the American Oriental Society* 109, no. 1 (1991): 1–7.

———. "Wives, Daughters, and Lovers: Three Ming Dynasty Women Painters." In *Views from Jade Terrace: Chinese Women Artists, 1300–1912*, edited by Marsha Weidner, 31–39. New York: Rizzoli, 1988.

Lee, Thomas. "Books and Bookworms in Song China: Book Collection and the Appreciation of Books." *Journal of Sung-Yuan Studies* 25 (1995): 193–218.

Leppert, Richard. *Art and the Committed Eye: The Cultural Functions of Imagery*. Boulder, Colo.: Westview Press, 1996.

————. *The Sight of Sound: Music, Representation, and the History of the Body*. Berkeley and Los Angeles: University of California Press, 1993.

Li Chu-tsing. "The Oberlin Orchid and the Problem of P'u Ming." *Archives of the Chinese Art Society of America* 16 (1962): 49–76.

Li Hua. *Chinese Woodcuts*. Translated by Zuo Boyang. Beijing: Foreign Languages Press, 1995.

Li Wai-yee. "The Late Ming Courtesan: Invention of a Cultural Ideal." In *Writing Women in Late Imperial China*, edited by Ellen Widmer and Kang-i Sun Chang, 46–73. Stanford, Calif.: Stanford University Press, 1997.

————. "Rhetoric of Spontaneity in Late-Ming Literature." *Ming Studies* 35 (1995): 32–52.

Lin, Li-chiang. "The Proliferation of Images: The Ink-Stick Designs and the Printing of the Fang-Shih Mo-P'u and the Ch'eng-Shih Mo-Yuan." Ph.D. diss., Princeton University, 1998.

Lin Yutang. *The Chinese Theory of Art*. New York: Putnam, 1967.

Lippe, Aschwin. "Li K'an und seine 'Ausfürliche Beschreibung des Bambus,' Beitrage zur Bambusmalerei der Yüan-Zeit." *Ostasiatische Zeitschrift, Neue Folge* 18, no. 1/2 (1942–1943): 1–35; no. 3/4: 83–114; no. 5/6: 166–83.

Liscomb, Kathlyn M. "Social Status and Art Collecting: The Collection of Shen Zhou and Wang Zhen." *Art Bulletin* 78 (March 1996): 111–36.

Little, Stephen. "Dimensions of a Portrait: Du Jin's *The Poet Lin Bu Walking in the Moonlight*." *Bulletin of the Cleveland Museum of Art* 75, no. 9 (1988): 331–51.

————. "Literati Views of the Zhe School." *Oriental Art* 37, no. 4 (1991/1992): 192–208.

Liu, James J.Y. *The Poems of Li Shangyin*. Chicago: University of Chicago Press, 1969.

Liu Yiqing (Liu I-ch'ing). *A New Account of Tales of the World*. Translated by Richard Mather. 2nd edition, revised. Ann Arbor: Center for Chinese Studies, University of Michigan, 2002.

Lo Ch'ing. *Guide to Capturing a Plum Blossom*. San Francisco: Mercury House, 1995.

Loehr, Max. "The Beginning of Portrait Painting in China." *Proceedings of the International Congress of Oritentalists*, 25th Congress, vol. 5, Moscow (1960): 210–14.

————. *Chinese Landscape Woodcuts*. Cambridge, Mass.: Harvard University Press, 1968.

Lowry, Kathryn. "Duplicating the Strength of Feeling: The Circulation of *Qingshu* in the Late Ming." In *Writing and Materiality in China: Essays in Honor of Patrick Hanan*, edited by Judith T. Zeitlin and Lydia H. Liu, 239–70. Cambridge, Mass.: Harvard University Asia Center, 2003.

————. "Personal Letters in Seventeenth-Century Epistolary Guides." In *Under Confucian Eyes: Writings on Gender in Chinese History*, edited by Susan Mann and Yu-Yin Cheng, 155–68. Berkeley: University of California Press, 2001.

Lufrano, Richard. *Honorable Merchants: Commerce and Self-Cultivation in Late Imperial China*. Honolulu: University of Hawaii Press, 1997.

Lust, John. *Chinese Popular Prints*. Leiden, Netherlands: E.J. Brill, 1996.

Macdonald, Dwight. "A Theory of Mass Culture." In *Mass Culture: The Popular Arts in America*, edited by Bernard Rosenberg and David Manning White, 59–73. Glencoe, Ill.: Free Press, 1957.

MacGregor, William B. "The Authority of Prints: An Early Modern Perspective." *Art History* 22, no. 3 (September 1999): 389–420.

Maeda, Robert J. *Two Sung Texts on Chinese Painting and the Landscape Styles of the 11th and 12th Centuries*. New York: Garland Publishing, 1978.

Mann, Susan. *Precious Records: Women in China's Long Eighteenth Century*. Stanford, Calif.: Stanford University Press, 1997.

———. "Widows in the Kinship, Class, and Community Structure of Qing Dynasty China." *Journal of Asian Studies* 46, no. 1 (February 1987): 37–56.

Mann, Susan, and Yu-Yin Cheng, eds. *Under Confucian Eyes: Writings on Gender in Chinese History*. Berkeley: University of California Press, 2001.

Marling, Karal Ann. *As Seen on TV: The Visual Culture of Everyday Life in the 1950s*. Cambridge, Mass.: Harvard University Press, 1994.

Marmé, Michael. *Suzhou: Where the Goods of All the Provinces Converge*. Stanford, Calif.: Stanford University Press, 2005.

Masao, Mori. "Gentry in the Ming—An Outline of the Relations between the Shih-ta-fu and Local Society." *Acta Asiatica* 38 (1980): 31–53.

McDermott, Joseph P. "The Art of Making a Living in Sixteenth-Century China." *Kaikodo Journal* 5 (Autumn 1997): 63–81.

McLaren, Anne E. "Investigating Readership in Late-Imperial China: A Reflection on Methodologies." *East Asian Library Journal* 10, no. 2 (2001): 104–59.

———. "Popularising *The Romance of the Three Kingdoms*: A Study of Two Early Editions." *Journal of Oriental Studies* 33, no. 2 (1995): 165–85.

McNair, Amy. "Engraved Calligraphy in China: Recession and Reception." *Art Bulletin* 160, no. 1 (March 1995): 106–14.

———. "The Engraved Model-Letters Compendia of the Song Dynasty." *Journal of the American Oriental Society* 114, no. 2 (1994): 209–25.

McTighe, Sheila. "Abraham Bosse and the Language of Artisans: Genre and Perspective in the Academie royale de peinture et de sculpture, 1648–1670." *Oxford Art Journal* 21, no. 1 (1998): 1–26.

Meskill, John. *Ch'oe Pu's Diary: A Record of Drifting across the Sea*. Tucson: University of Arizona Press, 1965.

———. *Gentlemanly Interests and Wealth on the Yangtze Delta*. New York: AAS, 1994.

Mirzoeff, Nicholas. *An Introduction to Visual Culture*. London and New York: Routledge, 1999.

Monnet, Nathalie. *Chine: L'empire du trait: Calligraphies et Dessins du Ve au XIXe siècle*. Paris: Bibliothèque nationale de France, 2004.

Morton, Dianne L. "Paintings as Social Rhetoric: Wei-Jin Themes in Ming Dynasty Illustrations and Inscriptions." Ph.D. diss., University of Kansas, 2001.

Moss, Paul. *Emperor, Scholar, Artisan, Monk: The Creative Personality in Chinese Works of Art*. London: Sydney L. Moss, 1984.

Mote, Frederick, and Hung-lam Chu. *Calligraphy and the East Asian Book*. Boston: Shambhala, 1989.

Murck, Christian. *Artists and Traditions: Uses of the Past in Chinese Culture*. Princeton, N.J.: Princeton University Press, 1976.

Murray, K. Julia. "The Hangzhou *Portraits of Confucius and Seventy-two Disciples (Sheng xian tu)*: Art in the Service of Politics." *Art Bulletin* 4, no. 1 (1992): 7–18.

———. "Illustrations of the Life of Confucius: Their Revolution, Functions, and Significance in Late Ming China." *Artibus Asiae* 57, nos. 1/2 (1997): 73–134.

———. "The Temple of Confucius and Pictorial Biographies of the Sage." *Journal of Asian Studies* 55, no. 2 (May 1996): 269–300.

Nelson, Susan. "Catching Sight of South Mountain: Tao Yuanming, Mount Lu, and the Landscape of Escape." *Archives of Asian Art* 52 (2000–2001): 11–43.

———. "Revisiting the Eastern Fence: Tao Qian's Chrysanthemums." *Art Bulletin* 83, no. 3 (September 2001): 437–60.

———. "Tao Yuanming's Sashes: Or, The Gendering of Immortality." *Ars Orientalis* 39 (1999): 1–27.

Nienhauser, William. "A Reading of the Poetic Captions in an Illustrated Version of the *Sui Yang-ti Yen-shih*." *Hanxue yanjiu* 6, no. 1 (1991): 17–35.

O'Neil, Eileen. "(Re)Presentations of Eros:

Exploiting Female Sexual Agency." In *Gender, Body, Knowledge: Female Reconstructions of Being and Knowing*, edited by Alison M. Jaggar and Susan R. Bordo, 68–91. New Brunswick, N.J.: Rutgers University Press, 1990.

Orenstein, Nadine. *Hendrick Hondius and the Business of Prints in Seventeenth-Century Holland*. Rotterdam: Sound & Vision Interactive, 1996.

———. "Marketing Prints to the Dutch Republic: Novelty and the Print Publisher." *Journal of Medieval and Early Modern Studies* 28, no. 1 (1998): 141–65.

Park, J.P. "Instrument as Device: Social Consumption of the Qin Zither in Late Ming China (1550–1644)." *Music in Art: International Journal for Music Iconography* 43, nos.1–2 (2008): 136–48.

———. "The Publisher's Dilemma: A Study of Editorial Statements on Late Ming Book Illustrations (1550–1644)." *Chinese Historical Review* 15, no. 1 (2008): 25–49.

Parshall, Peter. "Prints as Objects of Consumption in Early Modern Europe." *Journal of Medieval and Early Modern Studies* 28, no. 1 (1998): 19–36.

Peterson, Willard J. *Bitter Gourd: Fang I'chih and the Impetus for Intellectual Change*. New Haven, Conn.: Yale University Press, 1979.

Plaks, Andrew H. "Aesthetics of Irony in Late Ming Literature and Painting." In *Word and Images: Chinese Poetry, Calligraphy, and Painting*, edited by Alfreda Murck and Wen C. Fong, 487–500. Princeton, N.J.: Princeton University Press, 1991.

———. *The Power of Culture: Studies in Chinese Cultural History*. Hong Kong: Chinese University Press, 1994.

Pollard, David. *A Chinese Look at Literature: The Literature Values of Chou Tso-jen in Relation to the Tradition*. Berkeley: University of California Press, 1973.

Powers, Martin J. "Garden Rocks, Fractals and Freedom: Tao Yuanming Comes Home." *Oriental Art* 49 (Winter 1998): 28–38.

———. "Love and Marriage in Song China: Tao Yuanming Comes Home." *Ars Orientalis* 28 (1998): 51–62.

———. "When Is a Landscape Like a Body?" In *Landscape, Culture and Power*, edited by Yeh Xin Liu, 1–21. Berkeley, Calif.: Center for Chinese Studies, 1998.

Qian Nanxiu. *Spirit and Self in Medieval China: The Shih-shuo hsin-yü and Its Legacy*. Honolulu: University of Hawaii Press, 2001.

Ransome, Paul. *Antonio Gramsci: A New Introduction*. New York: Prentice-Hall, 1992.

Rawski, Evelyn. "Economic and Social Foundations of Late Imperial Culture." In *Popular Culture in Late Imperial China*, edited by David Johnson, Andrew J. Nathan, and Evelyn S. Rawski, 3–33. Berkeley: University of California Press, 1985.

———. *Education and Popular Literature in Ch'ing China*. Ann Arbor: University of Michigan Press, 1979.

Ricoeur, Paul. *Time and Narrative*. Translated by Kathleen Blamey and David Pellauer. Chicago: University of Chicago Press, 1985.

Riggs, Timothy. *Graven Images: The Rise of Professional Printmakers in Antwerp and Haarlem, 1540–1640*. Evanston, Ill.: Northwestern University Press, 1993.

Rolston, David L. "Formal Aspects of Fiction Criticism and Commentary in China." In *How to Read the Chinese Novel*, edited by David Rolston, 42–74. Princeton, N.J.: Princeton University Press, 1990.

Ropp, Paul. *Banished Immortal: Searching for Shuangqing, China's Peasant Woman Poet*. Ann Arbor: University of Michigan Press, 2002.

———. "*Now Cease Painting Eyebrows, Don A Scholar's Cap and Pin*: The Frustrated Ambition of Wang Yun, Gentry Woman Poet and Dramatist." *Ming Studies* 40 (1999): 86–100.

Ruskin, John. *Modern Painters*. Boston: D. Estes, 1900.

Sakai Tadao. "Confucianism and Popular Educational Works." In *Self and Society in Ming Thought*, edited by William Theodore de Bary, 331–66. New York: Columbia University Press, 1970.

Schorr, Adam. "Connoisseurship and the Defense against Vulgarity: Yang Shen (1488–1559) and His Work." *Monumenta Serica* 16 (1993): 89–128.

Seckel, Dietrich. "The Rise of Portraiture in Chinese Art." *Artibus Asiae* 53, no. 1/2 (1993): 7–26.

Sekula, Allan. "The Body and the Archive." *October* 39 (1986): 3–64.

Sellink, Manfred. "As a Guide to the Highest Learning: An Antwerp Drawing Book Dated 1589." *Simiolus* 21, no. 1/2 (1992): 40–56.

Shang Wei. "*Jin Ping Mei* and Late Ming Print Culture." In *Writing and Materiality in China: Essays in Honor of Patrick Hanan*, edited by Judith T. Zeitlin and Lydia H. Liu, 187–238. Cambridge, Mass.: Harvard University Asia Center, 2003.

———. "The Making of the Everyday World: *Jin Ping Mei* and Encyclopedias for Daily Use." In *Dynastic Decline and Cultural Innovations: From the Late Ming to the Late Qing*, edited by David Der-wei Wang and Shang Wei, 63–92. Cambridge, Mass.: Harvard University Asia Center, 2005.

Shen, Grant. "Acting in the Private Theatre of the Ming Dynasty." *Asian Theater Journal* 15, no. 1 (Spring 1998): 64–86.

Shih Shou-Chien. "The Landscape Painting of Frustrated Literati: The Wen Chengming Style in the Sixteenth Century." In *The Power of Culture: Studies in Chinese Cultural History*, edited by Willard J. Peterson, Andrew H. Plaks, and Ying-shih Yü, 218–46. Hong Kong: Chinese University Press, 1944.

Shio Sakanishi. *The Spirit of the Brush*. London: John Murray, 1949.

Siggstedt, Mette. "Forms of Fate: An Investigation of the Relationship between Formal Portraiture, Especially Ancestral Portraits, and Physiognomy (*xiangshu*) in China." In *Proceedings of the International Colloquium on Chinese Art History*, 713–48. Taipei: National Palace Museum, 1991.

Sirén, Osvald. *The Chinese on the Art of Painting: Translations and Comments*. New York: Schocken Books, 1963.

———. *Chinese Paintings: Leading Masters and Principles*. New York: Ronald Press, 1956.

Soper, Alexander. "Some Technical Terms in the Early Literature of Chinese Painting." *Harvard Journal of Asiatic Studies* 11 (1948): 163–73.

Spiro, Audrey. *Contemplating the Ancients*. Berkeley: University of California Press, 1990.

Stanley-Baker, Joan. *Old Masters Reprinted*. Hong Kong: Hong Kong University Press, 1992.

Starr, Kenneth. *Black Tigers: A Grammar of Chinese Rubbings*. Seattle and London: University of Washington Press, 2008.

Strassberg, Richard. *Inscribed Landscape: Travel Writing from Imperial China*. Berkeley: University of California Press, 1994.

Strinati, Dominic. *An Introduction to Theories of Popular Culture*. London: Routledge, 1995.

Swartz, Wendy. *Reading Tao Yuanming: Shifting Paradigms of Historical Reception (427–1900)*. Cambridge, Mass.: Harvard University Asia Center, 2008.

Sze, Mai-mai. *The Way of Chinese Painting: Its Ideas and Technique*. New York: Vintage Books, 1959.

Talbot, Charles. "Prints and the Definitive Image." In *Print and Culture in the Renaissance*, edited by Gerald P. Tyson and Sylvia S. Wagonheim, 189–205. Newark: University of Delaware Press, 1986.

T'ien Ju-k'ang. *Male Anxiety and Female Chastity: A Comparative Study of Chinese Ethical Values in Ming-Ch'ing Times*. Leiden, Netherlands: E.J. Brill, 1988.

Tseng Yuho. "Women Painters of the Ming Dynasty." *Artibus Asiae* 53, no. 1/2 (1993): 249–61.

Tsien, Tsuen-hsuin. *Paper and Printing: Science and Civilization in China*, vol. 5, pt.1. Cambridge: Cambridge University Press, 1985.

———. "Technical Aspects of Chinese Printing." In *Chinese Rare Books in American Collections*, edited by Sören Edgren, 16–25. New York: China Institute in America, 1984.

Van Gulik, R. H. *Chinese Pictorial Art: As Viewed by the Connoisseur*. New York: Hacker Art Books, 1981.

———. *The Lore of the Chinese Lute: An Essay in the Ideology of the Ch'in*. Tokyo: Sophia University, 1969.

———. *Sexual Life in Ancient China*. Leiden, Netherlands: E.J. Brill, 1961.

Veblen, Thorstein. *Theory of the Leisure Class*. 1899. Reprint, New York: Modern Library, 2001.

Vicinus, Martha. "Introduction: The Perfect Victorian Lady." In *Suffer and Be Still: Women in the Victorian Age*, edited by Martha Vicinus, vi–xv. Bloomington: Indiana University Press, 1972.

Vinograd, Richard. "Private Art and Public Knowledge in Later Chinese Painting." In *Images of Memory*, edited by Susan Küchler and Walter Melion, 176–202. Washington, D.C.: Smithsonian Institution Press, 1991.

———. "Situation and Response in Traditional Chinese Scholar Painting." *Journal of Aesthetics and Art Criticism* 46, no. 3 (Spring 1988): 365–74.

———. *The Southern Metropolis: Pictorial Art in 17th-Century Nanjing*. Stanford, Calif.: Iris & B. Gerald Cantor Center, 2002.

Volkmar, Barbara. "The Physician and the Plagiarists: The Fate of the Legacy of Wan Quan." *East Asian Library Journal* 9, no. 1 (Spring 2000): 1–77.

Waltner, Ann. "Building on the Ladder of Success: The Ladder of Success in Imperial China and Recent Work on Social Mobility." *Ming Studies* 17 (1983): 25–55.

Wang, Eugene. *Treasures of the Yenching: Exhibition Catalogue*. Cambridge, Mass.: Harvard University Press, 2003.

Weidner (Haufler), Marsha. "Women in the History of Chinese Painting." In *Views from Jade Terrace: Chinese Women Artists, 1300–1912*, 13–29. New York: Rizzoli, 1988.

Weitz, Ankeney. "Sung Dynasty Fan Painting and the Late Ming Antiquities Market." Paper presented at the International Symposium on Antiquarianism and Novelty: Art Appreciation in Ming and Ch'ing China, Taipei, National Palace Museum, January 2005.

Wen Fong. *Beyond Representation: Chinese Painting and Calligraphy, 8th–14th Century*. New York: Metropolitan Museum of Art, 1992.

———. "Monumental Landscape Painting." In *Possessing the Past: Treasures from the National Palace Museum, Taipei*, 121–37. New York: Metropolitan Museum of Art, 1996.

West, Stephen H., and Wilt L. Idema. "Sexuality and Innocence: The Characterization of Oriole in the Hongzhi Edition of the *Xixiang ji*." In *Paradoxes of Traditional Chinese Literature*, edited by Eva Hung, 21–59. Hong Kong: Chinese University Press, 1994.

White, Hayden. *The Content of the Form: Narrative, Discourse and Historical Representation*. Baltimore: Johns Hopkins University Press, 1987.

Widmer, Ellen. "The Epistolary World of Female Talent in Seventeenth-Century China." *Late Imperial China* 10, no. 2 (1989): 1–43.

———. "The Huanduzhai of Hangzhou and Suzhou: A Study in Seventeenth-Century Publishing." *Harvard Journal of Asiatic Studies* 56, no. 1 (June 1996): 77–122.

Williams, Raymond. *Keywords: A Vocabulary of Culture and Society*. New York: Oxford University Press, 1976.

———. *Problems in Materialism and Culture.* London: NLB, 1980.

Wilson, Jean. *Painting in Bruges at the Close of the Middle Ages: Studies in Society and Visual Culture.* University Park: Pennsylvania State University Press, 1998.

Wong, Ka. F. "The Anatomy of Eroticism: Reimagining Sex and Sexuality in the Late Ming Novel *Xiuta yeshi.*" *Nan Nü* 9 (2007): 284–29.

Wong, Kwan S. "Hsiang Yüan-Pien and Suchou Artists." In *Artists and Patrons: Some Social and Economic Aspects of Chinese Painting*, edited by Chu-Tsing Li, 155–58. Lawrence: University of Kansas Press, 1989.

Wood, Frances. *Chinese Illustration.* London: British Library, 1985.

Wright, Suzanne Elaine. "*Luoxuan Biangu Jianpu* and *Shizhuzhai Jianpu*: Two Late-Ming Catalogues of Letter Paper Designs." *Artibus Asiae* 63, no. 1 (2003): 69–122.

Wu Hung. "On Rubbings: Their Materiality and Historicity." In *Writing and Materiality in China: Essays in Honor of Patrick Hanan*, edited by Judith Zeitlin and Lydia Liu, 29–72. Cambridge, Mass.: Harvard University Asian Center, 2003.

———. "The Origins of Chinese Painting." In *Three Thousand Years of Chinese Painting*, 15–85. New Haven, Conn., and London: Yale University Press, 1997.

Wu, K.T. "Ming Printing and Printers." *Harvard Journal of Asiatic Studies* 7 (February 1943): 203–61.

Wu, Nelson I. "Tung Ch'i-ch'ang (1555–1636): Apathy in Government and Fervor in Art." In *Confucian Personalities*, edited by Arthur F. Wright and Denis Twitchett, 260–93. Stanford, Calif.: Stanford University Press, 1962.

Wu, P.S. Marshall. *The Orchid Pavilion Gathering: Chinese Painting from the University of Michigan Museum of Art.* Ann Arbor: University of Michigan Press, 2000.

Xiao Chi. *The Chinese Garden as Lyrical Enclave: A Generic Study of the Story of the Stone.* Ann Arbor: University of Michigan Press, 2001.

Yang Shuhui. *Appropriation and Representation: Feng Menglong and the Chinese Vernacular Story.* Ann Arbor: Center for Chinese Studies, University of Michigan, 1998.

Yang Ye. *Vignettes from the Late Ming: A Hsiao-p'in Anthology.* Seattle and London: University of Washington Press, 1999.

Yao Dajuin. "The Pleasure of Reading Drama: Illustrations to the Hongzhi Edition of the *Story of the Western Chamber.*" In *The Moon and the Zither*, edited by Stephen H. West and Wilt L. Idema, 437–68. Berkeley: University of California Press, 1991.

Ye Dehui. "Bookman's Decalogue." Translated by Achilles Fang. *Harvard Journal of Asiatic Studies* 13 (1950): 133–73.

Zeitlin, Judith. "Disappearing Verses: Writing on Walls and Anxieties of Loss." In *Writing and Materiality in China*, edited by Judith T. Zeitlin and Lydia H. Liu, 73–125. Cambridge, Mass.: Harvard University Asia Center, 2003.

———. "The Petrified Heart: Obsession in Chinese Literature, Art, and Medicine." *Late Imperial China* 12, no. 1 (1991): 1–26.

———. "Shared Dreams: The Story of the Three Wives' Commentary on the Peony Pavilion." *Harvard Journal of Asiatic Studies* 54, no. 1 (1994): 127–79.

Zhao Changcai. "The History of Ancient Chinese Books." *Chinese Literature* 2 (1993): 184–89.

Zhao, Henry. "Subculturalness as Moral Paradox: A Study of the Texts of the White Rabbit Play." In *Paradoxes of Traditional Chinese Literature*, edited by Eva Hung, 89–122. Hong Kong: Chinese University Press, 1984.

Zhao Qian and Zhang Zhiqing. "Book Publishing by the Princely Household during the Ming Dynasty: A Preliminary Study." *East Asian Library Journal* 10, no. 1 (2001): 85–128.

Index

banana plant images, 90, 173, 181, 239n11

Barthes, Roland, 27, 96, 120, 136

"A Beauty and a Parrot," in Chen's *Story of the Western Chamber,* 173

A Beauty and a Red Leaf, 176

A Beauty Writing on a Red Leaf, 176

Bencao gangmu (Li Shizhen), 229n77

Benjamin, Walter, 206

Bequested Jades to Plum Village, 53

Bian Wenjin, 75, 254n10

Bickford, Maggie, 33, 78–79, 194

Biographies of Notable Women, 187

bird images: early Ming manuals, 43, 46–47; with embroidery theme, 252n45; and female images, 170–73; and gender roles, 196–98; in pre-Ming manuals, 195, 254n10; study sketches, 27, pl. 3; title meanings, 254n11; in Zhou's painting manuals, 57–58, 60, 67, 88, 195–96, 254n9; in Zhu's *Great Synthesis,* 75

"Birds on a Peach Branch," 198

blank surface format, figure images, 126–29, 245nn19–20, pl.5

Blue Stream Society, 54

Bodhisattva images, in *Canon of Paintings,* 70, 237n107

Bolten, Jaap, 30

Book of Horticulture (Guo Tuotuo), 66

Borges, Jorge Luis, 84

botanical images. *See specific plants, e.g.,* bamboo painting; orchid painting

boundary blurring: class structure, 14–16, 227nn48–50, n52, n56; elegant *vs.* vulgar categories, 117–19, 243nn80–81; literati class, 14–16, 117–19, 227n56, 228n62, n68, 244n87; popular culture, 117–19, 213–16, 244n87

Bourdieu, Pierre, 96–97

bridge image, in songbook, 107–8

Brisk West Club, 15

Brook, Timothy, 14–15

Broom Tree Stream Union, 15

brushstroke techniques: in *Elementary Learning* manual, 77, 78f; lists of, 124, 244n17; Wu Daozi's reputation, 121–22, 126–27

Bryson, Norman, 203

bureaucracy, examinations, 9, 10, 12–13, 226n42

Burnett, Katharine, 210

Bussotti, Michela, 241n51

Butterfly Dream, 109–10

Cahill, James, 122, 239n5, 250n117, 254n3

Cai Ruzuo, 105

calligraphy, painting analogy, 121–23

"Calling a boy-attendant," in Zhou's *Heavenly Forms,* 138

Canon of Paintings, editions of: female images, 173–74; illustrator/carver names, 105; inspiration image, 246n59; locations of, 220; as recycled text, 67, 68–69, 96; recycling/pirating of, 69–73, 237n107, nn109–10, n112

Cao Xi, 164

Cao Zhao, 64–65

Cao Zhengyong, 152–53

Cao Zhongda, 121–22, 124

Carlitz, Katherine, 187

"Carrying a zither," in Zhou's *Heavenly Forms,* 142, 145f

Catalog of the Thousand-Volume Hall (Zhu Mujie), 232n34

Catalpa Leaf, 178f

catalpa stories/images, 131, 177–79, pl. 6

Chang'e legend, 174–75, 251nn19–20

"Chanting drunk," in Zhou's *Heavenly Forms,* 147, 150, 151f, 158

Chao Wujiu, 4

character-image duplication, summary formulas/songs, 194–95

Chartier, Roger, 114–15

Chavannes, Édouard, 138

Chen Bangtai, 51

Chen Baoliang, 248n95, 252n50

Chen Dongyuan, 252n50

Chen emperor, 127, pl. 5

Chen Hong, 127

Chen Hongshou, 105, 173, 208, 247n80, 251n15, pl. 16

Chen Jiru: as contributor, 53, 54, 55–56, 65, 234n71; degree abandonment, 14; friendships, 52, 227n56, 234n69; manual locations listed, 217; as mountain hermit ideal, 22; on study copies, 27; in Sun Pixian's book, 73; on Zhu Xi's paintings, 5, 6

drinking behavior: as consistent artwork motif, 151–52, 155–56, 161f, 162–63, 247n81, 249n104, pl. 11; criticisms of, 147, 248n92, n94; as independence symbol, 152; for inspiration, 35, 89, 133, 150–51, 246n59, n61, 247n73; at Orchid Pavilion Gathering, 156; sharing expectations, 148, 247n69; valorization of, 152–55, 159–60, 248nn95–96; wine bowl design, 162, pl. 12; wine cup game, 159–61, 163; in Zhou's *Heavenly Forms*, 147–50, 152, 154–55, 249n110

"Drinking up," in Zhou's *Heavenly Forms*, 148–49

drug use, admiration of, 152, 156, 248n83

Drunken Guest, 151

Drunken Scholars, 151

Drunken Scholars of the Jin Dynasty (Li Gonglin), 151

Du Fu, 121, 122, 148

Du Liniang, 181–82

Du Mu, 159

Du Qiong, 39–40

Du Wan, 32

Dummies series, painting manuals comparison, 205–6

Dunhuang Cave mural, pl. 7

duster images, in Zhou's *Heavenly Forms*, 136–37, 138–40

ears, in Zhou's *Heavenly Forms*, 125

Eastern Woods society, 52, 234n70

economic conditions, painting manual context, 7–9, 17–18, 225n21

editorial statements, 101–4, 107, 109–10, 111–12, 241n45

education system, 9, 12–13, 21, 185, 229n77

Eight Treatises on the Nurturing of Life (Gao Lian), 139

Eighteen Arhats (Zhou Lüjing), 155

Eighteen Sages of the Lotus Society (Zhou Lüjing), 155

elderly woman images, pounding clothes theme, 167–70

Elegant Gathering in the Western Garden, 144, 163–65, 250n119, pl. 9

elegant *vs.* vulgar categories, boundary blurring, 117–19, 243nn80–81

Elementary Learning in the Rules of Painting (Wang Siyi), 44, 77, 78f, 218

elite status pathway, 10–14, 227n46

Elle journal, 27

Elman, Benjamin, 12

embroidering theme, 182–84, 186, 252n42, pl. 14–15

"Emitting fragrance," in Zhou's *Lingering Beauty*, 201–2

"Emotions of the Inner Quarters," in *Collection of Songs*, 179–80

emotion/spirit advice: earliest Ming manuals, 39, 41–43, 232n41; in songbook editorial statement, 107–8; in Zhou's painting manuals, 86, 88–89, 123

Emperors of the Successive Dynasties (Yan Liben), pl. 5

erotica, pornography compared, 253n68

"An Essay on the Plum Blossom" (Xiao Gang), 202–3

Essential Criteria of Antiquities (Cao Zhao), 64–65

Eulogies and Portraits of Confucious and Seventy-two Disciples, 128f

An Everyman's Physiognomy (Lu Weichong), 80–81

examinations, imperial, 9, 10, 12–13, 226n42

Examinations of Paintings (Tang Hou), 94

Experiences in Painting... (Guo Ruoxu), 4, 94, 122

Exploitation of the Works of Nature, 128

Extensive Records from Secluded Doors (Zhou Lüjing), 51, 53, 57, 65–66, 236n92. See also *Grove of Paintings* (Zhou Lüjing)

eye/eyebrow shapes, drawing instructions, 81f, 82f, 125

family letters, generally, 251n37. *See also* leaf-writing scenes

Fan Chengda, 32–33, 34–35, 255n19

fan images, 136–37, 138, 139f, pl. 7

Fan Lian, 19–20

Fan Yunlin, 211

Fan-Village Plum Register (Fan Chengda), 32–33, 34–35

feather fan images, 136–37, 138, 139f, pl. 7

reference copies, 27–29, 256*n*42, pl. 3–4
"Regarding Painting Trees," in Zhou's *Painting Critique,* 90–91
Register of Bamboo (Gu Kaizhi), 67
Register of Paintings Left Over from Poetry, 83
Register of Plum Blossom Portraits (Song Boren), 30–32
religious figures: in *Canon of Paintings,* 69, 70, 237*n*107; in early Ming manuals, 44–45, 46*f,* 47; with feather fans, 138, pl. 7–8; in Wang's *Assembled Illustrations,* 238*n*124; in Zhou's *Heavenly Forms,* 124
religious societies, literary identification, 14–15
Ren Jitu, 178–79
Renowned Works of the Hundred Schools (Hu Wenhuan), 40, 232*n*37
review contributions, practice of, 53, 234*n*71, *n*75
rock images: in early Ming manuals, 43; leaf-writing scenes, 176, 177*f,* 181; pre-Ming manuals, 32, 37; reference copies, 27, 29, pl. 3; in Zhou's painting manuals, 88, 90–91, 98–100
rock/wall writing, 144–47, 247*n*63, *nn*65–67, pl. 9–10
romance literature, generally, 181–82, 252*n*38
Romance of the Lute, 81, 109
Romance of the Three Kingdoms, 77, 81, 104
Rongyutang, 250*n*7
Ropp, Paul, 181
Ruan Ji, 249*n*104
Rules of Decorum in Drinking (Yuan Hong-dao), 154, 248*n*96
rules section, in Zhou's *Painting Critique,* 85–86. *See also* summary formulas/songs
Ruskin, John, 202
ruyi images, 138, 139*f,* 141, pl. 7–8
Ruyuan, 113

sample images, standardization, 191, 193–95
Sang Zhenbai, 65
scholars. *See* literati class
seal imprints, in Zhou's *Forest of Paintings,* 59–60, 61*f*
"Searching for a phrase," in Zhou's *Heavenly Forms,* 144, 246*n*59
season motifs, 43, 87, 90, 239*n*6

"Seated firmly," in Zhou's *Heavenly Forms,* 246*n*47
Second Treatise on Bamboo (Liu Meizhi), 32
"Secrets of Landscape Painting" (Huang Gongwang), 86, 239*n*5
Secrets of Portraiture (Weng Ang), 80, 81, 217
Sekula, Allan, 127
sensuality portrayals, 180–81, 186–89, 202–3, 255*nn*19–20. *See also* female images
Seven Sages, 155–56, 164, 165, 249*n*100, *n*104
"The Seven Sages of the Bamboo Grove," in *Master Cheng's Ink-Stick Collection,* 162–63
sexual behavior, valorization of, 153–55, 248*n*92, *n*94. *See also* drinking behavior
Shadows over the Qi River (Zhou Lüjing), 66, 191–93, 253*n*1
Shan Tao, 249*n*104
Shen, Grant, 117, 243*n*81
Shen Bin, 223–24
Shen Defu, 4–5
Shen Gua, 89–90
Shen Shen, 154
Shen Xiang, 223
Shen Yixiu, 21, 229*n*77
Shen Zhou, 22, 100, 131, pl. 6
Sheng Maoye, 162
Sheng Zhenying, 233*n*50
shengyuan degrees, 10, 12–14, 226*n*42
Shi Guang, 67
Shi Quanshu, 121
Shimada Shūjirō, 33–34
Shitao, 208
Sima Guang, 4, 5–7
Single Whip Tax, 7
Sirén, Osvald, 91
"Sitting by water," in *Heavenly Forms,* 131, 132*f*
Six Canons rule, 85–86
Six Essentials rule, 85–86
Sketches after the Old Masters (Gu Jianlong), pl. 4
Sketches of Birds and Insects (Huang Quan), pl. 3
Sketches of Traditional Tree and rock Types (Dong Qichang), 27, 29*f*
Skinner, Cornelia Otis, 166